THE REDEMPTION OF THINGS

signale
modern german letters, cultures, and thought

Series editor: Peter Uwe Hohendahl, Cornell University

Signale: Modern German Letters, Cultures, and Thought publishes new English language books in literary studies, criticism, cultural studies, and intellectual history pertaining to the German-speaking world, as well as translations of important German-language works. *Signale* construes "modern" in the broadest terms: the series covers topics ranging from the early modern period to the present. *Signale* books are published under a joint imprint of Cornell University Press and Cornell University Library in electronic and print formats. Please see http://signale.cornell.edu/.

THE REDEMPTION OF THINGS

Collecting and Dispersal in German Realism and Modernism

SAMUEL FREDERICK

A Signale Book

CORNELL UNIVERSITY PRESS AND CORNELL UNIVERSITY LIBRARY
ITHACA AND LONDON

Cornell University Press and Cornell University Library gratefully acknowledge the College of Arts & Sciences, Cornell University, for support of the Signale series.

First published 2021 by Cornell University Press
and Cornell University Library

Library of Congress Cataloging-in-Publication Data

Names: Frederick, Samuel, author.
Title: The redemption of things: collecting and dispersal in German
 realism and modernism / Samuel Frederick.
Description: Ithaca [New York]: Cornell University Press and Cornell
 University Library, 2021. | Series: Signale: modern German letters,
 cultures, and thought | Includes bibliographical references and index.
Identifiers: LCCN 2021011477 (print) | LCCN 2021011478 (ebook) |
 ISBN 9781501761553 (hardback) | ISBN 9781501761560 (paperback) |
 ISBN 9781501761584 (pdf) | ISBN 9781501761577 (epub)
Subjects: LCSH: Object (Aesthetics) | Collectors and collecting. |
 German literature—19th century—History and criticism. |
 German literature—20th century—History and criticism.
Classification: LCC BH301.O24 F74 2022 (print) | LCC BH301.O24
 (ebook) | DDC 830.9/353—dc23
LC record available at https://lccn.loc.gov/2021011477
LC ebook record available at https://lccn.loc.gov/2021011478

For Henry,
collector extraordinaire

CONTENTS

ACKNOWLEDGMENTS

In writing this book I have benefited greatly from the input and support of many colleagues, students, and friends. Some answered specific research questions; others asked just the right questions of my research. Some made possible a venue for presenting my work in progress; others offered advice on specific aspects of that work. Some read and responded to early versions of chapters; others offered encouragement and support along the way. I thank you all: Erik Born, Ximena Briceño, Suzanne Buchan, Paul Buchholz, Sabine Doran, Eric Downing, Paul Flaig, Paul Fleming, Carl Gelderloos, Peter Gilgen, Eric Hayot, Laura Helton, Brook Henkel, Héctor Hoyos, Ilinca Iurascu, Anton Kaes, Julia Karolle-Berg, Michele Kennerly, Catriona MacLeod, Hannah Matangos, Patrizia McBride, Petra Mc-Gillen, Christopher Moore, Brad Prager, Daniel Purdy, Gonzalo Rubio, Anette Schwarz, Matt Tierney, Rochelle Tobias, Peter Utz, Adrian Wanner, William Waters, and Henning Wrage.

Special thanks go to Lea Pao for her enthusiasm and shrewd insights and for always being there to answer my questions about obscure German locutions, to Jeri Peck for teaching me about moss, and to Andrew Langridge for introducing me to Fischinger's *Walking from Munich to Berlin*. Drafts of different parts of the book were presented at Cornell University, Stanford University, Johns Hopkins University, Gettysburg College, and the University of California, Berkeley, as well as at the German Media Inventories Workshops at Dartmouth College and the University of Missouri, Columbia. I am grateful to the organizers of these events (whose names appear above) for the invitations and to the audiences for their incisive questions and feedback.

The first version of what would become chapter 2 was written while on faculty fellowship at Penn State's Center for Humanities and Information. The whole project was shaped by this semester and the intellectual exchange fostered by the director Eric Hayot. Chrisann Zuerner was my research assistant for one summer. Her help was indispensable. As successive heads of my department, Richard Page and Tom Beebee were essential to providing the needed time for research and writing. Archival research conducted at Yale's Beinecke Library was made by possible by a grant from the Botstiber Institute for Austrian-American Studies. The holdings at the Center for Visual Music, Los Angeles, were critical to writing chapter 3 on Oskar Fischinger. I am grateful to the director Cindy Keefer for accommodating me and for granting me permission to use two images from the archive. Some last-minute research for chapter 3 was carried out at the Cinematek in Brussels. I am appreciative of Nicolas Dernoncourt for making that visit and the subsequent writing possible. My father was always there for me when I needed something; his collection of Glauser in English, which he mailed to me at the drop of a hat, made adding translations to chapter 7 much easier.

A writing group consisting of Jonathan E. Abel, Benjamin Schreyer, and Jens Guettel provided support in the final stages of the project, even if that support was more moral (and of course bibulous) than always scholarly. The "Crew" in State College— Jessamyn Abel, Jon Abel, Jennifer Boittin, and Jens Guettel, as well

as Ben and Oliver—was a constant and essential source of support: intellectual, nutritional, and emotional. Numerous conversations with them about all aspects of the project made its successful completion easier.

Three colleagues provided more than the usual amount of feedback on drafts. Jon Abel read more than half the book at a critical stage and helped me figure out how to move forward with key parts of it. David Rando read and provided excellent feedback on the introduction, chapter 1, and the conclusion. His input during final revisions was also critical. Finally, Sean Franzel carefully read early drafts of well over half the book, giving me detailed comments on almost every page. I am lucky to have such generous scholars as friends. The book would not be what it is without their insights and support.

Two anonymous readers for Cornell University Press provided exemplary feedback and suggestions for revisions that made the book stronger. I would also like to thank Kizer Walker and the Signale editorial board for their support. One member of the board deserves special mention: Leslie Adelson provided vital suggestions that helped me to reshape the conclusion. Above all I am grateful to Peter Hohendahl for believing in the project and for shepherding it to publication.

Finally, I thank Maryam and Henry, without whom none of this would have been possible.

A version of chapter 2 originally appeared as "Cryptogamic Phylogeny: Moss and Family Lineage in Adalbert Stifter's 'Der Kuß von Sentze,'" in *Flüchtigkeit der Moderne: Eigenzeiten des Ephemeren im langen 19. Jahrhundert*, edited by Michael Bies, Sean Franzel, and Dirk Oschmann (Hannover: Wehrhahn Verlag, 2017). Chapter 3 first appeared sans the Marclay coda and with a different frame in *Animation: An Interdisciplinary Journal*, vol. 8, no. 3 (2013) as "Cinematic Collecting: The Continuous Discontinuity of the Still Frame in Oskar Fischinger's *Walking from Munich to Berlin*." And a slightly different version of chapter 4 titled "God's Trash? Theodicy of Things and the Paradox of Productive Refuse in Jeremias Gotthelf's 'Die

Wassernot im Emmental'" originally appeared in *Entsorgungspro-bleme: Müll in der Literatur*, a special issue of *Zeitschrift für deutsche Philologie* (2014) edited by David-Christopher Assmann, Norbert Otto Eke, and Eva Geulen. I thank the editors and presses for permission to reuse these publications here.

THE REDEMPTION OF THINGS

INTRODUCTION

Among the many upheavals—social, political, and epistemological—that mark the period around 1800 belongs a fundamental shift in our relation to the material world. Objects hitherto immediately and transparently available begin to appear abstract and opaque, precariously at home in a world slowly being altered by new technologies and mass-produced commodities. The ascendancy of bourgeois culture, the prevalence of new modes of production and exchange, and the breakdown of stable modes of perception in (rapidly growing) urban areas, among other transformations associated with the onset of modernity, result in objects becoming unmoored from the natural contexts in which they have meaning or usefulness.[1] Consequently, these objects are increasingly experienced indirectly and

1. For these and related reasons, Hartmut Böhme calls the nineteenth century "*the* saeculum of things." Böhme, *Fetishism and Culture: A Different Theory of Modernity*, trans. Anna Galt (Berlin: De Gruyter, 2014), 5.

fragmentarily.[2] As the whole into which they had seamlessly been integrated starts to break apart, such objects begin to seem like nothing more than *mere things*, bereft of concrete connections to everyday life, labor, or history.

These socioeconomic and experiential conditions are exacerbated by a waning belief in any predetermined metaphysical order of things. That missing order, as Boris Groys suggests, has to be established artificially, and it is collecting that emerges around this same time as one of the dominant means for generating this needed stability, unity, and meaning.[3] We see it above all in the rise of the museum, which along with historical preservation societies of various kinds, flourishes in the early nineteenth century, especially in Germany.[4] But it is not just in these institutional contexts that collecting thrives; in the private sphere, too, the impulse to gather objects together takes on new importance. This impulse, however, is directed at a different goal than aimed at by those forms of collecting characteristic of the early modern period, which generally sought to stimulate curiosity and promote knowledge by means of exhaustive classification and elaborate display (paradigmatically in the *Wunderkammer*).[5] After the turn of the nineteenth century, collecting instead takes place under the imperative to preserve, seeking to protect the old from deteriorating and disappearing or to prevent the objects around us from be-

2. Christoph Asendorf, *Batteries of Life: On the History of Things and Their Perception in Modernity* (Berkeley: University of California Press, 1993), 3. Asendorf lays out the historical shifts sketched here in some detail while also drawing attention to relevant analyses by Hegel, Nietzsche, Simmel, and Benjamin, among others (1–6).

3. Boris Groys, *Logik der Sammlung am Ende des musealen Zeitalters* (Munich: Hanser, 1997), 48.

4. Susan Crane, *Collecting and Historical Consciousness in Early Nineteenth-Century Germany* (Ithaca: Cornell University Press, 2000).

5. On early modern collecting, see the other essays collected in the volume edited by Andreas Grote, *Macrocosmos in Microcosmo: Die Welt in der Stube; Zur Geschichte des Sammelns 1450–1800* (Wiesbaden: Springer Fachmedien, 1994), as well as Oliver Impey and Arthur MacGregor, eds., *The Origins of Museums: The Cabinet of Curiosities in Sixteenth- and Seventeenth-Century Europe* (Oxford: Oxford University Press, 1986), and Michel Foucault, *The Order of Things: An Archaeology of the Human Sciences* (New York: Pantheon, 1970).

coming old in the first place.[6] Inundated with the new, it is the obsolete and outdated accumulating all around us that now need to be rescued from impending oblivion.[7]

In *The Redemption of Things* I examine collecting in the wake of these historical changes with a focus on how its dual aims of gathering and preservation both inform and complicate realist and modernist aesthetics in German-language spheres.[8] My starting point is the commonplace conception of collecting inherited from the shift to modernity just outlined, in which we bring together what is or would otherwise be scattered in some shared space or semblance of order.[9] To collect in this way is to intervene in the tendency of all things to drift away and apart; it is to resist the forces of entropy by, as Walter Benjamin puts it, "taking up the struggle

6. In Odo Marquard's genealogy, we move from collecting for provisions (prehistorical hunters and gatherers), to collecting for knowledge (from antiquity to the middle ages), to collecting for discovery (out of "curiosity," in the early modern period through the eighteenth century), to finally collecting to preserve (the "decisive change" in our attitudes to collecting beginning in the nineteenth century). Marquard, "Wegwerfgesellschaft und Bewahrungskultur," in *Macrocosmos in Microcosmo*, 911–917.

7. The experience of newness is not just the result of increased production and circulation but also, as Reinhart Koselleck has shown, the symptom of a larger shift in the experience of temporality that leads to the modern notion of historicity: an awareness of the past as "other," as cut off from the present, and thus as a detached object of historical investigation. Koselleck, "'Neuzeit': Remarks on the Semantics of Modern Concepts of Movement," in *Futures Past: On the Semantics of Historical Time*, trans. Keith Tribe (New York: Columbia University Press, 2004), 222–254.

8. I tend to use realism and modernism (in the German context) as shorthand for post-Romantic nineteenth-century literature and twentieth-century literature and film, respectively. In this way, the former designation includes the Biedermeier author Jeremias Gotthelf and the latter, the (primarily) post–World War II writer Max Frisch. I will say more about the pairing of realist and modernist examples later in the introduction and at the end of chapter 1.

9. I acknowledge that there are myriad other modes of collecting, some of which may end in the expenditure or consumption of the collected objects. These are not, however, the dominant paradigms in the period under consideration here, which begins around the end of the eighteenth century, emerging in what Koselleck calls the *Sattelzeit* and what Foucault designates as the shift from the classical to the modern episteme. See Marquard's historical genealogy of collecting, "Wegwerfgesellschaft," 911–913.

against dispersal," which is our attempt to piece together the fragmented world and save things from being irrevocably lost.[10] Collecting thus seeks to bring objects from this entropic world into proximity with one another—and with us—in the effort to assure their safekeeping, to preserve them in the face of a world in which transience, deterioration, and dispersal hold sway. In the process, the collector bestows meaning on the objects gathered, forging a sense of immediacy and unity that combats our alienation from things while assuring that they endure as more than intangible memories.[11]

In this book I argue that, although this model accurately describes the basic logic of collecting in the modern world (again, beginning roughly around the turn of the nineteenth century), it does not account for the paradoxical consequences of its implementation. Although collecting depends on a twofold process of gathering and preservation, which appear to complement and reinforce each other, these constituent undertakings turn out to be highly conflicted. If gathering something always entails bringing it close, doing so also necessarily displaces that object from where it was found, which is where it served (and might still serve) a purpose. Furthermore, such displacement usually also involves immobilizing—and, especially in the case of living things, inflicting harm or disfiguring—the collected specimen. How are we to preserve these objects in the states in which they were gathered if those states are unavoidably altered by the very procedure of gathering itself? If collecting attempts to achieve closeness to material objects, then the consequence of achieving this closeness would seem to be a distinct awareness of their distance

10. Benjamin, *The Arcades Project*, trans. Howard Eiland and Kevin McLaughlin (Cambridge, MA: Harvard University Press, 1999), 211. "[Der Sammelnde] nimmt den Kampf gegen die Zerstreuung auf." Benjamin, *Das Passagen-Werk*, in *Gesammelte Schriften*, ed. Rolf Tiedemann and Hermann Schweppenhäuser (Frankfurt am Main: Suhrkamp, 1991), 5:279. All subsequent references in the book to Benjamin in the original German will be to this edition, cited with *Gesammelte Schriften* followed by volume number and page number.

11. On the collector's desire to overcome death, see Asendorf, *Batteries of Life*, 51–52.

both from where they belong and from their original states. The thing in our collection will ultimately never be the same as the object we gathered to put there.[12]

To make matters worse, the unity strived for in the collection is similarly undermined by the activity that is supposed to guarantee it. If collectors seek to assemble a set of related things that is somehow complete or that makes up a unified whole, they will also always fall short of this goal. As multiple theorists have noted, a collection can never be fully complete.[13] The unity desired necessarily includes gaps, not only because it is these gaps that motivate the activity of collecting in the first place but also, more importantly, because the collection consists of an artificial assemblage of things that will only ever be a selection standing in for a whole. The collection is finite; the source from which objects might be taken to fill this finite assemblage is infinite. Our wish for a complete collection necessarily collides with the reality that the collection is inherently fragmentary.

Given these paradoxes, it would appear that our efforts to collect are doomed to fail, that the mode of collecting that has been prevalent since the early nineteenth century, though motivated by the desire to restore some missing (or at least palpably disappearing) state of unity, will only end in damage, disorder, and deficiency. Indeed, one of the most incisive theorists of collecting, Dominik Finkelde, has come to a similar conclusion, maintaining that the conditions of modernity preclude the successful reconstruction of lost historical meaning.[14] Drawing in particular on Benjamin's writings, Finkelde characterizes modern collecting's efforts to compensate for this experience of loss by reestablishing a totality as "futile,"

12. I discuss in detail the object–thing distinction in chapter 1. Briefly, objects belong to specific spheres of use or are integrated into the environment unproblematically, whereas things have fallen out of these realms of transparent meaningfulness, asserting themselves in their mere materiality. As will become clear throughout, this distinction is not so easily maintained.

13. See, for example, Benjamin, *Arcades Project*, 211; *Gesammelte Schriften* 5:279; and Jean Baudrillard, *The System of Objects* (London: Verso, 2005), 99.

14. Dominik Finkelde, "Vergebliches Sammeln: Walter Benjamins Analyse eines Unbehagens im fin de siècle und der europäischen Moderne," *Arcadia: Internationale Zeitschrift für Literaturwissenschaft* 41, no. 1 (2006): 187–204.

suggesting that the collector is ultimately engaged in an irrational passion that resembles a kind of "mania." Although I am sympathetic to Finkelde's Benjaminian critique of the restorative model, a variation of which I adopt and develop throughout the book, my interest lies in the productive possibilities opened up by this apparent impasse. To be sure, my position requires a sharp readjustment of what we think collecting ultimately accomplishes. If the promise of unification, restoration, and preservation cannot be fulfilled by taking objects from the world and installing them in a new context, what remains of the collector's undertaking? Does it have to end in "mania" or "futility," as Finkelde argues, with collectors at best engaged in an endless hermeneutic process that seeks to extract meaning from their disordered assemblages?[15] I claim instead that the achievement of the collection lies in the very paradoxes that appear to call it into question. Collecting in effect gathers, preserves, and presents the material world *in its fragmentariness and alienation*. It thus instantiates the condition of things in modernity: sans unity, sans stability, sans significance.

To collect therefore is to provide unique access to the world of scattered things by way of a process that ultimately participates in this dispersal. Collecting demands special attention to the procedures by which it is supposedly realized: displacement, decontextualization, denaturalization, disfigurement. In what ways might these procedures work as antidotes—perhaps homeopathically—to our alienated experience of the material world? The answer lies in what I identify as the redemptive achievement of modern collecting, by which the collected object becomes devalued and displaced in the collection in order to serve as a cipher for the world of scattered things. My main argument is that because the imperative to gather and preserve is inextricably tied to the very processes of dispersal it seeks to ameliorate, our grasp (both epistemic and tangible) on the chaotic world of things in which we live is fundamentally altered by the procedure of collecting, which does not so much rescue this world of things as make that world knowable—and thereby helps us manage it and our

15. Finkelde, "Vergebliches Sammeln," 202.

relations with it, in other words, deal with the proliferation and alien-
ation of materiality in its various forms. Collecting thus sets in mo-
tion a dialectic in which we only preserve an object *as* that which has
been displaced and possibly also damaged. Only by losing the object
in some way can we save it as a collected thing.

This book therefore reveals how the logic of collecting is insepa-
rable from that of dispersal, not primarily as that which it ostensi-
bly seeks to correct but rather, more critically, as that which it also
enacts in and through the process of gathering. Because the collec-
tion not only does not but, in fact, cannot restore any lost state of
things, it instead reveals a world in which things have—already—
lost their place. From this perspective, collecting's internal contra-
dictions become constitutive of the activity's success. If to gather al-
ways involves displacement and devaluation, then the collection
participates in what it apparently seeks to remedy and, in doing so,
makes uniquely palpable our world of scattered things. By remov-
ing the object from the world and transferring it into the collection,
we reprise the dislocation that has alienated it from us in the first
place, in some sense reproducing the precarious context in which it
is ostensibly "at home." Collecting thereby succeeds in capturing
and conveying the very quality of estrangement and loss that has
marked things since the turn of the nineteenth century, a quality to
which we have become increasingly habituated—and which there-
fore is in need of being experienced anew.

It is in the creative output of the previous two centuries that these
paradoxes emerge most clearly. Indeed, by virtue of the aesthetic
processes inherent to them (which involve, among other things, the
estrangement of the material world), the representational arts are
in the privileged position to explore the conflicted consequences of
collecting in ways that institutions and individuals typically can-
not—or at best, choose not to. Museums and private collections—
the conventional spaces of what I call "classical collecting"—must
highlight their preservationist programs by disavowing any displace-
ment, damage, or disunity. Their displays invest the things assem-
bled with a timelessness in the face of the fleeting and fragile mate-
rial world, thereby hiding—or at least attempting to hide—the loss

involved in constructing this artifice.[16] What I call "modern collecting" acknowledges and embraces the paradoxes involved in the undertaking, attempting to come to terms with the loss it instantiates. It is in literature (as well as film) that the logic of modern collecting becomes not just uniquely visible but also generative, as *The Redemption of Things* demonstrates by exploring a set of works featuring objects and things that in part challenge our notion of what is or ought to be collectable. This material stuff includes such ephemera, detritus, and trivia as moss, sludge, debris, maculature and paper scraps, junk, dust, scent, as well as, least tangibly of all, the fugitive moment.[17] I show that the difficulties posed by such limit cases, which foreground the tension involved in trying to save or hold on to a thing that resists such appropriation, help conceptualize collecting in terms of poetic activity, which at its most fundamental level aims at establishing the propinquity of things. If collecting performs the operation whereby objects are made present, prominent, even palpable *by virtue* of their removal from the environments in which they thrive or have meaning, the works animated by the logic of modern collecting seize on this paradox as potentially productive, a way to redeem precarious objects *as* dislocated, damaged, or dirty and to preserve them *as* insignificant, fleeting, or disruptive—in other words, *as things*. In the artwork as in the collection, these things remain out of place and yet thereby uniquely within our reach.

16. Didier Maleuvre details how these attempts were ultimately unsuccessful, arguing that nineteenth-century efforts to bestow "authenticity" onto artifacts by denying their displacement and loss failed in both the private sphere and the museum. Maleuvre, *Museum Memories: History, Technology, Art* (Stanford: Stanford University Press, 1999). See also Susan Stewart's claim that "the collection must destroy both labor and history." Stewart, *On Longing: Narratives of the Miniature, the Gigantic, the Souvenir, the Collection* (1984; repr., Durham, NC: Duke University Press, 1993), 160.

17. For an encyclopedic account of what he calls antifunctional objects in literature, see Francesco Orlando, *Obsolete Objects in the Literary Imagination: Ruins, Relics, Rarities, Rubbish, Uninhabited Places, and Hidden Treasures* (New Haven, CT: Yale University Press, 2006). Orlando also situates an historical shift in our relation to things around 1800, which he attributes to the rise of a utilitarian, "functional imperative" born of the new bourgeois class (14).

Collecting in Literature: Object and Scope of the Book

In pursuing these paradoxes, this book stakes out somewhat un-
usual territory within the German-language traditions of the nine-
teenth and twentieth centuries, identifying a set of texts (and one
film) that do not prominently feature collecting (when it is featured
at all) and that do not in any obvious way mobilize the activity as
a structural principle. By making this selection I aim to dispel the
expectation that an analysis of collecting in literature necessarily in-
volves locating that activity in the diegetic or thematic content of
the text. There are, of course, numerous prominent works of Ger-
man literature, from Wilhelm Raabe's novels and stories through
Elias Canetti's *Auto-da-Fé* (*Die Blendung*) and Arno Schmidt's *The
Stony Heart* (*Das steinerne Herz*) to W. G. Sebald's books and, most
recently, Evelyn Grill's *Der Sammler* (The collector), in which we
find figures at work on various kinds of collecting or in which that
activity is thematically integral. To focus exclusively on such works,
however, would limit the scope of analysis to the representational
level alone, leading to a circumscribed critical undertaking at risk
of producing a descriptive compendium, rather than exploring the
more subtle ways in which the logic of collecting can inform the
text.[18]

Locating that logic on the level of form may open up new pos-
sibilities for inquiry, but it similarly runs the risk of transforming
the critical investigation into a list of analogies. To be sure, the lit-
erary text can function as the site of collecting in a number of com-
pelling ways. The anthology, literary journal, or collected works of

18. For excellent scholarship on collecting in Raabe and Sebald that avoids
these pitfalls, see Eric Downing, "Caves, Collections, Classics: Displacement in
Wilhelm Raabe's *Das Odfeld*," *Germanic Review* 94, no. 1 (2019): 1–15; Dominik
Finkelde, "Wunderkammer und Apokalypse: Zu W. G. Sebalds Poetik des Sam-
melns zwischen Barock und Moderne," *German Life and Letters* 60, no. 4 (2007):
554–568; and Dominik Finkelde, "Der nicht aufgehende Rest—zum Widerstreit
zwischen Objekt und Ding in der Moderne," in *Sprachen des Sammelns: Literatur
als Medium und Reflexionsform des Sammelns*, ed. Sarah Schmidt (Paderborn:
Wilhelm Fink, 2016), 97–123.

a writer, for instance, each of which is the result of locating, select-
ing, sorting, compiling, and ordering diverse writings, serve as the
actual media of collecting.[19] Numerous texts moreover integrate or
even replicate features of the collection through structural and for-
mal imitation on the rhetorical, narratological, or even syntactical
level. The encyclopedic novel, for example, accumulates and stores
information as part of its epic mode. Consider the way Alfred Dö-
blin's *Berlin Alexanderplatz* incorporates newspaper reports, statis-
tics, and popular songs. Moreover, texts that make use of—or even
consist primarily of—paratactic lists, enumerative descriptions, ge-
nealogies, or indices all mobilize aspects of the collection by fore-
grounding objects, establishing the order and relation of persons
and things, or demonstrating the capacity of the text to aggregate
and inventory data.[20] Though examples can be found much earlier,
such as in the epic catalog or the early modern obsession with lists,
it is in experimental poetry of the late twentieth century that we find
some of the richest and most suggestive instances of how the archi-
val impulse manifests itself in literary form. Many of the experi-
ments with the lyric undertaken since the end of World War II—
from the Wiener Gruppe to concrete poetry to Oskar Pastior's
combinatory, algorithmic poetics—demonstrate, indeed, celebrate,

19. On the principles of inclusion and exclusion at work in the editorial prac-
tices of creating a "collected works" edition, see Philip Ajouri, "Zu einigen Samm-
lungs- und Ausschlussprinzipien beim Publikationstyp der 'Gesammelten Werke':
Gottfried Kellers *Gesammelte Werke* (1889) und Goethes Ausgabe letzter Hand
(1827–30)," in *Sprachen des Sammelns*, 513–527. On the Grimms' and Arnim/
Brentano's collections, see Günter Häntzschel, *Sammel(l)ei(denschaft): Literarisches
Sammeln im 19. Jahrhundert* (Würzburg: Königshausen & Neumann, 2014). On
the modernist literary journal (though limited to the Anglo-American tradition), see
Jeremy Braddock, *Collecting as Modernist Practice* (Baltimore: Johns Hopkins Uni-
versity Press, 2012).
20. See Sabine Mainberger, *Die Kunst des Aufzählens: Elemente zu einer
Poetik des Enumerativen* (Berlin: De Gruyter, 2003), and Robert E. Belknap,
The List: The Uses and Pleasures of Cataloguing (New Haven, CT: Yale Univer-
sity Press, 2004). Susan Stewart calls the collection "the list's double." Stewart,
On Longing, 96. The list is also key to Orlando's analysis of the antifunctional
and anticommodities in literature. Orlando, *Obsolete Objects in the Literary
Imagination*.

the awareness that language itself is a collection (of words, letters, symbols, markings, materiality).[21]

These and related modes of "literary collecting" are rich and highly suggestive for scholars thinking about the relationship between text and objects or artwork and archive. Motivated by similar examples and related parallels, a recent strand of criticism has in fact adopted collecting as a paradigm for approaching literature and its relation to the world of things.[22] This book is informed by and at times in dialogue with this body of work, though its specific approach, case studies, and conclusions differ in important ways.[23] First, even though I draw attention to related formal and thematic

21. Contemporary poetry likewise attests to the propensity for gathering and inventorying as elemental to the creative enterprise in ways that also indelibly shape the resulting works. In Herta Müller's *Die blassen Herren mit den Mokkatassen* (The pale gentlemen with the demitasses) and *Vater telefoniert mit den Fliegen* (*Father's on the Phone with the Flies*), for example, verses are constructed from cutouts of newspaper and magazine texts (from words to parts of words to individual letters): the collected refuse of the popular press is thereby extracted and recombined with both playful and critical purpose. On Müller's collage poems in relation to the concept of collecting, see Sarah Schmidt, "Fremdeigene Wortreste—Spache als Sammlung in Herta Müllers Collagen," in *Sprachen des Sammelns*, 593–620.

22. I make the specific case for using collecting to read cinema and other media in chapter 3. For the recent literature on collecting and its relation to literature, see, in particular (and here I only list monographs and edited volumes): Ulrike Vedder, Gisela Ecker, and Martina Stange, eds, *Sammeln—Ausstellen—Wegwerfen* (Königstein/Ts.: Helmer, 2001); Peter M. McIsaac, *Museums of the Mind: German Modernity and the Dynamics of Collecting* (University Park: Pennsylvania State University Press, 2007); Margret Westerwinter, *Museen erzählen: Sammeln, Ordnen und Repräsentieren in literarischen Texten des 20. Jahrhunderts* (Bielefeld: Transcript, 2008); and the massive *Sprachen des Sammelns: Literatur als Medium und Reflexionsform des Sammelns*. Individual publications by Ulrike Vedder and Dominik Finkelde, cited throughout the book, have influenced my thinking in this book the most.

23. The same can be said of the anthropological and historical scholarship on collectors and collecting, such as James Clifford, "On Collecting Art and Culture," in *The Predicament of Culture: Twentieth Century Ethnography, Literature, and Art* (Cambridge, MA: Harvard University Press, 1988), 215–252; Krzysztof Pomian, *Collectors and Curiosities: Paris and Venice, 1500–1800* (Cambridge: Polity Press, 1990); and George W. Stocking Jr., *Objects and Others: Essays on Museums and Material Culture* (Madison: University of Wisconsin Press, 1988). Although this literature informs my thinking, its objects of inquiry remain outside this book's purview.

features characterizing a set of realist and modernist works, these elements are by no means the primary focus of my individual investigations. I read them instead as symptoms of a more fundamental engagement with the problems and paradoxes of gathering and preserving things. We can see these paradoxes play out in the text in ways that go beyond any mere representation or formal imitation of collecting, emerging in a concern for the role and relevance of material things in a world in which such status is no longer guaranteed. These works activate the logic of collecting by foregrounding the movement of objects in and out of the contexts that (appear to) grant them value and permanence, drawing attention to how such displacements determine attempts to "save" and "save up" what is increasingly characterized by contingency, entropy, and insignificance.

Marked by dispersal and waning importance, the items central to my case studies appear as highly anomalous collectables, either falling outside the range of usually collected artifacts or occupying a precarious position vis-à-vis the collector. These are things that in one form or another resist being collected or problematize what it means to collect in the first place. To be sure, the abject status of these things makes them appear to be in real need of rescue, intensifying the imperative to gather and preserve them. And yet many of them threaten to escape the grasp of the collector, either because they are ephemeral (naturalia and the experiential instant) or approach the limits of tangibility (scent and dust). Whereas these kinds of fugacious things may pose a distinct problem for the collector seeking their safekeeping, other kinds (in particular, detritus, junk, and triviality) call into question the motivations for collecting in the first place.[24] This book's individual chapters consider the unusual

24. For recent interventions on ephemerality, see Michael Bies, Sean Franzel, and Dirk Oschmann, eds., *Flüchtigkeit der Moderne: Eigenzeiten des Ephemeren im langen 19. Jahrhundert* (Hannover: Wehrhahn Verlag, 2017), where an earlier version of chapter 2 first appeared. For recent work on trash and literature, with some emphasis on the trivial, see David-Christopher Assmann, Norbert Otto Eke, and Eva Geulen, eds., *Entsorgungsprobleme: Müll in der Literatur*, special issue, *Zeitschrift für deutsche Philologie* 133 (2014). A version of chapter 4 was first published in this issue.

collectability of these and similar *mere things*: things otherwise fleeting, forgotten, or fallen in the cracks, things in disrepair or discarded, things apparently beyond redemption.[25] In each case, they stand in for—and (once collected) point back to—the fundamental contingency and fragility of the material world. To "save" them in the act of collecting is not (just) to prevent their complete disappearance, but in fact to draw attention to their very vulnerability—their otherwise invisible status as the overlooked, incidental, or irrelevant.[26]

Finally, by focusing on such marginal and apparently uncollectable things, I uncover a pattern in which loss coincides with preservation and dispersal with gathering. My argument is that in the attempt to redeem these things, collecting reveals itself as an activity whose impulses to safeguard and unify meet up with—and at times reciprocally precipitate—the proclivity toward scattering. In other words: redemption is only possible through loss. If, however, the end or goal of collecting (whether or not intended) is not any unity but rather necessarily fragmentary and incomplete, a "patchwork" (*Stückwerk*), as Benjamin writes, then the collection does not so much salvage or preserve the object as it instantiates its loss.[27] My readings reveal how this loss is nonetheless constitutive of collecting's achievement, which manages to convey and make palpable the dispersal of things in the world. To collect is not to reverse this scattering, as the classical, preservationist endeavors pretend to do. Instead of restoring some lost state, collecting shows how things *are* in the states in which they are found. It follows that such collecting

25. It goes without saying that these mere things do not function like commodities. To begin with, they lack both use value and exchange value. On collecting as a mode of divesting the object of its commodity character, see Asendorf, *Batteries of Life*, 51, who views collecting as the negation of exchange. On the "anticommodity," see Orlando, *Obsolete Objects in the Literary Imagination*, 15–16. Alternately, for a reading of the "display object" (in a museum or collection) as conforming to the same logic of abstraction characteristic of the commodity fetish, see Finkelde, "Vergebliches Sammeln," 199.

26. Compare Ulrike Vedder's reading of Alexander Kluge's work as involving "the collection of the overlooked and discarded." Vedder, "Alexander Kluges Museumspoetik," *Alexander Kluge-Jahrbuch* 6 (2019): 85.

27. Benjamin, *Arcades Project*, 211; *Gesammelte Schriften*, 5:279.

provides a more accurate and authentic preservation of the thing (*as lost and out of place*) than would the classical collection and its imperative to create the perfectly unified assemblage. In carrying out the paradoxical procedure of rescue through loss, modern collecting is not just adequate to but also fully commensurate with this aim. The redemption of things thereby achieved thus ultimately affords a recognition of our alienation from objects and the promise not so much of overcoming this alienation but of coming to terms with it.

Returning to the literary text, we can see how these different modes of collecting might map onto different representational strategies; in particular, how the conventional understanding of representation as an imitation or duplication of reality would not fully account for—or make possible—any such recognition of objects and things. Indeed, the classical model of mimetic representation corresponds to the classical model of collecting, in which the part must be subsumed into the whole, the individual object joining a set of similar pieces in the service of (the semblance of) unity and closure. In the collection informed by dispersal, the set instead becomes reconfigured to allow for attention to that which is missing or to the piece that does not quite fit, the individual thing standing out from the others. The logic of collecting at work in the aesthetic spheres of the nineteenth and twentieth centuries in fact vacillates between these models, at times offering an image of the seamless collection, at other times exposing such assemblages as impossible.[28] My investigation privileges those cases in which the wish image of the complete collection and its corresponding mimetic semblance of the whole cannot be sustained, in which the idea of collecting is productively problematized within the parameters that make its classical form no longer tenable. Here the emphasis falls on the singularity of the thing and the (im)possibility of its preservation over against any systemized assemblage in which the object only assumes a place as the type representative of the set.

28. An especially fascinating representation of the classical collection can be found in Adalbert Stifter's *Indian Summer* (*Der Nachsommer*, 1857). Yet, even in this novel, which strives to erase any gaps and fissures in the collection, we find hints of that which it seeks to overcome.

The Redemption of Things locates the poetic function of German realist and modernist texts in the attempts to account for these singular things. The different presuppositions and motivations (aesthetic, epistemological, and ethical) under which these works from distinct historical periods operate naturally lead to divergent solutions. And these solutions inform the respective creative works in ways that reveal key differences in how materiality is mobilized— and to what end. Although I occasionally draw attention to these differences in the individual case studies, the book as a whole is meant to uncover points of contact. I thus emphasize the persistence and continuity across these periods of what I have identified as the logic of modern collecting, which I find at work even in those texts (such as Stifter's or Gotthelf's) that resist the encroachments of modernity. Ultimately, despite their differences, realists and modernists have inherited the same problem of things, and they consequently face the same fundamentally paradoxical task of "taking up the struggle against dispersal" (Benjamin) with means that either participate in that same dispersal or must learn to accept the fragmentariness of the outcome. This struggle is particularly pronounced with respect to the singular thing that stubbornly resists the modes by which it is typically made meaningful, the thing that falls outside the structures of use and value that would render it epistemically significant and thus in some way knowable. If, as Heidegger writes, "The inconspicuous thing withdraws from thought most persistently" (Das unscheinbare Ding entzieht sich dem Denken am hartnäckigsten), then the goal cannot be somehow to catch up to the thing that keeps eluding us, to get hold of what continues to slip away.[29] Such grasping—in both senses of the word—could only be achieved by sacrificing the very elusiveness and otherness that characterize the mere thing in the first place. An alternative lies in the mode of accessing things offered by modern collecting, in which we only get hold of the thing as that which points to its loss and in

29. Martin Heidegger, "Der Ursprung des Kunstwerkes," in *Holzwege* (Frankfurt am Main: V. Klostermann, 1994), 17; my translation. Compare to Heidegger, "The Origin of the Work of Art," in *Poetry, Language, Thought,* trans. Albert Hofstadter (New York: Harper & Row, 1971), 31.

which gathering and preservation cannot be achieved without either reinstantiating or reincorporating the dispersal it seeks to overcome. Translated into the aesthetic sphere, this paradoxical procedure becomes a poetic engine allowing us to imagine ways of grasping the mere thing, getting both an epistemic and tactile hold on it *in its withdrawal and inconspicuousness.*

Grasping Objects, Collecting Dispersal (*Rilke*)

Let us turn now to how this paradoxical procedure can be found at work in the literary text in which collecting itself is not directly thematized. For its foregrounding of an "inconspicuous thing" that "withdraws" (Heidegger) not only from our capacity to think it but also our basic ability to hold on to it, Rainer Maria Rilke's "Scent" (Der Duft) serves as an ideal object of analysis. "Scent" moreover is itself "uncollected," a leftover poem that Rilke chose not to gather together with the other verses that make up the volume *New Poems: The Other Part* (*Der Neuen Gedichte anderer Teil*, 1908). By way of its exclusion from this collection of poems, "Scent" remains a "dispersed work" whose subject, fittingly, is a dispersed thing: the minute, invisible, and scattered particles that contain and convey odor. The poem's history furthermore reveals that as textual object it is nearly as ephemeral as its eponymous addressee. Composed as part of the first manuscript of *New Poems: The Other Part*, it would still be effectively lost in the inaccessible archive of Rilke's literary remains were it not written out as an inscription in a single copy of the very book from which the poet excluded it.[30] Only much later (and well after Rilke's death) was this stray poem taken up into his published work, thereby assuring its permanent place—though always among the "dispersed poems"—in his oeuvre.[31]

30. Though we cannot know for sure, the original draft may still exist in one of Rilke's notebooks. These, however, have been carefully guarded by his surviving relatives.

31. It is collected together with the other *verstreute Gedichte* ("uncollected poems") of this period in the standard editions of his work.

And yet the poem also belongs to the larger poetic project of the *New Poems* and its companion volume, which together function as an "imaginary museum landscape," containing more than just a collection of poems, but a collection of things as poems (*Dinggedichte*) that probe the boundaries between subjectivity and a world of objects both close and far.[32] "Scent" participates in this project in its attention to the materiality of a thing in the world as well as in its concern with what William Waters has called these books' "hidden theme" of loss or "the elusiveness of reality altogether."[33] The poem takes up this elusiveness as a philosophical enigma embodied in a substance ostensibly without substance, which both as thing and experience becomes the problematic object of Rilke's poetic collecting:

Wer bist du, Unbegreiflicher: du Geist,
wie weißt du mich von wo und wann zu finden,
der du das Innere (wie ein Erblinden)
so innig machst, daß es sich schließt und kreist.
Der Liebende, der eine an sich reißt,
hat sie nicht nah; nur du allein bist Nähe.
Wen hast du nicht durchtränkt als ob du jähe
die Farbe seiner Augen seist.

Ach, wer Musik in einem Spiegel sähe,
der sähe dich und wüßte, wie du heißt.[34]

Who are you, ungraspable one: you specter,
how do you know to find me wherever, whenever,

32. See Peter McIsaac's chapter on Rilke's *New Poems* (both parts), which he reads as constructed by "museal operations" and the "museal gaze." McIsaac, *Museums of the Mind*, 153. William Waters notes, however, that because the poems themselves are not so easily fixed as "things in a static sense," the titles "give a much stronger impression of a museum or collection than do the poems themselves." William Waters, "The *New Poems*," in *The Cambridge Companion to Rilke*, ed. Karen Leeder and Robert Vilain (Cambridge: Cambridge University Press, 2010), 60.
33. Waters, "*New Poems*," 71.
34. Rainer Maria Rilke, *Werke: Kommentierte Ausgabe in vier Bänden*, ed. Manfred Engel et al. (Frankfurt am Main: Wissenschaftliche Buchgesellschaft, 1996), 1:403.

you who make the inside (like a blinding)
so intense that it closes and encircles.
The lover pulling his beloved to him
does not have her close; you alone are closeness.
Whom have you not saturated as if suddenly
you were the color of his eyes.

Oh, who could see music in a mirror
could see you and would know your name.[35]

The speaker here contemplates the peculiar proximity of a thing that
hardly even qualifies as materiality. Scent is among the most diffuse
and fleeting of substances, that which, because it is situated on the
border between thing and nothing, at once invisible and intangible,
we hardly even think of as a concrete entity. And yet precisely as
such, the speaker claims, it embodies closeness. Because it does not
appear to us but only invisibly permeates things, it can in fact achieve
a level of proximity that exceeds even the sense of touch. Scent is
thus paradoxically both dispersed (unlocatable, distant) and dis-
tinctly near (gathered, concentrated).

The poem as a whole articulates this strange propinquity of scent
in terms of its ungraspability and unnameability. The speaker be-
gins by characterizing the nearly immaterial substance as necessar-
ily eluding both our tactile and linguistic grasp, but he does so in
the form of a question that expresses his desire for these same miss-
ing qualities: "Who are you, ungraspable one." To answer this
question would be to grant scent a real name, to say what it is, and
thereby—as Rilke's wordplay suggests—to make it tangible. And yet
to do that would be to lose it *as* that which most essentially char-
acterizes it: an entity that cannot be "grasped," in either sense, nei-
ther seized as substance nor fully understood as thing. Thus, al-
though Rilke's poem does not thematize collecting as such, it
mobilizes the notions of gathering and preserving that which is dis-
persed; it asks how it is that such an evanescent substance can,
despite being scattered, invisible, and intangible, not only establish

35. My translation, though I borrow some phrases from Charlie Louth, *Rilke: The Life of the Work* (Oxford: Oxford University Press, 2020), 94–95.

closeness but also embody it, more profoundly even than we imagine is possible between humans (say, lovers, l. 5–6), let alone between humans and objects.[36]

Scent therefore poses a distinct problem for the one who seeks its closeness: it cannot actually be grasped in a way necessary to bring it near. To be at all collectable, scent would first need a medium, some kind of storage device or enclosure that could contain it and prevent it from dispersing. On the one hand, Rilke suggests it is *we* who are this medium. The speaker does not find and capture scent; rather, it is scent that "finds" him (l. 2). Rilke thereby grants agency to the vaporous particulate. It seeks us out, like a "specter" or "spirit" (*Geist*, l. 1), and "saturates" (*durchtränkt*, l. 7) our bodies, which become vehicles for its accumulation and preservation. Rilke develops this notion of the corporeal repository by depicting "the inside" (l. 3) that our bodies house as being made even more "intense" (*innig*, l. 4) by the scent that contracts, concentrates, and seals off this space, blocking out any light ("blinding"/ *Erblinden*, l. 3).

This inner body as container ultimately finds its analogy in the body of the poem itself. Rilke turns his own verses into a medium for collecting scent both in its diffuseness and intense closeness. The poem demonstrates its imperative for containment first and foremost structurally, by way of its unusual rhyme scheme—a / b / b / a / a / c / c / a // c / a—in which a series of embedded enclosures carry out the same closing and encircling (*sich schließt und kreist*, l. 4) that characterizes "the inside." Not only does each of the two quatrains comprising the first eight-line stanza use enclosed rhyme (abba) but

36. Collecting scent (as opposed to manufacturing it in essences or oils) might seem a futile endeavor. The activity, however, is not so unusual as to have escaped the imaginations of other writers. The most notable recent examples of scent collectors in literature include Jean-Baptiste Grenouille in Patrick Süskind's *Perfume* (1985) and the "freelance professional Nose" Conkling Speedwell in Thomas Pynchon's *Bleeding Edge* (2013). It is worth noting that reconstructed odors have been integrated into various museum exhibits, though such smells are as ephemeral as the scents they are supposed to evoke—scents long since dissipated. On the limits and possibilities of actually archiving odors, see Cecilia Bembibre and Matija Strlič, "Smell of Heritage: A Framework for the Identification, Analysis and Archival of Historic Odours," *Heritage Science 5*, article no. 2 (2017): 1–11.

these enclosed rhymes are also themselves enclosed within a poem that emphasizes its will to corral and contain by rhyming its first line with its final line (both of the first stanza and of the entire poem: *Geist / seist // heißst*). The poem thus structurally returns at its end to the beginning, circling back and closing off (*sich schließt und kreist*, l. 4). The rarity of this structure within Rilke's oeuvre further contributes to its effect here. Only one poem in either volume of the *New Poems* shares this aspect of the rhyme scheme with "Scent," and although Rilke frequently rhymes the first and final lines of a stanza in his other work, he seldom rhymes the first and final lines of an entire poem.[37] This peculiar and uncommon proliferation of similar sounds can be seen elsewhere in the poem, such as in the final couplet's repetition of *sähe* ("could see"):

> Ach, wer Musik in einem Spiegel sähe,
> der sähe dich und wüßte, wie du heißst.
>
> Oh, who could see music in a mirror
> could see you and would know your name.

This repetition phonically and visually performs the very mirroring it describes, the line break acting as the reflective surface. (It is also a nice touch that Rilke uses the irrealis mood of the verb *sehen*, indicating counterfactuality, for this insubstantial and unreal looking-glass reflection.) Overall, the persistent rhyme (half of the poem's lines rhyme with one another) and repetition (*du* is repeated eight times; the first word *wer* recurs in the penultimate line of the poem and, in the accusative form, in the penultimate line of the first stanza) create an echo chamber effect that intensifies the poem's concern with enclosure, with capturing and bringing close what seems destined to escape our grasp.

Since, of course, no one, except perhaps the rare synesthete, can see music (in a mirror or otherwise), the speaker's concluding in-

37. For the exception, see "Sappho an Eranna" (Rilke, *Werke*, 1:451), a five-line, single-stanza poem that is already, as such a short verse, anomalous. It appears that Rilke rhymes the first and final lines only because this poem consists solely of one stanza.

sight would seem to be tainted by resignation. And yet these lines are ambivalent, neither clearly expressing impossibility nor anticipatory glee (it all depends on how you read the "Oh"). This ambiguity suggests that grasping the ungraspable scent somehow remains at the same time out of reach and actualizable. The mirror is the catalyst for this coincidence of (im)possibilities. On the one hand, it represents our failure to perceive what is nonetheless so close (music, which encloses and permeates us but cannot be seen or felt), a failure related to our inability to grasp scent in words.[38] On the other hand, the mirror offers a way to overcome this failure in the form of the common metaphor for literary representation. It is literature, after all, that allows us to see things that are otherwise invisible. Indeed, the power of poetic language opens up numerous perceptual possibilities not limited to vision. Recall Viktor Shklovsky's famous description of literature's ability to "make a stone feel stony."[39] Rilke's poem is guided by a similar haptic imperative, which is activated in and through the poetic imagination. The mirror in the final couplet of "Scent" thus doubles as metaphor for this imagination and—with emphasis on its everydayness and materiality—as analog to that other two-dimensional surface "containing" depth: the piece of paper, the very page in front of us and on which we encounter this poem.

Yet although Rilke seeks with this poem to make scent "graspable," at once meaningful and tangible, he is also aware that to do so fully would be to inflict violence on the object of his poetic reflections. In negotiating this impasse, he activates the logic of collecting. The closeness to us that scent establishes is predicated on its ungraspability—its fundamental dispersal and ephemerality. To succeed in capturing and preserving it would be to strip it of these essential qualities. To "save" scent thus in a collection would necessarily involve "losing" it, not only because containing it would inhibit its defining characteristic of being diffuse and scattered but

38. Winfried Eckel, "Einzelgedichte 1902–1910," in *Rilke-Handbuch: Leben–Werk–Wirkung*, ed. Manfred Engel (Stuttgart: Metzler, 2013): 345.
39. Viktor Shklovsky, *Theory of Prose* (Normal, IL: Dalkey Archive Press, 1990), 6.

also because this defining characteristic cannot be fully eliminated, meaning that scent would, eventually, dissipate and fade away, even in a tightly sealed enclosure. Scent is ultimately best "collected" by letting it be scattered, by letting it establish closeness to us in its diffuseness and intangibility. We can thus really only capture and collect scent *as that which has been lost.* Put in the terms of Rilke's poem, scent's closeness can only be actualized in its constantly escaping our grasp. Only in being always just out of reach does scent instantiate proximity.[40]

It follows that for scent to be taken up into the poem, it must also relinquish its essential ungraspability. Indeed, even though Rilke gestures toward containment and enclosure in the poem's form, he does not, in the end, allow scent to be "grasped," either by granting it a name or by directly answering the speaker's opening question: "Who are you." Instead, he conveys the profound closeness that scent achieves *by way of* the fully elusive quality of its diffuseness. Rilke allows scent to come close by letting it fade away.[41] As such, we might group scent along with the missing head of Apollo (in "Archaic Torso of Apollo," the first poem of *New Poems: The Other Part*), another (un)collected object whose power and effectiveness derive from its absence, its distance from us. In fact, Rilke's poetic project as a whole can be read as an attempt to gather in words what always threatens to slip away or is otherwise inaccessible and to make it palpable *as* such fragile stuff. Rilke recognizes that the undertaking is self-defeating, because the poetic word cannot but fix a thing—however fleeting it may be—onto the page. Word, name, and concept are incommensurate with the mere, fleeting thing. The task of the poet, nonetheless, as Rilke writes in the ninth *Duino*

40. Compare with another of Rilke's poems from this period, "Die Nacht der Frühlingswende" (Night of the Spring Equinox), which includes the line, "Gefangener Duft, der widerstrebend bleibt" (Captured scent that remains reluctant).

41. That this fading would be both spatial (in the particles scattering from one source) and apparently temporal (in their pungency fading with time) only points to the complementary nature of these ostensibly different types of dispersal. Although I primarily treat dispersal as a spatial phenomenon in the book, in some cases (especially in chapter 3) I conceptualize it more in terms of temporality. And yet ultimately, as in the case of scent, one cannot be thought without the other.

Elegy, is to "rescue" or "save" (*retten*) these very things that only exist—indeed, have vitality—*by* passing away:

—Und diese, von Hingang
lebenden Dinge verstehn, daß du sie rühmst; vergänglich,
traun sie ein Rettendes uns, den Vergänglichsten, zu.[42]

—And these things
that keep alive on departure know that you praise them; transient,
they look to us, the *most* transient, to be their rescue.[43]

We, the most prone to demise, to fading from this world, are tasked with rescuing things by turning them into art. Only in this way can the ephemeral be grasped; it is saved by being transformed into the poem whose endurance encapsulates the fleeting substance of things—but only as a trace. The propinquity of things thus comes only in making palpable their fundamental dispersion, their impermanence, that they are *ungraspable*. In this way Rilke's poem demonstrates paradigmatically how literature can function as the site where the logic of collecting finds its dialectical realization in dispersal, where the loss of the object is both origin and endpoint of the effort to preserve it.

Method and Overview of Chapters

In philosophy, critical theory, and literary and cultural studies, a recent interest in materiality has broadened the range of approaches to thinking about this and related matter, both what is stubbornly concrete and, like scent, profoundly elusive. From Bruno Latour's actor-network theory to Jane Bennett's vital materialism, and beyond, we read about the complex ways in which what we typically think of as mere matter has an agency of its own, impinging on us and our social relations in ways not fully under our control. The

42. Rilke, *Werke*, 2:229.
43. Rilke, *Duino Elegies*, trans. Edward Snow (New York: North Point Press, 2000): 57.

world, it turns out, is not so easily divided up into subjects and objects, the human and nonhuman, active agency and passive inertia. We learn from these and related new materialisms that objects cannot be subsumed by our concepts without a remainder and that they determine us as much as we determine them.[44] These fundamental insights help dismantle some of our anthropocentric prejudices and reveal, even if only negatively, the gap between what we have and hold (and therefore think we fully grasp—in both senses of the word) and what escapes us by going the way of all things, namely by dispersing. The thing—elusively intelligible, beguilingly unfixable, stubbornly "other," and ultimately inexhaustible—ends up being the locus of "that which refuses to dissolve completely into the milieu of human knowledge."[45]

Informed by much of this work, this book takes seriously the inquiry into the peculiar status and even power of things. I remain skeptical, however, of any attempt to theorize objects fully independently of subjects, which seems to me to be both philosophically dubious and methodologically inconsistent.[46] Therefore, although I focus on things *as such* throughout the book, they are never fully removed from their relevance *for us*. Indeed, one of the motivating problems of *The Redemption of Things* is the threat *to us* of things' insignificance, a threat that is resisted—with varying degrees of success—by the human activities of collecting and poesis. We might thereby *resist* things' intransigence—their refusal "to dissolve completely into the milieu of human knowledge"—but we cannot nor should we want to overcome it. If our concepts can never fully match up with the objective world, our intellectual and creative endeavors should not pretend to be able to fill the remaining gaps. Like the wish image of the complete collection, such wholeness is not

44. Theodor W. Adorno, *Negative Dialectics*, trans. E. B. Ashton (London: Routledge, 1973), 5. See Jane Bennett, *Vibrant Matter: A Political Ecology of Things* (Durham, NC: Duke University Press, 2010), 14.

45. Bennett, *Vibrant Matter*, 3.

46. I am thinking here primarily of the aims and methods of object-oriented ontology. For a thorough critique of this philosophical movement, see Peter Wolfendale, *Object-Oriented Philosophy: The Noumenon's New Clothes* (Falmouth: Urbanomic, 2014).

possible. We should instead attend to the existence of these gaps and to the ways in which things help us see them—and in turn see their and our precarious place in the world.

It is the collection that uniquely instantiates this "nonidentical" status of things, bringing them close and displacing them at the same time. Displacement of the object makes its otherness perceptible, helping to estrange it from the spaces and situations in which it typically disappears. Removed from these natural contexts, the object is made a thing; its distance from where it belongs makes its otherness knowable. The ways in which it always already escapes our full conceptual knowledge—as, with Heidegger, the elusive, inconspicuous thing—are not overcome but made palpable. The collection presents us with the object as it normally eludes us—not as some fully knowable reality but rather as that which always evades our grasp. Collecting thereby conveys knowledge of our limitations with respect to both the objects and things of the world, an essential knowledge for helping us accept and manage the preponderance of materiality that defines our existence. The "literature of things" that emerges from this book, then, is less about things in and of themselves than about our contingent access to them, primarily through the poetic work. If, as Hartmut Böhme writes, echoing Heidegger, art is "that specifically *human* ability to help things (whatever they might be) to make an appearance (*zu ihrem Erscheinen zu verhelfen*)," then we need to look closely at the curious and complex roles things play within the artwork, where they arise and fade, gather and disperse as part of its structures of meaning.[47] My method thus remains text centered; I seek first and foremost to reveal the procedures by which the problem of things is negotiated in and through the work. The text becomes the site for reconceptualizing things' potential meaningfulness as always already in tension with their tendencies to elude both our conceptual and tactile grasp.

I look in more detail at the theoretical armature for this methodology in chapter 1, which develops the book's conceptual framework by way of engagement with the thought of Vilém Flusser, Walter

47. Böhme, *Fetishism and Culture*, 61. Hartmut Böhme, *Fetischismus und Kultur: Eine andere Theorie der Moderne* (Reinbek bei Hamburg: Rowohlt, 2012), 86.

Benjamin, Martin Heidegger, and Aleida Assmann. Here I explore the poetological implications of the following paradox: we gain privileged access to things only after we have—in some way—lost them. Put in the language of collecting, we can preserve the artifact only by assuring that it is missing from the place where it actually belongs. Collecting thus not only instantiates dispersal but dispersal also turns out to be constitutive of the collection as such. In this chapter I develop the notion of nonrestorative (*antapocatastatic*) collecting to describe the mode of gathering and preservation that abandons the desire to establish a perfectly ordered and unified assemblage in favor of making the gaps inherent in every collection palpable and knowable.

This theoretical chapter is followed by three sets of case studies, each focusing on one category of precarious thing and each setting side by side a realist and a modernist example. These pairs of chapters are grouped according to a distinct category of the marginal and inconspicuous: ephemera, refuse, and triviality. Thus, in part 1 (chapters 2–3), I focus on the difficulties posed by the thing that, as in the Rilke example earlier, resists being grasped. Because what is fundamentally impermanent necessarily eludes attempts to preserve or safeguard it, its collectability must be radically reconceptualized. In part 2 (chapters 4–5), I look at the problem of catastrophic debris, the wreckage—of both the natural environment (*naturalia*) and of manufactured things (*artificialia*)—resulting from natural disasters. Here it is flooding that disperses matter otherwise "in place." Collecting thus occurs under the aegis of Noah, who gathers in order to regenerate. But the possibilities for reconstructing what the deluge disintegrates and disperses remain tied to the paradoxical logic of gathering and preserving, which themselves instantiate destruction. Part 3 (chapters 6–7) concerns what is not apparently in need of being salvaged at all, namely the trivial or worthless. To collect such meaningless matter in the attempt to make it matter, to integrate it into a new context in which its triviality is overcome, ends up being a problematic endeavor, not least because it would involve the transformation of the mere thing into a valuable object, which would be to turn the logic of modern collecting on its head. No such rescue is possible without undoing the thing's fundamen-

tal triviality, which to preserve requires a mode of collecting in which the impulse to make significant (aligned, as it is, with the desire to piece together a whole) must come together, however paradoxically, with the proclivity for letting things be, for allowing them to scatter as they will—in other words, to be mere, trivial things.

In the first of the chapters that deal with ephemeral things—chapter 2—I analyze Adalbert Stifter's late story "Der Kuß von Sentze" (The kiss of Sentze, 1866), in which moss collecting offers an escape from the self-defeating impasse of collecting naturalia. If the ephemeral life of the plant must be sacrificed to collect and preserve it (as opposed to cultivating it in a garden, for instance), then moss is exempt from this problem: though effectively killed by drying and storing, it can be brought back to life with a drop of water. The implications of this storable ephemerality—known to German and Austrian moss collectors of the day—as well as moss's unusual cryptogamic reproduction—which was only discovered in the decade and a half before Stifter wrote this novella—provide the tale with biological models that bypass sexual contact without sacrificing the perpetuation of the family line. Nonetheless, even though strategic moistening (of the kissing lips or the desiccated plant) may allow for the continued flourishing of the collected organism in question, it also importantly re-exposes that now living thing to the possibility of dispersal and decay.

In chapter 3 I introduce a visual work of modernism that illustrates the degree to which collecting as poesis is not limited to the literary realm. At stake is the collectability of the experiential instant, which for Susan Sontag is made possible in the tangible object of the photographic print. The photograph, however, fixes what is essentially fleeting. The moving, cinematic image may instantiate that ephemerality, but it cannot be "held on to" (and therefore cannot be collected) as can the photograph. In closely examining a short film from 1927 by Oskar Fischinger I propose a way in which this dilemma is overcome. For this experiment in cinema is a work on the border between animation and live action that succeeds in making palpable the ephemeral instant—made matter in the single celluloid frame—even as it slips by. The chapter concludes with a brief foray into postmodernism by way of Swiss American musician and

artist Christian Marclay's *Record without a Cover* (1985), in which the materiality of the artwork itself performs ephemerality by storing the medium's own gradual deterioration.

The next set of case studies (part 2), concerning catastrophic debris, begins with chapter 4, whose main focus is Jeremias Gotthelf's *Die Wassernot im Emmental* (The flooding of the Emmental, 1838), a generically unstable work that combines features of the sermon and journalistic reportage with poetic flourishes. My reading uncovers the ways in which the refuse and debris caused by natural catastrophe become productive and generative in Gotthelf's text, which enacts a kind of "literary gleaning," both collecting together and reading or interpreting (a play on *zusammenlesen*: "to glean," but also, literally, "to read together") the flood's scattered and broken things. Gotthelf accepts these things as the products of God's intervention, which it is the writer's task neither to salvage before being swept away, nor to repair and make useful again, nor even to discard after being split to pieces, but instead to collect together *as* refuse that points back to the unified whole to which it once belonged but from which it is now irreparably severed.

Chapter 5 is also concerned with catastrophic refuse and the (potential) flooding of a Swiss valley. Here I look to Max Frisch's *Man in the Holocene* (*Der Mensch erscheint im Holozän*, 1979) to work out the relation between erosion (of landscape and memory/mind) and collecting as an attempt to resist dispersal through the creation of assemblages or "patchworks" (Benjamin). The site of collecting in this text is a wall in the protagonist's house on which he attaches handwritten notes (*Zettel*) and passages cut out from books. Thus, a preoccupation with worthless things (*Verzetteln*) is aligned with the redemptive activity of collecting as a patching or "holding together" of what is deteriorating. The effort to save what is being eroded and washed away, however, ultimately also involves the creation of debris. Frisch suggests that while catastrophes continue to threaten stability and order in the world—contributing to ever more dispersion—we can only really salvage the things in that world (and by extension the world itself) through an accumulation of (dead) knowledge, a fragmentary assemblage of waste and wisdom gleaned from the past.

The final pair of chapters (part 3) deals with triviality. In chapter 6 I read Gottfried Keller's *Green Henry* (*Der grüne Heinrich*, first version, 1854–1855) against the contemporary realist dilemma of how to integrate everyday triviality into the aesthetically unified representation of reality. The chapter demonstrates that the main collections in the novel—from Margret's rummage shop to its titular protagonist's travel chest and art portfolio—become the sites of trivialization and transferral, the spaces that both "contain" junk (allowing it to be visible) but do not "contain" it (by fixing it in place) and that they thereby present us with another model of collecting in which gathering and preservation are dialectically informed by dispersal. Keller furthermore inscribes this dialectic into the novel's structural design as *Bildungsroman* so that the recognition of the trivial becomes *the* epistemic achievement of Heinrich's development. For only by realizing that his paintings are trivial and letting them go (by selling them to the junk man, who disperses them further) can he redeem them: his artistic works thus ultimately only become important for having led him to the key insight that they are of no real importance.

Chapter 7 explores the complex ways in which dust, as well as its larger cousin, sand, figures in the modernist crime fiction of Friedrich Glauser, where these fine particles of matter are ubiquitous, raising critical questions about the role of particulate matter as evidence and how such seemingly trivial matter might be collected and preserved to provide epistemological and forensic clarity. As quintessentially dispersed matter, dust and sand are fundamentally uncollectable. To gather them, therefore, is to fail to preserve their essential dispersal. To preserve this state, then, one must *fail* to gather them, which is precisely what Sergeant Studer does in Glauser's first two novels (both published in 1936), where the detective succeeds in preserving particulate, scattered evidence *in* its fundamental uncollectability. Such a mode of (un)collecting provides epistemic access to things *as* trivial matter and to things *in* their dispersal. The standard model of collecting denies us this access. Studer, in contrast, safeguards the trivial and the scattered by letting them be—letting them slip away.

In the conclusion I reflect on how these individual case studies complicate the book's theoretical framework, especially with regard

to the distinction between object and thing, but also in relation to practical realms of collecting, otherwise marginal to my investigation. I thus briefly consider the problem of ephemeral art and the unconventional museum space of Porto M., where the debris and lost belongings of refugees are put on display. We find here an especially poignant and problematic instance of how displacement informs collecting and how dispersal becomes a potentially hopeful condition as an escape from violence and oppression. I end the book by returning to Rilke, whose early poem "You don't need to understand life" (Du mußt das Leben nicht verstehen, 1899) articulates an extreme view of collecting as not only impossible but also undesirable. Here Rilke ultimately rejects the imperative to collect while still insisting on the necessity of establishing a relation to things— by means of dispersal. This radical position allows the book's main arguments to be dialectically reformulated.

1

THEORIZING COLLECTING

We live in a world littered with things, an overwhelming abundance and variety of material stuff that is mute and—more often than not—inscrutable, when not entirely bereft of meaning. Some of these things are our own doing: they are clutter born of the industrial age, circulating among us in ways that have transformed our living spaces and our interactions with each other.[1] Others are the outgrowths or extrusions of our earthly environment: the stubborn persistence and preponderance of matter as such. More than ever before, these two realms are reciprocally intertwined: the ways in

1. For the longue durée historical background of this shift, with a focus on consumption, see Frank Trentmann, *Empire of Things: How We Became a World of Consumers, from the Fifteenth Century to the Twenty-First* (New York: Harper Collins, 2016). The more specific changes in our perception of things introduced around 1800 were addressed in the introduction with reference to Christoph Asendorf's work on things in the nineteenth century. Asendorf, *Batteries of Life*.

which the natural world encroaches on us as materiality—unwanted, unwieldly, threatening—is directly related to our encroachment on it, not least through the relentless manufacture of things, which pollutes the world and increases its volatility.

In this way the proliferation of things is inextricable from the fragility of things. In their increase and accumulation, objects end up losing distinction, becoming small and insignificant, if not invisible. It is therefore not just things' abundance that overwhelms us; their frailty and transience, too, leave us at a loss. Against the backdrop of things' accumulation, then, we also witness the disintegration, deterioration, decay, and even disappearance of objects all around us. It turns out that they—like us—are not long for this world. And yet, because their remains are not so easily gotten rid of, they typically continue to contribute to the increase of matter all around us, even in their afterlife. Our ever-expanding refuse heaps and floating garbage patches attest to this reality. In wearing away, breaking down, withering, flitting by, or simply ceasing to be, things thus feed into a cycle that only increases their—and our—vulnerability. In this way things' indisputable accretion and persistence find their unexpected corollary in their impermanence. The defining feature of objects all around us ends up being their propensity to become *mere things* and, as such, to lose both meaningfulness and, ultimately, durability. Thus, even though things continue to confront us with their materiality, it is a materiality indelibly marked by a fundamental instability, ephemerality, and dispersal.

As such, things do not just reflect but in fact infiltrate our own, very human, condition. Vilém Flusser plays on this invasion of things into our existence with a pun on the German word for "condition" (*Bedingung*), which has the word *Ding* ("thing") at its center: "The things [*Dinge*] in my surroundings are my condition [*Bedingung*]." For Flusser, this thingly condition is "exceedingly dissatisfying," and for two main reasons:

> Not only because I cannot get my bearings in and therefore cannot accept my condition, but also because I cannot actually find myself in it and thus seem to be located nowhere.

Zwar nicht nur, weil ich mich in meiner Bedingung nicht zurechtfinden kann und also nicht abfinden kann mit ihr, sondern auch, weil ich mich eigentlich gar nicht in ihr finde, mich also nirgends befinde.[2]

The world of things, as Flusser portrays it, leads to disorientation and to a sense of homelessness. The struggle to come to terms with things is a struggle to orient oneself among them, to find one's way—ultimately, to locate oneself in the preponderance of objects that refuse easy classification.[3] Flusser's wordplay (lost in translation to English, unfortunately) suggests that the problem—and thus also, we are led to believe, the solution—lies in some form of "finding." To "find one's way" or "get one's bearing" (*sich zurechtfinden*), to "come to terms with" or "accept" (*sich abfinden*), and to "find oneself" (*sich finden*) or "be located" (*sich befinden*) all deploy the root verb "to find" (*finden*). Although Flusser uses reflexive forms, the word *finden* nonetheless evokes—and in his usage still in part involves—a sense of encounter, indeed an encounter with the world around us and its troubling materiality.[4] This encounter, *finding* the thing in its particularity, importantly represents a first step in the process of gathering.[5] And to gather what one has found is one salient but also vital way of dealing with the very condition Flusser describes: that of always already *finding oneself* among things. But as the cycle of proliferation and deterioration tends toward entropy, these are things increasingly more used up than useful, more devalued than valuable. We find ourselves more and more among things both recalcitrant and fleeting, thus always tending toward the trivial, the transitory—ultimately,

2. Vilém Flusser, *Dinge und Undinge: Phenomenologische Skizzen* (Munich: Hanser, 1993), 9.

3. "The things in my surroundings resist being classified. . . . Were a—or at least some—classification of the surroundings possible, then one could orient oneself in them. Thus, the best one can do is to try not to lose oneself completely in them." Flusser, *Dinge und Undinge*, 9. With the phrase "preponderance of objects" I allude to Adorno's discussion of the object in Adorno, *Negative Dialectics*, 183.

4. This sense of encounter is reinforced by the etymology of *finden*: from the Old High German *findan*, which originally meant "to encounter."

5. See Manfred Sommer, *Sammeln: Ein philosophischer Versuch* (Frankfurt am Main: Suhrkamp, 1999), 53–57.

toward trash. "The dumb stuff [*das dumme Zeug*] in my surround-
ings has the tendency to be at once unusual and unusable [*unge-
bräuchlich und unverbräuchlich*] and thus to constitute not really
waste but rather junk [*nicht eigentlich Abfall sondern Müll*]," Flusser
observes.[6] These are the things used up and effectively worthless but
still all about us. And yet we cannot take comfort in them, because
their persistence as depleted or deteriorated stuff attests to their loss
as valuable objects. How do we find our way among such forsaken
things? How do we come to terms not only with their accumulation
but also with their dispersal and impermanence? By first *finding*
them, then gathering them, safeguarding them, and, finally, paying
them heed. In other words, by means of collecting.

In part because it flourishes in so many varieties and contexts,
collecting is the most prominent and widespread of the various
human endeavors that deal with our condition, this *Bedingung* in
which we find ourselves.[7] To collect, from this perspective, is to
manage the simultaneous proliferation and fragility of things. Since,
as Flusser and others note, the things in our surroundings are our
condition, the activity of collecting them (in one form or another)
is a fundamentally human activity, deeply ingrained in human na-
ture and instinct. To collect is, as one scholar puts it, a "primal drive"
of sorts.[8] Picking up this notion, Odo Marquard provides a novel
retranslation of Aristotle's definition of the human as "that creature
to whom belongs" not reason (*logos*), but "the activity of
collecting."[9] We collect all sorts of things: animate and inanimate,
natural and manufactured. In each case, the activity involves gath-
ering, ordering, setting aside, and preserving. And in each case, it

6. Flusser, *Dinge und Undinge*, 10.
7. Especially when considering the vast modes of collecting, from archaeo-
logical work to recycling and beyond.
8. Andreas Grote, "Vorrede—Das Objekt als Symbol," in *Macrocosmos in
Microcosmo*, 11.
9. Odo Marquard reads the *legein* of Aristotle's "zoon logon echon" as origi-
nally denoting "to collect." Marquard, "Wegwerfgesellschaft und Bewahrungskul-
tur," 911. On this etymology, see Sommer, *Sammeln*, 374–75. Heidegger also reads
logos in Aristotle's definition as meaning "gathering" or "collecting" (*Sammlung*).
Martin Heidegger, *Feldweg-Gespräche*, ed. Ingrid Schüßler, *Gesamtausgabe*
(Frankfurt am Main: V. Klostermann, 1995), 77:223.

also involves some attempt to *find*—not just the things that determine who we are by determining the world in which we live but also to find ourselves in and among those things, as Flusser suggests. In most of its variants, collecting promises some kind of orientation, accomplished not only by identifying and classifying things but also by paying attention to their materiality. We see this attention to some degree in the practical gathering of what we need to survive; for example, wood to burn or build with, food to eat, and the like—what Manfred Sommer calls "economical collecting." Yet the attention to materiality is most pronounced in those modes of gathering whose end is only to behold things, not to use them—for example, stamps, coins, or beetles—what Sommer calls "aesthetic collecting."[10]

It is a variation of this latter type of collecting—which I identified in the introduction as an historically determined mode—that is the focus of this book: a gathering together of things in the effort to bring them close and pay them heed, to access them in their particularity and materiality, and in doing so to safeguard these very qualities, which threaten to dissipate and become invisible. Thus, while we collect in order to orient ourselves in the world, we also collect in order to halt—even if temporarily—things' tendency to fade, fall apart, become lost, or what is more, lose their significance. To collect is therefore also to intervene in the cycle of proliferation and deterioration on behalf of the things around us for the sake of their permanence and meaningfulness. The practice of collecting is meant to *save* these things, in both senses of the word. As the *Oxford English Dictionary* tells us, to collect is to "reserve or lay aside," thus "to accrue" or "keep"—but it is also to "rescue" and "protect."[11]

10. Sommer, *Sammeln*, 31–32. Sommer later argues that economical collecting is in any case a derivative form of aesthetic collecting, which he claims is "fundamentally conservative," seeking to preserve the things collected, not use them (up). *Sammeln*, 46–47.

11. See Marx's reference to the double meaning of the English "to save" as at once *retten* and *sparen* (to rescue and to save/save up) and to the Greek Σώζειν (to save/rescue) as also indicating "hoarding." Karl Marx, *Capital: A Critique of Political Economy*, vol. 1, trans. Ben Fowkes (London: Penguin, 1990), 254. Cf. Asendorf, *Batteries of Life*, 48–49.

Even when such rescue is not immediately apparent, it nonetheless informs the way collecting establishes our relation to the world in its materiality.[12]

In the end, the act of "finding" in Flusser's reflections on things is not just a first step but also a final one. One must first find some *thing* to be able to collect it. However, the actual finding, the real encounter, is facilitated by means of the processes of gathering and preservation themselves. Only once collected—that is, removed from where one first locates it—does one truly "find" the object, which is to encounter it anew and to reorient oneself in relation to it by granting it the semblance of meaning, order, and protection. Collecting thus ultimately consists of the attempt to control the proliferation of things and to curtail their concomitant impermanence by lifting them out of the jumble of stuff in which they occur or have been abandoned and then installing them in a new space where they are saved from insignificance, displacement, and decay.

Nonrestorative Collecting (*Antapocatastasis*)

And yet, this mode of collecting is itself a form of dislocation and destruction. For even though the activity aims to suspend an object's life by halting its inevitable deterioration or assuring order and meaning where these are in decline or missing, it still exerts violence in the process.[13] This is because to collect anything requires extracting it from its natural environment and placing it in an artificial one, where it must be immobilized and defunctionalized. The useful object, removed from its sphere of practical application, is the most obvious victim of the collection's inexorable logic of deinstrumentalization. As the historian of collecting Krysztof Pomian writes, "Although they may well have served a definite purpose in their former existence,

12. Consider the following example: we collect trash. We do so, however, not to preserve it as such, of course, but to preserve the environment in which it would otherwise be dispersed. On trash collecting, see Sommer, *Sammeln*, 33–41.

13. On the destructiveness of collecting and museum practices, in particular, see Vedder, "Alexander Kluges Museumspoetik," 91–95. See also Maleuvre, *Museum Memories*, esp. 276–278.

museum and collection pieces no longer serve any at all."[14] Similarly, and echoing a number of other theorists, Susan Stewart notes that "the collection represents the total aestheticization of use value."[15] For those objects of nature not yet in the grip of instrumentalization, the consequences of being dislocated and immobilized are even more dire. Consider the butterfly or the flower, those iconic objects of collecting. To gather and preserve these and related naturalia requires not just fixing them in place but also—precisely to accomplish this immobilization—taking their life. Moreover, in the process, they are (even as dead things) unavoidably damaged if not irreparably disfigured: the butterfly is pinned, the flower dried and pressed.

The dislocation and defunctionalization of collected objects also have consequences, even if at first they are less obvious, for the places where they are found. After all, the object usually serves a specific function or fulfills a distinct role in the world from which it is taken, and its being gathered and installed in the collection inevitably means it will no longer satisfy these purposes. Of course, depending on the object, its absence may not be so noticeable: the single flower in a field will hardly be missed, the caryatid on a temple much more so. The consequences of the object's displacement are in any case always constitutive of collecting's paradoxical logic. For if the object can only be preserved by wresting it from the world, then it can only be saved in one place by being lost in another. To collect is therefore to set into motion a peculiar dialectic whereby the object collected is only made present and permanent by excising it from where it belongs and thereby leaving behind an absent spot.[16]

14. Pomian, *Collectors and Curiosities: Paris and Venice, 1500–1800*, 8. For Pomian, the loss of usefulness includes loss of the object's ability to adorn or be decorative.

15. Stewart, *On Longing*, 151. Those who have drawn attention to this same canceling out of use value include Benjamin, *Arcades Project*, 19, 204; *Gesammelte Schriften*, 5:53, 5:271; Baudrillard, *System of Objects*, 92. The degree to which the collected thing ceases to function as a commodity has been variously addressed in the literature. With one exception (chapter 6), the things central to this book do not function as commodities; hence I treat this category as marginal to my main concerns.

16. See Stewart, *On Longing*, 135, and Karl-Josef Pazzini, "'Das kleine Stück des Realen': Das Museum als 'Schema' (Kant) und als Medium," in *Open Box:*

Collecting therefore doubly imposes a loss: first, on the object, which must become a thing—losing its life, usefulness, or immediate meaningfulness—in order to enter the collection; and second, on the place in which that object was found, where—the object having been extricated from it—it is now missing. The latter loss is related to a third instance of absence that is constitutive of the collection: the gaps in the collection itself. Although establishing a collection always involves removing an object from where it is found, leaving behind an absence in the world, the drive to collect, too, is only maintained by what is absent in the collection as such. The collector, after all, seeks a set of related things, a set delimited by criteria that determine an item's inclusion in the collection. The impulse to collect is an impulse to populate the collection with objects that match these criteria. If the criteria are narrow, the collection may only be a small one; if they are broad, it could potentially be very large. In either case, what motivates the activity of collecting is what is missing from the collection. A collection without gaps would be a complete collection, which, if achieved, would spell the end of the activity of collecting. Once all the pieces have been found, there is no point in continuing to look for them. Collecting as a process, then, is only actualized and sustained by means of two interrelated absences: the absence in the collection that the collector desires to fill and the absence in the world that is the inescapable result of filling it.

These are the animating paradoxes of collecting. They foreground the degree to which the process of collecting tends to be a highly conflicted one, apparently at odds with its own desired outcome. Most models of collecting, however, cover over these gaps and tensions by emphasizing the totality and unity of the desired collection, which figures as the restitution of a lost order.[17] Such models

Künstlerische und wissenschaftliche Reflexionen des Museumsbegriffs, ed. Michael Fehr (Cologne: Wienand, 1998), 314. Cited in Ulrike Vedder, "Zwischen Depot und Display: Museumstechniken in der Literatur des 19. Jahrhunderts," in *Archiv/ Fiktionen: Verfahren des Archivierens in Literatur und Kultur des langen 19. Jahrhunderts*, ed. Daniela Gretz and Nicolas Pethes (Freiburg im Breisgau: Rombach, 2016), 35.

17. Ulrike Vedder offers an excellent overview of some of the primary means by which the "idea of totality" governs nineteenth- and twentieth-century collect-

conform to an eschatological conception of restoration that posits an original state of order and harmony located in some irretrievable past, recognizable only negatively in the present condition in which things are scattered. According to these models, to collect is not to remove something from where it belongs but rather to save it from this state of dispersion. In effect, these models treat the things encountered in our world as *already* missing from their original place. To collect is to attempt to reconstitute that order by placing these scattered things into an arrangement that approximates or actualizes what was lost.[18]

The restitution of things thus takes on theological dimensions. Indeed, the triadic and cyclical model of restoration is central to the Jewish mystical tradition (in the notion of *tikkun*), as well as to Christianity (in the notion of apocatastasis). Gershom Scholem describes *tikkun* as "restitution, re-integration of the original whole" in which "everything is put in its proper place."[19] This eschatological redemption of things coincides with their return to the beginning, to an original divine order, such that "the path to the end of all things, is also the path to the beginning."[20] The Christian concept of apocatastasis follows a similar recursive pattern in which a

ing in its attempts to "overcome contingency" and establish "a potential musealization of the world." Vedder, "Zwischen Depot und Display," 36–37 (for quoted phrases; the whole article presents this overview). For an alternate interpretation of the collection's restorative power, see Stewart, *On Longing*, 151–152, who argues that collecting does not look back but rather ahead, in anticipation not of a restoration but of a completely new context altogether: a new beginning.

18. On the historical practices and discourses in Germany grounded in this view of collecting as "saving and restoration" and therefore as "a 'return' to an imaginary original state of completeness," see Crane, *Collecting and Historical Consciousness*, 41. Collecting as an ersatz order in nineteenth-century German literature is fruitfully explored by Christoph Zeller, "Magisches Museum: Aspekte des Sammelns in der Literatur des 19. Jahrhunderts," *Jahrbuch der Raabe-Gesellschaft* (2005): 74–103.

19. Gershom Scholem, *Major Trends in Jewish Mysticism* (New York: Schocken Books, 1941), 268, 274. The German of the second quotation here is even more revealing: "jedes Ding an seinen rechten Ort gesetzt." Although the book was first published in English, it was based on drafts written in German, which Scholem drew on for the German edition. Gershom Scholem, *Die jüdische Mystik in seinen Hauptströmungen* (Frankfurt am Main: Alfred Metzner, 1957), 301.

20. Scholem, *Major Trends in Jewish Mysticism*, 274.

lost originary state of harmony will be reestablished in the end, "the times of the restoration [*apokatastaseos*] of all things" (Acts 3:21).[21] In the secularized version of this apocatastatic model, the collected thing belongs not to a lost paradisiacal order but to a specific history, so that it becomes the carrier of memory. To collect is to gather that object in the effort to save not so much it as the experience to which it is tied; to re-member coincides with a reconstitution of a lost and scattered past.[22] The collection seeks access to a time now gone through a constellation of objects that resembles the order of things past, an order that stands in stark contrast to the present state of dislocation and disunity.

The state of origin from which things have supposedly fallen, however, is neither fixed nor even determinable, and certainly—if it even existed—not repeatable. Any collection that promises completeness, consequently, is no more than a wish image of that restored world, as Walter Benjamin, for example, notes: "The collector delights in evoking a world that is not just distant and long gone but also better—a world in which, to be sure, human beings are no better provided with what they need than in the real world" (Der Sammler träumt sich nicht nur in eine ferne oder vergangene Welt sondern zugleich in eine bessere, in der zwar die Menschen ebensowenig mit dem versehen sind, was sie brauchen, als in der alltäglichen).[23] Without the prospect of recreating an original order—either because such a state never existed or because its restoration is simply not possible—the impulse to collect looks markedly different. Faced with the proliferation and fragility of things, we collect not to restore some preexisting order but rather to establish and maintain a (new) constellation of these things in the ef-

21. Walter Benjamin associates the concept of *tikkun*, which he knew from Scholem, with apocatastasis. See Andreas Pangritz, "Theologie," in *Benjamins Begriffe*, ed. Michael Opitz and Erdmut Wizisla (Frankfurt am Main: Suhrkamp, 2000), 799. Also compare Christoph Asendorf's reading of the transformation of the commodity in Marx, which he sees as following a similar tripartite structure. Asendorf, *Batteries of Life*, 35–36.

22. On the souvenir, cf. Stewart, *On Longing*, 132–151. On collecting as a form of practical memory, see Benjamin, *Arcades Project*, 205; *Gesammelte Schriften*, 5:271.

23. Benjamin, *Arcades Project*, 19; *Gesammelte Schriften*, 5:53.

fort to make sense of them and to—with Flusser, again—orient ourselves among them, which is both to endure them (in their inscrutable and at times intractable materiality) and to assure that they endure (despite the precariousness of that materiality). To collect in this way is not to gather scattered pieces or fragments in an attempt to reassemble a whole but to demonstrate the degree to which existence is indelibly marked by incompleteness, dispersion, and abandonment. To collect nonrestoratively—*antapocatastatically*, if you will—is thus not to escape from this state but to make it palpable, which is necessary for coming to terms with our condition, our *Bedingung*. This reconciliation requires direct attention to the disjecta that are typically lost in the random assortment and proliferation of things, but also—as we will see—equally overlooked in the taxonomical and systematizing imperative of conventional, classical models of collecting.

In subsequent chapters I develop and explore this nonrestorative, *ant*apocatastatic model of collecting on the basis of literary and cinematic examples that question or complicate the promise of restoration. Ultimately, we are dealing here with two modalities of collecting that emerge from the same preservationist impulses born of the early nineteenth century.[24] I argue that the classical, restorative form is a wish image at best: It expresses the desire for establishing order, unity, and completeness through classification and conservation. But its goals are ultimately illusory, because it must suppress the inherent paradoxes of collecting, the ways in which it is complicit in the displacement and even destruction it ostensibly prevents or corrects. What I have been calling "modern collecting" identifies the contradictory tendencies set in motion by the preservationist endeavor with an emphasis on the ways in which these tensions are picked up and made productive. Such collecting is thus not entirely "futile"; by acknowledging its fundamental paradoxes, the activity does not come to an end.[25] Modern collecting, rather, recognizes

24. On "preservationist" collecting, which has been the dominant mode since around 1800, see Marquard, "Wegwerfgesellschaft und Bewahrungskultur," 914.

25. Cf. Dominik Finkelde's notion of "futile collecting," discussed in the introduction. Finkelde, "Vergebliches Sammeln," 187–204.

that gathering and preservation are at odds with one another; it therefore does not fill, mend, or cover over but rather discloses the gaps inherent in the process. It follows that to collect in this way is not to approach, let alone achieve, any kind of restoration of a lost state of things, even though it may attempt to do that—or even may pretend to have done so. The process of collecting, rather, reveals that a restored state of things remains out of reach or impossible and that the world of scattered and contingent things ultimately lies beyond such redemption.

And yet this mode of collecting succeeds in exposing the state of things and their unredeemability by means of a redemption of another kind. Its demonstration that the scattered things of our world will not be restored to a lost order goes hand in hand with its rescue of the thing *in its particularity*. The collection that seeks to reestablish order and totality—the apocatastatic collection—is less concerned with the individual thing and more with its place in a constellation into which the particular is subsumed and necessarily disappears. By contrast, antapocatastatic collecting, in foregrounding incompleteness, makes the thing palpable in its singularity. Such emphasis on the particular is an unexpected, because seemingly contradictory, feature of modern collecting.[26]

Collecting thus carries out not a redemption *from* but rather a redemption *of* things. It does not save us from the world of scattered things by "fixing" or "restoring" them; it allows for these things themselves to be experienced fully. By means of its dialectic of preservation and loss, in which things are safeguarded at the same time as they are damaged and displaced and in which bringing the thing close always also involves absenting it from somewhere else, collecting draws attention to things as such, to their fragility and contingency. In both maintaining and putting on display things' marginal, precarious status, collecting allows us to grasp things— in both senses of the word—as always already displaced.

26. Alongside observations about collecting, Finkelde makes a similar claim with respect to classificatory systems of knowledge in general, which have to strip things of their particularity in order for them to be subsumed into the categories by which they can be known as such. Finkelde, "Der nicht aufgehende Rest," 107.

What collecting thereby preserves is the thing *as* contingent, the singularity and frailty of matter *as such* that in the apocatastatic model have to be elided or otherwise overcome in the (attempted) restoration of order and unity. What we safeguard by collecting, ultimately, is the proclivity for decay and damage, the fragility, finitude, and vulnerability of things around us—and therefore also of ourselves. In the effort to prevent the total disappearance of the object, this preservation might in some instances be meant to halt its deterioration, but it is by no means meant to correct or reverse it. To collect, rather, is to capture, hold on to, and bring close these very qualities of our contingent existence. Since collecting must participate in the damage and dispersal that it ostensibly seeks to curtail, the objects taken up into the collection relinquish their value and significance in the world from which they are taken in order to be kept safe. We thus "save" these objects—from insignificance, from deterioration, from disappearance—only by means of a procedure that at the same time reinforces these fates.[27] Ultimately, their redemption—saving them by saving them up—only comes through the simultaneous exposure of their ephemerality, dilapidation, or triviality, so that we come to see the thing in all its valences only after it has been divested of its objecthood.

Objects and Things (*Heidegger* and *Benjamin*)

Having already mobilized the distinction between object and thing, it behooves us to define it more concretely and to lay out its implications. If the object is that which has a place in the world, then the

27. This logic of collecting and dispersal bears some resemblance to certain models of economics, from Goethe's "circulation" in *Wilhelm Meister's Apprenticeship* (where in bk. 1, chap. 10, Werner extols the virtues of an exchange system in which the perpetual movement of goods contributes to a larger circulation that leads to prosperity) to Marx's conception of the workings of capitalism (wherein the accumulation of capital is only possible by way of its constant motion), and finally to Bataille's notion of expenditure (according to which conservation requires loss and waste). In these cases, various forms of dispersal feed into productive systems of dynamic growth.

thing has lost this place. The object serves a purpose and is integrated into our life or environment seamlessly and unproblematically. The thing is marked by incongruity or displacement: it announces its presence as *not* belonging, *not* fitting into its intended context, *not* fulfilling its role. Context here is key: the same entity might be an object in one environment and a thing in another. The surrealists exploited this contingency to great effect (fur belongs on an animal or in an article of clothing, not lining a teacup), though less extreme examples might be culled from our everyday experiences. Imagine, for instance, finding a small metal latch on the floor. Not integrated into the apparatus of which it is a part, we might not even recognize it. The thing strikes us as strange. Is this oddly shaped fragment of metal a part of something, a broken piece, or some scrap metal that has somehow made its way into the house? Even if we see it is a latch, what does it belong to? This is no object; it is a mere thing, bereft of belonging and thus demanding our attention, both in its particularity and materiality. When we go to use the sliding backdoor to which this latch belongs, we encounter that object too as a thing, not because it is out of place, but because in the absence of the latch we are unable to unlock and open it. The door fails to function as we expect it to, as an object that fulfills a particular purpose, namely to allow egress and ingress from that part of the house. It thus also strikes us as a mere thing: stubborn and unwieldy in its materiality. As objects within the contexts in which they belong or serve the function we expect, we would normally pay them no heed. As things divorced from these meaningful contexts or resistant to fulfilling their function for a particular task, they demand our attention.

This picture of encountering the thingliness of an object once it has broken down finds its classical description and analysis in Heidegger's discussion of tool being. In sections 15 and 16 of *Being and Time*, Heidegger distinguishes tools (*Zeug*) from all other things in the world (*Seiendes*).[28] *Zeug* is *Seiendes* encountered in our "concernful dealings" (*im Besorgen*) with the world around us. Such ob-

28. Martin Heidegger, *Sein und Zeit*, 17th ed. (Tübingen: Max Niemeyer, 1993), 66–76; Heidegger, *Being and Time*, trans. John Macquarrie and Edward Robinson (New York: Harper and Row, 1962), 95–107.

jects, indeed, only ever "are" in a context of use or service. They contribute to a task and are thus only meaningful within a larger situation that calls for a constitutive "in-order-to" (*Um-zu*), which, Heidegger explains, is the structure of *Zeug*. Tools or "equipment," in other words, are essentially "something, in-order-to . . . ," a mode of being Heidegger calls *Zuhandenheit*, their being "ready-at-hand." To be ready-at-hand, however, the object or tool in question must "withdraw" (*zurückziehen*) from our reflective understanding. In these circumstances, we are not concerned with the object's readiness-at-hand, but rather with the larger project or task in or for which that object's readiness-at-hand is needed and in which it "disappears" in the process of practical usefulness.[29] This activity (of task-oriented "concernful dealings") covers over not only the object's readiness-at-hand but also its *Vorhandenheit*: its being there, "present-at-hand," a mere thing—*Seiendes* that lacks the structure of the "in-order-to. . . ." Finally, although it is only on the basis of the object's readiness-at-hand that there can be such a thing as presence-at-hand, this does not mean that presence-at-hand is ontologically primary or superior.[30] It is simply a different mode of being.

It is the breakdown of *Zeug*, "equipment," that exposes these modes. Heidegger explains how the unusability of the tool—its being defective or unsuitable to the task—"uncovers" these layers of being that must necessarily remain concealed for the tool to properly be a tool.[31] We only notice the object once it ceases to be an object ready-at-hand and becomes a mere thing. The breakdown of the object, in other words, reveals both the object's former objecthood and its fundamental thingliness, its pure "presence-at-hand." It also thereby reveals the "worldly character" (*Weltmäßigkeit*) of

29. This disappearing is more explicit in Heidegger's essay on the artwork: "To be sure, 'that' it is made is a property also of all equipment that is available and in use. But this 'that' does not become prominent in the equipment; it disappears in usefulness" (Zwar gehört auch zu jedem verfügbaren und im Gebrauch befindlichen Zeug, "daß" es angefertigt ist. Aber dieses "Daß" tritt am Zeug nicht heraus, es verschwindet in der Dienlichkeit). Martin Heidegger, "The Origin of the Work of Art," in *Poetry, Language, Thought*, 65; Heidegger, "Der Ursprung des Kunstwerkes," 53.

30. Heidegger, *Being and Time*, 101; Heidegger, *Sein und Zeit*, 71.

31. Heidegger, *Being and Time*, 103–106; Heidegger, *Sein und Zeit*, 73–75.

the things we encounter, making possible an awareness of our sur-roundings as such.[32] This "noticing" of the object in its thingliness Heidegger calls *Auffallen*, which simply means "to become conspic-uous," but it seems also to suggest a lapsarian logic.[33] We only gain a sense of the object's objecthood once we have *lost* it—once the object has become a thing. In the same way we can only recognize paradise once we have lost it—*fallen*.

Channeling Heidegger, Bill Brown writes that the thing is some-how *more than* the object: "You could imagine things . . . as what is excessive in objects, as what exceeds their mere materialization as objects or their mere utilization as objects—their force as a sensu-ous presence or as a metaphysical presence."[34] As in Heidegger, how-ever, this excess comes only by way of a reduction of sorts. The object must lose its utility, clash with its environment, or be made no longer to fit into its natural context. The operative paradox in Brown's defi-nition is worth stressing. What is irreducible to the object can only be sensed, noticed, or otherwise known by reducing the object to a mere thing—or by letting objects slowly, inevitably, become things. For all objects ultimately tend toward the thing: this transformation is in-trinsic to the cycle of proliferation and deterioration, to our condi-tion of being surrounded by and determined (*be*-ding*t*) by things. Collecting as a process operationalizes this transformation. And this operation, as the subsequent chapters demonstrate, is also constitu-tive of the artwork, a driving force in its negotiation of things in the world in relation to itself as an object among them.

Heidegger was well aware of the problematic status of the artwork as thing by virtue of which it is uniquely capable of making "mere things" known.[35] In his later thinking he insists that the thingliness of the thing must be thought from out of the work-character of the art-work itself. Ultimately it is the artwork that uniquely reveals the thing-

32. Heidegger, *Being and Time*, 104; Heidegger, *Sein und Zeit*, 74.
33. See, in particular, Heidegger, *Being and Time*, 104; Heidegger, *Sein und Zeit*, 73.
34. Bill Brown, "Thing Theory," in *Things*, ed. Bill Brown (Chicago: Univer-sity of Chicago Press, 2004), 5.
35. On the "mere thing," see Heidegger, "Origin of the Work of Art," 21–22, 30; Heidegger, "Der Ursprung des Kunstwerkes," 6–7, 15.

character of the stuff around us by way of its own fundamental thing-hood: "Artworks consistently show, even if in completely different ways, thingliness" (Die Kunstwerke zeigen durchgängig, wenn auch in ganz verschiedener Weise, das Dinghafte).[36] They accomplish this disclosure of things in a way that harkens back to the discussion of the tool's breakdown in *Being and Time*. If the actual "matter" or material (*Stoff*) of the tool "disappears in usefulness" (*verschwindet in der Dienlichkeit*), then in the artwork this same matter is what is brought forth in its materiality. Similar to the way the broken tool makes the worldhood of things noticeable, the artwork opens up the world, namely by disclosing its particular elements and the ways they shape our environment. The "temple-work," Heidegger writes of one of his primary examples, the Greek temple, "does not cause the material to disappear, but rather causes it to come forth for the very first time and to come into the Open of the work's world. The rock comes to bear and rest and so first becomes rock; metals come to glitter and shimmer, colors to glow, tones to sing, the word to speak" (Das Tempel-Werk . . . läßt . . . den Stoff nicht verschwinden, sondern allererst hervorkommen und zwar im Offenen der Welt des Werkes: der Fels kommt zum Tragen und Ruhen und wird so erst Fels; die Metalle kommen zum Blitzen und Schimmern, die Farben zum Leuchten, der Ton zum Klingen, das Wort zum Sagen).[37] It is this matter, not only in its "force as sensuous presence," to quote Bill Brown again, but also in its inscrutability as what "remains undisclosed and unexplained" (*unentborgen und unerklärt bleibt*), which emerges from the art-work's "setting up of the world" (*eine Welt aufstellen*).[38]

The artwork accomplishes this disclosure in a process similar to defamiliarization. "In general, of everything present to us, we can

36. Heidegger, "Der Ursprung des Kunstwerkes," 25. My translation.

37. Heidegger, "Origin of the Work of Art," 46; Heidegger, "Der Ursprung des Kunstwerkes," 32.

38. Heidegger's specific example of what "remains undisclosed and unexplained" is color, though this example follows upon that of the stone's heaviness. Heidegger, "Origin of the Work of Art," 47; Heidegger, "Der Ursprung des Kunstwerkes," 33. On the artwork's setting up of the world: "To be a work means to set up a world." Heidegger, "Origin of the Work of Art," 44; Heidegger, "Der Ursprung des Kunstwerkes," 30.

note that it *is*; but this also, if it is noted at all, is noted only soon to fall into oblivion, as is the wont of everything commonplace," Heidegger writes near the end of the essay on the work of art. He continues with a rhetorical question: "And what is more commonplace than this, that a being is?" Precisely on account of its ordinariness, because we have become habituated to it, what is most familiar of all—the things all around us—remains hidden in its thingliness. The artwork allows these things to emerge in their unfamiliarity: "In a work, by contrast, this fact, that it *is* as a work, is just what is unusual."[39] In doing so, we are "transport[ed] . . . out of the realm of the ordinary" *(aus dem Gewöhnlichen heraus[gerückt])*.[40] The result is that we achieve an ontological closeness—though not a measurable one—to the world. As Heidegger writes in his later essay on the thing, "Thinging is the nearing of world" (Dingen ist Nähern von Welt).[41]

This closeness is only made possible by the distancing or displacing of objects, just as a renewed familiarity with them comes only

39. Heidegger, "Origin of the Work of Art," 65 (unless otherwise specified, all emphasis appears in the original). "Überhaupt können wir an jedem Vorhandenen bemerken, daß es ist; aber dies wird auch nur vermerkt, um alsbald nach der Art des Gewöhnlichen vergessen zu bleiben. Was aber ist gewöhnlicher als dieses, daß Seiendes ist? Im Werk dagegen ist dieses, daß es als solches *ist*, das Ungewöhnliche." Heidegger, "Der Ursprung des Kunstwerkes," 53.

40. Heidegger, "Origin of the Work of Art," 66; Heidegger, "Der Ursprung des Kunstwerkes," 54.

41. Martin Heidegger, "The Thing," in *Poetry, Language, Thought*, 181. Heidegger, "Das Ding (1950)," in *Vorträge und Aufsätze*, ed. Friedrich-Wilhelm von Hermann, *Gesamtausgabe* (Frankfurt am Main: V. Klostermann, 2000), 7:182. Heidegger notably links the thing directly to a notion of "collecting" and "gathering" *(Sammeln, Versammeln)*, which he writes is essential to the way in which things (and works of art) disclose themselves and the world. In the artwork essay, for instance, Heidegger describes the fundamental activity of the Greek temple in terms of its "gathering" ("Das Tempelwerk . . . sammelt . . ."). Later, he identifies the strife at the core of the artwork as a "gathering" of movements. Heidegger, "Origin of the Work of Art," 42, 48, 50, 57 (note that Hofstadter sometimes renders *Sammlung* or *gesammelt* as "concentrated"); Heidegger, "Der Ursprung des Kunstwerkes," 27, 34, 36, 45. In the "Thing" essay, this language becomes more pronounced. Here Heidegger equates *Versammeln* ("a gathering") with the thing: "Our language denotes what a gathering *is* by an ancient word. That word is: thing." And in answer to the question of how the thing *is* in essence ("Wie aber west das Ding"), he writes the following: "The thing things. Thinging gathers" (Das Ding dingt. Das Dingen versammelt). Heidegger, "Thing," 174; Heidegger, "Das Ding," 175.

at the price of the loss of their ordinariness. That proximity—as if encountering the object and its environment for the first time—is afforded by a process that effects or hastens the breakdown of the object, its transformation into a thing. We do not lose sight of or forget the object once it has become a thing, however. In fact, after it is gone, we gain a clearer or deeper sense of both its former objecthood and its underlying materiality. Heidegger's reflections provide one theoretical model for understanding this paradox. Another, surprisingly complementary, model comes from Walter Benjamin, to whose writings I now turn for further elucidation of the redemption of things through their apparent destruction. On the connection between these two thinkers with regard to objects and things, Gerhard Richter writes, "Both Benjamin and Heidegger require that the thing be torn out of its assumed context . . . in order to be thinkable in a new way." It is precisely this "denaturalizing [of] the contextual determination" of things that, as I argue in this and subsequent chapters, collecting instantiates.[42]

In his *Trauerspiel* book, in particular, Benjamin articulates a dialectical notion of redemption through destruction that undergirds the conception of collecting explored in this book. Critical to this conception is the figure of the allegorist, who picks up the singular, small, particular, and forsaken things that history has scattered and, instead of forging a unified picture that covers over this destruction, cobbles together a constellation that reveals them for what they are. Indeed, as Benjamin himself later notes in *The Arcades Project*, in the allegorist we find the prototype of the collector: "In every collector hides an allegorist, and in every allegorist a collector."[43] The redemption this figure makes possible involves finding an adequate means to experience things in their specificity and materiality that does not reduce them to abstractions or generalizations. It entails encountering what cannot be subsumed under concepts (what Adorno calls the "nonidentical"), the apparently meaningless or irregular, in "the

42. Gerhard Richter, "Critique and the Thing: Benjamin and Heidegger," in *Sparks Will Fly: Benjamin and Heidegger*, ed. Andrew Benjamin and Dimitris Vardoulakis (Albany: SUNY Press, 2015): 54.

43. Benjamin, *Arcades Project*, 211; *Gesammelte Schriften*, 5:279.

most singular and eccentric of phenomena" (*im Singulärsten und Verschrobensten der Phänomene*) that Benjamin identifies as "the genuine" (*das Echte*).[44] The allegorist, Benjamin claims, redeems the "mute" and "fallen" things of the world by means of their devaluation or "degradation": "For in the midst of that knowing degradation of the object, the melancholic intention maintains fidelity [*Treue*], altogether incomparably, with its being as thing" (Denn mitten in jener wissentlichen Entwürdigung des Gegenstandes bewahrt ja die melancholische Intention auf unvergleichliche Art seinem Dingsein die Treue).[45] This transformation of an object through devaluation into a thing thus preserves—in the manner of the dialectic—an essential connection to its fundamental thingliness, its brokenness, its dispersion.

Benjamin refers to the dialectical process of such redemption through loss as a "sudden reversal" (*Umschwung*).[46] What it accomplishes is decidedly *not* apocatastatic, which would bring the scattered fragments back into the unified, symbolic form that Benjamin defines in opposition to the allegorical. This "sudden reversal," rather, privileges the "fragmentary, disordered, and cluttered" (*[das] Bruchstückhafte, Ungeordnete und Überhäufte*) that, like the collection as Benjamin later defines it, appears as a "patchwork" (*Stückwerk*).[47] In this way, loss becomes constitutive of the redemp-

44. Walter Benjamin, *Origin of the German Trauerspiel*, trans. Howard Eiland (Cambridge, MA: Harvard University Press, 2019), 25–26. Benjamin, *Der Ursprung des deutschen Trauerspiels*, in *Gesammelte Schriften*, 1:227.

45. Benjamin, *Origin of the German Trauerspiel*, 245 (translation modified); *Gesammelte Schriften*, 1:398. Compare to earlier in the book, where Benjamin writes of the allegorical gaze that it "betrays and devalues things in an inexpressible manner" (*verrät und entwertet die Dinge auf unaussprechliche Weise*). Benjamin, *Origin of the German Trauerspiel*, 197; *Gesammelte Schriften*, 1:36.

46. Benjamin, *Origin of the German Trauerspiel*, 248; *Gesammelte Schriften*, 1:401, 1:405, 1:406.

47. Benjamin, *Origin of the German Trauerspiel*, 199, 201 (translation modified); *Gesammelte Schriften*, 1:362, 1:363. On the collection as "patchwork," see also Benjamin, *Arcades Project*, 211; *Gesammelte Schriften*, 5:279: "As far as the collector is concerned, his collection is never complete; for let him discover just a single piece missing, and everything he's collected remains a patchwork, which is what things are for allegory from the beginning" (Was den Sammler angeht, so ist ja seine Sammlung niemals vollständig; und fehlte ihm nur ein Stück, so bleibt doch

tive process. What is small, damaged, and insignificant is taken up and given attention *as* what it is. As Heinrich Kaulen puts it, Benjamin's melancholic allegorist "takes what has become meaningless seriously in its brokenness." The result is that "the false symbolic appearance [*Schein*] of reconciliation and wholeness fades away so that destruction reverts into its opposite, becoming a 'fidelity' [*Treue*] in the face of singular, extinct things."[48] This process also sets in motion a dialectic of the transitory and the eternal. Benjamin writes, "Indeed, the insight into the transience of things, and the concern to save them and render them eternal, is one of the strongest motives in the allegorical" (Ist doch die Einsicht ins Vergängliche der Dinge und jene Sorge, sie ins Ewige zu retten, im Allegorischen eins der stärksten Motive).[49] These two extremes "collide" (*zusammen-stoßen*) in allegory, where the fallen, scattered things of the world are at once saved from disintegrating entirely and preserved in their fallen state.[50] The preservation of the thing coincides with its disintegration, degradation, or disappearance as an object.

Taken together, Heidegger's and Benjamin's reflections on objects and things underscore the paradoxes of collecting sketched out at the beginning of this chapter, in particular the way that loss is constitutive of its undertaking. Collecting—per my guiding conception throughout this book—is a form of mediating this loss, both conveying and coming to grips with it, which often amount to the same thing. In the process of attempting to overcome loss (to fill the gaps, to restore things to a state of wholeness), the collector makes that same loss palpable as such. In freeing the object from its contexts, collecting makes it a thing, with the result that it becomes present to us in its particularity, fragility, and insignificance. That presence,

alles, was er versammelt hat, eben Stückwerk, wie es die Dinge für die Allegorie ja von vornherein sind).

48. Heinrich Kaulen, "Rettung," in *Benjamins Begriffe*, 640.

49. Benjamin, *Origin of the German Trauerspiel*, 243; *Gesammelte Schriften*, 1:397.

50. "Allegory is most abidingly there where transience and eternity most nearly collide" (Die Allegorie ist am bleibendsten dort angesiedelt, wo Vergänglichkeit und Ewigkeit am nächsten zusammenstoßen). Benjamin, *Origin of the German Trauerspiel*, 243; *Gesammelte Schriften*, 1:397.

however, is at once concrete and spectral or, in Bill Brown's words
again, both a "force as sensuous presence" and "as metaphysical
presence." What is concrete and sensuous is the thing; what is spec-
tral is the object, only present in its absence. What the collector loses,
then, is not just the original object's belonging to a particular place
or task. Palpable in the thing, too, is its temporal distance—its his-
tory. For Benjamin, the collector looks through his things, as if they
were telescopes, into that distance: "As he holds them in his hands,
he seems to be seeing through them into their distant past, as though
inspired" (Kaum hält er sie in Händen, so scheint er inspiriert durch
sie hindurch, in ihre Ferne zu schauen).[51] The "distant past" accrues
in the object as historical meaning, but it is only released in the pre-
sent: as a thing in the collection. There, suspended in time, the thing
allows time itself to be felt. There, the collected item's meaningful-
ness (its sensuous presence and its historical significance) emerges
most powerfully as that which has slipped away, has passed.

Collecting sets in motion this dialectical process of preserving im-
permanence, of making present something that is also at the same

51. Walter Benjamin, "Unpacking My Library: A Talk about Collecting," in
Selected Writings, 1927–1934, ed. Michael W. Jennings, Howard Eiland, and Gary
Smith (Cambridge, MA: Harvard University Press, 1999), 2:487. Walter Benjamin,
"Ich packe meine Bibliothek aus: Eine Rede über das Sammeln," in *Gesammelte
Schriften*, 4:389. *Ferne* ("distant past" in the translation, but actually just "dis-
tance") alludes to the aura, which Benjamin defines in his artwork essay as "the
unique apparition of a distance, however near it may be" (*einmalige Erscheinung
einer Ferne, so nah sie sein mag*). Walter Benjamin, "The Work of Art in the Age of
Its Technological Reproducibility," in *Selected Writings, 1935–1938*, ed. Howard
Eiland and Michael W. Jennings (Cambridge, MA: Harvard University Press, 2002),
3:104–105. Benjamin, "Das Kunstwerk im Zeitalter seiner technischen Reproduzier-
barkeit," in *Gesammelte Schriften*, 1:440. For a different approach to Benjamin's
thoughts on collecting in relation to allegory and Heidegger, see Michael P. Sternberg,
"The Collector as Allegorist: Goods, Gods, and the Objects of History," in *Walter
Benjamin and the Demands of History*, ed. Michael P. Sternberg (Ithaca: Cornell Uni-
versity Press: 1996), 88–118. Other helpful pieces on Benjamin and collecting include
Heiner Weidmann, *Flanerie, Sammlung, Spiel: Die Erinnerung des 19. Jahrhunderts
bei Walter Benjamin* (Munich: Wilhelm Fink, 1992); Eckhardt Köhn, "Sammler," in
Benjamins Begriffe, 695–724 (Köhn shows that Benjamin's conception of collecting
shifts over time and is by no means unified); and most recently, Annie Pfeifer, "A Col-
lector in a Collectivist State: Walter Benjamin's Russian Toy Collection," *New Ger-
man Critique 45*, no. 1 (2018): 49–78.

time absent, of bestowing significance on a thing *as* that which has lost its meaning in the world. To concretize these insights with respect to the practical activity of collecting, consider an ordinary object: the typewriter. As a mechanical tool, it is meant for a particular task. Put to use by the individual who knows how to use it, the typewriter is an object. That means that *as* a material, mechanical, and manufactured entity it withdraws from the user in his or her absorption in the task at hand. As a writing technology, however, the typewriter is becoming obsolete. Like all things, natural or manufactured, it will eventually disappear. But its immediate decline as an important and ubiquitous object of our culture makes this inevitable fate all the more palpable.

To collect the typewriter (perhaps along with other writing instruments or other typewriters) is to remove it from its sphere of use entirely. As a tool, it could still be used. In the collection, however, it will no longer be functionalized and will only be looked at. By virtue of its displacement into the collection, the object becomes thing-like. We see it in the collection differently from the way we would—and still might—encounter a typewriter in, for instance, an office. Although it is immediately present in front of us in the collection, we are nonetheless aware of where it once was, of what purpose it fulfilled, and that it no longer fulfills this purpose (this is the case whether we treat the object as particular or as representative of others like it). We are also reminded that even though devices like it are still being used around the globe, it is not long for this world: it and machines like it are being replaced by newer devices. Its collectability from this perspective corresponds to the degree to which it is (or is becoming) rare and unusual: an artifact of history. The act of collecting the typewriter saves it from being thrown into the junk heap, from eventually becoming landfill. But it achieves this rescue not by restoring it to the world of practical use, for instance by providing a new context in which it can be refunctionalized.[52] Collecting redeems the object-become-thing, rather, by preserving it *in its* obsolescence and near-disappearance. The thing that we come in contact with in the collection is thus no longer simply *this matter* or *this tool*, but rather an instrument that has lost both its objecthood and its place in the

52. Cf. Stewart, *On Longing*, 152.

world. We experience it not just as an aesthetic object, a cultural object, or even as an historical one but also as a thing that once was one of these objects. As such it exudes loss: of functionality, of cultural importance, of historical importance. The typewriter might have been restored, refurbished, and sent somewhere where it could be made useful as an object. As a thing, however, it draws attention to those aspects usually covered over in its everyday use: its manufacturedness, its materiality, its history, (the decline of) its cultural significance, the inevitability of its obsolescence, its disappearance. Collecting aims to hold on to these qualities as spectrally present. But it simultaneously reminds us that these qualities *cannot* be held on to, because they belong to an object that is no more and, furthermore, that this is the case in large part because of the act of collecting itself. Collecting thus makes permanent and meaningful that which is losing its permanence and meaningfulness. It does not restore these qualities; it captures them as they are in decline, making them palpable while at the same time assuring that they are no more.

Collecting therefore does not preserve the typewriter as object; it instantiates the typewriter as a thing, one whose objecthood, moreover, is necessarily, though only spectrally, present. The typewriter is present to us in the collection *as* that which is absent in the world, *as* that which is disappearing from the world, *as* that which is going the way of all things. Paradoxically, the only way to rescue this object from its fate—of becoming a mere thing and then disappearing entirely (becoming no-thing)—is to transform it into a thing. Collecting partakes in this process at the same time that it aims to protect from it. It exposes the ambiguous and precarious position of the object-become-thing, whose significance for us emerges from its having lost significance, from its being there in front of us while at the same time not being there as the object the collection is supposed to have preserved.

Materiality, Meaning, and Mimesis (*Assmann*)

How is this process at work in the creative arts, particularly in literature? In the chapters that follow I demonstrate via a series of case

studies the distinctive and often idiosyncratic ways in which the paradoxical logic of collecting becomes fundamental to how creative works constitute themselves, especially in relation to the material world and to the task of representing that world in its materiality. In this section, I draw out the implications of the preceding discussion of things for the mimetic form and function of the artwork. For in mobilizing the paradigm of modern collecting, the works that I analyze in this book demand that we recalibrate how we understand their representational achievement.

Let us begin by considering the semiotic character of representation, where the meaningfulness of a sequence of signs corresponds to its success in presenting the world of things. Aleida Assmann succinctly defines "the law of semiosis" as "the inverse relation of absence and presence" by which we arrive at meaning (which is absent) only by way of the materiality of the sign (which is present). "The gaze must penetrate the (present) materiality of the sign," she writes, "in order to be able to reach the (absent) layer of meaning." If we do not look through or past the sign as such and instead get held up by its materiality, then we are likely to be left with little to no understanding: "Whoever gets tangled up in the materiality of the sign cannot understand it any more than the dull gaze of the overtired and uninformed reader is able to pull back the curtain of the letters."[53] Assmann summarizes the consequences of this scenario with a simple formula: "Where things are present there are no signs—and the other way around." It follows from this semiotic law that art, which necessarily makes use of signs, must keep the world and its abundance of things at a distance if these signs are to generate meaning.[54] Those distant things do not themselves mean anything. In the absence of any transcendental framework that would allow them to be signatures of a divine order or the writing of God, to be read as if they were text (a notion that died in the eighteenth century, just before the works that are the case studies of this book

53. Aleida Assmann, "Die Sprache der Dinge: Der lange Blick und die wilde Semiose," in *Materialität der Kommunikation*, ed. Hans Ulrich Gumbrecht and K. Ludwig Pfeiffer (Frankfurt am Main: Suhrkamp, 1988), 238.
54. Assmann, "Die Sprache der Dinge," 239.

were written), they simply are.[55] The result is that the material stuff of this world necessarily resists becoming a vehicle of meaning.

But this materiality of the world does have its own inherent meaningfulness, distinct from the meaning of the sign, which is necessarily mediated. Assmann identifies the meaningfulness of things as a language, albeit a highly idiosyncratic, resistant one: a mute counter-language (*Gegensprache*) that "begins where human language ceases."[56] Of course, this is not a language that communicates anything corresponding to accepted categories of sense or information. It, in fact, only manifests itself, Assmann explains, in the interruption of conventional human discourse, in the often sudden breaks and ruptures afforded by the "sheer materiality" of things, all of which can precipitate "a new meaningfulness [*Bedeutungshaftigkeit*]."[57] If properly heeded, this "wild semiosis" of things, which "distorts, proliferates, and disrupts established meaning [*Sinn*]," thus provides "a new, unmediated significance [*Bedeutung*]" that is reducible neither to language nor to things, neither to concepts nor to the reality they seek to capture.[58]

Using Assmann's model, I propose that collecting reverses the vectors of linguistic semiosis. If the sign keeps the world at a distance, functioning properly because the thing to which it refers is absent *here* but present out there, then the collected thing brings the world close, functioning only because the thing is in fact absent *out there* while being present here. The law of "*the inverse relation of presence and absence*" still holds true.[59] Importantly, however, Assmann is not suggesting that we can somehow access this "unmediated significance" by simply paying attention to things present to us. If that were the case, then the collection would indeed offer a rather simplified model for encountering things in their "sheer materiality." To collect things would be to bypass language and

55. Indeed, this loss of a transcendental framework constitutes one of the shifts to classical modernity that marks the historical backdrop of this book's investigation into the problems of modern collecting.

56. Assmann, "Die Sprache der Dinge," 247.
57. Assmann, "Die Sprache der Dinge," 248.
58. Assmann, "Die Sprache der Dinge," 239.
59. Assmann, "Die Sprache der Dinge," 238.

thereby somehow to encounter the real directly—a naïve prospect, to be sure. On the contrary, the power of things emerges only in disrupting the conventions of communication and significance. This disruption or distortion of "established meaning" is a process, and it is a process that I insist is also set in motion by the activity of collecting, which foregrounds—and thereby mediates—the simultaneous production and loss of things' significance for us.

Collecting offers neither simply a mediated, semiotic access to things nor an unmediated encounter with them. Rather, it generates a dialectical movement in which both aspects are made palpable. For the collected object is never simply present as a thing; it also importantly functions as a sign. However, unlike the semiotic sign, this material sign refers not to the presence of an object in the world out there but rather to its absence from that world. As such, the collected thing at the same time points back to itself as that which is in fact missing out there but is present right here. (We might say that it successfully refers to its own absence by way of its presence.) This presence is, however, imbued with loss, both despite and by virtue of the fact that the thing is here. The displacement of the object into the collection—its transformation from object into thing—thus effects the disruption that Assmann identifies as making possible a renewed experience of the world. But that disruption is ongoing, woven into the complex relation of thing, sign, and world that the collection sets in motion.

Since Assmann is ultimately concerned with how the otherwise mute materiality of things becomes semiotically productive within and against established systems of communication, her model helps bring the paradoxical consequences of collecting (as outlined earlier in this chapter) to bear on the realm of the representational arts. First of all, although the "language of things" may "start where the language of humans stops," it can only really emerge in the breaks and ruptures of "the dominant rules of discourse": those conventional forms of linguistic practice that necessarily remain in place.[60] Like Heidegger and Benjamin, then, Assmann understands disruption and disorder as the privileged sites of thingly awareness: "Thus

60. Assmann, "Die Sprache der Dinge," 247–248.

whoever has a reason for escaping from human systems of order could become sensitively attuned [*hellhörig*] to the language of things."[61] This thingly language, Assmann suggests, reverberates in those sudden, fleeting, ecstatic, and singular moments in which the discourses we think of as transparent break down, become suspended, or are called into question. To make knowable and significant the otherwise mute and meaningless materiality of the world, therefore, requires some kind of defamiliarization of existing communication, which Heidegger and Benjamin each located in the realm of the aesthetic. Literature, in particular, has long been identified as the privileged site of this process, most famously by Viktor Shklovksy, whose notion of "enstrangement" (*ostranenie*) designates poetic language's ability to distort and impede ordinary communication in order to make the world in its sheer thingliness palpable, "to make us feel objects, to make a stone feel stony."[62] Shklovsky, in fact, describes this distortion through language as a *displacement* of the object from the domain in which it is normally encountered, which precisely describes the procedure of collecting. Moreover, such a "removal ... from the sphere of automatized perception" does not make that which was familiar somehow inaccessible to knowledge, as the notion of "making strange" might initially suggest; rather, it makes a thing known anew, "disrupting" habituated perception so as to enable one to encounter it as if for the first time.[63]

The modern collection and the work of art can thus be seen to conform to a similar logic by which dislocation and disruption become constitutive of a new experience of things. The subsequent chapters of this book explore the poetological and philosophical implications of this connection in detailed analyses of particular works of literature and—in one case—cinema. These case studies demonstrate the different ways in which the collection's play of presence and absence, dispersal and gathering, loss and redemption finds not just expression (as the descriptive content) but also real-

61. Assmann, "Die Sprache der Dinge," 249.
62. Shklovsky, *Theory of Prose*, 6.
63. Shklovsky, *Theory of Prose*, 6, 14. See also p. 12: "the transfer of an object from its customary sphere of perception"; "an artifact that has been intentionally removed from the domain of automatized perception."

ization (as the poetic material) in the artwork. This realization, how-
ever, has consequences for our conception of these and similar
works' mimetic qualities. No longer can we speak of an ordered and
unified construction in which the individual pieces have a necessary
place and function. Not surprisingly, such a classical model of mi-
mesis corresponds to the classical model of the collection, in which
the individual piece must be subservient to the set and its relation
to the whole, in which each thing therefore has its place and any
gaps must be smoothed over to create the false appearance of unity
or the promise of its completion.[64] The logic of modern collecting,
shot through as it is with paradoxes, offers a way to reconfigure
this relationship of part to whole and thereby account for the dis-
ruption and dislocation of things that—as Heidegger's, Benjamin's,
and Assmann's theories show—are deeply connected to the funda-
mental principles of the poetic and the aesthetic. For in the modern
collection things are both *in place* and *out of place* at the same time,
or rather, they are only in place by being out of place. In the art-
work informed by this logic, the thing is not subsumed into the
seamless construct but sits precariously in and stubbornly at odds
with the whole, making itself known in its particularity and vulner-
ability. It does not disappear in the assembled set of similar things;
it does not become only a type hardly indistinguishable from the
others gathered with it. Thus, instead of integrating the part into
the whole, the work animated by modern collecting reveals its gaps
and incongruities, allowing for the thing's singularity and inscruta-
bility to become palpable by generating, to quote Assmann, "disor-
der in the established relational systems of conventions and
associations."[65] This privileging of the thing is the representational
correlate to the nonrestorative, antapocatastatic model of collect-
ing, marking the artwork as an allegorical assemblage of disparate
pieces.

64. For a narratological explication and critique of this model, in which what-
ever seems not to belong must either be subsumed or excluded, see my own study of
digression: Samuel Frederick, *Narratives Unsettled: Digression in Robert Walser,
Thomas Bernhard, and Adalbert Stifter* (Evanston, IL: Northwestern University Press,
2012).
65. Assmann, "Die Sprache der Dinge," 239.

As subsequent chapters illustrate, however, this attention to the particularity of the thing does not translate into detailed descriptions of objects or things. In the works central to my analyses, things are not always (if at all) the centers of attention. Nor do they become animating forces that crowd out or demote human activity.[66] These works veer away from any such extended observation or dramatization of material stuff, which instead either lingers mutely at the margins, incidental to the putative main action, or assumes its expected place, inconspicuously, as diegetic prop alongside this action.[67] The precarious status of the ephemera, detritus, and trivia that appear in these works moreover marks these things as resistant to any efforts to make them prominent or central. Because it is precisely their position as fleeting, broken, or neglected that distinguishes them, they remain necessarily peripheral and contingent: They appear in the work as elements that never quite fully fit or as pieces that pose a problem to the world of human concerns to which they never entirely belong. They are—like the items of the modern collection—both in place and out of place simultaneously. In this way, these things indeed function

66. As such, my case studies comprise an anomalous "literature of things" that should be distinguished from those thing-centric works in which the inanimate stuff of the world becomes anthropomorphized or active or in which objects and things are shown to have a "life of their own." In the German tradition these works include Kafka's "The Cares of the Family Man" (Die Sorge des Hausvaters, 1920) with its enigmatic thing-figure Odradek, on whom there is an abundance of literature; Alfred Polgar's short pieces on the revolt of things; Friedrich Theodor Vischer's famous "malice of the object" (*Tücke des Objekts*) chapters in *Auch einer* (1879); and Ernst Bloch's thought pieces on things in *Traces* (*Spuren*, 1930). For critical literature on animate, agential objects and things, see Lorraine Daston, *Things that Talk: Object Lessons from Art and Science* (Cambridge, MA: MIT Press, 2004) and Jörg Kreienbrock, *Malicious Objects, Anger Management, and the Question of Modern Literature* (New York: Fordham University Press, 2012). In chapter 4, I venture into this territory, arguing that the catastrophic refuse in Gotthelf's *Die Wassernot im Emmental* becomes active as a site of "thing power." The eruption of things' apparent productivity in this text, however, is part of Gotthelf's attempt to redeem the inert and lifeless matter that is his main concern.

67. The apparent exceptions here—Fischinger's photographs (chapter 3) and Frisch's paper scraps (chapter 5)—complicate this picture because in each case these are media of representation. Here we find the attempt to make the media *as such* palpable in the face of our tendency to treat them as transparent surfaces through which we access some other (either experiential or textual) reality.

as a resistant and mute "counter-language" (Assmann) legible only in the interstices of the text, in those moments in which dominant discourses come to a halt or where these discourses seem unable to account for "sheer materiality" in its fundamental contingency.

The artwork concerned with this materiality thus becomes the space in which the mimetic imperative to "make present" must be tested and (in some cases) reconsidered. If conventional models of mimesis rely on unity and stability for their success, these qualities would seem to be inadequate for representing what is broken, inconsequential, or fleeting. One cannot fix in place what is ephemeral, make whole what is fragmented, or bestow importance on what is trivial without in some way doing damage to these things. Together, the theories of materiality and meaning presented in this chapter offer a paradoxical solution to this impasse. Heidegger's notion of ontological "disclosure" through "denaturalization" (Richter), Benjamin's allegorical redemption through "devaluation" and "destruction," and Assmann's "wild semiosis" by means of sudden and fleeting "disruptions" point to the ways in which the loss of things is essential to "saving" them. Seen through the prism of these models, an adequate representation of mere things can only be achievable by means that at the same time undo classical representation's imperative to offer a complete view of the world through the assimilation, classification, and ordering of the things that make up this world. Benjamin's statement about collecting from his essay on dolls remains, in this respect, paradigmatic:

> The true, much misunderstood passion of the collector is always anarchic, destructive. For this is its dialectic: to connect the intractable subversive protest against the typical, classifiable with fidelity to the thing, to the singular, that which is secured in it.

> Die wahre, sehr verkannte Leidenschaft des Sammlers ist immer anarchistisch, destruktiv. Denn dies ist ihre Dialektik: Mit der Treue zum Ding, zum Einzelnen, bei ihm Geborgenen, den eigensinnigen subversiven Protest gegen das Typische, Klassifizierbare zu verbinden.[68]

68. Benjamin, *Gesammelte Schriften*, 3:216. Benjamin goes to claim that the world is present and "ordered" in each of his things, but only by means of a surprising, profane, and incomprehensible relation (3:216–217).

Benjamin here locates the achievement of collecting in its failure to create order. To succeed in integrating the singular thing into the collection would be to lose it to the set that defines that collection's items only in terms of what is typical and classifiable. True "fidelity to the thing" in its singularity requires the destruction of such assimilating, homogenizing structures. My argument in this book is that modern collecting makes this destructiveness fundamental to its procedure: The object *must be* lost for it to be preserved as a thing. The following chapters do not just offer examples of this paradox; they present different—indeed, irreconcilable—ways of instantiating it. Some make collecting's need for sacrifice plain; others hide the consequences of collecting below the surface or seek to smooth it over. In each case, the paradoxes of gathering and preservation drive a profound engagement with the problem of things, which appears in various guises, at times aligned with apparently non-thingly concerns such as family lineage (chapter 2), the experience of temporality (chapter 3), theodicy (chapter 4), memory (chapter 5), *Bildung* (chapter 6), or criminal justice (chapter 7).

The means of redeeming precarious things that I locate in my case studies do not, however, transform them back into stable and useful objects, even where instrumentalization might initially be suggested. These things are neither reintegrated into the world nor fully into the work but remain marginal, broken, trivial, or damaged. They are only successfully gathered and preserved, in other words, in ways that make their loss and dislocation—their fundamental dispersal—palpable. What is distinctive about the works in question is their ability to make the paradoxes of collecting productive in ways that do not undo the precariousness of the things they seek to gather and preserve. In this they are commensurate with the impasses of collecting in the modern world.

It should be clear from this chapter that my primary concerns in the book as a whole remain philosophical and philological. I would nonetheless like in closing to return to the historical framework adumbrated in the introduction and say a little more about my selection of case studies, which spans almost 150 years, from the prerevolutionary nineteenth century to the postwar twentieth. On the

one hand, this historical breadth demonstrates that the problem of things which scholars such as Christoph Asendorf and Hartmut Böhme have identified as characteristic of the nineteenth century persists well into the twentieth.[69] Concrete circumstances change dramatically, to be sure, but these changes do not alter the course of our alienation from objects, which if anything intensifies in the early twentieth century as a result of the increased mechanization of production and the concomitant proliferation of things. The historical range of my case studies is thus meant to show a certain continuity across the periods into which we tend to partition the last two centuries. From the early nineteenth century to the late twentieth (and beyond) we find a shared concern with the possibilities and limits of gathering and preserving what is fleeting, fragile, or forgotten.

On the other hand, my selection and pairing of works from different periods explicitly foreground a distinction both aesthetic and historical. By placing one nineteenth-century work alongside one twentieth-century work in each of the book's three thematic parts, I appeal directly to the dominant movements—realism and modernism—by which we divide up and make sense of this stretch of cultural and literary history. In this way my selection carries out the classificatory impulse of collecting that undergirds our periodizing conventions. We gather examples, organize them by epoch, and present them as artifacts representative of that significant span of historical time. As applied in this book, such periodization acts as an organizational principle providing the conceptual clarity needed for defining and distinguishing the approaches to materiality and preservation that characterize the respective case studies.

The individual analyses undertaken in these chapters, however, tell a different, much less clear-cut story, one that calls into question any such easy distinction between realist and modernist paradigms. Indeed, my case studies reveal that the main differences between the nineteenth- and twentieth-century examples cannot always be so easily split along this historical divide. This is nowhere more evident than in chapter 6, whose extended engagement with

69. See Asendorf, *Batteries of Life*; Böhme, *Fetishism and Culture*.

theories of realism constitutes the most direct appeal to the programmatic aesthetics of either century's movements in the book. Except that although this chapter demonstrates how Gottfried Keller's *Green Henry* (*Der grüne Heinrich*) confronts a dilemma at the heart of realism's representational undertaking, the solution to this dilemma involves a radical vision of active dispersal that positions Keller closer to the modernists than to his near-contemporaries Stifter and Gotthelf. And yet, while Stifter's and Gotthelf's appeals to order, stability, and unity seem to align them firmly with the premodernist era (pointing to these writers' shared Biedermeier background), that connection, too, is belied by the palpable ambivalence they display toward the preservationist possibilities of collecting. These case studies thus appeal to historical differences—and to the conventions by which we classify these differences; yet at the same time, in establishing points of contact across periods, they unsettle the stable categories that would impose a general distinction. This book's "collection" of ostensibly representative realisms and modernisms, in other words, ends up looking more like the modern collection, in which the pieces cannot be fully subsumed into the categories that normally assure balance and unity.

My hope is that precisely *as* such a "patchwork" assemblage (Benjamin), the book provides a more authentic and detailed image of materiality in all its messiness and intractability across these two centuries. I thus do not mobilize the received notions of realism and modernism to pin down the different tendencies of the individual literary and cinematic works as they grapple with the problem of things. Instead, I let the singular examples demonstrate these periods' complexities, incongruities, and ambiguities. The divergent contexts in which we find the logic of modern collecting at work turn out not to be so easily contained (and explained) by the literary-historical designations we typically use. These categories ultimately fall short of fully accounting for the complex semiotics of materiality operative in our textual and cinematic examples. I thus use them more as heuristics—not as fixed terms into which individual works are made to fit but as flexible concepts that provide some historical orientation while making room for the intricacies and contradictions of each singular case. In the end, like the objects

taken up into the collection, these singularities at once define and disrupt the groupings they are meant to represent, so that their governing categories suggest a system of order and meaning that at the same time is shown to be elusive.

This elusiveness remains the predominant feature of our experience of materiality that collecting as a practice attempts to resist. The chapters that follow illustrate how efforts to rescue objects fleeting, frail, or forsaken activate the paradoxical logic of collecting in ways that make that experience matter. At the same time, they draw attention to the work of art as the site not only where these paradoxes are explored but also where they can be tested and played out. We might say, then, that they demonstrate another of collecting's fundamental displacements: the activity of gathering and preservation is uprooted from the practical realm and becomes operational in the semiotic and aesthetic realms of the imagination.

PART I

EPHEMERA

2

MOSS (*STIFTER*)

In his seminal work of botanical and zoological taxonomy, *Systema Naturae* (1735), Carl Linnaeus established a classificatory system for the vegetable kingdom in terms of "nuptial" relations among plants (*Nuptiæ plantarum*). Identifying the various ways that plants procreate (*Actus generationis*), Linnaeus distinguishes twenty-four classes in his "sexual system."[1] The nuptial metaphor guiding Linnaeus's classification is not incidental. Elsewhere he "describes the celebration of love and nuptials in plants, in the bridal bed provided by the petals."[2] Indeed, the site of this nuptial celebration determines Linnaeus's first-level subdivision of the plant kingdom. Either "the wedding is celebrated openly and visibly in

1. Carolus Linnaeus, *Systema naturae, 1735*. Facsimile of the first edition (Nieuwkoop: B. de Graaf, 1964), n.p.

2. Linnaeus, *Systema naturae*, 11. From the introduction by M. S. J. Engel-Ledeboer and H. Engel.

front of the whole world," or it is "established secretly." In thus distinguishing between plants whose nuptials are "Publicæ" and those whose are "Clandestinæ," however, Linnaeus creates an oddly lopsided taxonomy: his first twenty-three classes fall into the former category, leaving only a single class belonging to the latter.

This lone class Linnaeus calls "Cryptogamia," from the Greek *kryptos* ("hidden") and *gameein* ("to marry"), to be distinguished from seed-bearing plants later designated phanerogams, from *phaneros* ("visible") and *gameein*.[3] Cryptogams consist of four orders: algae, ferns, fungi, and those plants which we will focus on in this chapter, bryophytes, commonly known as mosses.[4] Before Linnaeus, botanists rarely dealt with these plants, whose lack of seeds or flowers left them outliers in the vegetable kingdom, when not simply ignored or excluded from it. The ancients made almost no mention of mosses, and when they did—see, for instance, Columella—the plants are seen as an invasive nuisance.[5] Francis Bacon (1561–1626) called mosses "but the rudiment of a plant," and Joachim Jungius (1587–1657) thought that they were aborted plant fetuses.[6] The botanist Johann Jacob Dillenius (1684–1747), a German who held a professorship at Oxford, was the first to study cryptogams in any detail, and although he made many advances in bryology (the study of moss) in particular, he misunderstood these plants' reproductive system. Another German botanist, Johann Hedwig (1730–1799), known as the father of bryology and the "Linnaeus of mosses," remedied this misunderstanding.[7] By putting moss under the microscope, something no one had done before, Hedwig was

3. Linnaeus provides the etymology in his description.

4. Linnaeus lists six orders: the fifth includes sponges and coral, and the sixth fig trees. These two orders are not counted among cryptogams today. The current classification also includes lichens and such nonphotosynthetic plants as slime molds and some bacteria.

5. Theophrastus and Aristotle allude to moss only in passing. On moss as infestation, see Columella, *On Agriculture* (Cambridge, MA: Harvard University Press, 1954), 2:84–85, 206–209, 412–413.

6. Howard Crum, *Structural Diversity of Bryophytes* (Ann Arbor: University of Michigan Herbarium, 2001), 39.

7. Jan-Peter Frahm and Jens Eggers, *Lexikon deutschsprachiger Bryologen* (Norderstedt: Books on Demand, 2001), 171.

able to identify the previously "hidden" sexual organs of this hith-
erto mysterious plant. Hedwig's work gave birth to the modern
study of moss. By the time his *Species muscorum* (Moss species) ap-
peared at the start of the nineteenth century (it was published post-
humously in 1801), the new science of moss had already generated
a swarm of amateur collectors eager to contribute to the observa-
tion, description, and classification of seemingly endless varieties of
bryophytes.

In 1866, when Adalbert Stifter published what would be the fi-
nal story to appear during his lifetime, "Der Kuß von Sentze" (The
kiss of Sentze), this moss craze had reached a peak, with scientific
papers, handbooks on collecting, and moss enthusiast groups ap-
pearing at a staggering rate throughout the German-speaking
world.[8] We have no knowledge of Stifter himself participating in
collecting moss alongside, for instance, his collecting of cacti, about
which he was passionate.[9] But details in "Der Kuß von Sentze" re-
veal that he was well aware of the discourses of bryology and the
practices of moss collecting, which play no less important a role in
this story than does the Cereus peruvianus (as plant and as part of
Risach's collection) in *Indian Summer* (*Der Nachsommer*, 1857). In
fact, one of the most important developments in bryology appeared
just fifteen years before the publication of "Der Kuß von Sentze." In
1851 the twenty-seven-year old Wilhelm Hofmeister (1824–1877),
who was a school dropout apprenticing by day in his father's book-
store while studying mosses at night, published *A Comparative*

8. See Frahm and Eggers's handbook of biographies and bibliographies, and
their opening remark: "Compared with the moss researchers of other countries, Ger-
man bryologists, especially those of the nineteenth century, were not only numerous
but also very successful" (*Lexikon deutschsprachiger Bryologen*, 3). Frahm and Egg-
ers's work appears to confirm bryologist Karl Mägdefrau's claim that the decade
between 1860 and 1870 saw more publications on moss than any other. Mägdefrau
is cited in Marcus Twellmann, "Literarische Osculologie nach Adalbert Stifter: 'Der
Kuß von Sentze,'" *Zeitschrift für deutsche Philologie* 128, no. 4 (2009): 540.

9. See the excellent discussion of Stifter's cactus collecting in relation to *Indian
Summer* in Catriona MacLeod, *Fugitive Objects: Sculpture and Literature in the
German Nineteenth Century* (Evanston, IL: Northwestern University Press, 2014),
107–142, esp. 129–142. One point of comparison is of significance to my investiga-
tion: both cacti and moss share a certain resilience in the face of an unforgiving
environment.

*Study of the Germination, Development, and Fructification of the
Higher Cryptogams*, a book in which the complex and unusual life
cycle of moss was fully laid out for the first time.[10] Hofmeister's
work showed how moss reproduction follows an alternation of gen-
erations in which a first, longer generation consists of the growth
of an enduring leafy plant that is nonetheless not yet genetically
complete, which is followed by a second, much shorter generation
consisting of a parasitic stalk that, although genetically complete,
is nonetheless inconspicuous and ephemeral.

The implications of moss's cryptogamic reproduction, as observed
by Hofmeister, along with its unusual collectability, as recorded in
contemporary manuals, are essential to Stifter's fundamental concern
with the phylogenetic structure of a human community in "Der Kuß
von Sentze."[11] I start from the observation that it is precisely the dis-
tinction between "clandestine" and "public" sexual contact (in the
form of the kiss) that matters in the novella, just as it is does for Lin-
naeus in his separation of cryptogams such as moss (which celebrate
a "hidden marriage") from seed-bearing phanerogams (which cele-
brate a "public marriage"). In what follows I demonstrate how
Stifter's late story takes up the problem of the desired but necessarily

10. Wilhelm Hofmeister, *Vergleichende Untersuchung der Keimung, Entwicke-
lung und Fruchtbildung höherer Kryptogamen (Moose, Farrn, Equisetaceen, Rhi-
zocarpeen und Lycopodiaceen) und der Samenbildung der Coniferen* (Leipzig: Ver-
lag von Friedrich Hofmeister, 1851).
11. These implications have been largely overlooked in the literature on this
story. The only works that discuss the role of moss in "Der Kuß von Sentze" in any
detail are Martin Selge, *Adalbert Stifter: Poesie aus dem Geist der Naturwissenschaft*
(Stuttgart: W. Kohlhammer, 1976), 64–69; Twellmann, "Literarische Osculologie,"
540–542; and, most recently, Michael Eggers, "Cryptogamic Kissing: Adalbert
Stifter's Novella *Der Kuss von Sentze* (1866) and the Reproduction of Mosses," in
Biological Discourses: The Language of Science and Literature around 1900, ed.
Robert Craig and Ina Linge (Oxford: Peter Lang, 2017), 169–187. Eggers's piece
overlaps in a number of important areas with the first half of this chapter (on moss's
reproduction in relation to the kinship structure of the House of Sentze), though it
should be noted that his article appeared about six months after the original version
of this chapter was first published. Birgit Ehlbeck suggests but does not develop the
connection between bryology and kinship. Ehlbeck, *Denken wie der Wald: Zur poe-
tologischen Funktionalisierung des Empirismus in den Romanen und Erzählungen
Adalbert Stifters und Wilhelm Raabes* (Bodenheim: Philo, 1998), 142.

transitory "continued flourishing of our family" (*Fortblühen unseres Geschlechtes*), as one character puts it, by introducing not a phanerogam such as the tree, which would produce such "blossoming," as the word *blühen* here suggests, but the cryptogam moss, whose seedless reproduction offers a novel paradigm for the preservation and perpetuation of a family line.[12] As with moss, the secret of the House of Sentze's survival lies in its difference from the phanerogamic life cycle of blossoming and decay. Its cryptogamic form makes possible a long, phylogenetic endurance over short periods of ontogenetic growth.

Moss offers a unique solution to the problem of preservation not only in its unusual reproductivity but also—and relatedly—as an object of the pragmatic activity of collecting, which is how the plant appears in Stifter's story in the first place. The problems of conserving a living, growing family thus become aligned with the problems of conserving a living, growing botanical organism in a collection. In each case, Stifter is concerned with overcoming ephemerality, of finding a way to suspend the cycle of flowering and decay by introducing an alternative principle of preservation in which the fleeting nature of things is made enduring without it being undone *as* what is ephemeral. This alternative principle lies hidden in the unique collectability of moss, which—unlike almost all other living things—can be gathered and stored without completely foreclosing its future flourishing. In being collected, moss enters into a state of dormancy not unlike that which characterizes its unusual reproductive cycle, a state from which it can be awakened by a drop of water. In the story, it is the moistening titular kiss that performs this (re)vivifying refunction, assuring the preservation *and* propagation of the family. Finally, both the plant moss and the collection that comprises this plant are necessarily incomplete, the former in terms of its genetic development, the latter in terms of the potentially infinite varieties of

12. Adalbert Stifter, *Werke und Briefe: Historisch-Kritische Gesamtausgabe*, ed. Alfred Doppler and Wolfgang Frühwald (Stuttgart: W. Kohlhammer, 1978–), 3:2, 158. Page references to the novella in the body of the text refer to this volume of the edition.

samples to be collected. This incompleteness, a marker of finitude, expresses a variation of Stifter's poetics of the small and apparently insignificant, which privileges the particularity of things against the backdrop of an unrealizable whole.

Phanerogams and Cryptogams

Before turning to Stifter's story I would like to make some important botanical distinctions that play a central role in my analysis. Phanerogams and cryptogams largely differ in the duration of their reproductive cycle relative to their life cycle. Phanerogams such as trees and flowers spend the majority of their life as the combination of male and female genetic material, be that an embryonic seed or the plant that grows from this seed. The period in which sperm and egg exist independently is by comparison extremely short, much the same as with humans. In fact, we consider the haploid (having only a single set of chromosomes) sperm or egg to not yet properly be the organism as such, which only emerges once these genetic materials join to form a diploid (having two sets of chromosomes) embryo. In phanerogams this embryo is the seed, which is the end point of the reproductive process and the beginning of the life of the organism. That seed has an exterior coating to protect the embryonic plant, which is packed with all the nutrients necessary for its growth. But the seed is nonetheless vulnerable, both to decay and to being eaten by animals. The life span of the seed that does not soon find the ecological conditions for its growth is therefore extremely limited.

With cryptogams the relative duration of the reproductive process in the plant's overall life cycle is reversed. Moss, for instance, spends the majority of its life cycle as haploid genetic material that is either male or female and only a very short period as the diploid combination of these two. Moss therefore exists (and grows) as such largely prior to the formation of an embryo. Its life is spent as a kind of "full-grown" sperm or egg, an organism that is known as a gametophyte. The gametophyte is the green growth we typically identify as moss. But by the measure of the phanerogam, moss has

at this stage not yet properly come into existence, because it is only haploid, not having completed (or even begun) the process of reproduction. It is no wonder early botanists were bewildered and that Jungius thought cryptogams were aborted plant fetuses.

When moisture brings sperm from one gametophyte together with the eggs from another gametophyte, an embryo is ultimately formed. This embryo, however, does not develop into another gametophyte. Instead it sprouts what is known as a sporophyte, which is small and inconspicuous compared to its host gametophyte and has a brief life—much like the lives of the haploid sperm and egg in phanerogams. The sporophyte is also parasitic in relation to the larger, haploid gametophyte. It grows up out of the gametophyte like a stalk, at the tip of which are housed a collection of spores. These spores are the equivalent of phanerogam seeds in that their dispersal leads to the growth of more plants. Yet unlike seeds, spores do not contain the joined male and female genetic material: they are not tiny embryos. Spores instead are either male or female, and they produce either male or female gametophytes, the full-grown plant that is nonetheless "incomplete" because it lacks a full set of chromosomes. As such, and again unlike seeds, spores are remarkably durable, in part because they lack the nutrients that make seeds a desirable food source for animals. Spores can also withstand extreme environmental conditions, and they are capable of enduring long periods of dormancy. Their capacity for survival is furthermore attested to by the fact that cryptogams are the oldest form of Earth's plant life, dating as far back as the Ordovician geologic period of the early Paleozoic Era (circa 470 million years ago), prior to the emergence of phanerogams.[13]

Almost all varieties of moss, then, grow and flourish before they form a full set of chromosomes. Moss spends the majority of its life cycle as a plant that has in a sense not yet been fully born. But as such it also largely escapes from the cycle of blossoming and decay that marks the life of most phanerogams.

13. Philippe Steemans et al., "Origin and Radiation of the Earliest Vascular Land Plants," *Science* 324, no. 5925 (2009): 353.

The Bryologic of the House of Sentze

For Stifter's "Der Kuß von Sentze"—a story deeply invested in the means and conditions for the continued growth and survival of an extended family—the distinction between the life and reproductive cycles of phanerogams and cryptogams is critical. It is the latter—plants whose propagation involves a "hidden marriage" and whose model of reproduction involves a long period of dormancy awakened by moistening—that are central to the novella's conception of the preservation and perpetuation of community.

The narrator of the frame narrative relates the prehistory of this community in the opening pages, where we learn the origin story of a family whose lineage can be traced to the early twelfth century. To maintain the integrity and unity of this family, the ancestral patriarch of the House of Sentze introduced a ritual kiss that bound its members to a pact of amity. The ritual was inaugurated as a measure to prevent an irreconcilable split in the family. To stop his sons from quarrelling, the patriarch made the two brothers give each other a kiss, a kind of inverse form of the "Judas kiss" by which Jesus was betrayed: "The brothers kissed one another at the right moment and subsequently had such a fear of the Judas kiss that from then on they no longer quarreled, in fact often came together by carrying out that same good deed" (Die Brüder küßten sich zu einer guten Zeit und hatten dann eine solche Furcht vor dem Judaskusse, daß sie fortan nicht mehr haderten, ja sich oft zu der nämlichen guten Handlung vereinigten, 144). This asexual kiss, then, while it does not precipitate procreation, is nonetheless productive because it engenders a "fear" of bringing discord into the world. (The fruit, *Frucht*, it produces requires shifting only one letter: *Furcht* ["fear"].) Its disciplinary power is further sustained by means of a second ritual: storytelling. When we read that the story of this original kiss "was passed on through the generations of the Sentze family" (Die Sache wurde in dem Geschlechte der Sentze fort erzählt, 144) we can see how the "flourishing" or "continued blossoming" (*Fortblühen*, 158) of the family becomes replaced by a "continued telling" (*Forterzählen*). It is, therefore, less pro-creation, *Fortblühen* or *Fortpflanzen*, the pass-

ing on of genetic material, than pro-narration, or *Forterzählen*, the passing on of narrative material, that makes permanent the familial pact. Thus, although the asexual kiss ultimately stands in for a moment of conception, the gestation, birth, and regeneration that follow from this oscular act are fulfilled in and through the surrogate body of narrative in the form of family history.

In this way the ritual, asexual kiss makes possible the survival of the House of Sentze by propagating and reenacting the story whose disciplinary power also reins in the bellicose tendencies of the family. The asexual kiss itself, however, is only possible if there continue to be kisses of the other, procreative sort. The narrator introduces this distinction in terms of an order of oscularity:

> Because the kiss could not only prevent strife but also generate love, the Sentze divided it into two kinds. They called the kiss of the first kind the kiss of love, or just the first kiss; they called the kiss of the second kind the kiss of peace, or just the second kiss.

> Weil nun der Kuß nicht blos den Streit verhindern, sondern auch Liebe erzeugen konnte, so theilten ihn die Sentze in zwei Arten ein. Den Liebeskuß nannten sie den Kuß der ersten Art, oder schlechtweg den ersten Kuß, den Friedenskuß nannten sie den Kuß der zweiten Art, oder schlechtweg den zweiten Kuß. (144–145)

It is the "kiss of love," given the priority of the "first kiss," that is explicitly linked to sexual procreation. The "kiss of peace," relegated to a "secondary" status, represents an alternative model for the perpetuation of the family line that is more concerned with preservation than propagation. The supposed primacy of the kiss of love over the kiss of peace, however, obscures the fact that, as we will see, the reproductive potential of the former (the first kiss) is contingent on the moral foundation established by the latter (the second kiss). Indeed, the second kiss does not follow the first kiss, but the other way around.

To better understand the different priorities granted these oscular acts we need to look at the ways in which they are embedded in the novella's other system of signs, which comes from the world of botany. On one level the "kiss of love" and the "kiss of peace" correspond to phanerogamic and cryptogamic models of reproduction,

respectively. Thus, for example, the narrator directly employs the phanerogamic metaphor of the family tree to describe the consequences of the "first kiss": "A nobleman from one branch of the tree . . . and a lady from the other branch . . . gave each other the kiss . . . and from them in turn come numerous Sentze who spread out in numerous branches" (Ein Junker von einem Zweige des Stammes . . . und ein Fräulein von einem anderen Zweige . . . gaben sich den Kuß . . . und von ihnen kommen wieder zahlreiche Sentze, die sich in zahlreiche Zweige vertheilten, 144). Here oscular contact of the first, sexual sort results in the extended growth of a plant in the form of branches emerging from a single trunk. The metaphor is a familiar one, not least because it informs the way we graphically represent patterns of phylogenetic growth and divergence.[14] And yet, however much the metaphor implies the processes of reproduction, it does not actually describe them. A phanerogam's branching growth is only incidentally related to the means whereby it creates new plants. In other words, the vehicle of the metaphor (a tree) relies on the ontogenetic logic of the growth and flourishing of a single botanical entity by way of a bi- or multifurcation of its limbs. The tenor of the metaphor (a family line), however, depends on the phylogenetic logic of a species, with multiple entities generating new entities by way of prosemination. Each branch of the tree is not, as is each offspring of the family tree, a distinct new being.

Stifter's characters nonetheless make use of this same metaphor. The main story, set in the mid- to late-1840s, concerns the two remaining members of the House of Sentze, the aging and widowed brothers Walchon and Erkambert, and their hope that the family might be preserved through the union of their respective offspring. These children, Erkambert's son Rupert and Walchon's daughter Hiltiburg, represent, as Walchon puts it, the "two youngest and only branches of our family" (*zwei jüngsten und einzigen Zweige unseres Geschlechtes*, 169). A similar arboreal metaphor runs through the

14. For a sophisticated, contemporaneous explanation of the metaphor, published only seven years before Stifter's story, see Charles Darwin, *Origin of the Species*, rev. ed. (1859; repr., Cambridge: Cambridge University Press, 2009), 108.

central "oath" (*Spruch*) repeated by Erkambert and Walchon, a re-affirmation of their ritual kiss of peace that also expresses their desire for the continuation of the family lineage:

> As once only one young man and one young woman had remained from our family, as they married and on the tree [*Stammes*] a blossom arose out of this union, so now are our two children the last of the lineage [*Stammes*]—if only it would again be as then and once more a blossom would shoot forth.

> Wie einst nur mehr ein Jüngling und eine Jungfrau aus unserem Geschlechte übrig gewesen waren, wie sie sich geehelicht haben und eine Blüthe des Stammes daraus hervorgegangen ist, so sind nun unsere zwei Kinder die letzten des Stammes, wenn es doch wieder würde wie damals, und noch einmal eine Blüthe emporkeimte. (146–147)

In this case, however, the image of the tree gives way to a more general phanerogamic one. *Stamm* can be trunk of tree or stem of flower, though its polysemy here—denoting the family line as much as the main shoot of a plant—more strongly evokes the former. And yet, it is not "branching" that indicates its continued growth here, but rather "blossoming" (*eine Blüthe*), which results directly from the plant's seed (*emporkeimen*). Flowering is one of the primary ways in which phanerogams carry out their sexual life "publicly," to appeal to Linnaeus. The flower exposes the sexual organs of the plant, making them attractive and accessible to pollinators. Stifter mobilizes these phanerogamic metaphors in the novella to characterize the immediate progenitive power of the "first kiss," the kiss of love, the kind of oscular contact that inaugurates the sexual union of male and female for the germination (*emporkeimen*) of a new flower.[15]

At the same time, however, Stifter also casts serious doubt on the propriety of this phanerogamic reproduction. For one, the various causes of family strife over the generations remain unnamed save for one: sexual desire. It turns out that when they were young Erkambert and Walchon each sought to marry the same woman and

15. On the erotic nature of the word *blühen* in *Indian Summer*, see Dominik Finkelde, "Tautologien der Ordnung: Zu einer Poetologie des Sammelns bei Adalbert Stifter," *German Quarterly* 80, no. 1 (2007): 10.

that their kiss of peace saved the family from splitting apart by dissipating their desires. Neutralization of the sexual drive allows for neutralization of discord in the family, making possible its continued growth, as Erkambert explains via a list of key events from his past: "Since Walchon and I wished to marry the same beautiful young woman, since we gave each other and adhered to the kiss of peace so that neither would desire the beautiful woman anymore, since we laid our wives in the grave" (*Seit Walchon und ich das nämliche, schöne Fräulein zu ehelichen gewünscht, seit wir uns den Friedenskuß gegeben und ihn gehalten haben, daß keiner mehr das schöne Fräulein begehrte, seit wir unsere Gattinen in das Grab gelegt haben*, 146). Peculiarly, however, this apparently chronological sequence of occurrences completely skips over the sanctioned marriages of these men. It moves from the inappropriate longing of each man for the same woman to the asexual kiss that dispels this longing and finally to the death of the men's respective spouses. The marriages (and by implication the conjugal activity appropriate to them) are fully elided. It is as if there were no place for sexual desire in the perpetuation of the family, as if any attraction of one sex to the other were inherently sinful.[16]

This puritanical view is shared by Rupert. His initial aversion to Hiltiburg ("something like contempt for Hiltiburg overtook me," 153) comes as a response to her ostentatious appearance, with which, as Rupert puts it, she attracts the attention of "many young men" (152). It is not just Hiltiburg's fancy attire and sparkling jewels that are the culprits, however; Rupert makes her natural beauty complicit. When he first sees her, for instance, she is wearing an exquisite diamond, whose flashy display Rupert immediately aligns with her eyes: "The girl's eyes were very large and glittered even more than the diamond" (149). The moral stakes are clear: in parading herself in public, Hiltiburg not only participates in the profane materialism and pageantry of the big city ("In Vienna at the

16. As Eric Downing explains with regard to the workings of desire in Stifter, "It is desire that interrupts and opposes the common ground that upholds the world 'the way it is.'" Downing, *Double Exposures: Repetition and Realism in Nineteenth-Century German Fiction* (Stanford: Stanford University Press, 2000), 37.

time there was a great pomp and extravagance in domiciles, household objects, and clothing") but she also outdoes them ("Yet in these things cousin Hiltiburg surpassed everyone," 152).

By playing a flirtatious mating game with her "outer appearance" (152), Hiltiburg is positioned as a kind of phanerogamic flower. The only appropriate expression of female sexuality for Stifter, however, is cryptogamic: hidden out of sight. We see the botanical implications of Hiltiburg's appearance most clearly when we contrast her flowery attire in Vienna with the unassuming, earthy garb she later wears in Walchon's home. In the big city,

> the fabrics of her clothing were always very sumptuous, and their trim and design were of the exquisite manner of the then dominant trends. She had many varieties of gold and jewels. Almost every day she wore a different dress.

> die Stoffe ihrer Kleider waren stets sehr kostbar, und der Schnitt und die Anordnung derselben war in der hervorragendsten Weise des eben herrschenden Gebrauches. An Gold und Edelsteinen hatte sie einen großen Wechsel. Sie zog fast jeden Tag ein anderes Kleid an. (152)

Whereas in the country,

> Hiltiburg always went in simple linen clothing that were printed with some color or marking. On her head she consistently had the same round straw hat and on her feet sturdy little boots. She also often wore a gray coat, like her father.

> Hiltiburg ging immer in einfachen Linnenkleidern, die mit irgend einer Farbe und Zeichnung bedruckt waren. Auf dem Haupte hatte sie stets den runden Strohhut, und an den Füßen starke Stiefelchen. Sie trug auch oft ein graues Kleid wie ihr Vater. (168)

Hiltiburg's constant changing of her jewels and clothing in the city reflects the erratic, impermanent, and coquettish character of urban life. This ornate beauty may play a role in the reproductive cycle (of both humans and plants), but for Rupert it is an unequivocal betrayal of a moral life. When Hiltiburg arrives at Walchon's, however, she is transformed. Her modest and simple appearance remains constant ("always," "consistently") and harmonizes with the humble

life in the forest. The straw hat unassumingly covers her hair and partly her eyes too. Her other attire serves only a practical—not an ornamental—function: boots for navigating the rocky forest, a coat (which matches the gray rocks around them) to keep her warm outdoors.[17] Now Rupert finds himself drawn to Hiltiburg, though not sexually. Their closeness emerges primarily from an education in cryptogamic plant life:

> I now spoke more often with Hiltiburg. I showed her the books on moss, and I instructed her a little. I also taught her about other plants that her father might find pleasing. I also showed her the books in which I was reading and loaned her some when she asked for them.
>
> Ich sprach nun öfter mit Hiltiburg. Ich zeigte ihr die Bücher der Moose, und unterrichtete sie ein wenig. Ich belehrte sie auch über andere Pflanzen, die ihrem Vater angenehm sein konnten. Ich zeigte ihr auch meine Bücher, in denen ich las, und lieh ihr einige auf ihr Verlangen. (168)

Rupert initiates Hiltiburg into the life of moss, an initiation that coincides with the gradual transformation of their relationship in which they are primed to become new progenitors of the Sentze line. Mosses, it turns out, teach them by providing a model for reproduction in which the phanerogamic logic of sexual passion is replaced by a cryptogamic logic of dormant passions.

This alternative model is first adumbrated architecturally in the story's opening description of the (literal) houses of Sentze. The narrator explains how the primary and largest of the "three strange houses or castles," located on the slope of a mountain, is made of red and white stones and is called "the striped Sentze" (*die gestreifte Sentze*). Down the main mountain, on two lesser mountains, lie the two smaller houses, one made of red stone and called "the red Sentze," the other of white stone and called "the white Sentze" (143). We soon learn that the two smaller houses were built by two quarreling sons who had agreed to give each other the conciliatory kiss of peace:

17. At the novella's end Rupert notes again the shift in Hiltiburg's appearance and allows for her beauty to emerge from simplicity: "Hiltiburg, who had earlier set her heart on her clothing, was now simple but beautiful, and set her heart on Walchon, on my father, and on me" (173).

The sons were divided; but they gave one another the assurance kiss, and when the father had died neither of the sons wanted to reside in the fortress so as not to insult the other. One of them built for himself the red fortress, after the model of the red color of the old house, and the other the white one after the model of the white trimming. The old house, however, they owned jointly.

Die Söhne waren uneinig; sie gaben sich aber den Gewährkuß, und als der Vater gestorben war, wollte keiner der Söhne die Burg bewohnen, um den anderen nicht zu beleidigen. Der eine baute sich die rothe Burg, nach dem Vorbilde der rothen Farbe des alten Hauses, und der andere die weiße nach dem Vorbilde der weißen Einfassung. Das alte Haus aber besaßen sie gemeinschaftlich. (144)

Here the asexual oscular act guarantees not that the family will reproduce but merely that it will endure. The proliferation of the father's house, both architecturally and genealogically, follows a different logic from that of sexual reproduction. Instead of two separate monochrome entities joining to form something bichrome, here it is the bichrome, striped house which "births" houses that each display only one distinct color. And importantly they are both inhabited by men (brothers no less). The growth of the family does not generate branching lines so much as static points representing distinct genetic material that cannot join together. The red and white houses can thus be said to represent spores, carriers of only one of the two genetic materials of their host (the striped house), and not seeds that carry both materials. The asexual kiss introduces a stage of dormancy in which only the individual, monochrome houses are occupied. The bichrome house, however, which belongs to both brothers, must remain unoccupied until such time as the second kiss, that of love, should join the genetic material together again.

That joining is accomplished paradigmatically by Rupert and Hiltiburg. But they, too, must first undergo a period of quiescence essential to the cryptogamic process of reproduction. The novella in fact stages the entire life cycle of moss via Rupert and Hiltiburg's courtship, which begins with a "hidden kiss," endures a period of (sexual) dormancy that nonetheless allows for individual growth, and is made reproductive with a second, "public kiss." Here we see how the order of oscularity introduced by the narrator is reversed. No longer is the

asexual "second" kiss only possible if there continue to be "first," procreative kisses; now, that generative kiss of love can come only after a long period of suspended desires introduced by the kiss of peace. In the narrative, that kiss—the first in the new oscular order—comes after Rupert's initial disappointment in Hiltiburg and right before he leaves to fight in the March revolutions, which have just broken out. Having given a speech on the importance of joining the fight (on behalf of the empire, it should be noted), Rupert makes his way through a dark passageway to exit the castle where he had spoken. In the shadows someone steals by him and kisses him on the lips. Rupert recognizes the figure as a woman because of the clothing but is unable to see her face before she slips back into the darkness (155–156). This stealth oscular contact on the eve of the revolutions is, we later find out, "only a kiss of peace" bestowed by none other than Hiltiburg (171). As such it inaugurates the suspension of desires required for Rupert to carry out his civic duty.

This suspension of desires coincides with the suspension of the law, the state of exception initiated to control political unrest. "The righteous person is free from the desires and vices [*Gelüsten und Lastern*] of the heart," Rupert says of the upright citizen, in whom political and sexual propriety are aligned. In his speech on the need to fight, Rupert curiously employs the phanerogamic imagery of "blossoming," which is transferred from person or family tree to the idea of (political) freedom: "I hope that there are men with us who will promote this freedom and blaze a trail for it into the workings of the state so that it may *blossom* in its beauty. How long it will take until then I do not know" (Ich hoffe, daß bei uns Männer sind, diese Freiheit zu fördern, und ihr einen Weg in das Staatsleben zu bahnen, daß sie in ihrer Schönheit *erblühe*. Wie lange es bis dahin dauern wird, weiß ich nicht, 154; my emphasis). That this "blossoming" lies at an unknowable point in the future reinforces the notion that a different kind of growth and endurance is demanded during this period. In this way, the 1848 Revolutions become the social and political manifestation of the extreme environmental conditions that the family of Sentze must be able to weather to survive. Together, Rupert's rejection of Hiltiburg's extravagant appearance, the impending war, and this asexual kiss of peace (even

if only retrospectively recognized as such) trigger the necessary period of dormancy that precedes the actual union of the couple. That union, however, is never properly narrated: the second, "public kiss" comes only at the very end of the story. Stifter's novella consists almost exclusively of the slow, vegetative growth of this primary narrative material, which corresponds to the eventless latency of moss's own primary phase of existence.

The two kisses that punctuate Rupert's and Hiltiburg's lives only rehearse on the smaller scale the cryptogamic logic that governs the protracted growth of a family in the novella. If the life cycle of moss is, on the one hand, told via Rupert and Hiltiburg's courtship, on the other hand it emerges as the principle by which the line of Sentze has endured over many generations. This principle corresponds to the alternation of generations. The first generation of moss is the product of the asexual germination of a spore (which, in contrast to the seed, contains only genetic material of one kind). Unlike with seed-bearing phanerogams, this first generation is the dominant phase of the plant's life, an extended period during which the plant develops but does not deploy its sexual organs. Because the plant is essentially incomplete, being haploid male or female, its growth is largely vegetative. It thus remains sexually dormant until moisture brings the sperm from one to the egg from another. The product of the resulting sexual union is the brief, ephemeral growth of the stalk (the diploid, completed plant), in which the spores are formed.[18] In the Sentze phylogeny, this process appears as the alternation between long, asexual stages of fallow quiescence and short periods of progeneration, each inaugurated by its respective kiss.

Stifter had already tested this model of alternating generations, one dormant, the other active, in *Indian Summer*, where the asexual

18. Technically the haploid first generation is sexual, and the diploid second generation is asexual. But such a designation obscures the fact that the first generation is the product of the asexual generation, and the second is the product of the sexual one. Seen in this way, the generations correspond perfectly to the two kisses in Stifter's novella. Hofmeister, who discovered the alternation of generations, drew the division similarly: "The vegetative life is assigned exclusively to the first generation of moss, its fructification exclusively to the second." Hofmeister, *Vergleichende Untersuchung*, 140.

bond between Risach and Mathilde is the first stage of Eros, nec-
essarily unfulfilled, that is (re)awakened and made productive only
by the next generation: Heinrich and Nathalie. In "Der Kuß von
Sentze" the central botanical metaphor of *Indian Summer*'s roses is
fittingly replaced by moss. In the novella, the first in a series of al-
ternating generations is that of the fathers. Their ritualized kiss is
critical to the survival of the family but not to its reproduction. Since
for Stifter the sexual union should be brief and largely "hidden,"
the second of these generations, as with the life cycle of moss, is in-
conspicuous and ephemeral. Indeed, this apparent fulfillment of
the life cycle is not its actual telos. Stifter grants priority to the first,
fundamentally incomplete and ultimately deficient generation. That
this inversion of priorities is highly unusual can be seen by contrast
with the model of cryptogamic reproduction found in Ludwig
Tieck's "Blond Eckbert" (Der blonde Eckbert, 1797). In this story,
which also features a moss collector (the shape-shifting Walther),
the titular Eckbert lives a life of seclusion in a "hidden" marriage
with his wife Bertha, who also happens to be his sister. Their union,
like Risach and Mathilde's or Rupert's and Hiltiburg's fathers', is
incomplete. But that incompleteness is a consequence of breaking
the incest taboo. The fathers in "Der Kuß von Sentze" can neither
reproduce with the same woman (whom they both desire) nor with
each other; their ersatz sexual union via an asexual kiss acknowl-
edges this incompleteness as a necessary phase in the growth of the
larger family, a phase preparatory to the second, progenitive gen-
eration. In Tieck's story, by contrast, Eckbert and Bertha cannot re-
produce because, like spores, they lack the necessary genetic diver-
sity. Their attempted union is thus cursed with childlessness—no
second generation is possible.

The second generation in Stifter's story finally does arrive at the
novella's very end, when Rupert and Hiltiburg publicly acknowledge
their love and bestow on one another the second of the two kisses.
But Stifter remains highly ambivalent in portraying this moment as
one of closure, abruptly and curtly cutting off the story with the
intrusion of the frame narrator: "Here the Sentze document ends."
And although this narrator provides three more sentences assuring
us that things are all rosy, he nonetheless betrays some uncertainty:

"Hiltiburg and Rupert are as happy as that single young lady and that single nobleman of the Palsentze family had been, and it appears that from them too a succession will emanate, as it did from that couple" (Hiltiburg und Rupert sind in einem Glücke, wie jenes einzige Fräulein, und jener einzige Junker des Geschlechtes der Palsentze gewesen waren, und es scheint auch von ihnen die Folge ausgehen zu wollen, wie von jenem Paare, 174). First of all, this prognostication is couched in an equivocal "appears," denying us the assurance that Rupert and Hiltiburg's union was fruitful. Second, even if it were fruitful, the result would be a duplication of the first Sentze couple; in other words, Rupert and Hiltiburg's offspring would, the narrator suggests, end up repeating the same cryptogamic cycle of drawn-out armistice followed by a brief reconciliation. There is no perpetual "flowering" in sight here.

Yet it is for precisely this reason, as I have already suggested, that Stifter deploys the cryptogam instead of the flowering phanerogam as the novella's *Dingsymbol*. The former develops primarily and for the most part during its extended period as an "incomplete" organism that by the standards of phanerogams (which is to say, the vast majority of all other plants) is not fully formed, being merely haploid. Stifter recuperates this inchoate, deficient form—we might say, the built-in failure of cryptogams—as proper, necessary, and productive. Here, for example, is Walchon relating the importance of the house where he collects moss, the Gray Sentze:

I built the house that I call the Gray Sentze at a time when something came to pass that I did not think I could overcome. I did however overcome it and again lived on through time. The house is good for overcoming some things and I have often visited it. All the things that I have undertaken in the interest of the good and great have not come to fulfillment. I resigned myself and once again lived on through time.

Ich habe das Haus, das ich die graue Sentze nenne, zu einer Zeit erbaut, da etwas eingetreten war, das ich nicht verwinden zu können gemeint hatte. Ich habe es aber verwunden und habe wieder in die Zeit fortgelebt. Das Haus ist zu manchen Ueberwindungen gut und ich habe es öfter besucht. Alle Dinge, die ich seit meiner Jugend zu Gutem und Großem unternommen hatte, sind nicht in Erfüllung gegangen. Ich habe mich gefügt und habe abermals in die Zeit hinüber gelebt. (166)

Paradoxically, the endurance Walchon attributes to this period co-
incides with a failure to bring things to "fulfillment." Lack of ful-
fillment thus corresponds to the possibility for "overcoming" diffi-
culties—to persevering. Much like the haploid spore and the equally
"incomplete" patch of green into which it germinates, Walchon's
sedentary post-kiss of peace *Fortleben* uniquely positions him to
persist—to live on.

Moss, in other words, holds the key to ontogenetic and phylo-
genic survival that bypasses the cycles of flowering, wilting, and
decay characterizing most other plants. In two other key passages
Walchon refers to a similar failure to reach fulfillment: one in the
perpetuation of the family lineage, the other in his knowledge of
moss. In the first case, discussing his wish that Rupert and Hiltiburg
would marry and thus allow for the Sentze line to continue growing,
Walchon uses the same language as he did in describing his own pe-
riod of failure: "but this wish could not be fulfilled [*in Erfüllung ge-
hen*]" (169). In the second case, Walchon articulates a lack of com-
pleteness in terms of human knowledge in the face of the mysterious
moss and its nearly endless varieties: he will never be able to know
them all (165). Each case leads to a certain ritualized activity: a kiss
of peace and collecting, respectively. And in each case this activity
preserves but does not propagate. Rupert and Hiltiburg's kiss of
peace would preserve the family unity without a sexual bond; Wal-
chon's moss collecting preserves the plant but does not cultivate it.
To what extent these are practices of overcoming lack rather than
perpetuating it remains unclear. The planned, conciliatory kiss of
peace seems to give way to fulfillment as the young couple change
their minds and hearts and perform the kiss of love instead. And
yet, as already noted, this resolution hardly eliminates the future
need for another cycle initiated by a long period of unfulfillment, a
period that Stifter cannot help but find more appealing.

In this next section I ask how the activity of collecting moss is
similarly wrapped up in this cycle. Is continuing to collect in the
recognition of its inevitable failure (because there can never be a
complete collection) an act of futility? Or does Walchon's bryophyte
collecting in fact suggest that such futility is integral to the activity,
that collecting cultivates a fragmentary whole, or even that it only

preserves the object while perpetuating its loss? I argue that moss uniquely allows for a way out of the paradox whereby the ephemeral, natural organism collected is necessarily deprived of its capacity for continued flourishing—and even, crucially, of its capacity for properly perishing.

Moss Collecting

The role of nature in Stifter's work has been accorded a great deal of attention. I sidestep most of the complexities raised by scholars here and highlight two important features. The first is best articulated by Eric Downing in reference to Stifter's preface to the collection of novellas *Many-Colored Stones* (*Bunte Steine*, 1853): "In depicting the world of Nature, Stifter is not describing its real objective workings but rather a set of inscribed social (and psychological) values."[19] The "external nature" (*äußere Natur*) to which Stifter so often turns, usually at the expense of character psychology and plot, always reflects the order and authority that he believes should undergird social relations.[20] The harmony, significance, and structural unity of the natural world become models for how humans ought to perpetuate the principles of divine law and participate in the practices ordained by it. The second distinguishing feature of Stifter's representation of the natural world is that it is focused on the minute level of particulars. Indeed, he privileges the small and insignificant over manifestations of grandeur and greatness, reversing these categories so that, as he famously writes in the *Many-Colored Stones* preface, inconspicuous things such as "the flow of the air, the rippling of the water, the growth of the grain, the waves of the sea, the greening of the earth, the gleaming of the sky, the twinkling of the stars" become "great" (*groß*), while forceful and grand natural phenomena such as "the splendidly rising

19. Downing, *Double Exposures*, 27.
20. Adalbert Stifter, "Preface to *Many-Colored Stones*," in *German Novellas of Realism*, ed. Jeffrey L. Sammons (New York: Continuum, 1989), 3. Stifter, *Werke und Briefe*, 2:2, 12.

storm, the lightning that splits houses, the tempest that drives the surf, the fire-spewing mountain, the earthquake that buries whole countries"—those powers of nature that can trigger the Kantian sublime—are deemed "smaller."[21] The writer's obligation, for Stifter, is to those usually overlooked things that actually manifest "greatness"; the task of the writer is thus related to that of the scientist who "assembles" (*trägt zusammen*) a coherent whole out of these scattered and infinite particulars.[22]

I return at the end of this section to this notion of constructing a whole out of minute particulars or "details" (*Einzelheiten*)—to what degree this is, in fact, desired or even possible. Important for our analysis of "Der Kuß von Sentze," however, is that, in Stifter's ecology, moss is exemplary of that inconspicuous and apparently insignificant natural phenomenon which, both despite and by virtue of its being so small, is in fact "great."[23] Indeed, in "From the Bavarian Forest" (Aus dem bairischen Walde, 1868), the last text he wrote before his death, Stifter echoes the *Many-Colored Stones* preface by listing moss among those natural objects whose minuteness reveals the greatness of the divine creator: "There in the smallest of things is revealed the greatness of the Almighty" (Da zeigt sich im Kleinsten die Größe der Allmacht). In this text, however, Stifter not only classifies moss among "the smallest" of natural things but also notes that it is generally "despised" or "disdained." Moss is a plant not merely lacking in value; it also has negative value: "the despised mosses that with their various little leaves or the thinnest golden

21. Stifter, "Preface to *Many-Colored Stones*," 2. Stifter, *Werke und Briefe*, 2:2, 10.

22. Stifter, "Preface to *Many-Colored Stones*," 3. Stifter, *Werke und Briefe*, 2:2, 11.

23. Stifter, "Preface to *Many-Colored Stones*," 2. Stifter, *Werke und Briefe*, 2:2, 10. Selge, *Adalbert Stifter*, 112–113. Twenty-first-century botanists apparently still largely ignore mosses. Crum notes that bryophytes "are generally *overlooked and neglected* because they are the wrong size." Crum, *Structural Diversity of Bryophytes*, 17 (my emphasis). There are, of course, exceptions. See Robin Wall Kimmerer, *Gathering Moss: A Natural and Cultural History of Mosses* (Corvallis: Oregon State University Press, 2003). Kimmerer recognizes that mosses are "largely unnoticed" but also shows the different ways they can be useful to humans (and the environment).

silk threads drape over stone" (*die verachteten Moose, die mit ihren verschiedenen Blättchen oder den dünnsten goldenen Seidenfäden den Stein überkleiden*). By means of scientific observation, however, this rejected or disregarded plant can be redeemed: "And how much more intensely and inspiringly does a thing have an effect on us when we make it the object of our observation or scientific research" (*Und wie eindringlicher und erweckender wirkt es erst, wenn man irgend ein Ding zum Gegenstande seiner Betrachtung oder wissenschaftlichen Forschung macht*).[24] All that is required is the methodical, meticulous attention of the researcher—or, following the *Many-Colored Stones* preface, the writer-as-researcher—to transform the apparently worthless object into something capable of inspiring wonder.

It is precisely this special attention to moss—in the form of observation and scientific study—that we find carried out in "Der Kuß von Sentze," first by Walchon and then, initially accompanying him and later on his own, by Rupert. Significantly, Walchon lives in relative seclusion in the Bavarian forest, the same region about which Stifter writes in describing the "disdained mosses" in "From the Bavarian Forest." Here, where trees shoot up amidst a landscape of granite boulders, there grow "countless mosses" (164). "You see," Walchon says to Rupert, "these forests are more abundant in mosses than others" (166). Walchon's daily existence appears to consist of nothing more than collecting, sorting, and studying these various mosses. Indeed, his "living room" is also his "plant room," a space covered with pictures of plants and containing a large table on which lie albums and books full of information on bryophytes (161), as well as piles of mosses (163). Walchon's activity is systematic: he goes out into the forest with a container covered in brown leather (160) into which he puts the various mosses he finds. These he then brings home to sort (164). After sorting the mosses, they are pressed onto paper to keep a record of their shape. Finally, using the moss-collecting manuals to determine their proper classification, the mosses are placed into a storage device (*Fach*, 165).

24. Adalbert Stifter, *Sämtliche Erzählungen nach den Erstdrucken*, ed. Wolfgang Metz (Munich: Deutscher Taschenbuch Verlag, 2005), 1521.

It is not entirely clear to what end Walchon—or any of the legion amateur bryophyte enthusiasts of the 1860s, for that matter—collects moss. The bryologist Karl Müller, author of a guide to collecting and studying the plant published in 1853, the same year as *Many-Colored Stones*, and who begins his book with a remark that would fit just as well in Stifter's preface to that volume—"At no time has the scientific inclination toward the observation of the small emerged so conspicuously as in the present"—provides the following list of reasons for spending so much time with this strange plant: "The delicacy of its structure, the ease with which it can be collected and preserved, its pleasant appearance in the collection, its prevalence, its importance in the economy and physiognomy of nature, the multifariousness of its shapes and many other things."[25] Yet most of these features—with the exception of the ease with which moss is collected and preserved (to which I return)—might well apply to other plants. Marcus Twellmann makes the important observation that unlike other plants, moss is typically not cultivated because it is neither useful nor decorative.[26] Plant ecologist Peter Dunwiddie goes one step further: "Mosses are biological widgets, useless inventions of a creator inordinately fond of the color green." They appear, in fact, Dunwiddie continues, "to have little demonstrable value": "They don't taste good, grow tall, supply valuable medicinal substances, or rally causes . . . as do, for example, the limpid eyes of a baby harp seal." Moss would seem to be the epitome of worthlessness among plants. The entire natural world, from animals and insects (none of which relies on mosses "as a major food resource") to "even those ultimate scavengers of decay, fungi and bacteria," Dunwiddie notes, "seems largely to have bypassed the mosses."[27] Their appeal, as bryologist Howard Crum writes at the end of the twentieth century, ultimately comes down to aesthetics: "They are biologically unique and have a beauty, macroscopic and

25. Karl Müller, *Deutschlands Moose oder Anleitung zur Kenntniss der Laubmoose Deutschlands, der Schweiz, der Niederlande und Dänemarks* (Halle: G. Schwetschke'scher Verlag, 1853).

26. Twellmann, "Literarische Osculologie," 540.

27. Peter Dunwiddie, "The Study of Useless Things," *Sanctuary* 29, no. 4 (1990): 24. Dunwiddie goes on to justify why he spends so much time studying mosses.

microscopic, that is difficult to match." Crum concludes, "The world would be dreary without them."[28] If, as Susan Stewart puts it in the context of reflections on the general practice of collecting, "The collection represents the total aestheticization of use value," then moss would thus seem already to be primed for collecting.[29] In one sense, moss represents one of the only purely aesthetic forms amidst the vast kingdom of useful botanical organisms.

As aesthetic objects, then, Walchon's mosses appear to be related to the plants that Risach tends in *Indian Summer*. And yet, although Risach's gardens, trees, roses, and enormous cactus exist alongside and share many of the properties of his other collections, these things differ from those objects in that they remain very much alive. Furthermore, with the exception of the cactus, they all belong to an intricate ecological system whose usefulness in maintaining the necessary natural balance to the Rose House's domestic space is at the very least on par with—one might even say it eclipses—their aesthetic value. As Risach's gardens make plain, to cultivate plants (even if for aesthetic reasons) is not to engage in the activity of collecting, similar to the way in which accumulating animals (for a farm, zoo, or aquarium) is not quite the same as "collecting" them. In each of these cases—garden or menagerie—one seeks to preserve the life of the organism. Collecting, in contrast, seeks to preserve the thing but, in accomplishing this preservation, necessarily ends the life of the organism. To collect is not just to remove the object from its natural habitat but—in doing so—also to deprive it of its proper or "natural" existence. When what is collected—whether butterfly, beetle, or bones—is (or was) a living organism, it must either be dead or be rendered dead for it to be collected. In the plant kingdom, moss would seem to be the perfect sacrificial object. Like all other plants, it is destined for desiccation when harvested; yet unlike other plants, it is fundamentally useless in its live state. To remove it from its natural environment does no harm to that environment, because no other living thing depends on it. In fact, removing it from its natural environment does not even do much harm to the plant itself.

28. Crum, *Structural Diversity of Bryophytes*, 17.
29. Stewart, *On Longing*, 151.

In this property, moss is unique. In contrast to most other plants, moss can endure lengthy periods of cryptobiosis, an ametabolic state triggered by desiccation or environmental factors such as extreme low temperatures. Moss can, in fact, be dried out and filed away, exactly the way Walchon's samples are, and still be brought back to life by means of a little moisture. Bryologists of the 1860s were well aware of this remarkable feature of the plant. In *Anleitung zum rationellen Botanisiren* (Manual for efficient plant collecting), for example, published in Leipzig six years before "Der Kuß von Sentze," the bryophyte collector Bernhard Auerswald draws attention to moss's peculiar ability to revive after desiccation: "You can then leave them as long as you want, so long as they aren't subject to decay from moisture. Later, throw them into water and they will immediately swell up and take on their former, natural shape." For Auerswald, this feature of moss puts it at a distinct advantage over phanerogams: "Indeed, you can leave them for years and they will always regain their previous shape—a quality that most advantageously distinguishes them from seed plants."[30] Recent research has proven that the period during which moss can be effectively dead before being revived is much longer than merely some years, as Auerswald suggests. A team of scientists in 2014 extracted moss from beneath the permafrost in Antarctica and were subsequently able to bring the plant back to life. The resurrected moss has been dated to be between 1,533 and 1,697 years old, and the authors of the published study note that "the potential clearly exists for much longer survival."[31] These possibilities remain latent in the intricate system of correspondences in Stifter's novella between the bryophytic and human life cycles. Not only moss's cryptogamic reproduction, as detailed in the previous section, but also its collectability thus point to the secret of the House of Sentze's survival in and through a period of dormancy, one that in fact borders on extinction.

30. Bernhard Auerswald, *Anleitung zum rationellen Botanisiren* (Leipzig: Verlag von Veir & Comp., 1860), 92.

31. Esme Roads, Royce E. Longton, and Peter Convey, "Millennial Timescale Regeneration in a Moss from Antarctica," *Current Biology* 24, no. 6 (2014): R222–R223.

We still do not have an answer as to why Walchon collects mosses. I hope to have shown how the plant functions thematically for Stifter to convey the story's peculiar economy of procreation. Indeed, this central concern for family "kinship" and the "transitions" that make possible the continued growth of the House of Sentze is evoked in the polysemous language with which Rupert describes the plants' minute features: "I saw relations, connections, and passages" (Ich sah Verwandtschaften, Verbindungen und Uebergänge, 165–166). I hope also to have shown how moss collecting contains the possibility for overcoming death through a mode of preservation that, paradoxically, involves for all intents and purposes terminating the life of the organism.[32] Walchon, in contrast, figures moss's value in transcendent terms, bestowing a revelatory quality on the plant. In the only passage in which he explicitly addresses his motivation for collecting mosses, Walchon claims that his hobby is a way of accessing truth. As he insists, "Only the things of nature are completely true" (Nur die Naturdinge sind ganz wahr). To obtain this truth in nature one must take it seriously, and that means engaging it in some of kind communicative game. "What ones asks of them reasonably they answer reasonably" (Um was man sie vernünftig fragt, das beantworten sie vernünftig, 166), Walchon explains. Immediately after speaking these words, Walchon gives Rupert a leather bag for collecting moss (167) as if to say, "Here's how you go about asking and getting your answer." Indeed, the description of Walchon's collecting process contains hints that it involves a mode of "reading" the moss. What he gathers (*zusammenlesen*) in the forest he subsequently sorts out at home: "He separated the mosses out stem for stem and laid them in the row" (Er las die Moose Stämmchen für Stämmchen auseinander und legte sie in eine Reihe,

32. For a psychoanalytic reading of Walchon's collecting, see Helena Ragg-Kirkby, *Adalbert Stifter's Late Prose: The Mania for Moderation* (Rochester, NY: Camden House, 2000), 30–31. Walchon's unfulfilled sexual desires, Ragg-Kirkby argues, "are forced beneath the surface rather than extinguished, and . . . their suppression is reflected in his ritualistic pressing and desiccation of nature" (30). See also Michael Kaiser, *Adalbert Stifter: Eine literaturpsychologische Untersuchung seiner Erzählungen* (Bonn: Bouvier, 1971), 106–110.

165). With the word *auseinanderlesen* ("to separate out"), which is the inverse of *zusammenlesen* ("to glean"), Stifter signals that the activity of collecting doubles as an activity of reading (*lesen*).[33] Such a correspondence is strengthened in the description of how Walchon presses the mosses he collects: "We press the mosses onto paper and they leave behind their shape with astonishing beauty" (Wir pressen die Moose auf Papier ab und sie geben ihre Gestaltungen erstaunlich schön, 165).[34] These "impressions" or "copies" (*Abdrücke*) are then placed in a "folder" (*Mappe*), as if they were documents to be read. The plants have their own secret language, the answers to the questions the collector poses them. These answers are recorded on paper and filed away, a legible double of the moss itself. In this way collecting becomes a hermeneutic exercise.[35]

Yet collecting is a hermeneutic exercise that seeks a transcendent, unified meaning underlying "despised," minute, and useless things such as moss and into which they can be integrated. Collecting is the attempt to redeem the overlooked particulars by ordering them within the larger structure of significance that is God's law. This process is not, however, restorative. No original unity or whole is re-created. As Stifter notes in the preface to *Many-Colored Stones*, the scope of these minute particulars is infinite: "The quantity of phenomena and the field of the given are infinitely large" (Die Menge der Erscheinungen und das Feld des Gegebenen [ist] unendlich groß).[36] There will always be another type of moss to be found and added to the collection: "The books and I are not complete" (Die Bücher und ich sind nicht vollkommen, 165), Walchon says. That whole remains out of reach. In fact, as a number of scholars have suggested, Stifter's obsession with order, ritual, and placidity reflects a fundamental

33. The etymology of *lesen* supports this analysis. The word comes from the Old High German *lesan*, which originally meant "to gather." The same connection exists in the etymologically unrelated English word "to collect," which comes from the Latin *co-* ("together") and *legere* ("to gather," but also "to read").

34. Müller, *Deutschlands Moose*, 67–68, describes a similar process.

35. For a slightly different articulation of the connection between reading and collecting in Stifter (though without reference to "Der Kuß von Sentze"), see Finkelde, "Tautologien der Ordnung," 3. See also Finkelde, "Vergebliches Sammeln," 202.

36. Stifter, "Preface to *Many-Colored Stones*," 3. Stifter, *Werke und Briefe*, 2:2, 11.

anxiety in the face of a reality in which these conditions are not—or not any longer—guaranteed.[37] As I noted earlier, Stifter suggests that the writer should follow in the footsteps of the scientist and "assemble the general out of the particular."[38] But because those particulars are infinite, what is brought together, "assembled," will never in fact be whole—it will always be a fragmentary construct.[39] Dominik Finkelde thus reads Risach's collecting efforts in *Indian Summer* as attempts to maintain the illusion "that things express a divine order which . . . emerges from the things themselves."[40] Risach's collections, Finkelde goes on, seek to establish "a totality without disruptive gaps."[41] Such may be the case with Risach, but it does not entirely apply to Walchon, who recognizes the gaps in his collection, accepts his inability to close this collection off, and even resigns himself to never fully comprehending the objects that comprise it: "I have sought to fathom the wondrous strangeness of these small things and have come nowhere near to an end" (Ich habe die Verwunderlichkeit dieser kleinen Dinge zu ergründen gesucht und bin noch lange zu keinem Ende gelangt). Like his books and his own amassed knowledge, his collection of pressed and stored mosses will always remain incomplete because, as he says to Rupert, "Things have their own tendency" (Die Dinge wollen ihre eigene Weise, 165). What characterizes Walchon's efforts to sort and categorize things, then, is not order—or the illusion of order—but rather remainder, excess, even aberration.[42] His collection will always remain unfinished and

37. For a brief literature review, see Finkelde, "Tautologien der Ordnung," 2.

38. Stifter, "Preface to *Many-Colored Stones*," 3. The German text reads, "aus Einzelnem das Allgemeine zusammen trägt." Stifter, *Werke und Briefe*, 2:2, 11. This compiling (*Zusammentragen*) is akin to gleaning or collecting (*Zusammenlesen*).

39. See Downing, *Double Exposures*, 31.

40. Finkelde, "Tautologien der Ordnung," 7.

41. Finkelde, "Tautologien der Ordnung," 9. For Finkelde, Risach's drive to collect and order things finally takes on "ludicrous and grotesque dimensions." Finkelde, "Vergebliches Sammeln," 195.

42. Ulrike Vedder characterizes the collecting that both Risach and Walchon engage in as "an activity . . . [aimed] at the complete gathering [*Erfassung*] of the world, at the construction of meaning without remainder, in the clear knowledge that this totality does not exist." Vedder, "Poetik des Sammelns," *Museumskunde* 78 (2013): 10. See also Paul Fleming's characterization of Stifter's realism as "the literary revelation of what hides and maintains itself in the margins, deviations, and

only partial not so much because there will be missing pieces (that is inevitable), but because there will be unruly pieces, objects that resist classification, objects that in "having their own tendency" seem to call into question the very pursuit of the ordered whole against which they are measured.[43] For centuries, of course, botanical tax-onomies treated moss as precisely such an adscititious, anomalous object. The fundamental incompleteness of Walchon's collection seems in this regard to be commensurate with the "incomplete plants" it comprises. Walchon may not quite be the figure of the Benjaminian collector, doubling as an allegorist for whom "every-thing he's collected remains a patchwork."[44] And yet, as with that figure, Walchon's attempt to gather together and understand what is minute and scattered can be seen as an attempt to redeem these same things as the fragmentary, finite objects that they are.

Preserved Ephemerality

What does that redemption entail? In closing I would like to sug-gest that it involves something unique to the collecting of moss: the possibility of preservation that is inextricable from the possibility of regeneration, both safeguarding or storing up the object while also allowing for it to have "its own tendency." This reciprocal dy-namic of conservation and propagation is precisely what is afforded by the dual cryptogamic kiss of Sentze: a state of unblemished dor-

exceptions." Fleming, *Exemplarity and Mediocrity: The Art of the Average from Bourgeois Tragedy to Realism* (Stanford: Stanford University Press, 2009), 162.

43. On the incomplete collection, in the course of the story Rupert discovers "a kind [of moss] that he [Walchon] did not at all have" (166). Walchon's notion of things "having their own tendency" might sound similar to Risach's call—in *Indian Summer*—for a "reverence for things as they are in themselves" (*Ehrfurcht vor den Dingen, wie sie an sich sind*). However, Risach's project, unlike Walchon's, is restor-ative: "so that they [things] would become again what they were, and that which was taken from them, without which they could not be what they are, would be recovered" (*damit sie das wieder werden, was sie waren, und das, was ihnen genom-men wurde, erhalten, ohne welchem sie nicht sein können, was sie sind*). Stifter, *Werke und Briefe*, 4:3, 145.

44. Benjamin, *Arcades Project*, 211; *Gesammelte Schriften*, 5:279.

mancy from which some fluid can trigger an awakening. The oscu-
lar moistening of the second kiss, the "kiss of love" that activates
procreative forces, anticipates this potential resuscitation of Wal-
chon's collected bryophytes.

What is collected, then, is more than just a natural artifact; it is
something that collecting usually aims to suspend: ephemerality. As
already noted, one of the paradoxes of collecting naturalia is that
the specimen collected is at once lost and preserved—that by pre-
serving the object one necessarily kills it. If collecting consists of the
effort to store in or as a permanent set of things that which is other-
wise fleeting, then the object taken up and thereby fixed in the col-
lection must also relinquish its ephemerality, even when this qual-
ity is intrinsic to it. Because Stifter's object-become-thing can be
resuscitated, its objecthood effectively reinstated, it offers a startling
way out of this paradox. To hydrate moss and bring it back to life,
however, as with the second oscular moistening, would signal a shift
from preservation to proliferation. To extract moss from its collec-
tion and revive it would seem to be an act of un-collecting—indeed,
of dispersal.[45] It would be to reintroduce the object into an ecol-
ogy, thereby exposing it to the possibility of mortality.

And that is precisely the point. Motivated by the desire for im-
mortality, to grant the object a new life in death as a thing, sus-
pended between the here and hereafter, collecting attempts to over-
come the object's inevitable ephemerality, even as that quality is
foregrounded. Think of the piece of coral or the pressed and dried
flower. What makes moss extraordinary is that by virtue of its la-
tent resurrectibility the thing's potential mortality as object is never
completely foreclosed. Collecting becomes the condition for the pos-
sibility of moss's continued life, even after death. The organic,
ephemeral object—made (more) permanent in the collection—is not
just transformed into "ephemerality on display," as is for instance
the fragile pinned butterfly (for which, see Stifter's "The Forest
Walker" [Der Waldgänger], 1847). Rather, once collected, moss
becomes a form of ephemerality preserved as such. If we say that

45. Not incidentally, dispersal is also the means by which moss carries out
its asexual reproduction.

souvenirs of nature, as Susan Stewart writes, "deny the moment of death by imposing the stasis of an eternal death," then collected moss is exempt from this fate.[46] Not only is the ephemeral object saved up and conserved; the object's potential ephemerality is held suspended, too. It can always be made ephemeral again.[47]

If, as I argue throughout this book, collecting carries out a dialectic of preservation and loss—the object is lost so as to be preserved as the thing—then moss would seem to offer a way out of this apparently ineluctable process. But this way out comes only at the cost of the permanence, and thus completeness, of the collection. As we have seen, however, incompleteness is for Stifter the source of profound value. It is the condition of our empirically knowable reality that guarantees that "the joy of discovering the hidden" will be "inexhaustible," as Paul Fleming, writing on Stifter, argues.[48] In the untiring activity of sorting and cataloging those mosses, Walchon participates in such joy of discovery in the face of the infinite.[49] In accepting the impossibility, indeed futility, of reaching an end point, of completing his catalog of the species, Walchon is able to maintain a collection adequate to the things it contains, in which preservation and regeneration—as with the House of Sentze—are built into the structure of the collected organism itself.

46. Stewart, *On Longing*, 144.

47. As detailed earlier, moss is hardly a fleeting appearance in the world of plants. It perseveres and, depending on the environment, can be ubiquitous. However, its fully formed second generation is extremely brief. The life of the complete plant is in this sense more ephemeral than that of any phanerogam.

48. Fleming, *Exemplarity and Mediocrity*, 145–146.

49. To quote Fleming again, writing about the preface to *Many-Colored Stones*, it is "the collective force of . . . quotidian minutiae—meticulously observed, recorded, and calculated—that offers a negative presentation of the infinite." Fleming, *Exemplarity and Mediocrity*, 143.

3

THE PHOTOGRAPHIC INSTANT (*FISCHINGER*)

At the beginning of *On Photography*, Susan Sontag contrasts the apparent permanence of photography with the perceived ephemerality of film: "To collect photographs is to collect the world. Movies and television programs light up walls, flicker, and go out," she writes, "but with still photographs the image is also an object . . . easy to carry about, accumulate, store."[1] What fascinates Sontag is the distinct material quality of the photographic print as opposed to the intangible light of film. For her the value of the photograph resides not so much in its visual capturing of the things of this world as in its own existence as a thing *in* this world—a thing we can hold, display, keep safe, and, when brought together with other such things, collect. The photograph, then, not the world, is collectable, in part because it is a reliably present-at-hand thing itself. And it is a thing, in turn, because unlike the ephemeral cinematic image, it

1. Susan Sontag, *On Photography* (1977; repr., New York: Picador, 2001), 3.

has "thinged" the world. In the photographic print, the actions and movements of the mutable world have not only been frozen but have also been made tangible as an object. What Sontag suggests, ultimately, is that only as such a static image-object, both inanimate and tactile, can we exert our desire to collect—seeking completeness in the face of ineluctable lack—the things of this world at all.[2]

Indeed, the precondition for something to be collectable is that it be tangible and immobile, if not—as we saw in the previous chapter—dead. The inanimate (stamps, coins, books) or the once animate (fossils, antlers) may enter a collection, but that which is animate cannot do so until it has been fixed in place. The insect (be it butterfly or beetle) is pinned to the page; the mammal, reptile, or bird is treated and stuffed; the flower is dried and flattened. Were the living animal to remain alive and be "captured," one would have a pet or, if that animal were to be joined by others like it, a menagerie of pets—but not a "collection" of them.[3] Furthermore, flowers, when kept and kept alive, make up a garden. Only when dead and dried out or pressed—their perishability simultaneously affirmed and overcome—can they assume their place in a collection proper. The paradox of collectors is that they strive for completeness but only with those things that are most incomplete, no longer moving, no longer functioning, no longer alive.

Similarly, the photograph is collectable, Sontag claims, because above all it is a tangible and inanimate object. But it is also collectable precisely because that which it presents has been lifted out of time, suspended, and arrested. It has been stripped of its mobility, its animateness—its *aliveness*. For the philosopher Manfred Sommer, photography's thingliness—and thus its collectability—lies in its temporal constancy, that it *has* time, even though this is a time that assures permanence, not flux: "Everything instantaneous and ephemeral has in some way or another to be connected back to things that 'conserve' it, things that make it enduring [*dauerhaft*]

2. As Walter Benjamin notes, "Possession and having are allied with the tactile, and stand in a certain opposition to the optical." Benjamin, *Arcades Project*, 206; *Gesammelte Schriften*, 5:274.

3. See chapter 6 for an exploration of the menagerie as a problematic collection.

by loaning it their constancy and persistence."[4] Roland Barthes regards this permanence as a reminder of the *having-been-there* of the subject photographed.[5] Confronted with the motionlessness of the person captured in the picture, the spectator projects "the pose" back onto the shot, now the arrested instant of time—and as such the moment that marks death. But it is a death we can hold on to, in part because photography has paradoxically rescued it by making it endure—much like the dead but preserved flower. Similar to Sontag, therefore, Barthes distinguishes photography from cinema in terms of their opposing temporalities of presence: "In the Photograph, something *has posed* in front of the tiny hole and has remained there forever . . . ; but in cinema, something *has passed* in front of this same tiny hole: the pose is swept away and denied by the continuous series of images."[6]

We might therefore collect films, but we experience the indexicality of this medium differently from the same indexicality of photography: this is in large part because, although the storage mechanisms of film and photography are the same (celluloid film), the forms their presentation takes are fundamentally different. In the case of film, this presentation is intangible light projected onto a screen.[7] Photography, in contrast, presents us with images in the form of prints that we can hold and hoard. It follows that, although both media capture things by way of the meeting of photons and halide, the tactility of the photographic object uniquely reinforces its indexicality, serving as a graspable ersatz for the material—yet absent—things it presents. Film is instead experienced as immaterial light in motion, which disguises the materiality of its medium: its images come to us in a fleeting form similar to the ever-changing

4. Sommer, *Sammeln*, 106.

5. Roland Barthes, "Rhetoric of the Image," in *Image-Music-Text*, trans. Stephen Heath (New York, Hill and Wang, 1977), 44.

6. Roland Barthes, *Camera Lucida: Reflections on Photography* (New York: Hill and Wang, 2010), 78.

7. As Mary Ann Doane puts it, "This archival artifact [of film] becomes strangely immaterial; existing nowhere but in its screening for a spectator." Doane, *The Emergence of Cinematic Time: Modernity, Contingency, the Archive* (Cambridge, MA: Harvard University Press, 2002), 23.

world it has recorded.[8] Therefore, although cinema may capture movement, the animate, and the living, its images—precisely *because* they are in motion—cannot endure. They "flicker, and go out," as Sontag writes; even their permanent poses are swept away. They mimic the very ephemerality of living things themselves, which cannot be grasped, held, collected together, or kept safe—at least not without first being immobilized and thus being drained of life. Cinema's images slip between the folds of time—the very time that, according to theorists such as Deleuze, cinema itself makes possible. Film, then, is a medium that can only make things palpable by making them disappear.

Film theory tells us that this disappearance is necessary for the production of a continuous presence.[9] Jean-Louis Baudry writes that the individual image that constitutes a film must "disappear so that movement and continuity can appear."[10] For Mary Ann Doane, among other theorists, that individual image—the single, still frame—represents both the contingent and elusive instant as well

8. The digital age has radically changed our interaction with both still and moving images. I argue, however, that particularly because of touch technology our computer-mediated access to still images nonetheless remains highly tactile. Furthermore, the computer has secured the archival permanence of such images more than celluloid ever could. With the digital moving image, however, things are more complicated. Although our ability "to collect" videos (digital clips or DVDs) more easily has not radically changed the fundamental way in which these moving images appear to us when viewed as fleeting images, new technology makes manipulating (e.g., freezing or slowing down) these images relatively simple. I see this technological shift as a broadening of accessibility, and not so much as a radical change in the ways we experience film. What has from the beginning been available to specialists working with film in the archives or in the cutting room is now more readily available to the layperson. On the fallacy of viewing the digital image's indexicality differently from that of the chemical photograph, see Tom Gunning, "What's the Point of an Index? Or, Faking Photographs," in *Still Moving: Between Cinema and Photography*, ed. Karen Beckman and Jean Ma (Durham, NC: Duke University Press, 2008), 23–40.

9. See Gilles Deleuze on the "any-instant-whatever," which is "selected so as to create an impression of continuity." Deleuze, *Cinema 1: The Movement-Image* (Minneapolis: University of Minnesota Press, 2001), 5. As Raymond Bellour helpfully explains, any "discontinuities and ruptures [including the still frame itself] are integrated into a continuous expansion." Bellour, "The Film Stilled," *Camera Obscura* 24 (1990): 102.

10. Jean-Louis Baudry, "The Ideological Effects of the Basic Cinematographic Apparatus," *Film Quarterly* 28, no. 2 (1974–1975): 43.

as a singular "thisness," a privileged indexicality of the things of this world.[11] But precisely *as* such a momentary, immobile imprint of the real, this instant has no place in film. Doane expresses this paradox most clearly: "The very concept of the instant is inappropriate for defining the cinema. . . . The instant, properly speaking, belongs to photography and to the individual frame, which is never seen as such by the spectator."[12] Even when "stilled" in the freeze-frame or drawn out in an uneventful long shot, film's constituent parts—those contingent instants that it is photography's privilege to make palpable for us—must remain inaccessible. Film's technology of repetition necessarily covers over the individual frame's singularity and inherent difference.[13] And yet when presented to us as the static photograph, the very life and presence of that singular instant are denied. As Thierry de Duve puts it, the instantaneous photograph "is a theft; it steals life." Although "intended to signify natural movement, it only produces a petrified analogue of it."[14] The photograph may offer permanence, but it is dead, and although film offers presence and life, it is necessarily fleeting.

This distinction between media that ultimately share the same physical substance (photographic film) is made uniquely palpable in an overlooked masterpiece of Weimar cinema by Oskar Fischinger (1900–1967), one of the twentieth century's most vibrant innovators of animation and experimental film. Often placed alongside Walter Ruttmann, Hans Richter, and Lotte Reiniger as a key figure of the avant-garde in 1920s Germany, he was just as important to the North American avant-garde in the succeeding three decades, where he influenced everyone from John Cage to Norman

11. Doane is channeling Barthes and Charles Sanders Peirce in her discussion of the instantaneous photograph: "'Thisness,' indexicality, and chance, as well as the notion of the present instant as a point of discontinuity, are wedded in Peirce's theory. All are attributes of the photographic image." Doane, *Emergence of Cinematic Time*, 101.

12. Doane, *Emergence of Cinematic Time*, 184.

13. Bellour, "Film Stilled," 105, insists that the freeze-frame makes "the photographic" appear "in the film's movement." I discuss this paradox and my qualifications of it later in the chapter.

14. Thierry de Duve, "Exposure and Snapshot: The Photograph as Paradox," *October* 5 (1978): 114.

McLaren. Whereas his early animation studies and later "musical poetry" have entered the history books of cinema and to a lesser extent become subjects of theoretical discussion, his short, experimental film from 1927 known as *Walking from Munich to Berlin* (*München-Berlin Wanderung*) has received almost no sustained attention by film scholars or theorists.[15] In this chapter I mean to rectify this neglect, drawing attention to Fischinger's utterly original hybrid of photography and film and its singular status in the history of cinema to argue that the film's idiosyncratic form grapples with and uniquely overcomes the paradox that emerges from the coupling of its two media.

Walking from Munich to Berlin negotiates film's ephemerality and photography's deadly permanence, bringing these temporalities into conflict to explore the liminal space between movement and stillness, presence and absence, continuity and discontinuity. The result makes use of a new visual language with profound implications for ongoing debates about the distinctions between these technologies, in particular their archivability and indexicality. Can a film be said to "collect together" instants, even as it lets them slip by? What "reality" might thereby be indexed and preserved? By analyzing Fischinger's film, these questions are not so much answered as re-posed, so that the paradigms of the respective technologies it mobilizes become dialectically renewed. In this case study I thus attempt above all to trace this dialectical movement so as to articulate Fischinger's unique contribution to animation and the avant-garde in terms of what Doane calls "the representability of the ephemeral" and the "contradictory desire of archiving presence."[16] Therefore, although my discussion situates *Walking from Munich to Berlin* within a

15. Although it is frequently mentioned in discussions of Fischinger's larger oeuvre and especially his early work, the only analyses of the film beyond such passing references or simple descriptions are relatively brief. These include William Moritz, *Optical Poetry: The Life and Work of Oskar Fischinger* (Bloomington: University of Indiana Press, 2002), 19–20, 207–208; Robin Curtis, *Conscientious Viscerality: The Autobiographical Stance in German Film and Video* (Berlin: Edition Imorde, 2006): 102–103; and Jennifer Lynn Peterson, *Education in the School of Dreams: Travelogues and Early Nonfiction Film* (Durham, NC: Duke University Press, 2013), 273–275.

16. Doane, *Emergence of Cinematic Time*, 25, 82.

broader trajectory of cinematic innovation, offering insight into the development of avant-garde film to help us more clearly conceptualize Fischinger's own resolute embrace of animation as a cinematic mode, it also serves as a meditation on the problem and paradox of collecting. Fischinger's film, I argue, is a startlingly original instantiation of collecting in which the ephemeral instant is gathered and preserved, but only *as* that which necessarily slips away.

Walking from Munich to Berlin: Its Creation and Form

Born in Gelnhausen, Fischinger started out his career in nearby Frankfurt, where in the early 1920s he invented a wax-slicing machine consisting of a blade synchronized with the shutter of a camera, which he used to create intricate time-lapse sequences showing the changing cross sections of wax. In 1922 he traveled to Munich to convince Ruttmann to purchase or license the machine and ended up staying in that city. (Ruttmann ultimately used the wax-slicing machine to create the background of the opening flying-horse sequence in Lotte Reiniger's *The Adventures of Prince Achmed* [*Die Abenteuer des Prinzen Achmed*, 1926].) For the next five years Fischinger lived and worked in Munich, where he would develop many of the animation techniques that he would later use in his most well-known works of abstract film. In June 1927 he made *Walking from Munich to Berlin* while traveling to Germany's capital, where he would make important contributions to film with his own series of abstract *Studies* (*Studien*, 1929–1933) and the early masterpiece *Composition in Blue* (*Komposition in Blau*, 1935), as well as by designing special effects for Fritz Lang's *Woman in the Moon* (*Frau im Mond*, 1929). Ernst Lubitsch helped him secure a position with Paramount Studios in Hollywood in 1936.[17] Fischinger moved to California that year, where he worked for various studios, including

17. For a useful chronology of Fischinger's years in Germany, see Jeanpaul Goergen, "Oskar Fischinger in Germany: 1900 to 1936," in *Oskar Fischinger 1900–1967: Experiments in Cinematic Abstraction*, ed. Cindy Keefer and Jaap Guldemond (Amsterdam: EYE Filmmuseum and Center for Visual Music, 2013), 42–49.

briefly for Disney on *Fantasia* (1940), and where he also created some of his most accomplished works of animation, including his magnum opus *Motion Painting No. 1* (1947).[18] He would never return to Germany.

The three-and-a-half minute *Walking from Munich to Berlin* is anomalous in Fischinger's oeuvre in two respects. First, the film emerged directly from a purely personal dilemma. By late spring 1927, Fischinger was struggling to make ends meet and was forced to borrow money from friends and family. He even accepted loans from his landlady, who also allowed him to fall behind on rent. But she had ulterior motives: she wanted a husband. If Fischinger agreed to marry her, she would cancel his debt. Fischinger decided instead to flee Munich and make a new life in Berlin. With a backpack, some film prints, and his camera, he set out on the first day of June to walk the entire 350-mile route. Not wanting to be found, Fischinger took back roads through the countryside, passing only through small villages and pasturelands. The journey took him three and a half weeks.[19] On the way he shot *Walking from Munich to Berlin*. The film is thus a record of the artist's flight, the product of an urgent desire to escape from a life where his creative output was being curtailed. In its exploration of a new cinematic temporality, the film reflects the circumstances of its creation. Fischinger's wish to overcome the stagnation and personal dead end of his life in Munich finds expression in the film's own attempted transformation of stasis into an emancipated movement.

Walking from Munich to Berlin is also unusual for Fischinger's cinematic output because it is one of only two completed works in which he points the camera at the world. With the exception of *Swiss Trip (Rivers and Landscapes)* (1934), every one of his other films uses things—in the forms of drawing, painting, silhouette, paper cutout, wax, and other objects—as the primary visual media,

18. For the story behind Fischinger's fraught collaboration with Disney, see Esther Leslie, *Hollywood Flatlands: Animation, Critical Theory and the Avant-Garde* (London: Verso, 2002), 187–191. See also Moritz, *Optical Poetry*, 83–87.

19. Moritz, *Optical Poetry*, 19–20.

which the camera then captures frame by frame. In *Walking from Munich to Berlin*, Fischinger trades these techniques for shots of both the natural and constructed world around him. Unlike *Swiss Trip*, however, the film is not exactly a live-action work but rather still—in a most idiosyncratic way—an experiment in animation. Instead of using his camera to capture action in motion, Fischinger shot clusters of single, still frames that were later projected as a moving picture, without any editing of the sequence in which they were shot and without adding or removing any pieces.

The film consists of 3,755 frames that, when projected at the speed of 18 frames/second (the frame rate commonly used in 1927), result in a moving picture of three minutes and 29 seconds in length.[20] These 3,755 frames contain 368 discrete clusters. Each cluster consists of stills taken from a single, unmoving position, typically in quick succession. These clusters of stills thus each show a particular subject or scene, mostly villages and isolated buildings, fields and forests, wild and farm animals, villagers and farmers, farmhouses and churches, clumps of dirt and outgrowths of vegetation, sky and clouds. The number of individual images that makes up each of the 368 clusters ranges from as few as one single frame to as many as 74 frames that, when projected, are from approximately one-thirty-sixth of a second to a little over four seconds in duration.[21] Only one of these clusters—the penultimate one in the film—is more than four seconds long. This and the relatively few other clusters that are more than one second in length are anomalous.[22] The vast majority of the film's apparently continuous sequences (333, to be precise)

20. We do not know for sure whether Fischinger screened the film during his lifetime. The Center for Visual Music screens the film print at 18 frames/second, though the *Oskar Fischinger: Ten Films* DVD has it transferred at 16 frames/second. I assume throughout that the film's projection speed is 18 frames/second. My source for the close study of the film was a 35mm print in the collection of the Center for Visual Music, Los Angeles, as well as the *Ten Films* DVD.

21. A single frame projected at 18 frames/second lasts about one-half of one-eighteenth of a second when taking the duration of the shutter blackout into consideration.

22. Only two clusters are longer than three seconds, eight are longer than two seconds; and twenty-four are longer than one second.

last literally only a fraction of a second, with the average (mean) duration of these clusters clocking in at a miniscule one-third of a second (or six frames).

One can hardly speak of continuity within each sequence: the brevity of each cluster barely allows for movement, let alone action, to unfold before its images disappear. Continuity is further problematized by Fischinger's technique of shooting instantaneous single frames. Even though each of the sequences of frames that make up the film's clusters appears to have been shot in relatively rapid succession, when projected the sequences are not characterized by smooth motion. Instead, continuous motion is cut up into pixilated bursts that make palpable the gaps in between still frames, the missing frames whose inclusion *might have* created a more naturalistic flow of continuous images.[23] Fischinger thus uses stillness to create motion, as every animator does, except that the motion he creates is—contrary to what an animator by definition tries to achieve—broken up, discontinuous. With moving subjects (people, animals, clouds drifting across the sky) this jerky movement is most apparent. But even sequences of otherwise motionless buildings, villages, or trees appear to be in flux by virtue of shifts in light.[24] The viewer thus sees neither static images nor smooth motion but clusters of stuttering activity: twitching, flashing, wavering.

This effect is heightened by the even more dramatic lack of continuity between clusters. Although each cluster was taken on a spe-

23. We do not and ultimately cannot know what kind of camera Fischinger used. It is thus possible that he employed a hybrid photo-cinematic device (such as the popular Debrie Sept) capable of shooting both stills and moving images. (Such a device would account for the relatively large number of shots.) Even if the clusters were captured as bursts or at an extremely slow moving-picture frame rate (which may have been the case for some of them), the effect remains that of flickering stills, which is how I treat them throughout. Because some of the photographed subjects pose for the camera, it is difficult to ascertain the length of the intervals between shots. With moving figures, the intervals are easier to estimate. Although the intervals in these cases remain relatively short, a number of them reveal gaps that can only have come from shooting a sequence of stills, suggesting the whole film was shot in this way.

24. It is impossible to tell whether these shifts in light are natural or artificial (i.e., from manipulating the camera aperture), though I suspect—because of the often-drastic shifts in exposure—the latter.

cific trajectory—the course Fischinger followed from one metropolis to the other—that trajectory is hardly evident. Most of the subjects or scenery in any one cluster do not suggest a contiguous or continuous relation to the subjects or scenery of the cluster immediately following it. In a number of cases, a group of two to five clusters reveals the same subject but from different angles, positions, or distances (see figure 1).

And in a few cases the clusters even reveal a clear direction to Fischinger's movements, showing, for example, a village in the distance, that same village at slightly closer intervals, and then a few clusters of people and buildings presumably photographed within that same village. Such continuity, however, is the exception rather than the rule and is made more tenuous by the extreme brevity of the sequences (as well as the extreme brevity of the film itself), so that any connection from cluster to cluster typically disappears as fast as the clusters themselves. Although we know that these clusters were captured consecutively, it is impossible to tell how much time elapsed between them, and the film itself provides few signposts for reading successive clusters as a continuous sequence. Furthermore, its juxtaposition of clusters is dictated by the element of chance. Since no editing was involved, Fischinger could only spontaneously consider what had preceded one cluster of exposures. Additionally, because the route he took from Munich to Berlin was improvised, the exposures he made could not have been planned in any way.

And yet, Fischinger was clearly aware of the effect these aleatoric juxtapositions would have, drawing attention to them by deliberately separating most of the clusters from one another with a specific and recurring means of visual punctuation. This punctuation comes in the form of overexposed frames that appear as flashes of white marking the end of one cluster and the beginning of the next. In almost all instances, this punctuation consists of one single overexposed frame (see figure 2).[25] Taken together, these

25. Close examination of the film reveals that most of these overexposed frames were made at the beginning of each cluster, rather than at the end. That these flashes are deliberate is reinforced by their frequency—there are more than 300 of them—and their appearance in *Swiss Trip* seven years later.

Figure 1. Scan of frames from Fischinger's *Walking from Munich to Berlin*. © Center for Visual Music, Los Angeles. Reproduced with permission.

overexposed frames participate in the film's play with the features of light, even as they contribute to its erratic pacing by adding another dimension to the restless and discontinuous movement of images. The bursting white frames thus serve as a kind of rhythmic constant in the film's unfolding, a visual beat—even if irregular—

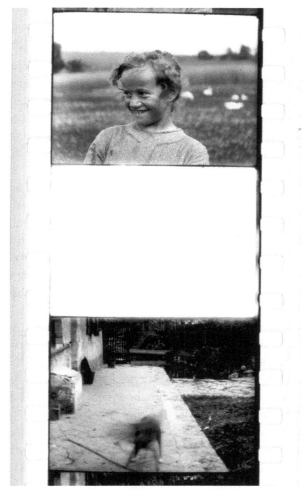

Figure 2. Scan of frames from Fischinger's *Walking from Munich to Berlin*. © Center for Visual Music, Los Angeles. Reproduced with permission.

that accompanies the film's representations, emphasizing the flashing of its images and marking its discontinuous breaks. The white, overexposed frame thus makes visible (by making invisible) its own rupturing of continuity.

Cinematic Predecessors and Heirs

The effect of Fischinger's unusual hybrid photographic-cinematic technique is unique in the history of cinema. Its closest contemporary cousins would be pixilation (stop-motion animation using live actors), which had been used only rarely before 1927, and time-lapse photography, which was used to great effect in the mountain films of the same period in Germany; for example, in Arnold Fanck's *The Holy Mountain* (*Der heilige Berg*, 1926).[26] Fischinger's film, however, achieves something different from each of these techniques. In contrast to how a pixilated film is made, most of Fischinger's moving subjects (for instance, farmers in the field and animals) do not pose motionlessly for the camera. Fischinger instead captures instantaneous photographs of their natural movement. Thus, even though the movement of the resulting projected clusters is often similar to pixilated movement in appearing slightly discontinuous and flickering, this is an effect of the photograph's stillness, not—as in pixilation—of the corresponding subject's stillness. And in those cases when human subjects do stand still in a series of partial poses, Fischinger's technique actually *introduces* discontinuity (in the form of flickering) to what *would be* a sequence of not just continuous but also unmoving (because mostly unchanging) shots. This technique thus exposes the paradox that the appearance of stasis in film requires absolute continuity. Fischinger, contrarily, uses stasis to create the appearance of discontinuity. The result is in effect the opposite of what pixilation attempts to achieve, which is to produce continuous movement out of a sequence of static but changing shots. In figure 2, one can see examples of single frames representing each of these kinds of stills (of the posing subject and of the moving subject). The first frame shows the end of a cluster of a girl who mostly stands

26. For an example of pixilation from the early years of cinema, see Émile Cohl's *Jobard Does not Want to See Women Working* (*Jobard ne veut pas voir les femmes travailler*, 1911), whose final scene is pixilated. For an example contemporaneous with Fischinger, see Hans Richter's *Ghosts Before Breakfast* (*Vormittagsspuk*, 1928).

still; the third frame shows the beginning of a cluster of a dog that is unable to stay still. This latter frame also reveals how Fischinger's stills sometimes freeze animated figures with a somewhat blurred effect similar to Étienne-Jules Marey's chronophotography or the photodynamism of Anton Giulio Bragaglia, emphasizing the instantaneity of the exposure, the moment of pure temporality otherwise invisible to the naked eye.[27]

Fischinger's film also differs from the time-lapse effect, even if it shares some of its characteristics. For although each cluster in *Walking from Munich to Berlin* displays a jerkiness similar to time-lapse photography, this visual stuttering is necessarily isolated to each of these clusters. The visible gaps between clusters prevent the effect from being maintained across any sequence of clusters because the white frames that punctuate and interrupt them correspond not just to lapses in time but to spatial shifts, as well. Consequently, it is the film's quasi-narrative structure and linear trajectory (which entail changing locations) that impede an uninterrupted time-lapse effect, paradoxically thereby denying the film the continuity such an effect would grant. Although they correspond to Fischinger's spatial progress on his journey, the irregular and ultimately indeterminate ellipses between clusters thus preclude this very progress from being represented as directional movement. The long duration of the journey from Munich to Berlin is therefore only evident in the scattered fragments that result from the lack of continuous space and matching cuts.[28]

27. See Doane, *Emergence of Cinematic Time*, for discussions of Marey's chronophotography (46–60) and Bragaglia's photodynamism (84–88). I briefly discuss Marey's work below.

28. I use "cut" for lack of a better word. The film was not edited; the order in which the frames were shot is the exact order in which they are projected. I would include amateur YouTube videos such as "One year in 40 seconds" and "41 years in 60 seconds" in this category of time-lapse films that also strive for absolute continuity. On the complexity of the notion of the "shot" in animation, see Suzanne Buchan's discussion of the term in relation to the Quay Brothers' *Street of Crocodiles* (1986), in which she distinguishes between the single-frame "shots" of animation and the spatiotemporal sequences that these frames can create (as per traditional film language). It is precisely because, as she puts it, "the cumulative 'shots' then appear as a continuous shot if the image composition, movement, and soundtrack have a coherent spatiotemporal flow," that Fischinger's film is so hard to categorize: its single-frame

The jerkiness and jumps characteristic of *Walking from Munich to Berlin*, however, do have other cinematic parallels. Indeed, they point both forward and backward along the historical trajectory of cinematic innovation. Sequences of discontinuous single frames can be found in a number of films of the American and European avant-gardes beginning a couple of decades after Fischinger's film, such as in the work of Paul Sharits, Ernie Gehr, Peter Kubelka, and Stan Brakhage. In each case, however, the exact implementation of the technique, its effect, and its theoretical implications remain distinct from what Fischinger achieves. Sequences of discontinuous, extremely short—even single-frame—shots found in Jonas Mekas's *Diaries, Notes, and Sketches* (aka *Walden*, 1969) come closest to creating the effect of *Walking from Munich to Berlin*. The specific technique differs, however: Mekas uses short bursts of multiple frames more often than single-frame exposures. Furthermore, he often combines the sequences of these flashes with other techniques, such as erratic camera movement and superimposition; these elements are also interspersed within a three-hour film of varying pixilated, but mostly nonpixilated, styles. Zbigniew Rybczynski's *Oh, I Can't Stop (Oj! Nie moge sie zatrzymac! 1975)* and the second segment of Hollis Frampton's *Surface Tension* (1968) are in some ways also belated siblings of *Walking from Munich to Berlin*. Each depicts a journey by foot represented via pixilated point-of-view shots that condense the time of the journey from hours to minutes. Despite surface similarities, these films differ considerably from Fischinger's in conveying the directional movement of their respective journeys with clear—even if jerky and highly sped-up—continuity.

At the other end of the spectrum is the early work of Robert Breer, who used single frames to create radical *dis*continuity. His first experiment, the loop *Image by Images I* (1954), is a purely single-frame construction; just a short time later, in *Recreation* (1956) he transforms this technique into a distinct cinematic style, which, as P. Adams Sitney writes, reveals "a heightened awareness

shots never seem entirely to add up to the sequence of shots they nonetheless fragmentarily provide. Buchan, *The Quay Brothers: Into a Metaphysical Playroom* (Minneapolis: University of Minnesota Press: 2011), 157–158.

of the operation of the single frame as the locus of the tension between the static and the moving."[29] Although brief moments of continuity do appear in the film (for example, a toy mouse moving across the screen), these are overwhelmed by its relentless barrage of single-frame images of varying depth, color, texture, and contrast. The effect is a "state of continual flux" in which the brief continuous moments do not provide relief so much as create a "coordinated tension."[30]

Lois Mendelson credits Breer with having "invented the strategy of single-frame construction" that she sees only Fernand Léger and Dziga Vertov having "flirted" with.[31] Although Fischinger's *Walking from Munich to Berlin* predates Breer's earliest experiments by twenty-six years, belying Mendelson's claim, any comparison should be tempered with a clear understanding of how these filmmakers' techniques (not to mention the resulting films) differ. First, Breer is not, properly speaking, using pixilation. Not only do his single frames capture already immobile objects but these objects are only actually animated in a few cases. Breer's film thus works by means of a "strategy of amalgamation" akin to the modernist collage.[32] As Breer himself puts it, he "cuts out" and "separates" things from their "original context" to draw attention to their disparities and to generate disjunctive rhythmic patterns.[33] Fischinger's film, by contrast, works by means of a strategy of accumulation and subtraction *from naturally animate life*. By creating a sequential accumulation of images, Fischinger provides the original, real-life context that Breer strategically denies his viewers. And yet he also subtracts from this context—though not so as to use the subtracted images anew. Fischinger's subtraction is a strategic not-filming, the

29. P. Adams Sitney, *Visionary Film: The American Avant-Garde 1943–2000*, 3rd ed. (Oxford: Oxford University Press: 2002), 272.

30. Lois Mendelson, *Robert Breer: A Study of His Work in the Context of the Modernist Tradition* (Ann Arbor, MI: UMI Research Press, 1981), 79. Sitney, *Visionary Film*, 273.

31. Mendelson, *Robert Breer*, 103, 73.

32. Mendelson, *Robert Breer*, 78.

33. Quoted in Mendelson, *Robert Breer*, 74. Interview with Breer by Mendelson in New York on August 9, 1977.

decision to *leave out* the frames that *would* create natural move-ment, thereby letting them disappear in the time between his suc-cessive pixilated shots. Thus, even though both films stage and in-terrogate the discontinuous effects of stillness in motion, they do so in importantly distinct ways. In particular, Fischinger's film draws attention to its concrete media (film via natural photography) in a way that Breer's work—which is obsessed with its captured objects and the anticontinuity of their juxtaposition—does not.

With *Walking from Munich to Berlin*, Fischinger can thus be said to have anticipated the single-frame experimentations of later gen-erations of filmmakers, with remarkably original implementation and results. His film, however, might be more fruitfully compared to pre-cinematic attempts to capture motion, particularly the work of Eadweard Muybridge and Étienne-Jules Marey, each of whom lived from 1830 to 1904 and separately experimented with media on the border between stillness and movement. Marey's work de-picts the movement of people and animals in separate exposures on the same photographic plates, showing either the distinct positions of the moving body or—with short intervals between exposures—a blurred image. Muybridge famously used multiple cameras to create stop-action exposures of things in motion. The glass plates that cap-tured these images were too cumbersome to be reanimated, but Muybridge used them to make drawings for early moving-image technology, such as his own zoopraxiscope. The moving images pro-duced by this device and other pre-cinematic technologies such as the praxinoscope and phenakistoscope, however, are not entirely smooth or naturalistic. Their flickering and skipping are reminiscent of the stuttering movements of Fischinger's film. Except that where these pre-cinematic devices were limited to using still images to achieve naturalistic movement, Fischinger had at his disposal the technology to capture movement *as movement* but chose to use this technology in a pre-cinematic manner to take only still images—despite his intent to later put these back into (a new kind of) motion.

Walking from Munich to Berlin thus moves from the potential for live-action filming of natural, continuous movement that early film pioneers were striving to achieve *backward* to stuttering, dis-continuous animation. Fischinger de-composes the fluid movement

his technology affords him, introducing disjunctive jumps and breaking down causality and continuity. He does this by capturing things that naturally move (clouds, animals, people), thereby turning them by means of photographic technology into things—but then only using these inanimate (though importantly *once animate*) things as the discrete parts for the cinematic technology of animation. This path from movement (life) to stillness (photograph) back to movement (film) produces the film's idiosyncratic rhythms and also plays with the viewer's desire for continuity, offering but then withdrawing the effect that animation is meant to create. The film intentionally breaks up the very potential for continuous movement made possible by its ostensible form (animation). As such it is an anomalous work of animation that both interrogates and celebrates its own origins (stillness) and effects (continuity). Indeed, the film continually keeps these features in tension, without entirely resolving them into one dominant visual language.

This purposefully cultivated in-betweenness is evident not only formally but also thematically, particularly in the film's exploration of rural space. If it is generally true that "cinema has always been an urban medium and art form," then it is even more so in the case of German cinema, which, especially in the Weimar years, is obsessed with the big city, imaginary (e.g., Lang's *Metropolis* [1927]) or real (usually Berlin, the setting of countless films from this period).[34] *Walking from Munich to Berlin* stands out sharply as an exception. Fischinger does not, as does Ruttmann in *Berlin—Symphony of a Metropolis (Berlin—Die Sinfonie der Großstadt)* made that very same year, seek out the symmetries and disjunctions of urban life, where he could have found the angles, shapes, lines, and movements that would occupy him for the rest of his career as abstract forms. Instead, he traverses a liminal space between the grand metropolises of Munich and Berlin, a space characterized by the fluid figures of nature, as well as by soft contours and amorphous shapes, both arresting and giving life to overlooked and marginal things as they exist off the beaten track. In explicitly eschewing images of the city,

34. Lynne Kirby, *Parallel Tracks: The Railroad and Silent Cinema* (Durham, NC: Duke University Press, 1997), 133.

Fischinger's film is a "Chamber Sonata of a Countryside" next to Ruttmann's "Symphony of a Metropolis."[35] Despite the titular origin and destination of Fischinger's walk, neither Munich nor Berlin makes an appearance in the film. In fact, only the train tracks and the poles for overhead electric wires in the film's very first cluster suggest anything like a postindustrial world. Fischinger's film in this sense represents the direct inverse of Ruttmann's, which also begins (after a brief prelude) with the image of train tracks. Ruttmann's tracks soon reveal a train that takes the viewer from the countryside outside the city straight into the heart of the metropolis, never to return. In contrast, Fischinger leaves any trace of the city behind in the very first second of the film (there are eighteen frames that show the empty train tracks) to explore the countryside that Ruttmann excludes, never to return to (or arrive in) the city. If with Ruttmann we are propelled directly into the city, with Fischinger we flee far from it.[36]

Walking from Munich to Berlin is from this perspective a celebration of the world beyond the encroachments of modernity, ironically made possible by the very tools of the modern world it excludes. This tension is part of the film's modernity itself. But it is also a product of its exploration of liminality, not just the overlooked spaces in between the grand metropolises but also—parallel to these—the aesthetic spaces where dominant conceptions of temporality and structuration are dissolved. By means of its medial hybridity, its opening up of the zone between the photographic and the cinematic, the film succeeds in forging this new cinematic space.[37] Its mobilization of the still frame to break up continuity is in this respect critical. For Doane, such points of discontinuity have explicitly ideological implications, because they resist the "otherwise

35. Curtis considers the film's "pastoral landscape" in relation to its "record of distraction." Curtis, *Conscientious Viscerality*, 103.

36. Kirby provocatively parallels train travel with cinema in terms of the "fundamental paradox: simultaneous motion and stillness." Kirby, *Parallel Tracks*, 2.

37. Raymond Bellour sees the photographic as existing "somewhere in-between" motion and stillness. Bellour, "Concerning 'The Photographic,'" in *Still Moving: Between Cinema and Photography*, ed. Karen Beckman and Jean Ma (Durham, NC: Duke University Press, 2008), 253.

continuous stream of time . . . in a capitalist economy," offering "the promise of something other, something outside of systematicity."[38] Fischinger's traversal of liminal space in *Walking from Munich to Berlin* indeed hints at such utopian overcoming, but it does so by mobilizing the still frame to interrogate itself—as an indexical and archival medium.

The way in which the film's archival impulse is intertwined with its indexical impulse is best explained by way of its shared lineage with the nonfiction nature films and travelogues that had been popular in the previous decade. The travelogue in particular, as Jennifer Lynn Peterson notes, does not follow the logic of narrative but rather "a logic of collection" in which "a series of single exterior shots of landscapes or people" are "joined together in a disjunctive manner that preserves the integrity of each shot rather than making connections between shots using continuous space or matching on action."[39] These films' shots are "typically arranged in a meandering, arbitrary fashion" that "emphasizes that the film is *a collection* of images, a succession of views resembling a series of postcards or snapshots."[40] *Walking from Munich to Berlin* definitely belongs to this tradition of travelogue filmmaking, though it radicalizes one of its key features: the emphasis on its constituent parts (its "collection of images"). It does so by making these present not just as images but also as the material object that has done this collecting. If we recall Sontag's description of the collectability of the photograph as dependent on its thingliness, the innovation of

38. Doane, *Emergence of Cinematic Time*, 106.
39. Jennifer Lynn Peterson, "Travelogues and Early Nonfiction Film: Education in the School of Dreams," in *American Cinema's Transitional Era: Audiences, Institutions, Practices*, ed. Charlie Keil and Shelley Stamp (Berkeley: University of California Press, 2004), 197.
40. My emphasis. In her recent book, Peterson expands this argument and includes a brief discussion of *Walking from Munich to Berlin*. Peterson, *Education in the School of Dreams*, 273–275. Looking at nonfiction films from this same period, Tom Gunning conceptualizes "the view" as—distinct from an artificially arranged scene—a sequence that "mimes the act of looking and observing" a subject that "preexisted the act of filming (a landscape, a social custom, a method of work)." Tom Gunning, "Before Documentary: Early Nonfiction Films and the 'View' Aesthetic," in *Uncharted Territory: Essays on Early Nonfiction Film*, ed. Daan Hertogs and Nico de Klerk (Amsterdam: Stichting Nederlands Filmmuseum, 1997), 4–15.

Fischinger's film announces itself. For what Fischinger ultimately collects and preserves by means of his hybrid visual medium are not the things captured *on* film (as Peterson argues), or even the "views" presented *by* it (as Gunning would say), so much as the photographs that do this capturing and presenting in and of themselves. What Fischinger's film makes uniquely palpable is the static photographic image as the stubborn material ingredient of cinema. When watching a film, we necessarily overlook the single, arrested image that constitutes it. Not only does it fly by too fast (when factoring in shutter blackout, in about one-thirty-sixth of a second) but by virtue of a cognitive and physiological process that is still not entirely clear to scientists, we only see a sequence of these motionless images as fluid and alive. Fischinger's film presents the photographic negatives that comprise a film as perceptible things—things that exist between presence and absence, permanence and ephemerality, stillness and motion. He does this not by editing a collection of duration shots (as in the travelogue) but by lining up a collection of static images, displayed at once as the records of time frozen *and* as moments lost in time. In this way, the film demonstrates that photography's having indexically "captured" reality is an illusion: all we have is the materiality of the archival medium. The things this medium appears to capture for us will forever slip away. Only in staging this ephemerality through cinematic means, while still holding on to the static image as its constitutive element—making its motionlessness palpable *in and through* film's inherent motion— does Fischinger achieve this extraordinary effect with its critical resonances for film and photography theory.

Stillness in Motion

These resonances, in particular, can be seen in the ways this short work uniquely intervenes in recent discussions about the ontology of the image and the distinctions between the still photograph and filmic movement. Most of the literature on the gray zone between these two media focuses on the appearance of stillness in film, either

as a (diegetic) photograph itself or in the long take that slows movement, sometimes to the point of bringing it to a standstill. These are moments when the photographic "interrupts" the cinematic, as Raymond Bellour puts it, opening up a new temporality in between stillness and motion. And yet that temporality is characterized by stillness that is *in motion*, even if it is perceived as still, such as in the famous case of Chris Marker's *La Jetée* (1962), a film that consists almost exclusively of stills that are granted an ordinary filmic duration to enable voiceover and narrative development. The difference between stillness and motion in *La Jetée* is made perceptible at the single moment when movement briefly appears within one of its static sequences. For Bellour such interruptions are critical, especially when stillness interrupts movement, as in the freeze-frame, which "makes reappear, in the film's movement . . . the photographic."[41] Writing on Rainer Werner Fassbinder's films, Christa Blümlinger argues, "Individual images are only perceptible if we slow down or stop the film"; that is, when it is "not run according to its realistic running time."[42] Fischinger's film differs significantly from Bellour's and Blümlinger's examples, offering a new model for conceptualizing the relation between stillness and motion on the border between the photographic and the cinematic. Unlike films by Marker or Fassbinder, or the works of other filmmakers often evoked in discussions of stillness in cinema such as Béla Tarr, Fischinger's film—like Breer's experiments after him—uses stasis to create more intense movement, not stillness. And yet the film's movement is such that its underlying stasis is made all the more apparent.

Thus, as viewers try to find continuity in *Walking from Munich to Berlin*'s disparate sequence of stills that flicker and fade, they are pulled into Fischinger's playful experiment on the threshold between two distinct but related media, an experiment that performs the paradox born of their coupling even as it tries to overcome it. If

41. Bellour, "Film Stilled," 105.
42. Christa Blümlinger, "The Figure of Visual Standstill in R. W. Fassbinder's Films," in *Between Stillness and Motion: Film, Photography, Algorithm*, ed. Eivind Røssaak (Amsterdam: University of Amsterdam Press, 2011), 101.

cinema—especially animated cinema—*must* cover over its constituent parts (the individual, static image) to be what it is, then Fischinger's hybrid photo-film reintroduces those parts in a most perceptible and powerful way, even as it emphasizes their necessary transitoriness. The film's flickering back-and-forth between grasping and losing also evokes the collector's impulse, forcefully colliding the temporalities of duration and impermanence. After all, we collect together and keep safe mere things—dead things—because we strive for completeness, something that will forever elude us, not least because that completeness was relinquished the moment we appropriated these things in the first place. Fischinger's work responds to this dilemma most profoundly: he *captures* things in a mode of cinematic collecting that paradoxically preserves and presents them *as things-that-cannot-be-captured*. He in effect performs their very uncapturability, making these things present—in a moment's flash—and then relinquishing them to the ether.[43]

In *Walking from Munich to Berlin*, however, it is not exactly the photographic that, to use Bellour's term, "interrupts" movement with stasis. Instead, what interrupts the film are the gaps that correspond to those missing frames that *would* create continuous movement, the frames that Fischinger did not have, in part because he presumably wanted the film he took with him on his journey to last the whole route. The continuous trajectory of that journey, therefore, might be posited as the "total film" next to which *Walking from Munich to Berlin* is a mere fragment. Except that the movements of the one correspond to the interruptions of the other, and vice versa. Only in interrupting his walk could Fischinger take the stills that comprise the film, and only in interrupting this photographing could Fischinger take the steps needed to complete his walk. The stills themselves, therefore, although they correspond to Fischinger's interruptions along his actual route to Berlin, are not

43. See Jacques Aumont's discussion of the Impressionists and their precursors as wanting "at the same time to seize the moment that flees and simultaneously grasp it as the fugitive moment." Aumont, *L'œil interminable: Cinéma et peinture* (Paris: Librairie Seguier, 1989), 43. Also cited in Doane, *Emergence of Cinematic Time*, 178.

what actually interrupt the movement of the film. Instead, the gaps that correspond to Fischinger's real-life movement on his journey grant the film its unique visual language by denying it continuity. It is these gaps (in real time) that interrupt (in diegetic time) the film's potential for continuous movement.

But these are also the gaps necessary to make the film, not only because Fischinger needed to move forward on his route from one city to the next but also because these gaps are what lend the film its specific rhythm. This paradox would not have escaped Fischinger. His actual movement corresponds to the lack in stills that *would* create the film's continuous movement, but instead introduce a new type of movement: its distinctive discontinuous stuttering. Even more critically, the gaps in Fischinger's film are more radical instances of what is ultimately necessary to make *any* film. Cinema, after all, *must* consist of static, still frames. And in between each of these stills one might have captured another "instant" of reality. In other words, although cinema attempts to reproduce the continuous movement of reality, it really only divides up this continuous movement into 18 or 24 frames/second.[44] Film translates the infinite into a finite and calculable number. As Doane puts it, "In concealing the division between frames, [cinema] refuses to acknowledge the loss of time on which it is based."[45] Cinema's temporality, she also notes, is a "duration based upon division, upon the sequential serialization of still photographs, which, projected, produced the illusion of motion and the capturing of time."[46] In this way, Fischinger's film points to the paradox of the cinematic in relation to photography and, by extension, to film's redemption in animation. *Walking from Munich to Berlin* uniquely makes palpable cinema's *necessary* gaps, the inevitable absences between filmic images. In effect, Fischinger's experimental short announces that film will *always* skip over the real, which

44. There are of course other film rates (16, 20, 22 frames/second, etc.). Recall Henri Bergson's critique of the cinematograph as falsely presenting the continuous, indivisible nature of duration in discrete, discontinuous segments. Bergson, *Creative Evolution*, trans. Arthur Mitchell (New York: Henry Holt, 1926), 303–308.

45. Doane, *Emergence of Cinematic Time*, 61–62.

46. Doane, *Emergence of Cinematic Time*, 208.

(as time) is infinite and thus indivisible. Film, it demonstrates, will *always* at core be a kind of animation.[47]

Collecting Lost Time

The preservationist impulse of collecting expresses a similar desire for attaining the infinite through finitude. In the longing for wholeness in a fragmentary world, as well as in the attempt to fix and make permanent what is otherwise fleeting, the collector gathers up what is scattered in the effort to overcome these things *as* finite objects. In the first part of his *Sleepwalkers* trilogy (*Die Schlaf-wandler*), written only a couple years after Fischinger made *Walking from Munich to Berlin*, Hermann Broch describes this propensity of the collector with acuity:

> Every collector hopes with the never-attained, never-attainable and yet inexorably striven-for absolute completeness [*lückenlosen Absolutheit*] of his collection to pass beyond the assembled things themselves, to pass over into infinity, and, entirely subsumed in his collection, to attain his own consummation [*Absolutheit*] and the suspension [*Aufhebung*] of death.[48]

This picture of collecting takes the idealized wish-image ("every collector hopes") of the preservationist endeavor to an existential level: the collector trying not only to save objects but also, in the process, him- or herself. Yet in the wish to overcome death in and through dead things, the collector's activity becomes, in effect, self-defeating.

47. This claim has only recently taken hold in film theory. See in particular the work of Alan Cholodenko and Lev Manovich. Also compare Peter Kubelka's statement that all cinema is "a projection of stills" and that "it's between the frames where cinema speaks." Kubelka, "The Theory of Metrical Film," in *The Avant-Garde Film: A Reader of Theory and Criticism*, ed. P. Adams Sitney (New York: New York University Press, 1978), 140–141.

48. Hermann Broch, *The Sleepwalkers*, trans. Willa and Edwin Muir (New York: Vintage, 1996), 71. Hermann Broch, *Die Schlafwandler, 1931–1932, Kommentierte Werkausgabe*, ed. Paul Michael Lützeler (Frankfurt am Main: Suhrkamp, 1979), 1:80.

Material stuff is not assembled to be preserved but is instead exploited for the purpose of transcending materiality altogether, an act that would end up being both totalizing and annihilating (a true *Aufhebung*). Broch's narrator recognizes this wished-for goal as illusory and unachievable: the "striven-for absolute completeness" (*lückenlose Absolutheit*; literally, "gapless absoluteness") is "never-attained" and "never-attainable," not least because its attainment would involve renouncing the mundane things that are supposed to make it possible. For in striving for a state in which nothing is missing, a state of "consummation," the collector disappears into his artificial construction of things as one among them, a piece whose proper place lies, he believes, beyond this world. The infinite can thus only be attained at the cost of finite things. Its realization would be a completely "gapless" whole ultimately no different from the apocatastatic—and thus eschatological—restoration of things.

Fischinger's film offers a singular and compelling corrective to this image of collecting, demonstrating with unique visual means that no collection can be gapless. Yet it also suggests that the infinite can still be accessed—known but not grasped—by way of the finite. The difference is that in this work the infinite is located not in the filling of gaps—as the apocatastatic model would have it—but in the gaps themselves, which are an essential feature of cinema's technologically captured and displayed temporality: the endless possible instants in between frames. For even at 48 frames/second (the rate at which, for instance, Peter Jackson's *The Hobbit* [2012–2014] was shot) or at an impossible (for now, at least) 480 frames/second, information is necessarily lost between each captured image. *Walking from Munich to Berlin* makes those gaps—those absences—perceptible, but it only does so by emphasizing the materiality—the presence—of its individual static parts: the photographic stills that comprise it. The finite frames point to the infinite and indivisible time of which they are only one possible snapshot. Thus, the instant represented in the single still frame, in being made visible as it fleets past us in its flickering discontinuity, conveys lost time even as it suggests having captured it. In this way, the film illustrates in an utterly unconventional form one of the axioms of

modern theories of collecting: the pieces that are missing are more important to the collector than the pieces collected.[49] These gaps in our collections are the negative traces of the potential for "absolute completeness" (Broch) or, as in Stifter, of the infinite discoverability of the world's minutiae. In acknowledging these absences in a remarkable, hitherto unseen way, Fischinger's film does what Mary Ann Doane argues cinema cannot (or refuses to) do: it recognizes—indeed, makes palpable—"the loss of time on which it is based."[50] Instead of being located beyond things, then, the infinite in Fischinger's work is situated among—more specifically, between—them. But because it is only accessible by way of the technological hybridity of photography and film, this fleeting infinite is inextricable from the technological affordances of film as a finite sequence of stilled instants, which Fischinger gathers together in and as the stubbornly material celluloid frames that make up the artwork.

If, as Doane's work in particular has cogently shown, "it is the cinema which directly confronts the problematic question of the representability of the ephemeral, of the archivability of presence," then *Walking from Munich to Berlin* stages this confrontation in a singularly forceful and visually unprecedented way.[51] Indeed, in grappling with the problem of preservationist collecting—with Sontag and Sommer I count photography as a critical medium for this preservation—Fischinger's film makes possible a new kind of vision, parallel to what Benjamin, writing only a few years later, would characterize as "the optical unconscious": photographic (and by extension cinematic) technology's ability to reveal through the contingent instant something that is invisible to the human eye but charged with utopian potential.[52] That potential finds its correlate

49. As noted by Benjamin and Baudrillard, among others. See chapter 1.
50. Doane, *Emergence of Cinematic Time*, 62.
51. Doane, *Emergence of Cinematic Time*, 25.
52. Walter Benjamin, "Little History of Photography," in *Selected Writings*, 2:510–512; *Gesammelte Schriften* 2:371. Kathrin Yacavone argues that Benjamin must have had Muybridge's experiments in mind and links Benjamin's thought to contemporary avant-garde beliefs in photography's utopian capabilities. Yacavone, *Benjamin, Barthes and the Singularity of Photography* (New York: Continuum, 2012), 38–40.

in Fischinger's film in the spaces outside the realm of conventional, corrosive temporality, which are represented by the absent but titularly present urban landscape. Like the early cinema of attractions as theorized by Tom Gunning, *Walking from Munich to Berlin* is an example of the "cinema of instants, rather than developing situations"; yet unlike it, Fischinger's film explores an explicitly rural space.[53] Fischinger thus takes the experience of fragmentation characteristic of modern urban life and transplants it into the country, not to show its inescapability but to redeem it. If the cinema of attractions replicates the experience of urban shock in "consciously heightening [its] use of discontinuous shocks," to quote Gunning's appropriation of Kracauer and Benjamin, then Fischinger takes this "discontinuous shock" of the city into the countryside, where he transforms it into the image that shocks us into seeing anew.[54] Here permanence and ephemerality, acquisition and loss, as well as presence and absence merge, as they do with the collector, in the gaps between clusters and frames that the film so powerfully and singularly conveys.

If the infinite is found in the time that cinema must elide to make smooth motion possible, then Fischinger's *Walking from Munich to Berlin* makes that infinite known in the stuttering discontinuity of its hybrid photo-cinematic form. In this way, however, the film does not lay claim to grasping, let alone directly representing, the infinite; it suggests it instead in its necessary negation. The film's persistent overexposed white flashes (see figure 2), finally, can be read as the markers of these ungraspable moments—instants that also contain the infinite. For unlike the relatively common black frame, which shows nothing by excluding all light, the overexposed frame is a result of film taking in everything. It is the index of the infinite (and necessarily protracted) moment that cannot appear as such or that can only be "present" as that which is invisible. In the context of Fischinger's film, these flashes suggest the ethereal, almost transcendent

53. Tom Gunning, "An Aesthetic of Astonishment: Early Film and the (In)credulous Spectator," in *Film Theory and Criticism: Introductory Readings*, ed. Leo Braudy and Marshall Cohen (Oxford: Oxford University Press, 1999), 826.

54. Gunning, "Aesthetic of Astonishment," 831.

moment of seeing everything—taking everything in—even as they reveal that, ultimately, any such transcendence is only ever available to us as emptiness, as the transparent frame through which the projector's light passes to reveal not any image but nothing—the mere functioning of the apparatus by itself. In the end, *Walking from Munich to Berlin* conflates this emptiness not only with photography's space and cinema's time and the peculiar zone between the two but also with the pure possibility of animation, in which that white rectangle invites artists to draw anything and everything they are capable of dreaming up. In Fischinger's case, those blank spaces would be the material of his cinematic production for the next forty years.

Coda: Storing the Ephemeral (*Marclay*)

Fischinger's film, however, is still an artifact that allows for repeated viewings, which have been made even easier with its transfer to digital media. One can start the film again; one can even pause it and hold on to the individual frames. (You yourself have some of these frames before you in this book.) This may not be the way the film was meant to be viewed—and indeed, it fundamentally alters the experience of the film. But that does not change the fact that once "gone," the images in Fischinger's film are still, of course, "there." The experience of the fleeting still image is built into the medium of film, but that medium itself is not really ephemeral. Celluloid deteriorates, to be sure, and films can be lost in this way; yet in the age of digital restoration and storage, this danger of ultimately destroying the artwork in the process of experiencing it is a thing of the past.

Walking from Munich to Berlin thus offers one way of representing ephemerality, but it does not entirely escape from the impasse of this paradoxical process. The most ephemeral of artworks are not artifacts but performances (one-time stagings or performance art). These, however, do not foreground the ephemerality of the aesthetic experience they offer, in part because they are not bound to any object of permanence. Without the tension between permanence and the ephemeral, the latter has no stake as an element of the artwork.

The experience of a piece of performance art is of the aesthetic in the present moment without appeal to permanence. One may reflect on it later, or even view a recording of it, but neither memory nor recorded medium counts for us as artifact inseparable from the artwork itself. Their permanence is incidental to the artwork.

When that artifactual or material permanence of an artwork is made essential to it, then the very problem of representing ephemerality as laid out in the discussion of Fischinger's film emerges again. The thing militates against what has no staying power. The materiality of the artwork with its attendant endurance stubbornly asserts itself in the face of the attempted representation of what does not endure.

But what if the materiality of the artwork were to perform the very ephemerality it aims to make present in its fleetingness? Such is the achievement of one singular artwork by the Swiss American Christian Marclay. Marclay was born in 1955 to a Swiss father and raised in Geneva but now lives in New York and London. He thus falls outside the realm of the German-language tradition considered in this book. But as a Swiss citizen and as someone deeply influenced by Swiss and German avant-garde movements and artists from Fluxus to Joseph Beuys to Dada, I still would like to situate him—even if only in passing—in my loose genealogy of artists concerned with aesthetic permanence and ephemerality at the intersection of the problems and possibilities of collecting.

Although initially Marclay was primarily known as a musician, he has worked with the media of film, video, and photography.[55] His most famous work is a video installation called *The Clock* (2010), a twenty-four-hour looped film consisting of clips from cinematic works that portray or tell the time—a kind of archive of represented timekeeping. The clips that make up this long film are synchronized with the real time of the screening, so that no matter when one enters the installation room, the screen will tell the correct time.

55. Christopher Cox provides a helpful introduction and analysis of Marclay's work with emphasis on the overlap and indeterminacy of the visual and sonic. Cox, *Sonic Flux: Sound, Art, and Metaphysics* (Chicago: University of Chicago Press, 2018), 64–72.

As a musician, Marclay's main instrument is the phonograph record. He is not a DJ per se, but rather a sound artist who creates sound montage and free improvised pieces using various vinyl records, often simultaneously. As Christopher Cox notes, he works "entirely with found objects—thrift-store albums and record players discarded by elementary schools."[56] He has created music by actually cutting up these salvaged phonograph records and pasting them together collage-style, resulting in frankensteined albums that he then plays on standard turntables. In 1985 Marclay released an album with the title *Record without a Cover.*[57] The vinyl disc comes as its title suggests: sans cover of any sort (neither outer nor inner sleeve). One side of the album is engraved with the artist, title, description of musical content ("manipulated records on multiple turntables"), and other details of recording. In all boldfaced letters, before any of this information we read the "instructions": "DO NOT STORE IN A PROTECTIVE PACKAGE." The other side contains a twenty-minute musique concrète composition that can be played like any other record.[58] Without protective cover, however, the record accumulates—*collects*—the traces of its use, including "scratches . . . dust and debris."[59] Its grooves thus store not just the musical composition—itself created by means of a process of collecting sounds from other records—but also the consequences of accessing that music and the contingencies of its "storage."

Built into the medium that conveys the musical experience, then, is the very deterioration of that music, which is inseparable from its medium. Marclay has remarked on the importance of medium for this work in particular: "*Record without a Cover* was about allowing the medium to come through, making a record that was not a document of a performance but a record that could change with time, and would be different from one copy to the next."[60] One

56. Cox, *Sonic Flux*, 64.

57. Christian Marclay, *Record without a Cover* (Recycled Records, 1985).

58. Cox says it is "a set of his own turntable performances." Cox, *Sonic Flux*, 65.

59. Cox, *Sonic Flux*, 65.

60. Rob Young, "Don't Sleeve Me This Way," *The Guardian*, February 14, 2005. Cox describes the album similarly: "What began as all-but-identical mass-

might argue that indeed all phonograph records function in this way: pops and clicks build up over time as the grooves are slowly and slightly worn by use. However, such an objection misunderstands how Marclay conceives of the music "contained" on this record. Any standard vinyl album may over decades of frequent use—especially if not cared for properly—indeed sound different than when it was first heard; yet the music its grooves store will still be accessible and recognizable as that music, however much the noise floor of the album will have been increased. Marclay's record, in contrast, is the sound of the stylus in the groove as much as it is the sound stored in that groove. The signs of use are strategically increased by its lack of protective cover, so that even "normal wear" begins to become highly pronounced as part of its soundscape. Indeed, the first minutes of the record appear to be completely silent, a blank slate where scratches and nicks along with dust and debris build up and leave their traces in the sound produced by the stylus running through the grooves.[61]

No experience of this artwork, then, will be the same, because each will have been altered by the prior experience. Consumption of the artwork in fact leads to its deterioration, which loss is taken up and made a crucial element of the artwork itself.[62] Here the object of art itself collects and preserves the very loss inherent in the singular aesthetic experience. What we hear when we listen to the album are the sounds of its impermanence, accumulating on

produced objects would slowly diverge from one another, becoming unique works of art via the accumulated traces of their singular and contingent trajectories." Cox, *Sonic Flux*, 65.

61. I am unable to determine exactly how many minutes at the start of the record are silent (if indeed they are totally silent at all) because my copy is so full of accumulated noises. I suspect it is fewer than five.

62. A related musical work ought to be mentioned here: William Basinski's *The Disintegration Loops* (2002–2003). This four-part composition consists of tape loops that the composer was trying to preserve by means of digitization. In the very process of storing the music, however, these tapes became increasingly worn and damaged. The result is a record (in both senses) of the deteriorating music itself, slowly warping and disappearing, with gaps and flaws emerging in and as the attempt to preserve them. The difference here, of course, is in the experience of this music, which—for us—never changes. Its decay has been perfectly captured in a digital format that itself is immune from the same decay.

the surface of the medium, stored ultimately as part of the musical composition it mediates. Marclay's record might be the most radical instance of the artwork as collection, the ineluctable paradoxes of gathering and preserving inscribed—literally—into its form and content.

Part II

Catastrophic Detritus

4

DIVINE DEBRIS (*GOTTHELF*)

Trash is undeniably a human problem. We not only create and impose the distinctions by which trash is classified as such but in every case we also generate the very stuff that falls into this category of worthless and thus disposable things. Nature itself does not create waste: animal discharge and natural deterioration are folded back into the ecological process of decay and regeneration that sustains the planet's existence. What threatens this existence is *human* refuse. We are the ones destroying the environment, either directly, with pollutants and waste mismanagement or, indirectly, in the extreme weather our trash and pollutants cause. What sense would it make to speak of the planet's waste products? And what sense would it make to position nature as the source of the material excess—trash—that we humans find disruptive of our own ordered lives?

For Albert Bitzius, a pastor living in rural Switzerland in the first half of the nineteenth century, these questions become increasingly

urgent in the aftermath of the floods that inundated the Emmental in August 1837. Under his pen name Jeremias Gotthelf, Bitzius wrote a novella-length text about this disaster, *Die Wassernot im Emmental am 13. August 1837* (The flooding of the Emmental on August 13, 1837), which combines elements of a sermon, a journalistic report, scientific literature, and a fantastical tale into a literary work that Peter Utz calls "a groundbreaking text of modern catastrophe literature."[1] Perhaps unsurprisingly, the problem of natural destruction takes on explicitly religious overtones in this work; genuinely surprising, however, is what in particular becomes theologically charged. Since, as Gotthelf makes plain, the inundation of the valley results directly from divine will, it must be God himself who is the source not only of the floodwaters but also of the accompanying debris and dirt that transform the Emmental into a wasteland. But herein lies a vexing incongruity: just as God cannot be the source of evil, neither can he be the source of refuse, especially if this refuse is a mere by-product, the accidental consequence of a providential injunction. If, as Bitzius believes, the absolute being is perfect and his creation necessary, then the contingent and accidental—which include useless and broken things—have no intrinsic place in that creation. Instead, such superfluous things are the products of people's neglect and wastefulness. Indeed, from the Christian perspective only human er-

1. Peter Utz, *Kultivierung der Katastrophe: Literarische Untergangsszenarien aus der Schweiz* (Munich: Fink, 2013), 37. *Die Wassernot im Emmental* was written and first published (as a standalone volume) in 1838. Hydrological simulations have shown that the flooding Gotthelf describes was the worst in recorded Swiss history. Rolf Weingartner and Thomas Reist, "Gotthelfs 'Wassernot im Emmental'—Hydrologische Simulation des Extremwassers vom 13. August 1837," in *Katastrophen und ihre Bewältigung: Perspektiven und Positionen*, ed. Christian Pfister and Stephanie Summermatter (Bern: Haupt Verlag, 2004), 21–41. On the question of genre and Gotthelf's mixture of scientific and literary discourses, see Hanns Peter Holl, "Über Gotthelf's *Die Wassernot im Emmental am 13. August 1837*," in *Katastrophen und ihre Bewältigung*, 43–51. Klauspeter Blaser shows how *Die Wassernot im Emmental* is carefully structured in the form of a sermon. See Blaser, "Totesfluten—Glaubensbrücken—Lebensströme: Theologische Anmerkungen zu Gotthelfs 'Die Wassernot im Emmental,'" in *Erzählkunst und Volkserziehung: Das literarische Werk des Jeremias Gotthelf*, ed. Walter Pape, Hellmut Thomke, and Silvia Serena Tschopp (Tübingen: De Gruyter, 1999), 185–198.

ror can be the source of waste.[2] It is sinful activity that ultimately leads to excess and defilement, which generate matter with neither place nor value in the divine order of things.[3] The presence and prominence of debris that results from the divinely willed floods of August 1837 would thus appear to pose an inherent problem for both Bitzius the pastor and Gotthelf the author.[4]

And yet, instead of shying away from describing this refuse, sludge, and rubble, Gotthelf dedicates many passages to these unwanted things, often at the expense of attention to human suffering. Gotthelf thus does not engage in the conventional theodicean discourse on natural destruction, which focuses on human casualties.[5] Instead, he is unusually interested in the wreckage, the dirt, the collapsed domestic spaces, the disfigurement of the environment,

2. If, as Mary Douglas says, "A polluting person is always in the wrong," then God, who is incapable of doing wrong, certainly cannot be a polluter. Douglas, *Purity and Danger: An Analysis of Concepts of Pollution and Taboo*, 2nd ed. (1966; London: Routledge, 2002), 140. Near the end of *Die Wassernot im Emmental* Gotthelf interprets the flood's destruction as mirroring back to humans the destruction *they* are always already involved in: "that it is they who split apart houses, slay the living, and lay waste to lands" (*daß sie es seien, die Häuser brechen, Leben töten, Länder verzehren*). Jeremias Gotthelf, "Die Wassernot im Emmental am 13. August 1837," in *Sämtliche Werke in 24 Bänden [und 18 Ergänzungsbänden]*, ed. Rudolf Hunziker and Hans Bloesch (Erlenbach-Zurich: Eugen Rentz Verlag, 1921– 1977), 15:79. (Henceforth cited parenthetically as *SW* with the corresponding volume number followed by the page number. The supplemental *Ergänzungsbände* are indicated with an additional *EB* preceding the volume number.)

3. Gluttony, for instance, both "wastes" what might feed the poor (i.e., it is privative) and produces "waste" in the form of excess body fat and excrement (i.e., it is generative). More contemporary views of gluttony express a similar connection between human error (especially excess consumption) and waste: "Consumerism breeds gluttony, gluttony breeds profligacy, profligacy breeds waste, waste poisons the planet." Martin O'Brien, *A Crisis of Waste? Understanding the Rubbish Society* (London: Routledge, 2007), 197.

4. I switch between the names Bitzius and Gotthelf as the context requires, using the former to designate the person who was a pastor (and who wrote sermons and personal letters) and the latter to specify the author of the many texts Bitzius published under the name "Jeremias Gotthelf."

5. Cf. Blaser, "Totesfluten," 193, who rejects the idea that *Die Wassernot im Emmental* is a theodicy, and Christoph Weber, who qualifies its theodicean status. Weber, "Gottes lebendige Predigt: Katastrophendarstellung und -deutung in Jeremias Gotthelfs *Die Wassernot im Emmental*," *Euphorion: Zeitschrift für Literaturgeschichte*

and the household goods swept away by the floodwaters. His is, in part, what I call a "theodicy of things," an attempt to justify not the presence of death or evil in a world overseen by a benevolent and omnipotent God but rather the presence of useless and disposable things in this same world. In this chapter I argue that Gotthelf's attention to the refuse, debris, and alluvium generated by the flood is driven by his need to explain and thus redeem what would otherwise have to be accepted as the waste products of God: divine detritus. I contend that Gotthelf aims to make this refuse productive, to show how it is in fact both debris and generative matter, and how what appears as mere matter nonetheless has the ability to salvage while also, in the process, itself being salvaged. Drawing on insights from Mary Douglas and Jane Bennett on the potential "power" of dirt and trash, my reading engages with the problem of matter and inanimate things in literature by uncovering the efficacy and value of what appears to be lifeless and useless. My analysis also ties the forces found in these things to Gotthelf's literary project in particular, which seeks to legitimate itself *as writing* in the face of God's floods and their debris, the fundamentally earthly phenomena that Gotthelf ultimately also figures as the "matter" of discourse, granting them textuality as the material manifestations of "God's sermon." I thus read the literary character of Gotthelf's early work against the ways in which he problematizes his task as an author (especially in relation to his duties as a pastor) vis-à-vis the divine "authorship" of God's floods and its concomitant trash.

Even though the concept of collecting developed in this book as a whole appears in this chapter only at its end, its basic structure of redemption through destruction, of the dialectical inextricability of dispersal (here in the form of a flood's actual diluvium) and restoration, and of the paradoxical salvaging of things in and through their loss runs through every aspect of the analysis of Gotthelf's text. Indeed, as we will see in the next chapter, the image of catastrophic flooding is often accompanied by measures of gathering and preservation meant to resist natural dispersal. Gotthelf's story may not

106, no. 4 (2012): 432–434. See Utz's *Kultivierung der Katastrophe* for the broader context of the role of catastrophe in the Swiss literary imagination.

be Noachian in the way I argue that Frisch's is, but his mission is firmly rooted in the idea of redemption that Noah's act of collecting meant to ensure. Only here, as in my other case studies, that redemption of things necessarily involves their abandonment. Gotthelf's project of finding power and productivity in what appears to have been abandoned may constitute a more overt attempt to "make whole" what has been wrecked and ruined. Yet it is ultimately—especially in its intertwinement with the matter of writing itself—another means to preserve such wreckage *as* the dirty, damaged, and dispersed matter that it is.

Defining Dirt

The complex interrelations between use and reuse, as well as decay and regeneration, make it difficult to define "trash" in the pre-industrial era, particularly in the rural settings (both real and imagined) of Gotthelf's works. There we typically find communities where even surplus productivity is seen as potentially dangerous and where most objects of use are either durable or used up, either supporting the community's self-sufficiency or feeding back into it.[6] There would thus appear to be little room for what Mary Douglas calls "matter out of place." This, Douglas's now-classic definition of "dirt," serves as both a "relative idea" and a "residual category," because, as she explains, it only exists in relation to ordered systems: "Where there is dirt there is system. Dirt is the by-product of a systematic ordering and classification of matter, in so far as ordering involves rejecting inappropriate elements."[7]

6. Hannah Arendt discusses this distinction between durable and consumable things in *The Human Condition*, where she differentiates labor from work in terms of that which produces the consumable goods needed for sustaining basic existence and that which creates the durable things that are "not consumed but used," respectively. The latter—the things of the world (the products of work)—"guarantee the permanence and durability without which a world would not be possible at all." Arendt, *The Human Condition*, 2nd ed. (1958; Chicago: University of Chicago Press, 1998), 94.

7. Douglas, *Purity and Danger*, 44.

We can see this ordering mechanism at work in the opening paragraphs of Gotthelf's most famous work, "The Black Spider" (Die schwarze Spinne, 1842), where the reader is introduced to an idyllic space of fertility, purity, and order that, as the narrator reminds us, "must be upheld day after day" (*alle Tage gepflegt werden muß*, SW 17:6).[8] Although it is clear that Gotthelf grants significance to this activity of maintaining purity primarily in terms of the community's spiritual life, he also shows how the same cleanliness and order must likewise be fostered in the material realm:

> Beside the well, horses were being curried with particular care, stately mothers with playful foals frolicking about them; in the wide trough beside the well, contented-looking cows slaked their thirst, and twice the boy had to take up broom and shovel because he had not cleared away the traces of their contentedness thoroughly enough. Sturdy maids gave their own red-cheeked faces a lusty scrubbing with handy cloths woven of coarse linen.[9]

> In des Brunnens Nähe wurden mit besonderer Sorgfalt Pferde gestriegelt, stattliche Mütter, umgaukelt von lustigen Füllen; im breiten Brunnentroge stillten behaglich blickende Kühe ihren Durst, und zweimal mußte der Bube Besen und Schaufel nehmen, weil er die Spuren ihrer Behaglichkeit nicht sauber genug weggeräumt. Herzhaft wuschen am Brunnen mit einem handlichen Zwilchfetzen stämmige Mägde ihre rotbrächten Gesichter. (*SW* 17:7)

Here the act of removing dirt extends from the particular environment to the individual body. The young women who wash their faces do so not out of vanity but to maintain a proper appearance that harmonizes with an inner, spiritual complexion. A spotless face reflects a spotless soul. Curiously and comically Gotthelf also draws attention to the animal excrement that repeatedly dirties the area. From the perspective of the farmer such excretions are hardly just dirt, because they will be used to create the manure necessary for ensuring a healthy harvest. But here, next to the well, these droppings are "out of place." The act of removing this most natural but

8. Jeremias Gotthelf, *The Black Spider*, trans. Susan Bernofsky (New York: New York Review of Books, 2013), 3.

9. Gotthelf, *Black Spider*, 4.

also most recognizable waste product involves a repeated effort ("twice") of disposing the matter and eliminating its "traces," an act of erasure that is then doubled on the linguistic level, where Gotthelf removes any direct designation of these animal excretions by using the euphemistic expression "their contentedness."

The activity of clearing away waste, as Douglas reminds us, "is not a negative movement, but a positive effort to organise the environment."[10] This example from "The Black Spider" shows, furthermore, that in narrating the "positive effort" to remove the traces of dirt, Gotthelf reinscribes that dirt back into the text, which suggests that this waste product is in fact a necessary element for maintaining order. Order would not be recognizable without the "trace" of the disorder that threatens it. "The Black Spider" makes this paradox palpable in its formal structure and, parallel to that, in the central artifact of its embedded narratives, the window post, or mullion (*Fensterpfosten*). For just as the idyllic frame story contains the stories-within-the-story that detail the community's sinful pact with the devil and its consequences, so too—in those very stories—the window post contains the spider that is the manifestation of evil. These acts of containment are both structural and metaphorical and, in each case, serve to remind the reader how important the presence of disorder is for establishing order. The window post that contains the spider, like the story about the origins of this window post, provides a negative trace of the transgression that is the foundational event of the community. By being both contained and thus controlled, evil becomes the necessary condition for the virtue and stability of the community that has succeeded in overcoming it—not by banishment or extirpation but by means of incorporation. The properly ordered and productive community is

10. Douglas, *Purity and Danger*, 2. In Gotthelf's late story "Der Besuch" (The visit, 1854), the narrator figures a similar gesture of removing trash as a divinely sanctioned act of both domestic and inner cleansing: "Put every object in its right place, and what doesn't belong in the kitchen, throw it out, all trash [*Ghüder*] goes in baskets so that we can take them tomorrow up to the heap [*Mist*]. You see, do that with your heart, too. Every evening wipe it clean of all daily filth [*Unrat*] that wants to attach itself, that doesn't belong. . . . Put everything in the right place where it belongs, where it will please God" (*SW* 22:234).

thus made possible by means of an act of "organization" (to borrow from Douglas again) that, in this particular novella, positions the "dirt" right at the center, its negative force neutralized and then made productive by means of its constant presence.

The Refuse and Debris of *Die Wassernot im Emmental*

"The Black Spider," however, is not particularly interested in the *matter* of dirt or waste. Its titular spider represents above all a spiritual blemish that leaves human death and suffering, not refuse, pollution, or defiled things, in its wake. As theodicy then, the novella's concerns are fairly conventional and not at all surprising, especially when read as an allegory of the plague.[11] Written four years earlier, soon after Gotthelf decided to start a literary career alongside his pastoral duties, *Die Wassernot im Emmental* reads not so much like a "preliminary exercise" for the later novella, as Walter Muschg describes it, but as a peculiar variation on the standard theodicean discourse found there.[12] As stated earlier, what is peculiar is Gotthelf's attention to an outburst of destructive natural energy without much regard for the individuals killed or injured by the disaster, who play only a minor role in his narrative. In fact, he only mentions three human casualties and only one of these three by name. Although Gotthelf does not exclude these victims entirely from his text, they are unapologetically overshadowed by the abundant presence of things, the refuse that is generated by the flooding. This debris contains remnants of nature such as stones, pieces of boulders, sand, soil, sediment, whole trees and parts of trees, as well as, above all, sludge. In addition to this natural wreckage there are all kinds of domestic items and work tools among the debris: saws, pieces of lumber, chairs, commodes, clothes closets, shoes, and beds, alongside "household objects of all kinds . . . : vats, spinning

11. A reading that the text itself directly encourages: "Now the black death had come to an end." Gotthelf, *Black Spider*, 81; *SW* 17:74.

12. Walter Muschg, "Einleitung des Herausgebers," in *Werke in zwanzig Bänden*, by Jeremias Gotthelf, ed. Walter Muschg (Basel: Verlag Birkhäuser, 1951), 15:xiii.

wheels, tables, tubs, pieces of houses." These last-named parts of houses, such as beams and even whole roofs, combine with ripped-apart bridges and other destroyed structures to send massive amounts of broken pieces of wood into the valley. When this wood joins together with the sludge, stones, sand, and various dislodged domestic things, the debris grows—both piling up and dispersing out—into an excess of mere matter that seems, as Gotthelf describes it, to be endless: "This rubble [*Trümmer*] had no end" (*SW* 15:33).

None of the things that make up this rubble is trash to begin with. Indeed, no trash enters the world as trash (this is part of Gotthelf's conundrum). Trash is instead the end result of a process of trans-formation. Either something is damaged or destroyed and thus ceases to be useful in its particular context, or else something re-mains intact but is displaced to a context in which it has no func-tion.[13] In each case something imposes itself on us as "matter out of place." The broken thing no longer belongs in the sphere of prac-tical life; the displaced thing is a hindrance to the practical activity of the space into which it has intruded. The former are usually the worn-out or broken artifacts of human labor or the traces, remains, and byproducts of basic human activity. As such we call them trash or refuse. The latter are usually the displaced elements of nature, such as mud tracked into the domestic space or—as in the earlier example from "The Black Spider"—animal droppings left in places of social gathering. These we do not typically call trash, though fol-lowing Douglas's definition of "dirt," they share the same funda-mental feature of being not only "out of place," a threat to the or-der we maintain, but also a necessary "byproduct" of the creation of that very order.[14]

Gotthelf does not distinguish between these types of refuse in *Die Wassernot im Emmental*, because both represent an uprooting of the proper place and order of things. In one passage he refers to the buildup of sludge and sand within a home as *Unrat* (*SW* 15:28),

13. In this latter case, trash is similar to the item taken up into the collection.

14. Adalbert Stifter's "Granite" (the first novella in *Many-Colored Stones*, 1853), to give an example written within fifteen years of Gotthelf's text, drama-tizes dirt tracked into the domestic space as an infiltration of disorder that is ulti-mately also fundamental to the proper establishment of ritual and order.

which can mean "debris," "filth," "rubbish," or "trash." Removed
from their natural places by the flooding, sand and sludge, along
with rocks, soil, vegetation, and even simply water, cease to func-
tion within a stable ecosystem and become either burdensome or
threatening. Gotthelf grants special attention to the grotesque con-
vergence of natural and artificial things. Sludge does not just inun-
date domestic spaces; the dislodged implements and furniture it bur-
ies become alien objects half emerging out of this muck: "Here and
there a household object, a piece of a bed peeked out of the fetid
mass" (Hie und da guckte ein Hausgeräte, ein Bettstück aus der übel-
riechenden Masse, *SW* 15:50). What at one point Gotthelf de-
scribes simply as trees poking out through the windows of a home
("The flood . . . tossed pine trees through the windows" [Die Flut . . .
warf Tannen durch die Fenster, *SW* 15:25]) he later transforms into
a horrific image of battlefield violence:

> The windows were smashed in, and from their empty window-holes they
> looked at you like blinded people looking through empty eye sockets;
> and out of such window-holes immense pine trees protruded as in olden
> days spears would protrude out of the eyes of people after a fierce battle.

> Eingeschlagen waren die Fenster, und aus ihren leeren Fensterlöchern sa-
> hen sie einen an wie erblindete Menschen aus leeren Augenhöhlen; und
> aus solchen Fensterlöchern ragten ungeheure Tannen heraus wie vor
> Zeit [*sic*] nach wilder Schlacht Speere aus Menschenaugen. (*SW* 15:50)

Here matter "out of place" manifests itself as a cruel interpenetration
of the natural and the domestic, where the violence inflicted on the
latter becomes akin to a monstrous (*ungeheuer* can mean both "im-
mense" and "monstrous") exoculation. And yet nature too suffers, as
Gotthelf makes clear when he anthropomorphizes the landscape, de-
scribing its disfigurement by the floodwaters as "deep wounds" that
leave behind their traces in the form of "scars" (*SW* 15:49).

Even though nature sometimes appears to be an independent
agent of violence, Gotthelf does not present it as the actual source of
the destruction. The elements of nature do indeed contribute to the
general wreckage, but they are as much what comprise the resulting
debris as are the tools, furniture, and domestic rubble. For Gotthelf,

the violent weather is the outward manifestation of God's will: "The Lord who sent the disaster can add a second to the first, can hurl lightning every day, can open his water chambers at any time" (Der Herr, der ein Unglück gesendet, kann ein zweites zum ersten fügen, kann seine Blitze schleudern alle Tage, kann seine Wasserkammern öffnen zu jeder Stunde, *SW* 15:76). There is nothing unusual about this conception of natural destruction as an instrument (and sign) of God's wrath. It is a commonplace of theodicean literature, particularly of flood myths, with which Gotthelf would have been familiar from the Old Testament. Two features of the divinely willed natural destruction in *Die Wassernot im Emmental*, however, complicate and distinguish Gotthelf's theodicy. One is that Gotthelf figures the storms as "sermons" from God, granting them a peculiar textuality that has consequences for his own writing. I return to this important issue in the final section of the chapter. The other feature that sets Gotthelf's theodicy apart is that it is motivated less by any distress over human suffering than by an interest in the abundance of worthless stuff generated in the flood. Gotthelf is concerned with this proliferation of detritus not only because it calls into question a divine order in which everything has its place but, more urgently, because it also suggests that, if God did not directly create this worthless matter, then it must be the byproduct generated by the storms and floods that God himself has willed. Neither possibility is acceptable because, for Gotthelf, God can neither create nor cause what is without place or purpose. From this perspective the flood's human casualties (who, as I noted earlier, are barely mentioned in the text anyway) are less theologically problematic than is its generation of refuse and rubble. The human soul, after all, is eternal, and the body will return to dust. But once that dust—as useless residue or dirty trace—starts intruding on the divinely ordered system (to use Douglas's language again) it begins to pose a more difficult problem.

Gotthelf confronts this problem by making the flood's refuse productive. In one case a family in the village of Eggywil is saved from the waters but realizes after a headcount that their three-year-old daughter is still missing. At first, they believe she most certainly drowned, but she is subsequently found alive among the sand, sludge, and refuse. Gotthelf's description of the child trapped in this

debris, however, suggests that it was the "trash" generated by the flood that actually saved her: "There he [a 'brave man' who had sought safety in a nearby tree] found the little child inert, walled in up to the neck by sludge and sand, her little head sunk in the filth [*Unrat*], between two beds." Had her head been "sunk" into the water instead of the "filth" or "rubbish" (*Unrat*) she would have died. Had the sand and sludge not "walled her in," she might have been swept away. The scene of domesticity and family safety may be disrupted, having been infiltrated by the destructive debris of the flood—but that same debris becomes instrumental in ensuring that the space, "to which the parents had often carried her when the need to sleep overcame her," still functions as a place not just of refuge but of unexpected "rescue" (*Rettung, SW* 15:28).

In one instance the storm's detritus does not provide refuge so much as carry out a semiotic function, pointing to the salvation hiding in the destruction: "The bridge split into two pieces; these crossed each other majestically in the middle of the Emme, floated upright some hundred paces further down, propped themselves up there not far from the riverbanks" (Die Brücke brach in zwei Teile, diese kreuzten sich majestätisch mitten auf der Emme, schwammen aufrecht einige hundert Schritte weit hinunter, pflanzten dort nicht weit von beiden Ufern sich auf, *SW* 15:34). Peter Utz notes that Gotthelf changed *chassierten majestätisch* ("chasséd majestically") to *kreuzten sich majestätisch* ("crossed each other majestically") in the final version of this passage to construct "out of the destroyed works of man the sign of the cross, which the two halves of the bridge form anew in the river." Thus, as Utz writes, Gotthelf is able to forge "out of the sign of destruction . . . the signs of redemption," so that the remnants of the bridge become infused with allegorical meaning.[15] That these remnants would "prop" or more literally "plant" themselves (*sich aufpflanzen*) into the ground also suggests they have be-

15. Peter Utz, "Redeströme, Bilderbrücken, Schriftschwellen: Gotthelfs 'Wassernot im Emmental' in literarischer Sicht," in *Erzählkunst und Volkserziehung*, 177. Drawing on Benjamin, Utz goes on to read this moment as representative of Gotthelf's text in its "artistry itself," which in its "condensation to an image" is able to stop the flow of God's floods momentarily so as to grant them meaning within the context of the history of salvation (178).

come generative, transformed from dead things into productive organic objects. In other passages Gotthelf shows directly how the things that cannot be salvaged in the floods are nonetheless effective in salvaging others. An empty, uprooted schoolhouse temporarily protects one family by acting as "a shield" that catches and builds up enough wood to serve as "a bulwark that keeps getting more and more safe." Although this schoolhouse is soon washed away, "the protective wood" provides some hope, and the family is eventually spared (*SW* 15:26). One man whose hut the flood destroys and who is himself about to be swept away in its waters is saved by a piece of lumber that these waters bring with it: "He mounted on a log that came through the hut for him and rode a breakneck race with a thousand pine trees until he felt the ground beneath his feet and could save himself up on a hill" (Auf einen Trämel, der ihm durch die Hütte fuhr, setzte er sich und ritt nun ein halsbrechend Rennen mit tausend Tannen, bis er Boden unter seinen Füßen fühlte und an dem Berge hinauf sich retten konnte, *SW* 15:23–24). Where only a hint of agency is granted the inanimate thing here (the dative pronoun *ihm* ["for him"] makes the poor man the benefactor of an otherwise impersonal occurrence), in the preceding paragraph this agency emerges fully. The situation is different, however: the salvaging activity of things begins only after the victim has succumbed to the floodwaters. After telling how a young girl drowns "in the fierce grave of the flood," Gotthelf describes in detail how the lumber, now personified and granted full agency, keeps the body of the young girl intact:

> But as if the cut logs had wanted to remain faithful to the child, they caught her in their midst, vaulting up to form a little mortuary for her and piling up down by Röthenbach into an enormous mausoleum over her. They didn't want the serpent [the fantastical manifestation of the violent Emme] to snatch her away from her native soil; they protected her in their faithful arms until weeks later her parents found her and could bring her to a place of rest.

> Aber als ob die Sägeträmel dem Kinde hätten treu bleiben wollen, faßten sie es in ihre Mitte, wölbten ihm ein Totenkämmerlein und türmten sich unterhalb Röthenbach zu einem gewaltigen Grabmale über ihm auf. Sie wollten nicht, daß die Schlange es entführe dem heimischen

Boden; sie hüteten es in ihren treuen Armen, bis nach Wochen die Eltern
es fanden und es bringen konnten an den Ort der Ruhe. (*SW* 15:23)

Here the concrete objects of human labor (sawn pieces of lumber)
resist the forces of nature, which have nonetheless dislodged them
from their proper place. For Gotthelf, these spans of wood (which
are the material for constructing a "safe" domestic space) seem to
"remain faithful" to the drowned girl by constructing for her a kind
of protective coffin that prevents the waters from washing her into
oblivion. The ability of inanimate things to salvage is limited in this
case, because the girl is already dead. But the lumber that is caught
up in the destructive force of the flooding and is thereby made use-
less as the material for construction, having been displaced with the
rest of the storm's debris, becomes more than just useful again. It
takes on human qualities of care ("protected her") along with an-
thropomorphic features ("in its faithful arms"). This debris ulti-
mately functions both as an instrument for preservation and as a
device with signifying power: not only does it keep the child's body
from being lost in the waters but it also erects a "mausoleum" ca-
pable of signaling to her parents where they can find her, so that
they might bury her properly in her "native soil."[16] Matter "out of
place" here redeems itself and ensures that the human body, though
dead, finds its "proper place," that it does not become the refuse of
God—that it is not, in other words, *refused* by God.

"Thing-Power" (*Bennett*) and the "Potency of Disorder" (*Douglas*)

Before looking at other examples of the ways Gotthelf makes the
flood's debris productive, let us consider two theoretical models that
will help illuminate his peculiar positioning of refuse in this text. The
first of these paradigms comes from political theorist Jane Bennett,

16. Utz reads this mausoleum or monument to the dead as resisting the "flow
of time," thus emerging as "an allegory in its more original form, insofar as the
allegory is the monument [*Grabmal*] of the thing it designates." Utz, "Redeströme,
Bilderbrücken, Schriftschwellen," 176.

who in her book *Vibrant Matter* pushes back against the dominant conception of "matter as passive stuff, as raw, brute, or inert" that emerges from what she sees as the problematic division of the world into "dull matter (it, things) and vibrant life (us, beings)." This division only covers over or leads us to disregard "the vitality *of* and the lively powers *of* material formations." Bennett focuses on precisely such vital materiality as "the material agency or effectivity of nonhuman or not-quite-human things," specific examples of which include debris, trash, and storms. Drawing in part on Bruno Latour's concept of the "actant" (a source of action and efficacy that can be either human or nonhuman) and on Spinoza's notion of "conatus" (an active persistence that nonhuman bodies share with human bodies), Bennett aims "to theorize a vitality intrinsic to materiality as such." In developing her theory, she is especially attuned to the "positive, productive power" of things, which she contrasts with the mere usefulness of objects, whose meaning and function are exhausted in the everyday contexts in which we use them.[17]

This distinction harks back to Heidegger's discussion in *Being and Time* between "presence-at-hand" (*Vorhandenheit*), the mere physical existence of that which is (*Seiendes*), and "readiness-to-hand" (*Zuhandenheit*), the serviceability of that which is.[18] We elaborated this distinction in chapter 1. In Bennett's model the "thing" would appear to correspond to that which is present-at-hand and the "object" to what is ready-to-hand, as in our earlier discussion of these types of material entity. Like Heidegger, Bennett regards the former as only ever accessible by means of the latter: there is "no way for us to grasp or know it, for the thing is always already humanized; its object status arises at the very instant something comes into our awareness."[19] For Heidegger such awareness is only possible through the "obtrusiveness" (*Aufdringlichkeit*) of broken-down equipment, the way in which objects that should carry out a specific function exert their presence on us when they refuse this

17. Bennett, *Vibrant Matter*, vii, ix, xiii, 1.
18. Heidegger, *Being and Time*, 97–107. Martin Heidegger, *Sein und Zeit*, 63–88. I should note that Bennett rarely invokes Heidegger and does not even cite *Being and Time*.
19. Bennett, *Vibrant Matter*, 18.

very function.[20] Heidegger's analysis suggests that it is not just its "object status" but also that object's *thingliness* that emerges in such moments of breakdown, both despite and by virtue of the fact that these moments are necessarily those in which objects fail us. Because the failed object par excellence is trash, we can see how its particular status as the object-broken-down-beyond-repair puts it in a privileged position for this *thingliness* not just to become noticeable but also to take on effectivity. Indeed, for Bennett this substance that is utterly removed from its objecthood gains significance precisely *as* matter due to its "independence from and resistance to us and other bodies." Bennett finds in this independence and resistance a particular vitality that she dubs "Thing-Power," the often uncanny "ability of inanimate things to animate, to act, to produce effects dramatic and subtle." Especially in assemblages, mere things (junk, debris, inert matter) become, for Bennett, "vibratory—at one moment disclosing themselves as dead stuff and at the next as live presence." Bennett is especially interested in how mere matter can enter into productive relations with other bodies, human and nonhuman, and with their potential for effecting change, "their ability to make something happen."[21]

Bennett's notions of "vital materiality" and "thing-power" are meant to expose the fallacy that "real agency belongs only to humans or to God."[22] In this sense her ideas would seem to be incompatible with the world of things in Gotthelf's text, where the storm is the act of God and its consequences (the flooding and its debris) are directly linked to this divine will. And yet the refuse and displaced things in *Die Wassernot im Emmental* are by no means examples of "divinely infused substance," as Bennett describes a notion of materiality she wishes to defuse with her theory.[23] The debris in *Die Wassernot im Emmental* is mere matter. And as such matter it produces effects, in some cases even appearing to display

20. Heidegger, *Being and Time*, 103; Heidegger, *Sein und Zeit*, 73.
21. Bennett, *Vibrant Matter*, 18, 6, 5, 24.
22. Bennett, *Vibrant Matter*, 119.
23. Bennett, *Vibrant Matter*, xiii. Bennett in no way takes this view as a philosophical position to be reckoned with, though she does list it along with conceptions of matter as "passive" or "mechanistic."

agency. These effects are unrelated to these things' former places and functions (their "object status") but instead only reveal themselves after objects have been moved "out of place" or been dismembered and destroyed—turned into trash.

Bennett's notion of "thing-power" is in this way extremely helpful in accounting for the ways in which things become productive in Gotthelf's piece, despite the obvious tensions between her firmly materialist and his unwaveringly theological positions. In the cases discussed in the previous section, matter (furniture, sludge, wood) does indeed manifest positive agency, a certain "vibrancy of materiality," as Bennett would call it. There are also other ways in which displaced matter becomes vital in *Die Wassernot im Emmental*, namely as the raw material for renewed fecundity and productivity. The sludge and sand that the floodwaters deposit into the valley are ultimately not at all, as they first appear, "matter out of place," merely destructive and unwanted dirt; instead, they contain rich nutrients that make them ideal soil for the new harvest: "Where a hard-working hand entrusts the sludge and sand with seeds, there rises up an abundant crop" (Wo eine fleißige Hand dem Schlamm und Sand Samen anvertraute, da steigt zutage eine üppige Saat, *SW* 15:78).[24] Additionally, not only has the flood brought enriched new

24. Gotthelf had previously written about the positive effects of this sand and sludge in a brief report published in the *Berner Volksfreund* on September 3, 1837, "Recommendations for Measures to be Taken after the Storms of 12–13 August, 1837" (Vorschläge über Maßnahmen nach dem Unwetter vom 12./13. August 1837). The relevant passage reads, "The sludge and sand that has overrun many properties is not as bad as one thinks. There are areas where the most beautiful grass is already growing. . . . One can see that the most beautiful topsoil, marl, and also silt are mixed in the sludge, so that on some pieces of land this year's harvest is lost, but may be doubled in the future" (*SW EB* 13:81). The editors note that this description contradicts reports found in other newspapers, "in which we read of extremely severe erosion of the riverbanks and farmland overrun by debris, stones, and trees" (*SW EB* 13:368–369). A similar rhetoric of the positive force of meteorologically generated debris can be found in Gotthelf's second novel *Leiden und Freuden eines Schulmeisters* (Sorrows and joys of a schoolmaster, 1838–1839), in which the narrator describes the creative and intellectual processes of the mind by mobilizing the metaphor of flooding (of the Emme, no less) that results in "a fertile deposit" (*einen fruchtbaren Niederschlag*), which makes possible a "festive harvest" (*SW* 2:96). Compare also, Gotthelf's later novel, *Käthi die Großmutter* (Käthi the grandmother, 1847), which begins with a description of extreme weather

sediment, the vital ingredient of "revivified soil" (*neubelebten Bodens*), making possible a land "born again" (*neu geboren*, *SW* 15:80), but the waters have also left behind massive amounts of lumber. What was a large part of the disaster's debris is now seen as "good fortune" (*das gute Geschick*, *SW* 15:60); the fragmentary, mangled remains of hand-built structures (houses, bridges, farms, mills) become the essential material for rebuilding what was lost.

This wood, however, immediately also becomes a source of social unrest, because many begin to appropriate, hoard, and sell for profit what they see as having dropped into their laps "for free." Yet these selfish impulses have nothing to do with the raw material itself, originating instead in the weaknesses of people, who ought to have distributed the wood "for all to use" (*SW* 15:60) instead of fighting over it. Wood is more easily commodified than is soil, and for Gotthelf what is at once a bounty of material for positive, productive activity also threatens to ignite the greedy desires that he sees as characteristic of the modern world. In "The Black Spider," for instance, Gotthelf dramatizes the danger inherent in any productivity that exceeds what is necessary to sustain the modest existence of the self-sufficient family unit. The plague of spiders that first wreaks havoc on the village is a direct result of the surplus labor (the uprooting, transporting, and replanting of trees) required by the knight von Stoffeln. To meet this demand, one woman, Christine, enters into a pact with the devil, whose kiss on her cheek doubles as demonic insemination that results in her giving birth to a pestilent swarm of spiders. This monstrous parturition, a distinctly female manifestation of fecundity, importantly points to the specific place where negative and positive productivities meet in Gotthelf's work: the body of the woman. On the one hand, women's weaknesses make them susceptible to a perverse and dangerous productivity (manifested in the birth of pestilence); on the other hand, in their role as mothers they enact a sacred and virtuous productivity

in which the narrator insists we see the *creative*, not destructive, power of God. See Utz's discussion, in which he calls *Käthi* a novel "that picks up various elements of *Die Wassernot im Emmental* and expands them into a large-scale epic." Utz, "Redeströme, Bilderbrücken, Schriftschwellen," 179.

(giving proper birth) that is essential to the regeneration of the community. In *Die Wassernot im Emmental* this dual role of the feminine appears in two gendered metaphors of the storm: "these masses [of clouds] carried ruin *in their womb* [in ihrem Schoße] and erupted violently [*gewaltig*] and destructively in thunder and lightning" and "the terrifying [*furchtbare*] mass of water, *pregnant* [geschwängert] with thick earth and therefore doubly heavy and doubly powerful [*gewaltig*]" (*SW* 15:18, 27; my emphases). Gotthelf's task is to redeem these "births" of destruction by turning their negative productivity into a positive one. That the word *fruchtbar* ("fertile") is already contained in *furchtbar* ("terrifying")—indeed, it only requires shifting one letter—subtly demonstrates the dialectical play of destruction and fecundity at work in this text.[25]

The scraps, shards, and broken pieces of wood in *Die Wassernot im Emmental*, then, as raw material, as refuse made useful again, are in and of themselves something to be welcomed and are aligned with the rich soil provided by the flood's deposits of sludge and sand as debris transformed into newly productive matter. Unlike in the instances discussed in the previous section, however, in each of these cases dirt and debris do not display any agency. They would not, therefore, entirely fit Bennett's classification. As she writes, with emphasis, "Vibrant matter is *not* the raw material for the creative activity of humans or God."[26] I thus broaden the conception of productive refuse at work in Gotthelf's text by appealing not just to Bennett's theory but also (again) to Mary Douglas's. As explained earlier, dirt is for Douglas the negative residue of organized systems, "a by-product of the creation of order" that has been rejected from classification and thereby in turn makes classification possible.[27] The line from dirt to pollution to disorder that Douglas traces thus

25. In chapter 2 we saw this same proximity of *Furcht* (fear) and *Frucht* (fruit) suggested in Stifter's text. Compare Utz's expression "the dialectic of salvation through destruction" ("Redeströme, Bilderbrücken, Schriftschwellen," 177), which he takes from the text itself: "In destruction there always lies the seed of a wonderful creation" (In der Zerstörung [liegt] immer der Keim einer herrlichen Schöpfung, *SW* 15:79).

26. Bennett, *Vibrant Matter*, xiii.

27. Douglas, *Purity and Danger*, 198.

ends up exposing how refuse (dirt, trash, unwanted matter) is not just dangerous but also powerful and ultimately even creative. This power and creativity are essential characteristics of dirt's formlessness, the end state of the processes by which order is created and maintained. The ordered system assumes its contours only once the elements it includes can be distinguished from those elements that will be excluded. These excluded elements Douglas aligns with dirt and disorder, which are (unlike the "limited selection" of the ordered system) "unlimited" and thus able to provide "the material of pattern"—to reestablish order. This "potential for patterning" inherent in what has been rejected from the system asserts itself as "potency," so that what we categorize as dirt becomes, for Douglas, "an apt symbol of creative formlessness."[28] But it only attains this status because of its exclusion from the system of order and form. Dirt, "matter out of place," *by virtue of* its being refused and rejected, is instilled with potentiality and possibility. In the end it emerges as nonidentical matter awaiting its appropriation and definition, processes that will in turn generate more (potentially productive) waste.[29]

It is nowhere evident in Gotthelf's text that, in breaking down form, the flood is also establishing order, nor that its destruction of the Emmental is the flipside of ensuring order and stability elsewhere. This is because these two acts coincide. In the context of Christian eschatology, the Flood is the end point of a cycle—the point at which all things are disintegrated so as to be renewed: things are first dissolved in the purifying waters and then regenerated. Douglas quotes Mircea Eliade's discussion of total immersion to explain this "revivifying role of water":[30]

> Immersion is the equivalent, at the human level, of death at the cosmic level, of the cataclysm (the Flood) which periodically dissolves the world into the primeval ocean. Breaking up all forms, doing away with the past, water possesses this power of purifying, of regenerating, of giving new

28. Douglas, *Purity and Danger*, 117, 199.
29. Compare Bennett's analysis of Adorno's "nonidentity." Bennett, *Vibrant Matter*, 13–17.
30. Douglas, *Purity and Danger*, 198.

birth. . . . Water purifies and regenerates because it nullifies the past, and *restores—*even if only for a moment—*the integrity of . . . things.*[31]

This mythic conception of the deluge profoundly informs Gotthelf's text, where the floodwaters simultaneously reduce things to debris and restore them to their originary, unsullied state of potential, which is also their originary "integrity" *as* things.[32] God's storms and floods thus transform natural and handmade objects into mere things that can reveal their "thing-power" only because they have been *refused*—in other words: *made refuse.*

Gotthelf is keenly aware of this paradoxical dual function of the flood's thingly collateral damage, the detritus it leaves in its wake. In fact, the doubling of trash as both that which is reduced down and that which enables restoration back up echoes Paul's First Letter to the Corinthians 4:13, which in the Piscator translation of the New Testament used by Gotthelf reads, "Wir sind worden wie der kehricht der welt und ein kehrwisch aller menschen bis auf diese zeit" (We have become the refuse of the world and are the broom of all men unto this day).[33] We know that Gotthelf had pondered this verse thoroughly, because before he adopted his pen name, Pastor Albert Bitzius selected this exact verse from Corinthians as the

31. From Mircea Eliade's *Patterns in Comparative Religion*, chap. 5, quoted in Douglas, *Purity and Danger*, 198–199. My emphasis.

32. Where in *Die Wassernot im Emmental* Gotthelf reads the productivity of post–natural disaster rubble in a real-life occurrence, in "A Swiss Man's Word" (Eines Schweizers Wort), a talk delivered two years after the publication of *Die Wassernot im Emmental* at the Schweizerische Schutzverein, Gotthelf employs a similar paradigm as a metaphor for the formation of the Swiss confederation. There he imagines the population of Europe as a "flood of people" (*Völkerflut*) that leaves behind a landscape covered with "debris and stones" (*Schutt und Steinen*) along with "the rubble of people" (*Trümmern von Völkern, SW* 15:429). This rubble, however, is the very material—disorganized and damaged—necessary for a unitary (political and social) whole to emerge: "From out of the great pile of rubble there gradually emerged the confederacy, which, joined together in equality, appeared to the observer as a unity" (*SW* 15:430). Utz reads this passage as a paradigmatic "foundation story." Utz, *Kultivierung der Katastrophe,* 155–156.

33. BIBLIA, *Das ist: Die gantze Heilige Schrifft, Alten und Neuen Testaments,* trans. Johannes Piscator (Bern: Bondeli, 1755). Here and later I translate Piscator's German as literally as possible instead of using, as I do elsewhere in the book, the King James version. Note that *Kehrwisch* indicates a small broom or hand brush.

scriptural passage for a Visitation sermon he delivered on May 7, 1827. The annual "visitation" served as an evaluation of the parish and its pastor, and Bitzius used the opportunity to reflect, in part critically, on his own position. The title of his sermon is "The Refuse of the World" (Der Kehricht der Welt). In it Bitzius homes in on verse 4:13 to consider the metaphor of trash as both *Kehricht* ("refuse") and *Kehrwisch* ("broom"), both that which one "desires to get rid of" (*fortzuschaffen wünscht*) because it is "superfluous" (*überflüssig*) and the tool one would use to dispose of that unwanted, sullied matter (*SW EB* 3:105).[34]

In his sermon Bitzius identifies both refuse and broom with the figure of "the pastor." It is the pastor's teachings that are brushed aside as unneeded "in these enlightened times," being either considered an annoyance (*Ärgerniß*) or simply held in contempt (*gering geachtet, SW EB* 3:104).[35] Both the preacher and his message are thus seen as "rubbish." And yet it is precisely *as* such a marginal, rejected figure that the preacher can—indeed, must—get his hands dirty, doing "everything that otherwise no one else likes to do," cleaning up or throwing away "what is unclean" (*Unsauberes, SW EB* 3:104, 107). The tone of this sermon alternates between resentment at being made to carry out this role only to be tossed aside and the resolute embrace of this role, a redemption of its lowliness. Most important for my analysis of *Die Wassernot im Emmental* is the way Bitzius takes what is devalued and *re*values it by way of a binary pair of opposites (*Kehricht/Kehrwisch*) that at the same time functions as a set of equivalents. What is *Kehricht* (refuse), that

34. In the original Greek the key words in question (περίψημα and περικαθάρματα) are two different kinds of refuse. Piscator appears to have wanted to preserve the repetition of the prefix *peri-* by rendering these as *Kehricht* and *Kehrwisch*.

35. Bitzius uses *Ärgerniß* (which can mean annoyance or, even stronger, offense) to express the Christians' relation to the Jews in the time of Paul: "They were an annoyance [*Ärgerniß*] to the Jews." Yet it is clear that he views his own position in relation to the community (and to his advisers) similarly. See Muschg's description of this tension: "Early on and repeatedly [Bitzius] caused offense [*hat Ärgerniß erregt*] in ecclesiastical circles, and his advisers sought anxiously to remind him of his duties as a pastor." Walter Muschg, "Jeremias Gotthelf: Sein Leben und seine Dichtung," in *Werke in zwanzig Bänden*, 1:19.

is, turns over into the *Kehrwisch* (broom), whose activity of brushing or sweeping away (*kehren*) effectively replaces the dirt it means to remove with itself, now the newly sullied object to be "thrown away" (*SW EB* 3:107). The *Kehrwisch* thus turns (*kehren*) itself into the very rubbish (*Kehricht*) it is meant to turn away (*kehren*) in the very activity of this turning or sweeping away. This dialectic of redemption is set in motion in and through Bitzius's exegesis. What others perceive as lowly, unimportant, and disposable becomes integral to his conception of salvation. The preacher's words and actions may precipitate what appears to be mere refuse; but this refuse, having been *refused* by the common people, is all the more potent in its redemptive potential.

Situated outside the system of order, the refuse and debris in *Die Wassernot im Emmental* similarly turn over into their opposite, displaying the negative potential for order and productivity. Furthermore, just as the figures of trash (*Kehricht*) and broom (*Kehrwisch*) in Bitzius's sermon are equated, so too in *Die Wassernot im Emmental* are the destructive and cleansing forces of the flood. In the process of generating debris, the floodwaters also prepare this same debris for renewal; in doing so, they imbue this refuse with what Bennett calls "thing-power," a vitality independent of any human agency. Stripped of their objecthood, these things have become "refuse"; yet precisely *as* such rejected matter, now on their way to complete disintegration, they display a new kind of potency. In Douglas's language, this potency resides in their flirtation with formlessness; their fate is to return to mere matter, figured in Gotthelf's text as sludge, *Schlamm*—a kind of primal muck that comes from combining the dust to which all things are reduced in the end with the revivifying substance of water.[36] This "sludge" emerges as the final stage in the breakdown of objects triggered by the flooding and thus represents a fundamental "potential for patterning" that is the

36. "For you are dust, and dust you will again become" (Genesis 3:19). This is the same dust from which, according to Genesis 2:7, the first human was made: "And the Lord GOD formed man from the dust of the earth." Both verses are echoed in *Die Wassernot im Emmental*: "in the knowledge of being dust in the hand of the great Lord" (*im Bewußtsein, Staub zu sein in des großen Herrn Hand*, *SW* 15:68).

flipside of the flood's devastation.[37] The processes of destruction and renewal are thus dialectically intertwined in *Die Wassernot im Emmental*: the breakdown of objects into mere things contains the potential for order whose (re)establishment requires a systemic exclusion of the very formless stuff that made this order (and the objects that belonged to it) possible in the first place.

The Textuality of Trash: God's Sermon, Gotthelf's Writing, and Their Reciprocal Redemption

And yet the refuse matter of *Die Wassernot im Emmental* is still directly linked to divine intervention. As Gotthelf repeatedly drives home, the storms are God's doing: they are manifestations not only of his divine will but also of his divine "voice" (for example, *SW* 15:7, 9, 22). In figuring meteorological disturbances as vocal articulations from God, Gotthelf is, on the one hand, staying true to the biblical sources he knew well. Bitzius's 1823 sermon on "God's Voice in the Storms" (Gottes Stimme im Gewitter), which draws on the Book of Job, attests to his direct engagement with these textual sources.[38] The Old Testament, which Bitzius knew intimately, would have supplied him with many examples not only of thunder equated with God's voice but also of other extreme manifestations of weather directly linked to God's materialized act of speech.[39] Psalm 104, for instance, describes the effects of divine scolding as a swift and forceful flow of waters: "The waters stood above the moun-

37. Douglas, *Purity and Danger*, 117.

38. *SW EB* 3:285. In this sermon Bitzius explains that God's sometimes "violent voice" is necessary to reach those who would otherwise not listen. He cites Job 36 and borrows images from Job 37: "the movement of his voice, and the rumbling that comes from his mouth" (37:2); and "GOD thunders magnificently with his voice" (37:5).

39. The comparison of the divine voice and thunder is not just a Judeo-Christian trope but also can be found in various cultures. Giambattista Vico even posited that human speech first began as an onomatopoetic imitation of Zeus's thunder roars and lightning whistles. Vico, *The New Science of Giambattista Vico: Unabridged Translation of the Third Edition (1744)*, trans. Thomas Goddard Bergin and Max Harold Fisch (Ithaca: Cornell University Press, 1988), 150.

tains. From your rebuke they fled; from the voice of your thunder they swiftly took flight" (6–7). Gotthelf appropriates these metaphors in *Die Wassernot im Emmental*, as well as in his later novels. The narrator of *Uli der Pächter* (Uli the tenant farmer, 1849), to give one example, depicts a powerful storm as God's direct intervention into human affairs: it is seen and heard in flashes of lightning and rumblings of thunder, but is felt when it takes the form of large hailstones whose violent force is likened to God's will to destruction: "God seemed to want to smash the earth to smithereens" (In Fetzen schien Gott die Erde zerschlagen wollen, *SW* 11:305). The narrator of this novel even compares the resulting natural damage in this scene to the aftermath of a battle in which God was the enemy attacker: "God's battlefield" (*ein Schlachtfeld Gottes*, *SW* 11:307).[40]

Although in *Die Wassernot im Emmental* Gotthelf similarly figures natural destruction as a direct, even at times bellicose, intervention from God, the governing metaphor he chooses comes directly from his vocation. Gotthelf insists not only that thunder in particular is the "voice of God" but also that both the aural *and* material manifestations of the storm are aspects of his "sermon":

In this way, you Emmentaler, your Lord preaches to you with his very own mouth. Now open your ears and listen to the Lord's sermon, recognize his benevolent guidance, the miracle of his omnipotence in the valley; but understand him, too, the Lord, who through the visible wants to awaken, revivify, and bless your invisible souls.

So, ihr Emmentaler, predigt euch der Herr mit selbsteigenem Munde. Tut nun eure Ohren auf und hört des Herrn Predigt, erkennet sein gütig Leiten, die Wunder seiner Allmacht im Tale; verstehet ihn aber auch, den Herrn, der durch das Sichtbare erwecken, beleben, beseligen will eure unsichtbaren Seelen! (*SW* 15:80)

40. One might even read the floods and their resulting pollution as God *marking* his sacred territory. On such a reading of dirt, see Michel Serres's *La Mal propre*, in which he argues that dirtying a clean space is an act of appropriation that is natural to all living species: "*Appropriation takes place through dirt*. More precisely, what is properly one's own is dirt." Serres, *Malfeasance: Appropriation through Pollution?*, trans. Anne-Marie Feenberg-Dibon (Stanford: Stanford University Press, 2011), 3.

Because the wind, rain, thunder, and resulting flooding all emanated directly from God's "own mouth," we are at first led to imagine his sermon solely as oral discourse. Indeed, in asking his readers to "open your ears and hear" this divine discourse, Gotthelf further emphasizes its aurality. Midway through this sentence, however, he shifts the metaphorical framework by contrasting the "invisible" souls of the people with the power of what God has made "visible." God's words, then, are not simply to be heard; they are also to be seen and, as will become evident, *to be read*. God's sermon, like most sermons, seems in this way to consist of both materiality (the written text) and aurality (the text delivered through public speech). Though his "voice" is heard in the thunder's rumblings, its actual power lies in its material effects, not in such intangible, merely audible sounds. In Gotthelf's language, the divine sermon does not start as material text and end in oral recitation; rather, it begins with an immaterial "voice" that then precipitates an overabundance of materiality.

This materiality—as the substance and force of the floodwaters and its debris—is as much a feature of "God's sermon" as are the audible sounds of the storm. Indeed, Gotthelf presents his own text not just as a witness to God's Word but also as an interpretation of his sermon, which becomes the object of Gotthelf's scriptural exegesis: "I have tried to interpret it" (Ich habe sie zu deuten versucht, *SW* 15:82). As Klauspeter Blaser notes, though the generic form of the sermon that Gotthelf in part imitates always incorporates a biblical passage as material for interpretation, such a text is absent in *Die Wassernot im Emmental*. In place of scripture Gotthelf introduces a different kind of divine text: the visible manifestation of "the Lord's living Word" (*des Herrn lebendig Wort*, *SW* 15:82).[41] Although at first Gotthelf articulates a conventional physicotheological conception of the world in which God's presence can be seen in the animated things around us, such as in the flourishing garden, he goes on to emphasize the destructive side of God's legible "living Word," in which "the Lord's sermon has split moun-

41. Blaser says that a "divine text" hides behind the "poetic text." Blaser, "Totesfluten," 185.

tains, buried valleys, destroyed man's happiness and his works by means of blazing lightning and the violent force of water" (*SW* 15:79).[42] The particular physico-theology underlying *Die Wassernot im Emmental* is thus unorthodox in insisting that "God's language" can be found in the cataclysmic forces of nature as well as in its material byproducts: in the rocks, rubble, and broken things generated in and by this violent nature.

In this violent and visible form, God's "oral Word" (as opposed to his "written Word" [*SW* 15:80], the Bible) is also, for Gotthelf, far more effective:

> The good God finds it necessary to preach himself and through his own sermon to bless those who believe in it. He *speaks quietly*, mostly in the wind's whispering, but he also speaks mightily to burst open hardened ears. And when he *speaks loudly* over mountain and valley, then mountain and valley tremble, and the pallid humans are silenced in a profound shudder; they know who is speaking. And when the Lord's sermon has split mountains, buried valleys, destroyed man's happiness and his works by means of blazing lightning and the violent force of water, thus has the Lord *shown* mankind his majesty.

> Der gute Gott findet es nötig, selbst zu predigen und durch seine eigene Predigt selig zu machen, die daran glauben. Er *redet leise*, meist im Säuseln des Windes, aber er redet auch gewaltig, harte Ohren aufzusprengen. Und wenn er *laut redet* über Berg und Tal, dann zittert Berg und Tal, und das blasse Menschenkind schweigt in tiefem Schauer; es weiß, wer redet. Und wenn des Herrn Predigt Berge gespalten, Täler verschüttet, Menschenglück und -arbeit zerstört hat durch feurige Blitze, durch der Wasser Gewalt, so hat der Herr dem Menschen *gezeigt* seine Majestät. (*SW* 15:79; my emphasis)

Gotthelf here shows how an increase in the volume of God's "voice" corresponds to distinct effects that ultimately require a different sense faculty to perceive. When God speaks "quietly," we barely *sense* it in the soft wind. When he speaks "loudly," however, we *hear*

42. Blaser offers a clear and succinct definition of physico-theology: "God speaks not only in the book of the scriptures but also in the book of nature." Blaser, "Totesfluten," 185. For the garden metaphor: "If only people would open their eyes and look at God's garden instead of only looking at books, especially worldly ones, then many would see more than they see" (*SW* 15:46–47).

it in the trembling mountains and valleys. But when he unleashes his "sermon" in full force, we *see* it in the damage it causes to the works of both nature and people. It may therefore be Christians' task to try to "interpret" the "parable" of nature, which requires responding to the voice of God that they hear at varying levels of audibility in the natural world.[43] But when that voice begins to sermonize, to truly resound, no Christians can turn away from its effects, because they are "visible" all around them. The debris and sludge left behind by the flooding of the Emmental ultimately function as this visible residue, which becomes a new kind of script—the fragments of divine writing in and as worldly things. The larger text thereby generated is a legible landscape littered with displaced and damaged but nonetheless—to speak with Bennett—"vibrant matter." But although the people of the Emmental definitely see God's "majesty" in this debris, they seem unable to understand it completely and instead only stand awestruck before the divine text: "Where the devastation was the most prodigious, visitors stood still, in profound reverence, as if at God's altars, and prostrated their hearts in profound reverence before the infinite power of the Lord" (Wo die Verwüstung am gewaltigsten hervortrat, stunden die Wanderer in tiefer Ehrfurcht still wie an Altären Gottes und beugten in tiefer Ehrfurcht ihre Herzen vor des Herrn unendlicher Macht, *SW* 15:68). The might of God's sermon has been demonstrated, though its message remains hard to decipher. It is therefore Gotthelf's task to gather together the scattered script of God's sermon, to read it, and finally to interpret it for the larger community.

We can better see how he accomplishes this task by taking a short detour through Bitzius's private correspondence from this same time, where the deluge and its debris also serve as metaphors for textual production. Reading this correspondence next to *Die Wassernot im Emmental* reveals a curious symmetry between the legible detritus of God's meteorological sermon and Gotthelf's poetological figuration of own literary writing. In a letter to his nephew, most likely written while he was completing or just after he had

43. On the deciphering of nature: "all of nature is a parable that the Christian must interpret" (*SW* 15:7).

concluded his work on *Die Wassernot im Emmental*, Bitzius describes his desire to write literary works as "a natural compulsion" (*eine Naturnotwendigkeit, SW EB* 4:281) that, when it broke loose, resulted in a violent outburst of water.[44] "This wild life" inside him, Bitzius writes, "either had to consume itself or in some way break loose." Writing itself becomes both medium and material for accomplishing this breaking free: "It was accomplished through writing" (Es tat es in Schrift). Bitzius depicts this literary writing as an "eruption [*Ausbruch*] of a mountain lake" that takes the form of unstoppable floodwaters together with the "dirt and stones" these waters carry: "Such a lake breaks loose in wild floods, until it has broken a path for itself, carrying dirt and stones with it in wild horror" (Ein solcher See bricht in wilden Fluten los, bis er sich Bahn gebrochen, und führt Dreck und Steine mit in wildem Graus, *SW EB* 4:280).[45] This explosion of immense natural force represents Bitzius's transformation from pastor into poet. Walter Muschg writes that Bitzius experienced "this event as a veritable poet's consecration [*Dichterweihe*]."[46] Since overflowing water is ultimately responsible for a new name, one might even call it his baptism from Bitzius to Gotthelf. It was in fact around this time that Bitzius stopped writing out his sermons and began only relying on notes to deliver them.[47] As Bitzius's textual output wanes, Gotthelf's increases prodigiously. The calm textual production of the pastor turns over into the fierce waters and attendant rubble of literature.

The imagery Bitzius uses to describe his literary output in this letter, however, is profoundly ambivalent. What may be freeing also brings with it destructiveness. Once Gotthelf aligns his literary writing with the floodwaters' "dirt and stones," a normative paradigm begins to emerge: if literary writing is matter "out of place," then the sermon is the "proper place" of writing. Echoing his sermon on

44. Letter to Carl Bitzius dated December 16, 1838.
45. Utz reads in this letter's imagery of "backwater and eruption" a "metaphorical formula" for Gotthelf's authorship that reveals how *Die Wassernot im Emmental* is "decisive for his poetic-theological self-understanding." Utz, "Redeströme, Bilderbrücken, Schriftschwellen," 171.
46. Quoted in Blaser, "Totesfluten," 186.
47. Muschg, "Jeremias Gotthelf," 20.

the pastor as "refuse," Bitzius's epistolary confession implicitly casts his nonpastoral writings as superfluous, incidental matter that is useless next to the texts he produces as a pastor. As such they are instances of surplus: writings in excess of socially necessary production. Although Gotthelf would soon reconcile his pastoring with his literary writing (by viewing the latter as the new forum for the former), at this critical moment in his life the two remain in tension.[48] *Die Wassernot im Emmental*, though published under the name Gotthelf, represents the meeting of these two versions of authorship. In Peter Utz's estimation, among all of Gotthelf's works it uniquely displays "the complex intertwining of a theological message and its linguistic forms on the one side with poetic speech on the other."[49] The conventional, constricting form of the sermon meets the overflowing impulse to write literature—but is unable to rein it in.

Like God's sermon, the impulse to write literature generates debris. Both Gotthelf's and God's "texts," that is, ultimately create and incorporate "dirt and stones." The same surplus that characterizes God's "textual" production, the rubble and refuse generated in and as his sermon, also characterizes Gotthelf's textual production. Seen together, it becomes evident that Gotthelf's underlying impulse to justify the existence of excess and unwanted matter in the context of natural destruction informs a similar impulse to legitimate his own writing. Gotthelf, of course, starkly differentiates his words from God's, contrasting his lowly and limited language with God's great and unlimited Word. His humble writing, the Swiss author admits, is not even capable of properly depicting God's majestic devastation, which displays a power and paradoxical unity that seem even to exceed what we find in his creation: "There is in the destruc-

48. Bitzius's literary career brought him no modicum of disapproval because many found it to be irreconcilable with his duties as a pastor. As Muschg points out, it is not until around the time that he begins writing *Uli der Knecht* (Uli the farmhand, 1841)—about four years after writing his first novel—that this tension is in part resolved for Bitzius personally. In the earliest phase of his career, during which he wrote *Die Wassernot im Emmental*, he saw his literary writing as "in profound opposition to his pastoral profession." Muschg, "Jeremias Gotthelf," 20.

49. Utz, "Redeströme, Bilderbrücken, Schriftschwellen," 171.

tion a magnificent uniformity, an immensity, which all letters are too small to express" (Da ist in der Zerstörung eine großartige Einförmigkeit, ein Ungeheures, welches auszudrücken alle Buchstaben zu klein sind, *SW* 15:48). But it is not just humans' finite language that falls short of God's infinite powers of destruction.[50] Human destructiveness (*Zerstörungen von Menschenhänden*) also appears by comparison to be "only something little, disjointed, arbitrary" (*nur etwas Kleinliches, Unzusammenhängendes, Zufälliges*, *SW* 15:48). Yet in this description of *people's* destruction as trivial, broken up, and contingent, Gotthelf reintroduces the very features of *God's* destruction that he has been trying to justify throughout this text. His task has been to show how the flood's fallout is precisely *not* irrelevant, disjointed, incoherent, or accidental: instead, it is great, unified, meaningful, and purposeful. We have already seen how Gotthelf responds to the threat of things that might appear to be God's byproducts by turning such ostensibly worthless stuff into productive and potentially potent matter. But what are we to make of this same detritus in the context of "God's sermon," where it emerges as the fragments of divine textual production? Does Gotthelf succeed in transforming what seems to be inconsequential, scattered, and incoherent into something displaying unity, necessity, and real (semiotic) effectiveness?

Picking up Trash: Gathering and Preserving Wreckage

The answer to these questions lies in how Gotthelf's own small and insufficient writing becomes instrumental to the process of "interpreting" the textual landscape of the ostensibly meaningless detritus. Ultimately Gotthelf's text does not stand opposite God's grand, unified sermon but rather seeks to reunify the fragments precipitated by that sermon. This restorative process turns out to be dialectical: in rescuing God's detritus, Gotthelf also legitimates his own writing

50. There is a hint of the discourse on the sublime in this expression of linguistic inadequacy. For a reading of *Die Wassernot im Emmental* that considers it in the context of the sublime, see Weber, "Gottes lebendige Predigt."

as that in and through which this rescue is made possible. What Gotthelf mobilizes to reassemble the wreckage, however, is not conventional narrative representation but rather a mode of *literary gleaning*. *Die Wassernot im Emmental* is less a story or history than it is an index of lost and broken things, its narrative structure less decisive than its descriptive details.[51] Gotthelf uses his text to collect together the storm's detritus in a way similar to how the Emmentaler glean its debris: One could "see them there *gathering together* flax and hemp. . . . To be sure, people *gathered together* what they found on hillsides and trees, pulled out of the sludge what they could" ([man] sah sie dort *zusammenlesen* Flachs und Hanf. . . . Wohl *las* man *zusammen*, was man an Hägen und Bäumen fand, riß aus dem Schlamm, was man konnte, *SW* 15:57; my emphasis). Such are the people's attempts, which teeter between success and discouragement, to salvage what was left behind by the waters through the activity of gleaning: gathering back into a unity (back "into place") what was dispersed and sullied in the flood, what was shifted "out of place." Gotthelf's writing parallels this activity and thereby becomes a doubled instance of *Zusammenlesen*, in which the acts of gleaning and reading (as a bestowing of meaning) coincide. Gotthelf "gathers" God's trash "together" both *in* his text and *as* text. The storm's debris may be the actual matter that this text gathers (on the diegetic level); yet the process of gleaning at the same time treats this debris as fragments of text (as God's sermon, on the metadiegetic level), which Gotthelf is then able to "read" (*-lesen*). Ultimately, Gotthelf's "gathering together" (*Zusammenlesen*) corresponds to a "reading together" (*Zusammen-lesen*), both of which activate his text's redemptive hermeneutics. For in "reading" the sermon ("I tried to interpret it"), Gotthelf simultaneously gathers together (*zusammenlesen*) the things it—as storm and flood—dispersed. And in doing so, he grants these dispersed and broken things a new unity, stability, and meaning. Gotthelf reads "God's

51. On the marginalized role of plot in this work, see Hugo Aust, "Apekte des Beschreibens und Verstehens von Handlungen: Zu Jeremias Gotthelfs *Die Wassernot im Emmental*," in *Formen realistischer Erzählkunst: Festschrift for Charlotte Jolles*, ed. Jörg Thunecke and Eda Sagarra (Nottingham: Sherwood Press, 1979), 93–98.

sermon" by surveying the wasteland, seeing its scattered things, its matter "out of place," and imbuing these things with productive power so as to reintegrate them into a purposeful system—to put them back "into place."[52]

In gathering these dispersed things—the fragments of God's text—back into a proper order via another text, Gotthelf also reflects on the role of writing and textuality in the context of its potential excesses. *Die Wassernot im Emmental*—precisely because its language appears, as Gotthelf suggests, "little, disjointed, arbitrary"—is capable of coming to terms with what Gotthelf implies is the paradox of God's "language": that it might start out as something grand and unified but ends up producing a trail of debris and detritus. Gotthelf's own writing, likewise comprised of "dirt and stones," is commensurate with those fragments of rubbish. At times his language of muck and stones even embodies the split-apart world stylistically: "Trees crashed, houses cracked, towers faltered" (Bäume brachen, Häuser krachten, Türme wankten, *SW* 15:19). These three clauses, for instance, which together read like a poem by August Stramm, express the collapse of natural and human stability via compressed syntactic structures. Gotthelf at once shows himself to be at the mercy of an environment that was coming apart in front of him. And yet his words—lowly, simple, small—unite these things into a list held together by alliteration, rhyme, and metrical consistency. If its linguistic reduction reflects a world where things have been razed to the ground, then this list's formal regularity raises these same things back up. This tension between creation and destruction, as displayed in miniature in these six words, ultimately drives the dialectical movement of the entire text. We can see it at work wherever Gotthelf strives to piece together the whole to which the flood's debris and rubble once belonged, simultaneously exposing the disjointedness and destruction that first robbed these things of this same whole.

52. Utz's description of the act of representing disaster as paradigmatic for the Swiss tradition as a whole resembles Douglas's model of the potency of disorder: "Through the catastrophic destruction of the world forces are unleashed that divert [the catastrophe] into creative energy." Utz, *Kultivierung der Katastrophe*, 17.

In the end, it is the structural and metaphorical congruence between the debris of Gotthelf's linguistic deluge and the debris of God's actual deluge that makes the Swiss author's redemptive task possible. In picking up God's trash, Gotthelf also picks up his own "dirt and stones" and, in the process, affirms that mode of textual production whose power lies in its "gleaning" and "reading" (*Zusammen-lesen*) of *disjecta membra*, its ability to collect the world's discarded matter together while at the same time making it matter. The text that results will never reach the state of the perfectly unified sermon—but that is not Gotthelf's aim. After all, his writing may rescue God's detritus, but it can only do so by also incorporating this trash—prior to its redemption—into the text, where its traces cannot be erased. Gotthelf may ultimately have "God's trash," the textualized refuse of his all-powerful Word, at his disposal; yet instead of *disposing of* it as waste (an impossible task anyway), he *disposes* it, putting it in its proper place, which is to reclaim and mobilize it as the productive matter of writing itself—in all its dirtiness and displacement.

That proper place in Gotthelf's work comes closest—of all the case studies in this book—to resembling the apocatastatic whole, the restoration of things. I hope to have shown, however, that any semblance of unity and stability in *Die Wassernot im Emmental* is only made possible by virtue of the debris that comprises it. Gotthelf may attempt to reintegrate the fragments of the flood into a new whole, but he cannot escape the logic whereby these things' productivity requires their displacement in the first place. As "dirt and stones," ultimately, this writing thus always stands in stark contrast to any full restoration of things, which is why Gotthelf attends so persistently to the fundamental displacement by which objects become things. From this perspective, the original dispersal—manifested by the flood itself—becomes integral to the restorative project in a way that calls into question the supposed unity achieved in the end. Furthermore, because the dispersed debris of the flood also stands in for Gotthelf's writing, itself made of "dirt and stones," it carries allegorical significance that points beyond the catastrophic circumstances of the story to the power and productivity of literature itself,

the site where dispersal and its redemption ultimately meet.[53] Gotthelf's writing itself therefore becomes the scene of an attempted restoration, of gestures (rhetorical, narrative, thematic) toward unity, which in the end expose the damaged things of which it is comprised. Because these things can only become productive *as* the broken and splintered pieces of the world, *Die Wassernot im Emmental* enacts the paradoxical logic of modern collecting whereby loss becomes constitutive of redemption. To gather and preserve debris and sludge, Gotthelf demonstrates, requires a language of "dirt and stones," itself dispersed diluvium, which cannot fully recreate the order prior to its destruction. The best it can do is show the potential for order inherent in things' destruction and deterioration, the way in which dispersal is an unavoidable element of any attempt to overcome it.

53. In this way Gotthelf might be read alongside the Baroque authors who renounce the idealized form of the symbol in favor of a patchwork assemblage of the "fragmentary, disordered, and cluttered," as Benjamin figures their work. These writers, too, were faced with extraordinary, catastrophic circumstances; their poetic and dramatic works picked up the pieces being splintered around them by the Thirty Years' War. Benjamin, *Origin of the German Trauerspiel*, 201 (translation modified); *Ursprung des deutschen Trauerspiels*, in *Gesammelte Schriften*, 1:362.

5

MACULATURE / *ZETTEL* (*FRISCH*)

Published in 1979, nearly a century and a half after Jeremias Got-
thelf's *Die Wassernot im Emmental*, Max Frisch's late story, the
book-length *Man in the Holocene* (*Der Mensch erscheint im Ho-
lozän*), reads like a late modernist reimagining of Gotthelf's text.[1]
It, too, relates the incidents surrounding the flooding of a Swiss val-

1. It does not seem to me fruitful or even necessary to debate whether Frisch
is a modernist or a postmodernist author, because these are descriptive categories
relevant only to specific texts. Broadly speaking, Frisch comes out of a modernist
tradition (his first novels were published in the 1930s) and at times toys with the
elements we identify as postmodernist, in a few cases even fully embracing them.
Using Brian McHale's distinction, however, I designate *Man in the Holocene* as an
example of modernist fiction, because its "dominant" is epistemological, not onto-
logical. This work clearly foregrounds questions of knowing, staging doubts about
the stability, authority, and accessibility of knowledge as such. In some ways the
book might be read as a final attempt to uphold epistemological certainty in the
face of a world threatening to disappear. Brian McHale, *Postmodernist Fiction*
(London: Routledge, 1987), 9–11.

ley. It, too, presents the threat of sludge and mud using apocalyptic tropes. It, too, mixes fictional narrative with historical detail. And it, too, I argue in this chapter, mobilizes the logic of collecting as a potentially redemptive response to catastrophe.

Unlike Gotthelf's narrative, however, Frisch's focuses on one individual, the septuagenarian only ever referred to as *Herr Geiser* (Frisch even denies him pronouns), who during a few days of strong rainfall struggles to stay dry and safe in his house located in an unnamed village in the Ticino Valley. Geiser treats the continuous downpour as a portent of some more threatening diluvial activity, worrying about his own safety, the structural soundness of his home, the possibility of food shortages in the event that mudslides and flooding block access to the village (there is only one road in and out) or—if the retaining walls do not hold—even bury the village entirely. At one point, in a kind of purgatorial ascent, he attempts to hike out of the valley to catch a bus to his hometown of Basel. He turns around, however, and ends up back in his house where he becomes increasingly agitated, refusing to leave or even open the door to concerned neighbors. If throughout it is suggested that Geiser suffers from an onset of dementia, by the end he appears to have had a stroke. We are left with no clear indication that he survives.

Frisch presents Geiser's fictional plight against the backdrop of Earth's geological history, which, as concrete scientific data, takes the place of the trust in divine authority that undergirds Gotthelf's work. The questions that motivate Geiser, an agnostic if not an atheist, are thus of a different kind from—though they remain on the same order of magnitude as—Gotthelf's, concerned as they are with the meaning and place of humankind in the universe.[2] Because he does not, for instance, believe in divine retribution in the form of extreme weather—"Geiser does not believe in the Flood [*Sintflut*]" (16; 26)—the debris caused by the flooding of the Ticino Valley

2. "Geiser wonders whether there would still be a God if there were no longer a human brain, which cannot accept the idea of a creation without a creator." Max Frisch, *Man in the Holocene*, trans. Geoffrey Skelton (Champaign, IL: Dalkey Archive Press, 2007), 9; Max Frisch, *Der Mensch erscheint im Holozän* (Frankfurt am Main: Suhrkamp, 1979): 17. Henceforth all references to these editions will appear parenthetically, English followed by German.

where he resides is not legible in the way that the debris caused by the flooding of the Emmental was for Gotthelf. What Geiser reads instead are the books in his small library. Because, as we are twice told, "there is nothing to do but read" (8, 27; 16, 38), Geiser leafs through works of regional history, the Bible, and a *Brockhaus* encyclopedia, among other books, in order to better understand the environmental catastrophe that he thinks is underway, particularly in terms of the planet's evolution, geological formation, and ecological changes.[3]

Reading is thus central to both Gotthelf's and Frisch's texts. In each it serves as a means to grasp (or try to grasp) a picture of the world that transcends the present time and the individual. Indeed, Geiser's mode of reading is, like Gotthelf's *Zusammen-lesen*, both highly idiosyncratic and deeply informed by the procedures and paradoxes of collecting. For Geiser does not simply read—or read around in—his books. He is engaged in the specific process of gathering, preserving, and displaying information that he finds in these books by tactile means, which transform their facts, figures, and illustrations into graspable and orderable—in other words, *collectable*—pieces of paper. This process at first takes the form of copying the data from his books onto paper notes (*Zettel*). These Geiser pins to the living room wall using thumbtacks. Soon, however, this method of selective transcription by hand turns into the manual excision of passages from these same books using scissors (35; 48). These cutout sections from his books (also designated "Zettel") he adds to the wall alongside his handwritten notes, which he continues to write when he wants to record information gleaned from his own memory (39; 53). When he runs out of tacks, he begins using tape to secure the scraps of paper to the wall (63, 87; 83, 114). On the one hand, these *Zettel* hold the information that Geiser himself cannot prevent slipping away from his slowly deteriorating mind. The collection thus serves as a mnemonic aid. On the other hand, this erosion of the mind is aligned with Earth's erosion, so that the scraps of paper, notes, and cutout sections of books form a

3. A paratextual list of the works consulted and pictured appears at the end of the book (113; 145).

patchwork on the wall that suggests they are keeping it from cracking or crumbling in the torrential onslaught.

In this chapter I read Geiser's attempts to prevent these erosions as part of a practice of collecting, an attempt to resist disintegration and dispersal through the creation of assemblages or what Benjamin—in recognition that no collection can be complete—calls a "patchwork."[4] This redemptive activity, however, is inextricably linked to a perpetuation of the very dispersal it aims to overcome. Geiser does more than simply extract information from his books: he cuts them up. Reading is thus not exactly, as in Gotthelf, *Zusammenlesen*, a "gathering together," but rather a rending apart, a mode of apprehension only made possible by dismemberment, by cutting up what is whole into disparate pieces. The effort to save what is being eroded and washed away—what is, ultimately, being turned into waste—thus involves the creation of waste itself. I refer to this paper waste using the word "maculature," which typically refers to blotting paper and misprinted pages, which are either unreadable or not meant to be read (or both) and are thus designated for the trash.[5] Though Geiser's *Zettel* are not maculature in this strict sense, the term is helpful in articulating what is distinctive about his paper scraps and what makes them the site of paradox. For one, they exist on the border between readable material and waste, a liminal status to which the book frequently draws attention: although the *Zettel* are meant to be read, the process by which they are made and attached to the wall (cutting, pinning, taping) also renders them (in part, at least) unreadable. As unreadable material, they also function metaphorically, I argue, to indicate the attempted patching of cracks in the wall, the structural reinforcement against the threat of diluvial water. As such, they are, like blotting paper, waste material whose purpose is to absorb excess liquid and control its spread.

4. Benjamin, *Arcades Project*, 211; *Gesammelte Schriften*, 5:279.

5. For a brief critical overview of the concept for the study of material objects in literature, see Dennis Senzel, "Makulatur," in *Handbuch Literatur & Materielle Kultur*, ed. Susanne Scholz and Ulrike Vedder (Berlin: De Gruyter, 2018), 422–424. The German word, which can also refer to any old and unusable printed material, is slightly more common in present-day usage than is the English cognate, which is rarely used.

Geiser's gathering and preservation in the face of a potentially catastrophic deluge ultimately position him, despite his protestations, as a Noah figure, the archetypal collector.[6] His wall of *Zettel* is supposed to provide coherence and order in the face of the impending flood, to rescue what would be lost in its waters, and to help reconstitute postdiluvial existence. What Geiser lacks, however, is community (which is another kind of collection: the *collective*). Alone, he is a failed Noah, struggling only to save himself in his physical and mental decline. That his salvage operation ends up generating maculature is not only a self-reflexive moment for Frisch as aging writer. It also reveals the way in which our efforts to gather and preserve what seems to be slipping away tend to participate in the dispersal these efforts seek to overcome: what they preserve, ultimately, is the deterioration of order itself, making a record of what has, in a sense, already escaped from our grasp. Collecting therefore does not so much protect what is in decline or threatening to disappear; nor does it, as with Gotthelf, redeem what is scattered and dirty by bringing it back together and making it productive. Collecting, Frisch's late story teaches us, can also be destructive. And yet, unlike in Stifter's "Der Kuß von Sentze" (discussed in detail in chapter 2), the damage done in the process cannot necessarily be reversed. The original state cannot be restored. Frisch's frail and forlorn Geiser is a Noah resigned to forgetting; his collection of *Zettel* thus does not remedy his scattered mind but in fact instantiates it.

In this chapter I explore the implications of collecting in the face not only of things' disintegration but also of the disintegration of the human for whom these things matter. With the disappearance of the human (or of human cognition) as a possibility—indeed, an inevitability—a new set of questions emerges around the idea of collecting. Does the natural state of things that collecting seeks to restore predate the human? If so, to what degree are humans them-

6. Susan Stewart calls Noah's Ark "the archetypal collection." Stewart, *On Longing*, 152. John Elsner and Roger Cardinal begin the introduction to their volume on collecting with the observation that "Noah was the first collector." Elsner and Cardinal, introduction to *The Cultures of Collecting*, ed. Elsner and Cardinal (London: Reaktion, 1994), 1. They go on to say that Noah "represents the extreme case of the collector," because he "suffers the pathology of completeness at all costs."

selves the problem to which collecting serves as the solution? Have *we* introduced dispersion into the world—or just the concepts (gathering and preservation) by which it is recognizable? In either case, how are we supposed to aid in restoring a state that might predate us, one in which it seems we have no place?

Frisch's story engages these questions on multiple levels. It dramatizes the disappearance of human cognition along with an effort to collect and preserve that places emphasis not so much on the things in the world as on our methods of understanding these things. Frisch thereby suggests that while catastrophes continue to threaten stability and order in the world—contributing to ever more dispersion—we can only really salvage the things of that world (and by extension the world itself) through an accumulation of (dead) knowledge, a patchwork assemblage of wisdom gleaned from the past. But at the same time, because *Man in the Holocene* reveals that this attempted gathering and preservation doubles as dispersal and destruction, it offers only an ambiguous assessment of the practice, seeming to implicate humankind in the problem in ways that have surprising consequences.

Structures of Support: Architecture and Memory

The book begins with Geiser constructing an edifice out of food:

> It should be possible to build a pagoda of crispbread, to think of nothing, to hear no thunder, no rain, no splashing from the gutter, no gurgling around the house. Perhaps no pagoda will emerge, but the night will pass.
>
> Somewhere a tapping on metal.
>
> It is always with the fourth floor that the wobbling begins; a trembling hand as the next piece of crispbread is put in place, a cough when the gable is already standing, and the whole things collapses—
>
> Geiser has time to spare. (3; modified translation)

> Es müßte möglich sein, eine Pagode zu türmen aus Knäckebrot, nichts zu denken und keinen Donner zu hören, keinen Regen, kein Plätschern aus der Traufe, kein Gurgeln ums Haus. Vielleicht wird es nie eine Pagode, aber die Nacht vergeht.

Irgendwo klöppelt es auf Blech.

Wackelig wird es immer beim vierten Stockwerk; ein Zittern der
Hand, wenn das nächste Knäckebrot angelehnt werden soll, oder ein
Husten, nachdem der Giebel eigentlich schon steht, und alles ist wieder
eingestürzt—

Herr Geiser hat Zeit. (9)

With these opening blocks of text Frisch elegantly sets up the prob-
lem of the whole story. Faced with a storm and its inundation of
the valley where he lives, Geiser, alone, attempts to build a struc-
ture that will hold up against the elements. Because to "build a house
has always been a gesture of resistance against nature," as Walter
Obschlager, one of the most insightful commentators of this late
story, writes, Geiser's construction of a pagoda out of crispbread
becomes "a symbolic act with which he counters nature's invasion
with a deed that evokes civilization and technology."[7] This effort,
however, seems to be in vain. For like the engineer Walter Faber in
Frisch's 1957 novel *Homo Faber*, Geiser finds the forces of nature
are not so easily kept at bay. Even this crispbread model of a build-
ing keeps foundering—"the whole thing collapses"—so that, as we
are told in the emotionless, though still ironic, tone of Frisch's nar-
rated monologue, "It is midnight, but still no pagoda" (4; Es ist
keine Pagode geworden, aber Mitternacht, 10). That sentiment of
defeat—especially in the face of a ticking clock—follows our soli-
tary protagonist through the whole book. Although at the start
Geiser may think he "has time to spare," near the end of the story,
time having run out, he expresses what appears to be total resigna-
tion: "There will never be a pagoda—" (106; 137).[8]

This final resignation with respect to the pagoda, however, has
less to do with a lack of trust in the architectural structure as such
than with a distrust of the kind of protection that a specifically re-

7. Walter Obschlager, "Man, Culture, and Nature in Max Frisch's *Der Mensch
erscheint im Holozän*," in *A Companion to the Works of Max Frisch*, ed. Olaf
Berwald (Rochester, NY: Camden House, 2013), 201.
8. For a detailed discussion of the pagoda in this story (and in relation to
Frisch's work as a whole), see Gertrud Bauer Pickar, "'Es wird nie eine Pagode': Max
Frisch's *Der Mensch erscheint im Holozän*," *Seminar* 19, no. 1 (1983): 33–56.

ligious building is meant to offer. A man of facts and figures, Geiser places little hope in the spiritual realm. Thus, when near the story's end he remarks, "This once caused the collapse of a church" (95; So ist einmal eine Kirche eingestürzt, 123), we are meant to hear an echo of the earlier collapse of the pagoda. Neither an eastern nor a western house of worship can be counted on for protection: both lack integrity, structural and spiritual. Geiser worries that his house, not to mention the structures of support in his village, such as its retaining walls, are similarly compromised. When the next "collapse" occurs on his own property—"A little wall in the lower garden (dry-stone) has collapsed [*eingestürzt*]" (7; 14)—he finds his fears confirmed, despite the fact that the crumbling of this most pedestrian structure poses no significant threat.[9] Nonetheless, by way of the repeated word *eingestürzt*, Geiser aligns this garden wall with the toppling pagoda as an example of architectural failure that is, he insists, foreboding. Both structures also appear to be the handiwork of the same individual: "The collapse [*Einsturz*] of a little drystone wall, built with his own hands by a pensioner who has spent his life doing other things" (13; 22). What Geiser builds apparently does not endure. It seems bound to fall, much like Geiser himself, who also "collapses" near the story's end. Whether he "fell down the stairs" (92; *herunter*gestürzt, 119; my emphasis) or from a chair (94; *gestürzt*, 121), he does not remember. In any event, his "collapse" recalls that of the self-constructed crispbread pagoda and the garden wall, exposing the degree to which the septuagenarian cannot rely on support of any kind, be it religious, architectural, or even bodily. He is beset by frailty all around him.

Geiser's attempts to compensate for these frailties in all three interrelated areas—religion, architecture, and the body—constitute the thematic and narrative core of the story. As we will see, his undertaking emerges as a kind of Noachian salvage that has a redemptive dimension. This aspect of the story, however, is anchored in concerns for shelter and the deterioration of the body. And although this

9. The results of its collapse are "debris among the lettuces" (7; 14), not all that catastrophic, though it bothers Geiser enough that he goes to inspect it (12–13; 21) and thinks of it again on two occasions later in the narrative (94, 122; 106, 138).

deterioration culminates in physical collapse, it manifests itself primarily as a decline of cognitive powers. Thus, even though the actual architectural structures in the book—from the valley's critical retaining walls to the bridges over the ravines to the house itself—ostensibly serve as Geiser's protection against inclement weather and its attendant flooding and mudslides, they also belong to a network of motifs expressing the struggle to prevent the erosion of his own mind. It is not only the actual earth around him that is slipping out from under his feet (or so he imagines); his cognitive grounding is falling away, too.

His worries about collapsing walls reflect a concern for maintaining his own lucidity of mind, in particular his ability to remember. Geiser expresses this trepidation early on, though at first only conditionally: "What would be bad would be losing one's memory—" (6; 13).[10] How bad this loss would be becomes clear in the subsequent observation that without memory there can be no real knowledge (6; 14). And although he ultimately questions the value and purpose of the knowledge he gathers—"Now and again Geiser finds himself wondering what he really wants to know, what he hopes to gain from all this knowledge" (90; 117)—it is clear that it is essential to his self-preservation, the desire to protect himself in the face of the elements, to prevent himself from being washed away in the flood. To hold on to what knowledge he can is to hold on to what makes him human, a task made more difficult by the hour.[11] At first Geiser considers the loss of memory only as a possibility ("would be"), but he soon begins to experience its real effects. "One is becoming stupid—!" he remarks after realizing that, although the electricity went out, he need not have donated his refrigerated perishables because

10. Walter Obschlager argues that it remains ambiguous whether this statement is conveyed by the narrator or is a presentation of Geiser's thoughts. Obschlager, "Man, Culture, and Nature," 205. I see little evidence that the story ever leaves Geiser's perspective (with the possible exception of the ending—more on that later) and read this passage as a narrated monologue (*erlebte Rede*).
11. Along these lines, Obschlager argues that the repeated quotation on metamorphosis (34, 74) reveals Geiser's "diffuse and latent fear of losing the quality that distinguishes him from mere nature, the world of animals, plants, and minerals." Obschlager, "Man, Culture, and Nature," 204.

he could have used the fireplace to cook them (24; 34). Before too long the *Brockhaus* entry on "Weakness of memory" appears (39; 53), letting us know that Geiser is well aware of his problem. Soon after, we read how he keeps forgetting things ("One always forgets something" [56; 75]), such as why he has cut out pictures of dinosaurs and amphibians (95; 122–123) or why he is wearing a hat (56; 74). Walter Obschlager points to the repetition of one of the notes (24 and again 55–56; 35 and 74) as a possible indication that "the diligent note-taker has lost oversight over the snippets of knowledge that he is collecting on his wall."[12] Such evidence confirms what Geiser has already observed about himself, which is that he is unable to keep track of his cuttings, repeatedly forgetting "what he so carefully cut out an hour ago" (38; 51). The irony of this failure to recall is that these cuttings are precisely the means that Geiser uses to compensate for his fading memory. They are his tools for keeping track of number-based facts, maintaining oversight of large swaths of history and prehistory, and holding on to esoteric pieces of knowledge.

What ends up becoming his wall of notes initially takes shape as an extension of the reading process: it is figured as a mining of information, the extraction and storage of facts from a variety of printed works. To gather, sort, and preserve these facts requires more than locating and marking them in these books, where they would still be fixed in place and where they would still need to be retrieved. Thus, Geiser begins to copy out what is "worth knowing" from his small collection of books:

> It is not enough for Geiser to draw a line with his ballpoint pen against passages in this book or that worth knowing; within an hour his memory of them has become hazy; names and dates in particular refuse to stick [*prägen sich nicht ein*]; the things he does not wish to forget Geiser must write down in his own hand on pieces of paper [*Zettel*], which he must then affix to the wall. There are thumbtacks enough in the house. (19; translation modified)

> Es genügt nicht, daß Herr Geiser in diesem oder jenem Buch mit seinem Kugelschreiber anstreicht, was wissenswert ist; schon eine Stunde später

12. Obschlager, "Man, Culture, and Nature," 204. Note that in the English version of the story the translator appears to have combined two separate notes on p. 24.

> erinnert man sich nur noch ungenau; vor allem Namen und Daten prä-
> gen sich nicht ein; Herr Geiser muß es eigenhändig auf einen Zettel
> schreiben, was er nicht vergessen will, und die Zettel an die Wand
> heften, Reißnägel sind genug im Haus. (28)

This method of reading by creating paper slips depends not so much, as it may at first appear, on mere duplication. It is not the act of writing out that helps Geiser hold on to the information he has gleaned from his books but rather its transformation into the concrete and graspable, as the language of leaving an impression (*einprägen*) suggests. Critical to his mnemonic strategy is the tangible product of this writing out, which he can collect together with other paper notes, sorting, arranging, and displaying them on the wall. In the interest of convenience and speed, he soon stops copying out sections from his books by hand and begins cutting them out with scissors:

> It is idiotic to write out in one's own hand (in the evenings by candle-
> light) things already in print. Why not use scissors to cut out items that
> are worth knowing and deserve a place on the wall? Geiser is surprised
> that he did not think of this before. There are scissors in the house; all
> he has to do is find them. (35; translation modified)

> Was schon gedruckt ist, nochmals abzuschreiben mit eigener Hand
> (abends bei Kerzenlicht), ist idiotisch. Warum nicht mit der Schere aus-
> schneiden, was wissenswert ist und an die Wand gehört? Herr Geiser
> wundert sich, daß er nicht eher auf die Idee gekommen ist. Eine Schere
> ist im Haus; Herr Geiser muß sie nur noch finden. (48)

By way of this increased efficiency, the number of *Zettel* soon increases (37; 50); on the wall are attached passages excised from books with scissors alongside older and newer handwritten notes, which Geiser continues to produce when he wants to remember something not found in his library: "Sometimes Geiser writes notes [*Zettel*] on things he believes he knows, without consulting an encyclopedia, things that also deserve a place on the wall, so that he will not forget them" (39; 53).

This explanation for why the septuagenarian constructs a wall of notes, coming as it does immediately after the *Brockhaus* entry on "Weakness of memory," brings home the practical purpose of

his odd undertaking. Because his mind is incapable of securely stor-
ing what he considers "worth knowing," he must somehow cobble
together a surrogate memory bank. In affixing these various *Zettel*—
neither too high nor too low but just at eye level (38; 51)—to the
inner side of the exterior wall of his home, Geiser not only makes
knowledge more easily accessible, providing a practical "overview"
or "overall review" (38; *Übersicht*, 51) of what he deems impor-
tant and of what he is otherwise unable to remember; he also thereby
externalizes his memory in a concrete and configurable way. The
wall allows him to sort and organize this same knowledge, as well
as store it, so that the interior vertical surface of the home's struc-
tural foundation becomes both the site and the medium of a more
complex mode of collecting. In situating, securing, classifying, and
ordering this knowledge as in a kind of two-dimensional card cata-
log, each entry on a slip of paper assumes a visible place in relation
to the others that also changes with the (ongoing) addition of more
notes. Architecture has long been a paradigm for memory; here it
is the site of its literal manifestation, and it joins with another mne-
monic model, collecting, to form both an actual tool and a power-
ful figure for modular and maintainable memory erected in the face
of the mind's gradual disintegration.[13]

Collecting becomes the method for—and thus determines the
logic of—this mnemonic practice. And yet, although it is true that,
as Benjamin writes in *The Arcades Project*, "collecting is a form of
practical memory," Geiser's project of writing and cutting out *Zettel*
is not exactly aimed at recollecting some preexisting constellation of
knowledge.[14] His collage does not reconstruct—nor is it meant to
reconstruct—a unified memory of the past. The recollection that
motivates the project is instead future oriented and anticipated.[15] In
other words, Geiser's wall of notes and cutouts serves as a practical

13. The classic text on architecture and memory remains Frances Yates, *The Art of Memory* (1966; repr., Chicago: University of Chicago Press, 2001).

14. Benjamin, *Arcades Project*, 205; *Gesammelte Schriften* 5:271. Cf. Walter Benjamin, "Unpacking My Library: A Talk about Collecting," in *Selected Writings*, 2:487; *Gesammelte Schriften*, 4:388.

15. Susan Stewart links anticipation to the collection specifically via the figure of Noah, whose "ark is a world not of nostalgia but of anticipation." Stewart, *On*

tool for what he wishes to remember later, for what he wants to be able easily to re-collect. The wall thus becomes a kind of prosthetic extension of his mind: a collage of collected knowledge in front of which he can orient himself cognitively and mnemonically at any future point.[16] But because it is unclear to what, if anything, this collected knowledge as a whole is supposed to lead, and because the pieces of paper become objects of fascination and attention themselves, without any care for the sources of the facts and figures they contain, the aging man fits the profile of what Benjamin calls the "brooder" (*Grübler*)—that melancholic thinker plagued by forgetting who continually seeks and continually fails to reestablish a connection with the thoughts and ideas he once had. The brooder never succeeds in recuperating what he has forgotten because he can only contemplate his prior contemplation of the lost idea.[17] Thus trapped in a self-reflective loop, he grasps at dead knowledge in a futile attempt to create order and meaning. "The brooder's memory [*Erinnerung*] ranges over the disordered mass of dead knowledge," Benjamin writes, though this distinctly "human knowledge" is, as Benjamin stresses, "a *patchwork*—in an especially

Longing, 152. Later in the chapter I draw out the consequences of the shift in temporality that Stewart theorizes.

16. On the relation between the wall collage and memory (a common topic in the literature on this text), see Sonja Arnold, *Erzählte Erinnerung: Das autobiographische Gedächtnis im Prosawerk Max Frischs* (Freiburg im Breisgau: Rombach Verlag, 2012). Arnold reads the wall of *Zettel* as a form of bricolage (294–298). On the collage in this work as a means to express what exceeds language and its relation to memory, see Geert Crauwels, "Über die sprachlose Sprache: Modi memoranda und Collage als Kompositionstechnik in *Der Mensch erscheint im Holozän*," in *Max Frisch: Citoyen und Poet*, ed. Daniel de Vin (Göttingen: Wallstein Verlag, 2011), 106–199. Another discussion of the text with a focus on the collage can be found in Robert Cohen, "Zumutungen der Spätmoderne: Max Frischs 'Der Mensch erscheint im Holozän,'" *Weimarer Beiträge 54*, no. 4 (2008): 541–556.

17. "What fundamentally distinguishes the brooder from the thinker is that the former not only meditates a thing but also meditates his meditation of the thing [*nicht einer Sache allein sondern seinem Sinnen über sie nachsinnt*]. The case of the brooder is that of the man who has arrived at the solution of a great problem but then has forgotten it. And now he broods—not so much over the matter itself as over his past reflections on it. The brooder's thinking, therefore, bears the imprint of memory. Brooder and allegorist are cut from the same cloth." Benjamin, *Arcades Project*, 367; *Gesammelte Schriften*, 5:465.

pregnant sense: it is like the jumble of arbitrarily *cut-up pieces* from which a puzzle is assembled" (*Stückwerk* in einem besonders prägnanten Sinn: nämlich wie der Haufen willkürlich *geschnittener Stücke*, aus denen man ein puzzle zusammensetzt).[18] The collage of *Zettel* on Geiser's wall resembles precisely such a "patchwork," comprised of "*cut-up* pieces" with no possible correct configuration: there is no way to (re)assemble the whole or complete the "puzzle." The septuagenarian fails not just because no complete picture emerges but also simply because his task remains incomplete. Near the story's end there still remains "a lot to be done" (94; 122): "Lying on the table are . . . various bits of paper [*Zettel*], scraps of print that Geiser had cut out but not yet stuck to the wall" (94; 121–122). He will not have the chance to affix these remaining pieces to the wall. Ultimately, they along with many of the already attached notes end up scattered across the floor in an image of uncollected, meaningless disjecta: "The slips of paper [*Zettel*] are lying on the floor, a confused heap that makes no sense [*keinen Sinn gibt*]" (106; 137).

We can see why Benjamin also aligns the helpless brooder with the allegorist, that figure doomed to create assemblages out of the fragments of history and knowledge and to seek meaning in what will never correspond to a coherent picture of the world: "The brooder, whose startled gaze falls on the fragment in his hand, becomes an allegorist."[19] Consider how the following image of the allegorist, which follows Benjamin's discussion of the brooder, resonates with Frisch's story:

> Through the disorderly fund which his knowledge places at his disposal, the allegorist rummages here and there for a particular piece, holds it next to some other piece, and tests to see if they fit together—that meaning with this image or this image with that meaning. The result can never be known beforehand, for there is no natural mediation between the two.[20]

18. Benjamin, *Arcades Project*, 368 (translation modified); *Gesammelte Schriften*, 5:466. My emphasis. Compare Benjamin's description of the collection as a "patchwork." Benjamin, *Arcades Project*, 211; *Gesammelte Schriften*, 5:279.
19. Benjamin, *Arcades Project*, 324; *Gesammelte Schriften*, 5:408.
20. Benjamin, *Arcades Project*, 368.

> Der Allegoriker greift bald da bald dort aus dem wüsten Fundus, den
> sein Wissen ihm zur Verfügung stellt, ein Stück heraus, hält es neben ein
> anderes und versucht, ob sie zu einander passen: jene Bedeutung zu die-
> sem Bild oder dieses Bild zu jener Bedeutung. Vorhersagen läßt das Ergeb-
> nis sich nie; denn es gibt keine natürliche Vermittelung zwischen den
> beiden.[21]

This description applies equally well to Geiser, whose collection of
Zettel, although it aims to establish coherence, only seems to repre-
sent a jumble of words, facts, and images, the proper configuration
of which remains elusive. From this passage, too, we see why Ben-
jamin conceives of the collector as a kind of allegorist for whom
the whole or complete collection is—and must remain—an impos-
sibility, despite the fact that the collector is driven by the desire for
wholeness and unity. If "human knowledge" itself is a "patchwork"
comprising a "jumble of arbitrarily cut-up pieces," it would falsify
the world as we know it to construct from them a seamlessly com-
plete puzzle in which those pieces disappear for the sake of the
whole. Every collection must thus only ever appear as something
piecemeal—an allegorically fragmented assemblage.

Such a "patchwork" is the form not only of Geiser's wall but
also of the book as a whole: its textual and graphic design ap-
proximates his collage-like constellation of paper notes. Frisch be-
gins the work with a sequence of un-indented prose segments that
are aphoristic in nature and length and that convey in narrated
monologue Geiser's thoughts and activities without any signpost-
ing from a heterodiegetic narrator. Lacking any transitional pas-
sages and consistently separated by an entire empty line, these text
blocks form a sequence that is causally weak and highly elliptical,
a mere concatenation of discrete observations or fragments of
thought ordered temporally. Eight pages in, these blocks of text
begin to alternate with facsimile excerpts from the books Geiser
consults (see figure 3) along with images of the notes he begins to
write on graph paper (see figure 4). At first the reproductions of
pages from books appear only to present to the reader the precise
text Geiser wants to remember, perhaps what he underlines (19;

21. Benjamin, *Gesammelte Schriften*, 5:466.

nächsten Tanne, so ist keine Stille, im Gegenteil, jetzt erst hört man es rauschen aus dem Tal; es müssen Bäche sein überall, viele Bäche, die es sonst nicht gibt. Ein stetes Rauschen aus dem ganzen Tal.

<div style="text-align:center">

Die Schöpfung der Welt
(Hiob 38; Ps. 33, 6–9; Ps. 104; Spr. 8, 22–31)

</div>

IM Anfang schuf Gott den Himmel und die Erde. 2 Die Erde war aber wüst und öde, und Finsternis lag auf der Urflut, und der Geist Gottes schwebte über den Wassern.

Ob es Gott gibt, wenn es einmal kein menschliches Hirn mehr gibt, das sich eine Schöpfung ohne Schöpfer nicht denken kann, fragt sich Herr Geiser.

Heute ist Mittwoch.

(Oder Donnerstag?)

Eine Bibliothek kann man es nicht nennen, was Herrn Geiser in diesen Tagen, da Gartenarbeit nicht möglich ist, zur Verfügung steht; Elsbeth hat hauptsächlich Romane gelesen, klassische und andere, Herr Geiser lieber Sachbücher (HELLER ALS TAUSEND SONNEN); das Logbuch von Robert Scott, der am Südpol erfroren ist,

17

$1/2 \ AB = BC = CD$
$AE = AD$
$EB : AE = AE : AB \ !$

Der kleine Rutsch im Garten (Geröll im Salat) hat sich über Nacht nicht vergrößert. Auch ist es, soweit Herr Geiser im Morgengrauen sehen kann, zu keinem neuen Rutschen gekommen, zumindest nicht auf seinem Gelände. Der graue Lehm unter den Tomaten, die noch bleich sind, klebt mit zähen Klumpen am Spaten. Auch wenn Herr Geiser es ohne Spaten versucht, wenn er kniet und mit seinen Händen das Geröll entfernt aus dem grünen Salat, so oder so ist der Salat kaputt, und die kleine Mauer wieder in Ordnung zu bringen, dazu ist es nicht die Stunde. Das wird eine Arbeit von Tagen. Schon nach einer Stunde ist man platschnaß trotz Regenmantel und Hut.

Ein Helikopter ist nicht zu hören.

21

Figure 3. Scan of p. 17 from Frisch's *Der Mensch erscheint im Holozän.*

Figure 4. Scan of p. 21 from Frisch's *Der Mensch erscheint im Holozän.*

28). But as soon as he begins removing sections from these books with scissors (35; 48), it becomes clear that these facsimiles are supposed to make the cuttings *as material paper objects*—in other words, as maculature—visible on the page.[22] Collected and situated together on the page, however, the juxtaposition of typeset text blocks, images of handwritten notes, and facsimiles of book clippings, the last of which include both text and pictures, begins to resemble on a further mimetic level the "patchwork" assemblage

22. Frisch intended this effect, as is confirmed in a letter to Elisabeth Borchers from January 9, 1978: "It also seems important to me that the wall of notes [*die Zettelwand*] that emerges is not just mentioned, but that it becomes visible . . . which is why the quotations must also appear in facsimile, as senory material." Quoted in Arnold, *Erzählte Erinnerung*, 292.

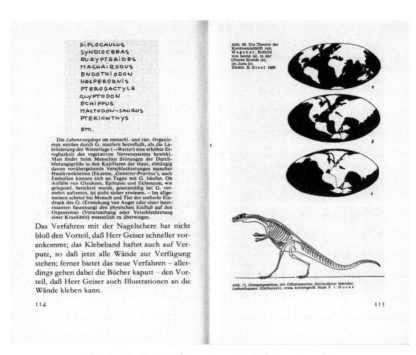

Figure 5. Scan of pp. 114–115 from Frisch's
Der Mensch erscheint im Holozän.

that the isolated and fearful Geiser creates on his wall (see figure 5).[23]
In an arrangement that emphasizes materiality as much as mean-
ing, therefore, Frisch's book graphically, formally, and textually pre-
sents the scraps of paper and scraps of knowledge accumulated,
arranged, and arrayed by the worried man as he anxiously antici-
pates the worsening erosion.

23. For Crauwels, the excerpts and quotations presented on the page as fac-
similes have been removed from their original spheres of intended use and, much
like the *ready-made*, are "deautomized." This of course describes the logic of col-
lecting, though Crauwels does not appeal to that concept. Crauwels, "Über die
sprachlose Sprache," 117.

Risse: Patching the Cracks

The erosion of the mind that this patchwork is ostensibly in the service of remedying parallels the erosion of the landscape and the threat that the mudslides and flooding pose to the architectural integrity of Geiser's home. Although he expresses doubt about the seriousness of this threat at the beginning of the story—"Nobody in the village thinks that the day, or perhaps the night, will come when the whole mountain could begin to slide, burying the village for all time" (4; 10)—it sounds more like a weak and ultimately unsuccessful attempt to reassure himself that what he fears will happen is not inevitable. The histories of the region Geiser consults tell a different story from those heard in the village. Erosion, it turns out, has been a common geological occurrence in the valley all the way back to prehistory and has by no means subsided entirely. One history of Ticino, for instance, details flooding and avalanches from the previous century that resulted in human casualties (14; 23). And although the mason in the village does not believe the mountain will ever begin to slide (22; 33), Geiser cannot stop thinking about the possibility and soon takes it as a given, even if no one else seems to be worried about it: "The youngsters are loud in their enjoyment; the erosion going on outside does not worry them in the least" (31; 44).

His principal concern is that the architectural structures of the valley will not hold against erosion and landslides. Geiser consequently goes looking for evidence of "cracks" outside in the asphalt and exterior retaining walls and, later, in the interior walls of his own house. It seems at first that such evidence is missing. He finds "no cracks [*Risse*] in the asphalt," which initially "comforts" him (29; 40). The visible fissure in the nearby cliffs is not, Geiser ascertains, a result of the recent weather—"A huge crack [*Riß*] in the cliff behind the village . . . is from neither yesterday nor today"—but rather dates from much farther back. It is "a crack [*Riß*] from gray, prehistoric ages" (33; 46). Geiser subsequently spends an hour looking through his binoculars for evidence of a newer fissure in the cliffs that could lead to rock- or landslides and finds "no new crack [*Spalt*]" (34; 47). None of this fully comforts him. "One must be prepared for everything" (33; 45), he

maintains; anyway, he cannot rely on the technology with which he observes the environment: "Even field glasses can deceive" (33; 46).

As we will see, Geiser is later similarly deceived by what he thinks he discovers inside his home. In the end, whether he can trust his own eyes (with or without the assistance of binoculars) hardly matters. His worry about erosion expresses less a real concern about environmental catastrophe than it does an individual, existential fear of death, imagined as a form of interment via landslide. For if the earth begins to slide in vast amounts, he could be buried alive (4 and 34; *verschüttet*, 10 and 47). Cracks thus appear to be everywhere, even when they are only anticipated or imagined:

> More serious than the collapse of a dry-stone wall would be a crack across the grounds, a narrow crack at first, no broader than a hand, but a crack—
>
> (That is the way landslides begin, cracks appearing noiselessly, not widening, or hardly at all, for weeks on end, until suddenly, when one is least expecting it, the whole slope below the crack begins to slide, carrying even forests and all else that is not firm rock down with it.) (32–33; translation modified)
>
> Bedenklicher als der Einsturz einer Trockenmauer wäre ein Riß durchs Gelände, ein vorerst schmaler Riß, handbreit, aber ein Riß—
>
> (So fangen Erdrutsche an, wobei solche Risse lautlos entstehen und sich Wochen lang nicht erweitern oder kaum, bis plötzlich, wenn man nichts erwartet, der ganze Hang unterhalb des Risses rutscht und auch Wälder mit sich reißt und alles, was nicht Grundfels ist.) (45)

Here the parenthetical description of how cracks can lead to landslides emerges visually out of the word "Riß" itself. What at first is only a "narrow crack" becomes "no broader than a hand" before splitting the text open, cutting off the sentence, and graphically announcing itself in the widening fissure of the parentheses. Frisch even gestures toward the "narrow crack" with the dash that breaks off the first text block, a punctuation mark that here stands in for the tiny rift before it expands into the dilating curved brackets of the next block of text. The description of landslides caused by cracks in the hillside that we find in this textual gap seems to indicate a further level of graphic mimesis whereby the string of words that

fill up the parentheses, like Gotthelf's written words, assume the place of earth and dirt. The cracks, however, persist, both as triggers of Geiser's anxiety and as textual symbols, although it becomes clear from here on out that they are no longer marked with the aid of graphemes or punctuation but rather appear as the actual gaps on the page. Because Frisch's peculiar paragraphing requires an empty line between each text block, the impression left on the reader is that the whole book is constituted not so much by a sequence of differently sized segments of text as by a series of cracks.

Walter Obschlager has shown that the motif of the fissure or crack (*Riss*) in Frisch's work can be traced all the way to his earliest writings in the 1930s, where we already see the soon-to-be student of architecture cultivating an "eye for cracks [*Risse*]."[24] Before too long, Frisch would become a practicing architect, working in this capacity until his literary career took off in the 1950s. Yet it is clear from an autobiographical piece published in 1938, for instance, that as a child he was already deeply concerned with the structural integrity of buildings. In this early text, which was not included in any editions of Frisch's work published during his lifetime (or since) and was only rediscovered and republished after his death, we read about how as a child he noticed a crack in the wall of his home. His mother blithely tells him it will get bigger with time, which instills in him a panic bordering on existential dread:

> I must have stared at the small defect for a long time and perhaps thought, what it would mean if the crack would get ever larger. With every hour and minute that ticks by, a tiny bit larger. It was an unsettling thought that evidently didn't leave me so fast. In any event, even today the child-like image sticks with me, how ultimately the whole wall of the house, like a large piece of cardboard, would end up falling down to the street; how our cozy room—it was at the time the first and only one in my young life, hence the epitome of the parental home—would suddenly be exposed to all winds and every stranger's stares. It was, even though still very small, the first crack through the world in which I had up to

24. Walter Obschlager, "Risse: Kleiner Versuch, einer Spur im Werk Max Frischs nachzugehen," in *Leben gefällt mir: Begegnungen mit Max Frisch*, ed. Daniel de Vin (Brussels: Literarischer Treffpunkt, 1992), 51–57. "Blick für die Risse" on 54. For another reading of this motif in Frisch and in *Man in the Holocene* in particular, with emphasis on questions of identity, see Arnold, *Erzählte Erinnerung*, 298–314.

then felt extremely safe, totally protected and secure, fully without doubts, and yet a crack that continually—as my mother, after all, had said, while knitting—would become larger and larger . . .

But who can know if I really experienced it that way back then, as a boy? I only know that when I think of it today, this crack goes through the whole world, through everything that I feel, everything that I think, everything that I attempt to do.

Ich starrte wohl den kleinen Schaden noch lange an und dachte vielleicht, was das hieße, wenn der Riß immer größer würde. Mit jeder Stunde und Minute, die da tickt, ein ganz wenig größer. Es war ein aufregender Gedanke, der mich offenbar so rasch nicht verließ. Jedenfalls haftet mir noch heute die kindliche Vorstellung, wie schließlich die ganze Hauswand, gleichsam wie ein großer Karton, einmal auf die Straße hinausfallen müßte; wie unsere gemütliche Stube, es war damals die erste und einzige in meinem jungen Leben, somit der Inbegriff des elterlichen Heimes, plötzlich allen fremden Blicken und allen Winden offen wäre. Es war, wenn auch noch ganz klein, der erste Riß durch eine Welt, wo man sich bisher ganz sicher, ganz aufgehoben und geborgen, ganz zweifellos gefühlt hatte, und zwar ein Riß, der immer, wie meine strickende Mutter doch gesagt hatte, größer und größer würde . . .

Aber wer kann wissen, ob ich es damals, als Bub, wirklich so empfunden hatte? Ich weiß nur, daß heute, wo ich mich erinnere, dieser Riß durch die ganze Welt geht; durch alles, was ich empfinde, was ich denke, was ich versuche.[25]

The home here functions as more than a familial place or architectural structure that offers the young Frisch safety and protection: it holds together his sense of the world. A fissure in one of its walls could lead not just to his house collapsing, which would leave him exposed to the harsh elements and the penetrating gazes of strangers, but also to his world being torn apart. As with the cracks Geiser anticipates, this crack in Frisch's childhood house is initially small before it slowly expands "larger and larger," ultimately swallowing up not only the home but also, potentially, everything else. That the crack precipitating this apocalyptic scenario originates within the home is critical: the threat comes not from outside but from the very space that is supposed to be a shelter from that outside. The home is

the space that makes the young Frisch feel "extremely safe, totally protected and secure"; it is the space that thereby guarantees the stability and reliability of the world outside. What is most familiar, then, becomes the site of potential collapse. The crack in the wall in this early text thus manifests a version of the uncanny. Indeed, one way to parse *das Unheimliche* is as the "un-home-ly," that gap in the otherwise familiar that undoes whatever intimacy and protection the home as the most familiar of places supposedly grants us.

The "cracks" that so worry Geiser represent a return of this fear that the world could end by splitting apart from within. Like the young Frisch, the septuagenarian is most concerned with those cracks that would threaten the architectural integrity of his own home:

> A crack in the plaster, fine as a hair, which was not there yesterday—that could spell trouble, as could a crack in the floor tiles in the kitchen; this could mean, not that the whole slope is about to slide, but that the house might no longer be able to withstand the pressure of the water coming down the slope.
>
> (This once caused the collapse of a church.) (95)

> Bedenklich wäre ein Riß im Verputz, ein haarfeiner Riß, den es gestern noch nicht gegeben hat, oder ein Riß in den Platten des Küchenbodens; das könnte bedeuten, daß zwar nicht der ganze Hang herunter kommt, daß aber das Haus langsam dem Druck des Hangwassers nicht mehr standhält.
>
> (so ist einmal eine Kirche eingestürzt). (123)

Any cracks in the foundation or walls would be truly alarming; they would be portents of collapse. The church mentioned here reminds us of both the collapsed pagoda from the book's beginning and the collapsed garden wall. (Like the text block beginning "That is the way landslides begin" discussed earlier, this short block also gestures toward a small opening by way of its parentheses.) Yet it is not entirely clear that cracks of any kind exist at all in or around Geiser's home. The crack that appears in the ground outside ends up being a trace in the high grass left by his cat (33; 46). The crack from the day before turns out to be a piece of string (95; 123). As with his apparent misrecognition of a rift in the hillside, Geiser's weakened perception exacerbates the search for signs of architectural instability. The

autobiographical anecdote about Frisch's childhood fear, however, puts this motif into perspective as an expression of a larger worry about finding horror in the familiar, about the possibility of losing that which guarantees order, structure, and coherence in life as such.

Geiser treats this possibility as an inevitability and makes the necessary preparations. His collection of *Zettel* must be seen in this context as attempts to prevent the cracks from widening to the point where his home becomes unlivable, either by being inundated by the water that could enter through these openings or by simply no longer being able to stand. The home as architectural structure, however, assumes multiple roles in the symbolic and narrative economy of Frisch's story. It is not just—or even primarily—the physical construction that keeps Geiser protected from the elements; it also represents the space of order and familiarity that guarantees both meaning and, as we have seen, memory. The *Zettel* collected and displayed on the wall thus double as structural reinforcements: they are the patches over the cracks that are in danger of widening. As such they serve to hold together both home and mind, each of which is on the verge of cracking open and crumbling apart.[26] The dictionary entry for "coherent" (108; 140), which directly follows entries on "erosion" and "eschatology," brings these thematic strands together, establishing a counterpoint to the mental, architectural, and environmental erosions of the story in its definition: "holding together" (*zusammenhängend*).[27] Geiser's patchwork collection aims to create "coherence" by "holding together" what is eroding, splitting open, collapsing. His *Zettel* constitute a bulwark against the cracks all around him. In this way, Frisch's story aligns the fate of an aging individual, who is on the verge of physical and mental collapse, with that of the world itself, under duress from environmental and anthropogenic assault.[28] It intertwines the "final fate of the individual human being and of the world" (108; 139), as the encyclopedia entry on eschatology puts it, positioning

26. Walter Obschlager suggests they constitute "a kind of magical circle" that keeps a space ritually protected. Obschlager, "Man, Culture, and Nature," 203. Also in Obschlager, "Risse," 55.

27. Translation modified.

28. See Bernhard Malkmus, "'Man in the Anthropocene': Max Frisch's Environmental History," *PMLA* 132, no. 1 (2017): 71–85.

Geiser's paper-plastered wall as an effort to stay the immanent rupture
of the protective structures around him, to create a patchwork that
will "hold together" his world. That this holding together involves
both the activities of bringing together and of reading—in other
words, modes of *col-lecting* (*legere* = "to read" + *col* = "together")—
places him in the role of prophet who not only divines the coming
catastrophe but also takes steps to salvage things from it.

Verzetteln: Collecting as Noachian Salvage

As collector and salvager, especially in the face of catastrophic flood-
ing, Geiser thus ultimately emerges as a Noah figure. Frisch is not
subtle in establishing this parallel. A key passage from the biblical
Noah story is among the first of the book's facsimile cutouts (16;
25–26). And yet the verses we read here (Genesis 7:17–24) tell only
of the flooding and its destruction, not of Noah's gathering of ani-
mals or his construction of the ark (which are described in the pre-
ceding verses, Genesis 6:9–7:16). Although Geiser claims not to be-
lieve in the biblical Flood (16; 26), he is deeply concerned about the
inundation of his valley and at one point, after noting how in the
moonlight the fog can make the valley look like it is underwater, even
notes, "All it would need is a ship lying at anchor below the village"
(50; 67). It seems he lacks more than just an ark, however. There is no
sign that he is engaged in gathering any animals to take with him on
this (nonexistent) vessel. The text nonetheless conspicuously abounds
in nonhuman creatures of all kinds. In Geiser's local ecosphere, we
learn of the existence (outside the house) of gnats, owls, various kinds
of snakes, marmots, sheep, goats, lizards, chickens, woodpeckers,
dogs, ants, cows, butterflies, bees, and flies, not to mention (inside the
house) Geiser's cat, as well as the fire salamander that he finds in his
bathtub and the one he finds on the rug. We even learn that bears,
wild boars, foxes, and wolves are rare or simply no longer sighted.
The old man by no means rescues these creatures; in fact, he ends up
killing and roasting the cat and throwing one of the salamanders into
the fire and the other into the garden. Still, quite a few animals make
it into Geiser's collection of *Zettel* and onto the wall. Information

about dinosaurs of various kinds and amphibians (salamanders and newts) becomes prominent in his patchwork of notes. We get, for instance, a handwritten list of dinosaur species (86–87; 113–114) followed by seven encyclopedia cutouts on dinosaurs spread out over five pages (88–92; 115–119), complete with illustrations (see figure 5 for pp. 114–115). An ichthyosaurus skeleton is also pictured earlier (65; 85), as is a facsimile of the definition of "plesiosaurs" (65; 84), which follows two substantial excerpts on "The Era of the Dinosaurs" and one of Geiser's handwritten notes with an etymological breakdown of the word "dinosaur" (63–64; 83–84). These come almost immediately after four cutouts on amphibians (61–62; 81–82), one of which pictures the skeleton of a Micropholis stowi, an extinct species from the early mid-Triassic period.

Amphibians, of course, would be able to endure flooding better than most of the other animals, which might explain Geiser's fascination with them and especially with the fire salamander in his bathtub, the only living creature in which he shows any real interest (he even observes it with a magnifying glass [61; 81]). That animal's ability to survive on land, in water, and (mythically, at least) in fire makes it uniquely immune to various natural catastrophes. The only element the salamander is not the master of is air. It is the bird that survives and thrives in this, the fourth element (ether). Birds are thus also mostly protected from the threat posed by a flood, although they are specifically listed among the creatures Noah collects (Genesis 6:20 and 7:3). In the biblical story, the appearance of a bird also represents the end of the Flood, as Noah sends out a dove to find dry land (Genesis 8:8–8:13). It is for that reason, perhaps, that the last word in *Man in the Holocene* designates a bird: "a little owl" (111; *Käuzchen*, 143). Birds along with ants (which feature prominently in the story) are also creatures that engage in the activity of collecting. Benjamin includes both in a short list of collector types in his *Arcades Project*. This list notably also features the figure of the old man: "animals (birds, ants), children, and old men [*Greise*] as collectors."[29] Another

29. Benjamin, *Arcades Project*, 211; *Gesammelte Schriften*, 5:280. Much has been said about Geiser's name (see Malkmus, "'Man in the Anthropocene,'" 75), but it is worth noting that *Geiser* is in fact an anagram of "old men" (*Greise*).

animal known for collecting, the hamster, appears in Frisch's text only in the form of the idiomatic verb for "stockpiling" or "hoarding," *hamstern*—what everyone in the valley seems to be doing in case the road gets blocked by the downpour: "Obviously people have already started hoarding" (28; Offenbar wird schon gehamstert, 40). Finally, although we may collect the bones of dinosaurs in our attempts to learn about them, the thematic role of these prehistoric reptiles in the book is, in fact, related again to the story of Noah. For unlike the other animals mentioned (save the Micropholis stowi), dinosaurs are extinct, and their disappearance from Earth is a direct result of *not* having survived a natural catastrophe that wiped out almost all life on the planet. (Not that an ark would have saved them from their fiery extinction.)

 Among all these creatures, Geiser's collection of notes, cutouts, and paper scraps—many of which inventory, describe, or picture animals—takes on Noachian dimensions. Like the biblical patriarch, Geiser is an old collector whose undertaking is motivated by environmental catastrophe. Like Noah, his gathering and preservation are anticipatory. And like the architect of the ark, Geiser is engaged in building a structure that would protect him from drowning. The object of Geiser's collecting, the maculature that he refers to as *Zettel*, also carries Noachian overtones, especially in its evocation of the polysemic verb *verzetteln*. The intransitive form of this verb, for instance, indicates the activity of making notes for the purpose of inventorying. It thus describes the classificatory drive of the collector, drawing attention to the intimate connection between paper (as a tool for cataloging) and the collection of objects.[30] One of the definitions for *verzetteln* in Grimms' *Dictionary* places emphasis on the idea of "holding on" to knowledge by way of note taking: "to record [*festhalten*] observations, findings on pieces of paper [*zettel*]." This elucidation of the verb serves as an auspicious description of Geiser's

30. See, for instance, Reinhard Buchberger, Gerhard Renner, and Isabella Wasner-Peter, eds. *Portheim: sammeln & verzetteln: Die Bibliothek und der Zettelkatalog des Sammlers Max von Portheim in der Wienbibliothek* (Vienna: Wienbibliothek im Rathaus / Sonderzahl Verlagsgesellschaft, 2007). See also Markus Krajewski, *Paper Machines: About Cards and Catalogs, 1548–1929* (Cambridge, MA: MIT Press, 2011).

distinctly tactile efforts to keep track of important pieces of information. It also evokes the card catalog, that paper-based system of inventory that, it turns out, brings us back to Noah, especially in the Swiss context. For as Peter Utz has shown in his reading of the Swiss Enlightenment scholar Johann Jakob Scheuchzer, the ark appears early on in the Helvetian imagination as a massive "floating card catalog" (*ein schwimmender Zettelkasten*).[31] In addition to this denotation, which combines the idea of the inventory with the materiality of paper, the word *verzetteln* has other meanings that directly resonate with *Man in the Holocene* and its conception of collecting. In Swiss German, Frisch's native tongue, for instance, *verzetteln* denotes "to dry out by spreading out."[32] Although usually used to refer to agricultural tasks such as making hay, *verzetteln* in this sense evokes the salvaging of what has been inundated by water. Geiser's activity of patchwork collecting thus emerges on multiple, overlapping levels as a Noachian undertaking: it is inventorial and redemptive, an attempt to rescue from the apocalyptic deluge what remnants one can—to spread them out to dry so as to use them in rebuilding what has eroded.

In this picture of salvage as *Verzetteln*, that which is laid out to dry will have necessarily already been damaged, drowned, or destroyed by diluvial forces. If the *Zettel*, on the one hand, function metaphorically as maculature, blotting paper that soaks up excess liquid, they must, on the other, once used, be spread out to dry: *verzettelt*. Like the salamander, such maculature (from the Latin *macula*, a stain or spot) is "spotted," marked by the blots of liquid it absorbs. But it is also thereby "defiled," unclean, and thus in need of redemption. The activity of "spreading out to dry" is one form of such salvage as salvation. But it is also a form of "dispersal," as another definition and the etymology of *verzetteln* affirm: *verzetteln* (from *verzetten* or *zetten*) can also simply mean "to scatter," "to lose," or "to let fall" (*aus-, verstreuen; hin und wieder fallen lassen; verlieren* [Grimms'

31. Utz, *Kultivierung der Katastrophe*, 150.
32. See Grimms' *Dictionary*: "*gras, heu, stroh o. ä. zum trocknen ausbreiten, ausstreuen*." Their sources include the *Schweizerisches Idiotikon* and Gotthelf. See also *Duden*, where this definition is flagged as southern German or Swiss.

Dictionary]).[33] In fact, this dispersal at the core of the word informs its definition as "note taking" (*verzetteln*). The Grimms define the verb thus: "to separate [*auflösen*] content that belongs together [*zusammengehöriges*] into individual notes [*einzelzettel*] and to place them together and order them in the form of a card file [*kartei*]." In this elucidation, to create *Zettel* inherently involves a breaking up (*auflösen*) of what was unified (*zusammengehöriges*); to make possible the sorting, ordering, (re)assembly, and thus preservation of knowledge, the task of note taking necessarily involves the disassembly of what was together and integral—its removal from the place where it was found and its transplantation to another place (via the mobile and sortable *Zettel*). Geiser's *Verzetteln* makes this destructive aspect of collecting knowledge patently and materially present. Using scissors to cut up books is only one—very literal—example of this process of the disintegration of the whole. When Geiser begins using tape to attach these cutouts and his handwritten notes to the wall, he inflicts further damage on them ("admittedly this ruins the books," 87; 114; translation modified). In particular, he notices how the backsides of the pages he has cut out become ruined in the process: "now this text has been cut to pieces, useless for his wall of notes [*Zettelwand*]" (89; 116; translation modified). This "dismemberment" of the books carries out the process of *Verzetteln* in an extreme form. Collecting knowledge in the attempt to save it (from the collapse of house and mind) requires an activity that instantiates the opposite of that gathering and preservation, namely dispersal and destruction. To achieve his collage of knowledge, Geiser cannot of course avoid cutting up and thus destroying his books. He must generate maculature to save himself from being washed away. The activity of losing, scattering, and letting fall is thus dialectically implicated in the activity of collecting and rescue.

33. This etymology explains the more common usage of *verzetteln* in the reflexive form to denote getting bogged down in incidental details at the expense of actually accomplishing anything useful, another meaning at play in Frisch's text. Claudia Müller alludes to this denotation: "Je mehr Merkzettel Herr Geiser aufhängt, desto mehr verzettelt er sich." Müller, *"Ich habe viele Namen": Polyphonie und Dialogizität im autobiographischen Spätwerk Max Frischs und Friedrich Dürrenmatts* (Munich: Wilhelm Fink, 2009), 84.

The inextricability of dispersal and gathering, of loss and redemption, to the logic of collecting takes on a new guise in Frisch's story. Here we see how it is manifest at the cross section of the monumental and the mundane, where the long, tumultuous course of Earth's geological ages collides with the everyday banality of one man's old age and his struggle in the face of inevitable physical and mental decline. In his efforts to stop the erosion of his mind and the erosion of Earth, to "make coherent" by "holding together" the pieces that are falling apart, "to take up the struggle," as Benjamin says of the collector, "against dispersal" (*er nimmt den Kampf gegen die Zerstreuung auf*), Geiser participates in it.[34] He is thus unable to see that the flooding is not really a danger. Instead, he considers just about everything, including that which points to his protection or rescue, to be a threat. A piece of string, for instance, appears to be one of the cracks in his home's foundation that will lead to its collapse and his ruin (95; 123). In fact, this string is probably the same one he had previously used to construct an ad-hoc bow compass with which to draw out the golden ratio for one of his *Zettel* (12; 20–21; see figure 4). Indeed, he uses the piece he finds on the floor for a related measurement. Attaching it to a weight, he creates a plumb line to test whether the walls and his house are still standing straight (95–96; 123–124). Both the golden ratio and the perpendicularity test are necessary for constructing a building with structural integrity. For Geiser, however, the string that allows him to make these measurements appears as the very thing—a crack (*Riss*)—that would undermine that integrity.

String, of course, binds things together. It is an instrument of gathering, a tool for holding together what might otherwise fall apart. In this way Frisch aligns the crack with the things that would aid in correcting it or preventing it from widening. Like the *Zettel*, which are both product of and remedy for flooding, both maculature and patch, the string is at once the product of and remedy for erosion.

34. Benjamin, *Arcades Project*, 211; *Gesammelte Schriften*, 5:179.

Collecting to Forget

In this way, as intimated at the beginning of this chapter, Geiser's efforts to stay his disintegrating mind end up instantiating it, just as his efforts to piece together knowledge results in a fragmented patchwork and dismembered source texts.[35] Frisch's book is strangely ambivalent about this interdependence—we might even say codependence—of dispersal and collecting, which manifests itself as a peculiar correlation between forgetting and remembering, as well as between Earth's erosion and our need for a stable ground of existence (in both the figurative sense and in the literal sense of a ground for building structures that will not collapse). In fact, *Man in the Holocene* ultimately arrives at a radical conclusion with respect to Geiser's fate (as well as our own) in relation to Earth's history: a return to prehistory, to before "man appeared in the Holocene," may be the realization of complete forgetting for which collecting strives. From this perspective, our protagonist's deteriorating mind and ultimate demise—his "erosions"—are part of a necessary process that points to how the planet restores itself to a state of natural equilibrium.

Consider first how erosion is shown to be both destructive and, by virtue of this destructiveness, at the same time productive. We read, for instance, early on in the book that "weathering and erosion" are "the natural forces" that, along with flooding, essentially gave birth to the region of Ticino. Glaciers and diluvial waters "carved out the first valleys" (10; 18). Ostensibly destructive natural occurrences such as debris avalanches and landslides, we learn, "played no little part in giving many districts in the canton of Ticino the appearance [*Gepräge*] they have today" (11; 19). Yet this

35. For an interpretation of Geiser's activity as representing a "collapse of the classical ideals of the Enlightenment," see Michael Butler, "Max Frisch's *Man in the Holocene*: An Interpretation," *World Literature Today* 60, no. 4 (1986): 575–576. Butler writes, "Geiser's scraps of paper represent in a most visually effective way the reduction of a once-humane science to a conglomeration of disparate facts" (576).

form-giving aspect of what we consider an environmental dissolution of form has in large part to do with a shift in perspective from human history to a geological history of Earth from which humans are absent.[36] What is threatening to human life today was in prehistory essential to the emergence of the very geographical space in which humans would flourish. The glaciers of the Ice Age (which preceded the Holocene) are identified in the cutout encyclopedia entry on "geological formations" as the primary cause of the complex layers of the earth, its valleys and gorges, as well as its sinkholes and erosions (35–37; 49–50). In fact, the debris left behind by the glaciers, known as moraine, makes up the ground on which Geiser's particular village is built: "The village lies on a narrow ledge covered with ground moraine, the remains of a former valley bed that can be traced as far as Spruga" (43; 58). As in Gotthelf's text, the ostensibly unwanted matter of geological debris and residue becomes essential to human habitation as the actual foundation on which structures for living can be built.

From the perspective of Judeo-Christian salvation history, too, environmental catastrophe ushers in the era of human thriving. As Peter Utz writes of Scheuchzer's Enlightenment rereading of the Noah story, "The Flood is a positive catastrophe."[37] It reshapes Earth's habitable terrain, wiping out most life forms, thereby creating a kind of tabula rasa for cultural and spiritual development. It eradicates the past in order to create a new world. The Flood's waters and consequent erosions of the earth dissolve everything that was: it is thus a force not just of obliteration but also of oblivion.[38]

For Susan Stewart, Noah's ark represents the archetypal collection precisely by virtue of this logic of forgetting. "The world of the

36. For a reading of the book that emphasizes the geological horizon of Earth's history as providing a "transhuman perspective," see Georg Braungart, "'Katastrophen kennt allein der Mensch, sofern er sie überlebt': Max Frisch, Peter Handke und die Geologie," in *Figurationen der literarischen Moderne*, ed. Carsten Dutt and Roman Luckscheiter (Heidelberg: Winter Verlag, 2007), 23–41.

37. Utz, *Kultivierung der Katastrophe*, 150.

38. Compare Utz's reading of the Flood motif in Frisch in relation to *Man in the Holocene*, where "the negated Flood remains contained in the text as the text." Utz, *Kultivierung der Katastrophe*, 170.

ark," she writes, "is a world not of nostalgia but of anticipation. While the earth and its redundancies are destroyed, the collection maintains its integrity and boundary. Once the object is completely severed from its origin, it is possible to generate a new series, to start again within a context that is framed by the selectivity of the collector." Note that in this model of collecting as redemption there is no restoration of a prior order. Instead of "saving" the old from oblivion, the collector rescues only, as Stewart puts it, "the two that is one plus one"; in other words, the possibility of "seriality and infinity" promised by the pairs of collected creatures. Because these animals are not gathered together and preserved for the purpose of remembering the world that is going under, it cannot be said that the Noachian collection is undertaken in the service of memory. Rather, as Stewart boldly claims, "The point of the collection is forgetting."[39]

Frisch would at first glance appear not to be activating this model of collecting in *Man in the Holocene*. Geiser, after all, seems desperate *not* to forget, and his wall of notes functions, as we have shown, as a means to hold on to what he fears might slip away from him. And yet, as we also saw, his struggles seem to be in vain. Despite his efforts, he keeps forgetting, with the result that his *Zettel* appear more as symptoms of, rather than as remedies for, his waning cognitive and mnemonic abilities. Moreover, the practical purpose of his collage of knowledge is not actually to aid in recollection. The old man's collecting solely concerns impersonal facts and figures. As I argued earlier, he is not engaged in establishing a personal history or reconstructing memories of his own past. Only one such personal memory asserts itself during the days the story relates, and it is telling that Geiser does *not* record it onto a *Zettel*.[40] Instead, the septuagenarian gathers scientific data about Earth, its geological ages, and its nonhuman extinct inhabitants or makes lists of animal names and facts, thereby accumulating impersonal data

39. Stewart, *On Longing*, 152.

40. This is the memory of his expedition to Iceland with his brother. The memory mobilizes many of the book's thematic elements (glaciers, a wall, the struggle against nature, the threat of dying) and serves as an intangible counterpoint to the concrete wall of facts.

instead of re-*collecting* the details of a personal past.[41] Indeed, he even removes from the wall a portrait of his dead wife to make room for more *Zettel* (39; 53). On the one hand, Geiser hoards these notes in the same way and for the same purpose that his neighbors hoard food: as a future-oriented tactic of survival. And yet, on the other hand, being thus able to access information he had not previously known (or if he had, not in any personal and meaningful way) does not connect him to the world outside but only insulates him further from it. Ostensibly a means to preserve aspects of a world that is disappearing, Geiser's collection ends up sealing him off from that same world. As with the bourgeois collector described by Benjamin, Geiser's activity isolates him in an architecturally secured enclosure.[42] That the septuagenarian's wall also forecloses interpersonal relations is seen in his refusal to let anyone into his house for fear someone might see this wall and his collection of notes (55; 73).

Thus, like Noah, Geiser turns away from the world, which, ultimately, must go under for his collection to be at all meaningful. The Flood is as necessary as his collection: both are part of a cosmic plan for renewal predicated on obliterating the past by precipitating its forgetting. This is why the old man is aligned with the feared inundation of the valley, not only by way of his own eroding mind but also via his name. For in German as in English, the word *Geiser* ("geyser") indicates the bursting forth of water from below the surface of Earth. Although actual geysers cannot cause catastrophic flooding, in the story of Noah the water that inundated Earth came both from underneath and from on high, both geyser-like from below skyward and torrentially from above earthbound: "All the fountains of the great deep [were] broken up, and the windows of heaven were opened" (Genesis 7:11). In both the biblical story and in Frisch's book, this flooding wipes out the past and instills forgetting to suggest that no restoration of origin is possible. Such a restoration would lead to a repetition of the past; what is needed is an entirely

41. Even the recollection of his grandchildren's names, which requires effort (101; 131), occurs as part of the narration (of Geiser's thoughts) and is not written down to be added to the collage of *Zettel*.

42. Benjamin, *Arcades Project*, 9; *Gesammelte Schriften*, 5:53.

new beginning. The collection in service of this renewal, as Stewart writes, "replaces origin with classification, thereby making temporality a spatial and material phenomenon."[43] Indeed, while the flooding in Geiser's valley goes on outside, he remains protected inside, but only in a space whose fortification consists of a classificatory *Zettel*-collage, that "spatial and material" concretization of lost time. If "the collection presents the hermetic world," as Stewart claims, then our protagonist has used maculature to seal it tight.[44]

As geyser and amnesiac, then, Geiser is a force of flooding and forgetting. I have been stressing the way in which this flooding becomes synonymous with erosion, both of the mind and of the earth. But if it is true that this erosion covers over and thereby buries the past, then it is necessary that we also ask what it at the same time *un*covers. Sliding layers of earth, after all, do not just cover over but also expose deeper layers. Implicated in any erosional burial is an unearthing of the past. What lurks underneath and is occasionally brought to the surface, the story tells us, is in fact the debris of pre-Holocene history: "moraine, debris from the huge glaciers of the Ice Age" (43; 57). Geiser's amnesiac flooding participates in this excavation of the pre-human, simultaneously washing away Earth's surface to reveal a past prior to historical consciousness and spewing forth from deep below Earth's crust in an eruption of the nonhuman past into the present.[45] As the immediate past goes under, the remnants of something more primordial emerge. That immediate past appears to Geiser in terms of Earth's long geological development as the last eleven thousand odd years (that is, the Holocene). It is this geological era, which corresponds to the period of human recorded history, that will be buried and forgotten, and what preceded it, the eras of prehistory, will consequently return to view.

We can now begin to see how and why Geiser's collecting brings pieces together and dismembers them at the same time, gathering what is ostensibly in need of re-membering while also contributing

43. Stewart, *On Longing*, 153.
44. Stewart, *On Longing*, 152.
45. Obschlager reads the structures of memory loss and remembrance in terms of Freud's return of the repressed. Obschlager, "Man, Culture, and Nature," 206–207.

to a process of forgetting. For what is unearthed and enshrined on the wall is precisely this prehistory, whereas what is buried and forgotten is the recent past of human history.[46] Thus, in holding on to facts and figures about prehistory, Geiser instantiates a forgetting of everything else. His amnesiac flooding promises a new beginning that doubles as a return to a time when there were no creatures who could remember. "The rocks do not need his memory" (107; 139), Geiser announces at the very end, in an apparent repudiation of his collection. And yet such a refusal to remember is essential to the Noachian model of renewal. Hence the paradox: what Geiser remembers is a time without its own capacity for remembrance. What he memorializes on his wall is an era of forgetting. What his collection instantiates is a mnemonic remedy that precipitates the loss of memory as such.

I argued earlier that Geiser resembles Benjamin's brooder, that manifestation of the allegorist who is condemned to gather up the fragments of dead knowledge without ever being able to piece together a coherent whole. It seems clear now that this dead knowledge, aligned as it is with the septuagenarian's flooding and forgetting, stands in for more than just the remnants of an incomplete collection: instead, it points to the full realization (in all its paradoxicality) of collecting as such. If, following Stewart's reading of Noah, "the point of the collection is forgetting," a necessary step in the establishment of a new beginning, then such forgetting would seem to be consonant with—indeed, necessary for—the restoration of a time before human time, a time lost to time. And because such a prehistorical origin could only be restored under the aegis of forgetting, it would, in the end, be indistinguishable from a Noachian rebeginning. In fact, to experience it would be comparable to losing not just memory but also one's sense of place in an historical world. It would amount to a state of nonthinking, precisely that which Geiser sought in constructing the pagoda on the book's first page: "to think of nothing" (3; 9). Ultimately that nonthinking, al-

46. Even the few *Zettel* that deal with human history are primarily concerned with the extinction threat posed by catastrophe (e.g., 13–14, 17–18; 22–23, 27) or with defining the human *as* historical creature (e.g., 53–54; 71–72).

though it suggests a moment prior to the beginning, also coincides
with the end, death, which is what in fact arrives as the culmina-
tion of collecting in Geiser's home. His collapse in the final pages—
like the collapse of the pagoda on the opening page—marks the pos-
sibility of this restoration of prehistorical existence as coincident
with its impossibility. His undertaking has ushered in nonthinking
by occasioning complete forgetting, which is actualized in the form
of a lethal stroke. If the threat of amnesia appears as the promise
of a respite from thought, an escape from history, then in the end
this stroke fulfills that promise with ironic finality.

Restoration without Humans

But it is a finality that does not end things altogether. The world
does not go under; time does not stop for anyone else. "The village
stands unharmed" (110; 141), we read at the start of the final text
block, the only one in the book not focalized through Geiser, who
is now presumably dead. What, then, are we left with, in the end?
Beasts and plants and some humans, it seems. Quotidian life con-
tinues without much worry. The picture offered in this final two-
page paragraph, though, is hardly Edenic. We hear a helicopter and
the buzzing of chainsaws, among other encroachments of moder-
nity. Humans are still at work conquering nature. The last sentence
of the book, whose final nine words appeared in the exact same
sequence previously in the book (50; 67), suggests not only that
nothing has changed but that, indeed, the old is repeating itself: "In
August and September, at night, there are shooting stars to be seen,
or one hears the call of a little owl [*Käuzchen*]" (111; 143). If we
have begun again, it is not by forgetting the past, which here re-
turns in an almost identical form.[47] Though time plods on—in this

47. Butler claims this final section consists of no new narration, but only of "a
collage made up of fragmentary sentences from earlier pages," and that it thus
provides no happy ending but only "the restoration of a *pseudo-coherence*, a
Schein-Ordnung." Butler, "Max Frisch's *Man in the Holocene*," 579. Claudia Mül-
ler provides a thorough analysis of recurrences in a genetic study of the passage.
Müller, "*Ich habe viele Namen*," 95–99.

version of the sentence Frisch adds "and September"—the story ends, even as it returns us to an earlier point. This non-ending, however, is punctuated by a word that evokes the actual end of our protagonist while at the same time signaling a Noachian new beginning. For on the one hand, as Grimms' *Dictionary* explains, the cry of "the little owl," in particular, traditionally portends that someone is about to die. But on the other hand, it is—of all creatures—a bird that confirms the end of the Flood to Noah: "He sent forth the dove out of the ark. And the dove came in to him in the evening; and, lo, in her mouth was an olive leaf pluckt off: so Noah knew that the waters were abated from off the earth" (Genesis 8:10–11). That this "little owl" at the end of *Man in the Holocene* is no dove, but an omen of death, only drives home the point: the flooding may be over, but our protagonist has gone under.[48]

I read this alignment of Geiser's death with the fulfillment of the Noachian promise as a corrective of Noah's story and see its repetitions as a resignation to the impossibility of that fulfillment. On the one hand, the patriarch and collector might be able to save Earth's creatures, but only by sacrificing himself. He must die for his collection to survive. Our protagonist's failing memory, linked as it is to nature's erosion, suggests that his demise (by way of a loss of blood to the brain, no less) is a return to nature, which, without him, has no name and no memory. "All the papers [*Zettel*], whether on the wall or on the carpet, can go. Who cares about the Holocene? Nature needs no names" (107; 139), he proclaims before his final collapse. The collection seems only to be fulfilled in and through the collector's death, in his return to a state of total forgetting. And yet, on the other hand, life appears to go on in the end in a strange repetition of the same. Total forgetting has not set in for the other denizens of the valley, let alone the world. That would require mass extinction, which would render any fulfillment lost to a nature without memory.

Seen from this vantage point, Frisch's ending offers only an absurd fulfillment of collecting's promise, one that essentially restates

48. Another wordplay on the part of Frisch: the nondiminutive form of the owl, *Kauz*, is often combined with adjectives such as "old" and "curious" to designate a solitary and odd old man.

Franz Kafka's observation that "there is an infinite amount of hope, just not for us."[49] Translated into the terms developed in this book so far, the collection may fulfill the promise of restoring a supposed original state of things, but that state does not—indeed, cannot—include us. This reading is of course amplified in the Anthropocene, from the perspective of our increasingly volatile climate and collapsing ecosystem. I am not alone in approaching Frisch's text from this standpoint. As Bernhard Malkmus has recently shown, *Man in the Holocene* can fruitfully be read as "an aesthetic response to the global ecological crisis" of our age.[50] Against the looming threat of real apocalyptic weather, Frisch's story offers an ironic and misanthropic solution. We save the planet by dying off, which is the very thing our attempts to save the planet seem directed to prevent. Once Earth becomes uninhabitable because of us, it will have sloughed off that which made it uninhabitable in the first place. To actually restore a state of origin—which Frisch's text suggests is located prior to humans—thus requires the fulfillment of collecting in total forgetting. Geiser's stroke is the consummation of this act. In the absence of names, of memory, of humans, Earth may well recover from the afflictions wrought by its putatively most intelligent inhabitants.[51] From the perspective of Earth's geological history, which is the real narrative focus of Frisch's book, the decline of humans is thus a necessary and ineluctable extinction event. Erasing humankind would be nature's ultimate act of forgetting, a full extinction—without a Noah to replenish the human population.

49. This statement comes from a conversation with Max Brod. Originally published in Max Brod, "Der Dichter Franz Kafka," in *Juden in der deutschen Literatur*, ed. Gustav Krojanker (Berlin: Welt-Verlag, 1922), 58.

50. Malkmus, "'Man in the Anthropocene,'" 84. Other ecocritical readings of Frisch's text include Andrew Liston, *The Ecological Voice in Recent German-Swiss Prose* (Oxford: Peter Lang, 2011); Urte Stobbe, "Evolution und Resignation: Zur Verbindung von Klima-, Erd- und Menschheitsgeschichte in Max Frischs *Der Mensch erscheint im Holozän*," *Zeitschrift für Germanistik* 24, no. 2 (2014): 357–370; and, most recently, Matthias Preuss, "How to Disappear Completely: Poetics of Extinction in Max Frisch's *Man in the Holocene*," in *Texts, Animals, and Environments: Zoopoetics and Ecopoetics*, ed. Frederike Middlehoff (Freiburg im Breisgau: Rombach, 2019), 253–265.

51. This assumes, doubtfully, that the Anthropocene does not take nonhuman life with it.

That may sound like a radical conclusion, but I find little else to temper it in Frisch's otherwise misanthropic story. Because of its pessimistic view, Frisch's book thus serves as an ideal foil to Gotthelf's tale of catastrophic detritus. Where Gotthelf gathers together the strewn pieces of waste in order to make them productive, to redeem his work, as well as to affirm divine authority, Frisch ends his story with a strewn mass of *Zettel* that are indistinguishable from maculature. And no one remains to pick them up. These scraps of waste stand in for Frisch's own literary production, whose force as writing comes both despite and by virtue of its fragmentariness.[52] In this respect it is exemplary of high modernist aesthetics, at once suffering and celebrating the world in its fundamental fragility and incompleteness. The model of collecting developed in *Man in the Holocene* is commensurate with such a vision of the world; indeed, it is one of the few works of German-language literature that reveals the consequences—however conflicted and calamitous—of bringing the collection to completion. For it takes seriously, by taking *literally*, the paradox that the completed collection necessarily spells the end of collecting. In doing so it reveals that the efforts of collecting in modernity are not exactly, as Dominik Finkelde writes, "in vain," but instead that they only succeed by eliminating the conditions in which they were needed (or desired) in the first place.[53] Collecting, it turns out, offers plenty of hope—just not for us.

52. On the parallels between Geiser's *Zettel* activities and Frisch's compositional techniques (as attested to by his archives), see Müller, *"Ich habe viele Namen,"* 85.

53. Finkelde, "Vergebliches Sammeln," 187–204.

PART III

TRIVIALITY

6

Junk and Containers (*Keller*)

A constant concern of practitioners and theorists of German realism was how to represent everyday reality without ending up with a messy pile of details and trivialities. These incidental and marginal things, they agreed, have no place in the proper artwork, which ought to express "the purposeful, the meaningful, the truly necessary."[1] Without some kind of refinement or containment, the seemingly insignificant aspects of ordinary life would clutter the work with the "base reality of things," which, on its own, is "vacuous and meaningless."[2] Thus, although realists wanted to depict the everyday, they could not simply resort to "the naked reproduction [*Wiedergeben*] of everyday life" without abandoning the pursuit of

1. Emil Homberger, "Die Aporien des Realismus," in *Theorie des bürgerlichen Realismus*, ed. Gerhard Plumpe (Stuttgart: Reclam, 1985), 155.
2. Robert Prutz, "Realismus und Idealismus," in *Theorie des bürgerlichen Realismus*, 131. Arnold Ruge, "Gemeiner und poetischer Realismus," in *Theorie des bürgerlichen Realismus*, 132.

what is "true" and thereby succumbing to the randomness and contingency of the world.[3] Such "naked reproduction" would only result in a catalog of facts and observations, an unadorned presentation of matter in its minutiae and meaninglessness. This is the purview of that base and modern form of realism practiced by the naturalists. To avoid it—which the poetic realists say is imperative—requires taking appropriate measures in the face of the "multifariousness" of existence; in other words, managing the discrete and disorganized elements that make up our world as they are taken up into the artwork.[4]

For the young Theodor Fontane, a large part of this management involves a process of selection that entails knowing where to look. Realism, he writes, "doesn't rummage through junk rooms [*durchstöbert keine Rumpelkammern*] and never ever venerates antiques when they are nothing more than just—old."[5] In other words, although realism strives to capture the everyday, it cannot accomplish this task by gathering together what lacks function, value, or relevance, such as what one might find combing through the back of the closet or foraging among the things left to gather dust in the attic. Such models of debased collecting misconstrue the task of realism, which should, its practitioners claim, be a more refined undertaking. The realist depicted throughout the programmatic writings of the nineteenth century, in fact, more closely resembles the bourgeois collector of that same period, as identified by Walter Ben-

3. Theodor Fontane, "Realismus," in *Theorie des bürgerlichen Realismus*, 145 ("naked reproduction"). On what is "true," see Fontane, "Realismus," 147: "Der Realismus will . . . das *Wahre*" (Realism wants . . . *what is true*); and Homberger, "Die Aporien des Realismus," 153: "it [the mind of the writer] provides the law instead of what is random, the truth instead of reality."

4. Otto Ludwig, "Der poetische Realismus," in *Theorie des bürgerlichen Realismus*, 149.

5. Fontane, "Realismus," 145. In the context of his essay, Fontane intends this figure of the junk room to represent the site of "dead" historical material that has no bearing on contemporary life and of the discarded and obsolete parts of cultural history of which the writer should keep clear. He also acknowledges that an "eternal flower" might be found "among the rubble of half-forgotten centuries." It is worth noting that Fontane's essay dates from 1853, well before he began writing his own novels.

jamin, who "makes his concern the transfiguration of things."[6] In gathering unassuming things from the world and transplanting them into the artwork, the realist—like the collector—transforms them, bestowing on them a value they did not—indeed could not—previously have. In fact, "transfiguration" (*Verklärung*) emerges in the German nineteenth century as a key poetological concept to describe precisely this transformation: how "the real" is made "ideal," how the ordinary becomes aesthetic, and how what seems incidental and irrelevant is made consequential and even decisive in the artwork.[7] As with the bourgeois collector, transfiguration in poetic realism involves constructing an enclosed and artificial space in which things assume a new role, independent of their value or functionality in the world outside. In this way, the text becomes a kind of container that keeps the marginal and incidental in check by making it relevant in relation to a new constellation of things.

More recent theory has been less sanguine with respect to this transformative power of realism. The text may be a container of sorts, but it really only serves as the space in which the banal and inconsequential elements of the everyday pile up and, as it were, collect dust. In his structuralist typology of narrative, for example, Roland Barthes flags "trivial incidents," which he calls "catalyzers," as "weak" and "parasitic," saying that they "merely 'fill in' the narrative space" that opens up between significant events and actions.[8] Using Barthes's concept, Franco Moretti renames these incidental aspects "fillers," those elements that seep into the cracks and fissures between the decisive turning points of a narrative. In Moretti's estimation, it is realism that for the first time ushers in "fillers" as a constitutive feature of the novel; they are, he writes, "the only narrative invention of the entire nineteenth century." Nearly absent around 1800, by the turn of the next century "they are everywhere," including, in Moretti's list of authors whose work is nothing more

6. Benjamin, *Arcades Project*, 9. "Er [der Sammler] macht die Verklärung der Dinge zu seiner Sache." *Gesammelte Schriften*, 5:53.

7. For a critical overview of this concept for German realism, see Hugo Aust, *Realismus* (Stuttgart: Metzler, 2006), 49–88.

8. Roland Barthes, "Introduction to the Structural Analysis of Narratives," in *Image. Music. Text*, 93–95.

than "a great collection of fillers," in Fontane.[9] In the realist novel, the cracks and fissures of the narrative become veritable caverns, the text functioning like a receptacle designed to be filled up with whatever incidental details the author gleans from ordinary life.

These models of handling the trivial, each of which suggests an operation of containment, are nonetheless clearly in tension. The first describes a process of integration that effectively obscures the incidental; the second describes a process of infiltration that threatens to obscure the consequential. In the first, the task of capturing the everyday would seem to be eclipsed by the desire for a purposeful and meaningful whole. In the second, this desire for unity would seem to be eclipsed by the proliferation of the marginal, irrelevant, or accidental. Each model describes an essential feature of realism, which itself is driven by conflicting impulses: at once to convey and to contain the trivial, to fill the work with the ordinary and everyday while also ordering, transforming, and integrating these elements to prevent them from cluttering the work. If the realist text indeed functions as a medium of collecting—as I argue in this chapter—then it does so as the ordered display case of the bourgeois collector and as the jumbled junk room of the scavenger at one and the same time.

In no body of realist work is this intersection of conflicting impulses more evident and also productive than in that of Gottfried Keller. In his fiction we see how each impulse informs the other in a dialectical process that also demonstrates their essential interdependence. Whatever aesthetic order his works display can only be maintained by also making room for the clutter that characterizes our world. Keller's work thus offers neither an ordered and consequential picture of this world nor a random accumulation of "fillers": instead, it contains these fillers within a (mostly) unified and ordered structure.

This chapter aims to conceptualize this containment and its poetological power in Keller's work. If, as Wolfgang Preisendanz argues in

9. Franco Moretti, "Serious Century," in *The Novel: History, Geography, and Culture*, ed. Franco Moretti (Princeton, NJ: Princeton University Press, 2006), 1:379. His phrase "great collection of fillers" refers specifically to George Eliot's work.

his seminal essay on *Green Henry* (*Der grüne Heinrich*), Keller breaks from the Goethean model of the novel by revealing that "the actual structure of human reality" is constituted by the trivial, "the seemingly meaningless and irrelevant, the banal and common, the incidental and immaterial," it behooves us to ask *how*, precisely, these elements are, as Preisendanz writes, "understood and represented" in the work.[10] On the one hand, it is clear that we do not find *Green Henry* comprising a hodge-podge collection of random things, but neither do we, on the other hand, find a perfectly ordered space in which such trivialities have been aesthetically transformed. These represent distinct modes of containment that are at work in Keller's fiction, though never one to the exclusion of the other.

Consider, as a contrast, how Stifter's near-contemporaneous *Bildungsroman*, *Indian Summer* (1857), manages the incidental by constructing an aesthetic space in which life's inconsistencies and contingencies are either shut out or assimilated through relentless taxonomical description and inventory, so that everything ends up being accounted for as equally relevant and significant (and as such, ultimately, indistinguishable from the trivial). Of course, even this ostensibly airtight container is nearly impossible to maintain, betraying cracks and fissures, however minute. The container of Keller's work is far more capacious. Although his novels and stories incontestably order and make narratively and thematically consequential many of its seemingly incidental elements, they also allow for the trivial to appear *as* triviality. Keller thus does not achieve a balance of these impulses by mobilizing—as Stifter does—figures of classification, arrangement, restoration, and integration, let alone transfiguration. Instead, his work conforms to the logic of containment. For the container does not eliminate disorder but only keeps it confined to a limited space. The activities of gathering and preservation thus appear in Keller less as means to establish order than as tools for capturing and holding on to things precisely without having to impose any order—indeed, to capture and hold on to things *in* their disorder. In Keller's work, questions of order and disorder,

10. Wolfgang Preisendanz, *Wege des Realismus: Zur Poetik und Erzählkunst im 19. Jahrhundert* (Munich: Wilhelm Fink, 1977), 178.

along with collection and dispersal, intersect with those of value, such that the container becomes a figure for managing the trivial as it informs things displaced, disused, or in disarray. In *Green Henry* in particular, Keller invests containment with poetological implications. Containment offers the possibility of an alternative mode of collecting that affirms the interdependence of—or at the least allows for the simultaneous existence of—preservation and sequestration, integration and even elimination. In this way, it allows for marginal and multifarious matter to appear as "fillers" while at the same time maintaining the coherence and unity to which such fillers pose a threat. Furthermore, Keller's work demonstrates a central paradox of collecting, one that we have seen in various forms throughout the book so far: gathering and preservation exert violence on the object, such that the act of "giving space" or of "saving" it from the disorder of existence frequently also involves its displacement or destruction.

In this chapter I argue that Keller's containers reveal how disorder is not only incorporated into his work but is also made constitutive of its order. The trivial that Keller integrates into his work thus becomes essential to its significance. He contains it in order to contain it, assimilates it in order to control it, and, in the process, makes it productive. We might describe this paradox as a kind of inoculation. Indeed, Keller's work can be usefully understood as protecting itself against the threat of triviality and its attendant disorder by—as if homeopathically—taking in and transforming bits and pieces of the world's unmanageable multiplicity and "multifariousness," neutralizing their effect and allowing more to enter the "body" of the work without upsetting its overall unity.

Instead of the trivial being overcome and thereby effectively eliminated, I argue that it is truly *aufgehoben* in Keller's work, at once annihilated and maintained, negated and preserved. It is negated in being taken up into the meaningful construct of the aesthetic work and thereby being made, on this level at least, significant. But it is preserved in that, as we will see, this significance coincides with making visible the trivial *as* a category of thing in the world that poses a problem to significance in the first place. The trivial thus becomes important as that which reveals what is not impor-

tant. And as such it is contained: both kept in the text and managed at the same time. Consequently, the division between the significant and the trivial is maintained, as well as overcome, in that what remains as important is ultimately the text itself: that container in which what is trivial is both kept safe (*aufgehoben*) and neutralized (*aufgehoben*).

This dialectical process conforms to the logic of collecting. The object taken up into the collection is thereby safeguarded but also transformed in terms of its value. In a most peculiar way, the object gains significance and loses it at the same time. Its significance *as* object is asserted in the collection but thereby denied in the world, even though it is its significance *in* the world that makes it worth being collected in the first place. The process of collecting thus both undoes and reaffirms the object's significance, so that its true significance only emerges in being made trivial—in being made a thing.

Containment and Dispersal in Frau Margret's Junk Shop

In what follows I illustrate these paradoxes by investigating various trinkets and trivialities in Keller's work, with special attention to the containers meant to keep these things safe. I read these technologies of collecting the apparently irrelevant as poetologically charged figures that rehearse the paradoxes of realism itself, which, as a literary mode, collects the trivia of the everyday into an aesthetic construct that is meant not only to transform this trivia but also to preserve its triviality as constitutive of the reality it aims to make accessible. In this way everyday reality is redeemed in its irredeemability—or *as* the unredeemable. The necessary and contingent, the collected and dispersed, the essential and expendable, the distinctive and the ordinary, the consequential and the trivial—these end up being inextricably co-determined and co-constituted in Keller's work. His realism *contains* the incidental, both "managing it" and "incorporating it," both neutralizing it while also allowing it to "fill up" the pages of his books. These paradoxical processes of realism play themselves out most prominently and productively in his work's preoccupations

with gathering, safeguarding, and dispersal, which are critical above all to the narrative of *Green Henry*, a novel deeply concerned with the problems of the trivial and its containment.[11]

Not incidentally, young Heinrich's first forays into collecting come soon after he observes his neighbor Frau Margret and the fate of the objects she accumulates in her vast junk shop. Margret's mishmash world of abandoned things and the people from the margins of society who are drawn to it have a lasting impact on the impressionable Heinrich, who is just beginning to develop his own aesthetic sensibility. The boy's subsequent experiments with gathering and preservation, however feeble and ultimately unsuccessful, are critical to this development and must be seen as responses to Margret's undertaking, at once miniature duplications but also implicit correctives of the junk queen's realm of rummage. For while the analphabet neighbor presides over a space with the capacity to be "filled" with diverse things ("entirely stuffed full with old and new odds and ends" [*ganz mit altem und neuem Trödelkram angefüllt*]), that space is also the site of instability, excess, and exchange—aspects that Heinrich's later collections seek to curtail, if not to redress.[12]

Initially, however, the young Heinrich's encounter with Frau Margret's accumulation of curiosities and clutter fascinates and excites him. It offers him access to a world of anarchic creativity. We see this chaotic power already in the first inventory of the shop that Heinrich provides:

11. I focus primarily on the first edition of the novel from 1854–1855, for reasons that will become clear as my analysis unfolds.

12. Gottfried Keller, *Der grüne Heinrich: Erste Fassung*, in *Sämtliche Werke in fünf Bänden*, ed. Thomas Böning and Gerhard Kaiser (Frankfurt am Main: Deutscher Klassiker Verlag, 1985), 2:100. My translation. For subsequent English quotations I borrow and adapt as much as possible from A. M. Holt's translation of the second edition of the novel. Gottfried Keller, *Green Henry*, trans. A. M. Holt (London: John Calder, 1985). In most cases I have modified this translation. Both editions (first English, then German) are henceforth cited parenthetically, even where the German is not provided and even in those few cases when my translation bears little or no resemblance to Holt's rendering, as here (39). More often than not the lack of a corresponding passage in the existing translation is a result of the discrepancy between the first and second editions of the novel. The first version of *Green Henry* has yet to be translated into English.

The walls were hung with old silken draperies, tapestries, and rugs of all kinds. Rusty weapons and tools, blackened and torn oil-paintings, hung about the doorposts of the entrance and spread over on both sides of the exterior of the house; heaped up on a number of old-fashioned tables and other bits of furniture stood curious glass and china, in company with all sorts of wooden and earthenware figures. In the space further back were mountains of beds and household gear, laid in tiers, one above another, and everywhere on the tableland and shelving spots of these mountains, sometimes on a perilous, isolated peak, would be perched an ornate clock, a crucifix, a waxen angel, and so forth. (39)

Die Wände waren mit alten Seidengewändern, gewirkten Stoffen und Teppichen aller Art behangen. Rostige Waffen und Gerätschaften, schwarze zerrissene Ölgemälde bekleideten die Eingangspfosten und verbreiteten sich zu beiden Seiten an der Außenseite des Hauses; auf einer Menge altmodiger Tische und Geräte stand wunderliches Glasgeschirr und Porzellan aufgetürmt, mit allerhand hölzernen und irdenen Figuren vermischt. In den tieferen Räumen waren Berge von Betten und Hausgeräten übereinandergeschichtet und auf den Hochebenen und Absätzen derselben, manchmal auf einem gefährlichen einsamen Grate, stand überall noch eine schnörkelhafte Uhr, ein Kruzifix oder ein wächserner Engel u. dgl. mehr. (100–101)

Margret's junk and curiosity shop appears here as a dynamic space of abundance whose allure and vitality increase in direct relation to the dilapidation, incongruity, and disorder of the things that accumulate there. In this space, objects proliferate and pile up, both rising up vertically, "heaped up" and in layered "tiers" (*übereinandergeschichtet, aufgetürmt*) while also expanding horizontally like an invasive growth, "spreading" out and covering over all surfaces (*verbreiteten sich*), including the walls and the exterior of the house. The allotted room, which is earlier identified as "a spacious dark hall" (39; *eine offene dunkle Halle*, 100) within Frau Margret's larger domicile, cannot seem to contain this profusion of unfurling rummage, which not only tests but indeed actually breaks the boundaries meant to enclose it. Moreover, the amassed things themselves lack unity and integrity as distinct objects. Even though apparently both old and new goods are to be found here, Heinrich's catalog places the emphasis squarely on the dated and worn. What is not described as obsolete, rusty, old-fashioned, or torn nonetheless appears as clutter among the hodge-podge of diverse things, and

the prominence given to the disparate nature of these objects and to their apparently haphazard conglomeration leads to the impression that even what might seem pristine (perhaps the "curious glass and china") has been contaminated by virtue of its proximity to those things that are dirty, defective, or dilapidated.

These features are not incidental but in fact intrinsic to the objects Frau Margret gathers for her junk shop, which is a site for salvaging disjecta: she saves what has been discarded from becoming irredeemable trash. What Margret amasses here is the abandoned or decrepit, that which does not fit where it belongs, that which needed to be excluded in the effort to maintain integrity, unity, and order somewhere else. These, then, are the casualties of collecting. In other words, Margret gathers what is quintessentially scattered, that which is unable to be integrated into the functional or decorative system of an interior space. And yet she does not bestow on these scraps their missing order or grant them a space of belonging. Her shop only exists as a waystation for that which lacks a proper place. Because she does not gather what is scattered to make it whole again, her junk constitutes a kind of anti-collection. Thus, the things she accumulates do not share commonalities but are rather marked by incongruity. And instead of bringing together the disparate and discarded to overcome its lack of form in some new constellation, Frau Margret's agglomeration of abandoned things only intensifies the sense of amorphousness already adhering to them. Gathered together, they blend into one another, lacking even more the distinct features that would allow for classification and order. In fact, they are often not even distinguishable from the space in which they are stored, in some cases serving as structures or surfaces on which other items can be stacked. This disarrangement does not just reflect the state of the worn or dilapidated things themselves but also embodies their collective fragility. Ultimately, it is not just the things themselves that are falling apart; their assemblage, too, is unable to hold together, having been thrown together so precariously ("on a perilous, isolated peak") as to be on the verge of toppling over.

The final *u. dgl. mehr* ("and so forth") of the above quotation suggests that this list, like the abbreviated phrase itself, has been truncated and could go on forever. This potential endlessness, however,

underscores the aspect of Margret's shop that, although it is a source of anarchic energy that appeals to the young Heinrich, also taps into an unsettling, uncontrollable force, which he later seeks to bridle. The constant flow of things through the house makes palpable the vicissitudes of the material world, drawing attention to the main feature of the junk queen's trove that ultimately establishes it as a foil to Heinrich's later collections: it is not just internally unstable but also, in fact, uncontained and in flux. Hers is no fixed, permanent collection but instead a commercial enterprise in which items come and go and money is accumulated.[13] The haphazard way in which artifacts enter and exit the shop is further reflected in the willy-nilly fashion in which Frau Margret keeps the books. Using only the Roman numerals I, V, X, and C she writes sums in chalk on the surfaces around her, such as on tables. These markings do not last, so that the junk queen complains "that nothing fixed can be preserved" (*daß sie sich gar nichts Fixiertes aufbewahren könne*). She claims that this lack of a concrete record strengthens her "marvelous memory." Yet, in Heinrich's eyes, Margret's mnemonic method of bookkeeping only perpetuates the fluctuation between presence and absence that characterizes her larger undertaking: her memory is that inner space "out of which those teeming masses of figures suddenly appeared in shape and form and disappeared just as quickly" (40; 102). Neither the precise monetary value nor the actual concrete object to which this value ostensibly clings can be fixed by Margret. What she presides over is, from this perspective, a model of free-flowing material circulation utterly lacking the regularity and permanence the classical collection seeks to establish.

And yet Frau Margret is a productive catalyst for this accumulation and circulation of trivial and abandoned things. She not only sells and trades junk and curiosities but also occasionally extracts them from the exchange to install them in her own private and ostensibly permanent collection: "There [in her 'still odder living

13. Katharina Grätz argues that Margret's strategy of subsistence is "premodern" and her commerce thus "precapitalist," pointing to the gold she accumulates (and does not reinvest) and her tendency to barter. Grätz, *Musealer Historismus: Die Gegenwart des Vergangenen bei Stifter, Keller und Raabe* (Heidelberg: Universitätsverlag Winter, 2006), 262.

room'] Frau Margaret had accumulated [*zusammengehäuft*] and used as ornament those articles which had pleased her best in her trading [*in ihrem Handel und Wandel*], and she did not hesitate to keep [*aufzubewahren*] a thing for herself if it aroused her interest." These items she selects for reasons unrelated to usefulness. They appeal to her on a personal level, as ornamental or simply intriguing, and their exchange value is fully incidental to her. They become instead vessels for her imagination: Margret bestows on them "mysterious powers" (*geheime Kräfte*) that exceed both their purpose and their market value.[14] She therefore prizes things of little value, as well as those that are not in good shape, such as books with "immense copperplate engravings folded together, much crumpled and torn." Indeed, her impressive collection of printed matter assumes a special place among her personal stockpile: "Finally, on a bracket on the wall was stored a considerable number of shapeless old books which she used to collect with great zeal [*welche sie mit großem Eifer zusammenzusuchen pflegte*]" (41; 103). Yet because she can barely read, books are for her, like most everything else, mere things, the sources of "a certain truth" that cannot be reduced to the texts or pictures they contain. Thus, these books are "equally marvelous and significant" (42; 104) not because they contain knowledge but because, like talismanic objects, they inspire wonder and expand the boundaries of the imagination. They also reveal that the world of things is not lifeless but rather animated. Things are meaningful not because they have functional, sentimental, or symbolic value but because they themselves are—in some sense or another—alive: "Everything to her had significance and life" (47; Alles war ihr von Bedeutung und belebt, 110). The spiritual and mystical world that is so important for Frau Margret is neither invisible nor intangible;

14. Christoph Asendorf writes that the commodity here takes on the character of the fetish "in an archaic sense, and in no way in the sense that Marx considered to have discovered under the conditions of industrial commodity production." Asendorf, *Batteries of Life*, 34. See also Ulrike Vedder's discussion of things in Keller that fall outside the realm of economic exchange. Vedder, "'einige sonderbare Abfällsel': Gottfried Kellers verlustreiches Schreiben," in *Ökonomien der Armut: Soziale Verhältnisse in der Literatur*, ed. Elke Brüns (Munich: Wilhelm Fink, 2008), 143–156.

rather, it manifests itself in the sensuous, material world of things, *in der Sinnenwelt* (43; 105).

Therefore, although the things Frau Margret sets aside seem at first to make up a more stable collection than is found in the junk shop, these things too end up participating "in the changing outward phenomena" (43; 105) that characterizes this "world of the senses." They are, in other words, no less susceptible to the vicissitudes of material existence than is her rummage. In fact, despite the talismanic dynamism of the things Frau Margret keeps for herself, she has no compunction letting some of them go. Her personally collected things, then, are just as much a part of the "trade and transformation" (*Handel und Wandel*) of the junk queen's undertaking, especially when she sees the possibility of making a considerable profit ("if the profit was more than usually large")—which was "often the case" for the baubles, medallions, and jewelry she keeps in an ebony "chest" (*Truhe*), we are told—even though she holds "a great fondness" for these trinkets. And yet it turns out that this selling-off of collected things ultimately has little to do with material want. Her system of exchange maintains a steady influx of provisions—"Field produce and tree fruit of every kind, milk, honey, grapes, ham and sausages were brought her in heavily-laden baskets, and these stores were the foundation of a life of dignified ease" (41; 103)—that satisfy her and her husband's basic needs so that whatever profits accrue are not actually needed for subsistence. Neither are these earnings reinvested ("she invested no money in return for interest," 41; 102); Margret instead hoards them in the form of gold (51; 115), which seems to be her most stable collection, even though it too is ultimately also—even if rarely—used as capital for a special venture or loan (41; 102).

In the end, however, all these things—perishable provisions, trinkets, junk, and even the gold—are shown to be dispersed back into the world from which they came, further belying any stability that Margret's various forms of safekeeping might have intimated. After her death, a hoard of relatives arrives to take their share of goods. Much to their chagrin, Margret had left everything to an unassuming young man who had frequented her evening gatherings; he takes away everything that is useful and valuable, only leaving behind

"the store of provisions and the dead woman's collection of curi-osities and books" (55; 120). This division of Margret's accumu-lated things into what is supposedly important and what is dispos-able or trivial, however, is undermined in the final fate that befalls them. For the young heir immediately sells his inherited collectables to a junk dealer and the precious metals to a goldsmith (56; 120–121) who melts them down. They thus reenter the circulation of things that Margret had initially mobilized and perpetuated. The re-maining trinkets and trivialities at first appear to escape this fate, taken up as they are into the homes of the various relatives, who are intent on preserving them as keepsakes. This inheritance, how-ever, does not bestow stability, order, and unity on a set of scattered things so much as it splits up and disperses what had been collected, as Heinrich's diction makes explicit: the disappointed inheritors, having come from places "*scattered* about the country" (54; *welche im Lande* zerstreut *wohnten,* 119, my emphasis), undertake jour-neys back home in a movement that replicates this dispersal: "Then gradually they *dispersed*" (55; Sodann *zerstreuten* sie sich allmählich, 120, my emphasis). By coming to rest in the homes of distant rela-tives, Margret's things may—at least temporarily—avoid the fate of being shuffled from place to place via the mechanisms of exchange, but they only arrive in these homes by way of a trajectory that is no less precarious and ultimately no less destructive.

Consider, for example, the description that follows directly after the phrase, "then gradually they dispersed," in which Heinrich char-acterizes this relocation of things as a process not only of dispersal but also of disintegration:

One carried on his *shoulder* a lot of books of heathen and idolatrous lore, tied together with an excellent piece of rope through which a stick was thrust, and under his *arm* was a little bag of dried plums; another hung a picture of the Blessed Virgin on the staff he carried across his *back*, and on his *head* he balanced an ingeniously carved chest, all its compartments cleverly filled with potatoes. Tall, skinny old maids car-ried delicate, old-fashioned wicker baskets, and gaily painted boxes filled with artificial flowers and tarnished tinsel trappings; children were lug-ging waxen angels along their *arms*, or carrying Chinese jars in their *hands*; it was like seeing a crowd of iconoclasts coming away from a

plundered church. Yet each one of them intended to keep his booty as a worthy memento of the departed. (55; my emphases)

Der eine trug eine Partie Heiden- und Götzenbücher auf der *Schulter*, mit einem tüchtigen Stricke zusammengebunden und mit einem Scheite geknebelt, und unter dem *Arme* ein Säcklein getrockneter Pflaumen; der andere hing ein Muttergottesbild an seinem Stabe über den *Rücken* und wiegte auf dem *Kopfe* eine kunstreich geschnitzte Lade, sehr geschickt mit Kartoffeln angefüllt in allen ihren Fächern. Hagere lange Jungfrauen trugen zierliche altmodische Weidenkörbe und buntbemalte Schachteln, angefüllt mit künstlichen Blumen und vergilbtem Flitterkram, Kinder schleppten wächserne Engel in den *Armen* oder trugen chinesische Krüge in den *Händen*, es war als sähe man eine Schar Bilderstürmer aus einer geplünderten Kirche kommen. Doch gedachte ein jeder seine Beute als ein wertes Angedenken an die Verstorbene aufzubewahren. (120–121; my emphases)

This catalog of people and things begins by emphasizing the distinct body parts that are engaged in transporting the goods: shoulder, arm, back, head, and hands. Such disarticulation of limbs, trunk, and head marks the process of dispersion as one of dismemberment. Margret's collection, whatever its prior integrity, is here dealt a final blow that undoes any lingering sense of wholeness or stability: its pieces are split up and scattered much like the junk queen's own remains. This disassembling (of collection and of body) furthermore doubles as a desacralization, as announced in the metaphor of religious iconoclasm, which figures Margret's junk shop as a sacred space that is looted, disfigured, even defiled: "like seeing a crowd of iconoclasts coming away from a plundered church." By comparing the procession of inheritors with the iconoclastic fury of the sixteenth century, Keller suggests that the quasi-magical thing-power of Margret's remaining rummage does not survive its transplantation to a new space. Bereft of the mystical meaning bestowed on them by Margret, these things now take on a different, secular power: as "mementos," they preserve the memory of the departed.

The diction of the final sentence quoted in the preceding extract, however, calls even this power into question, implying that the looters only expected or "intended" (*gedachte*) to be able to set aside and preserve Margret's memory with her things, but that such preservation would not really be possible. Her memory would fade, the

things themselves being insufficient containers. Of course, things themselves do not actually *contain* memories; they occasion them.[15] And yet the notion of containment looms large over this passage, as indeed it does over the Margret section as a whole, which abounds with receptacles of various kinds that complicate the relationship between gathering, dispersal, and preservation. Consider, for instance, the different media for storing and transporting the inheritors' "booty" found in the extract: from the "little bag" one of them carries under his arm and the decorative "chest" with multiple "compartments" that the other balances on his head to "wicker baskets" and "painted boxes," as well as "Chinese jars." These receptacles ostensibly aid in the collection, safekeeping, and—potentially—preservation of things that would otherwise be scattered, lost, and ultimately reclaimed by the earth. And yet although each device promises resistance to, or even a remedy for, such dispersion, these vessels also serve as the very media of dispersion itself. It is precisely by means of these containers and repositories that Margret's leftover curiosities become spread out among the quarreling relatives. Gathering and dispersal, finally, appear here to coincide, as they do in Margret's realm as a whole.

This inextricability of gathering and dispersal runs deeper than their interdependence as conceptual—and practical—counterparts. Although it is true that gathering requires dispersion—if for no other reason than that in the absence of scattered things the activity of gathering would be unnecessary—it is also true that we gain epistemic access to this scattered state of things in and through the activity of gathering. To collect—as I have been arguing throughout this book—is not just to combat but also to mediate dispersal, to make palpable that which *would otherwise* be or *once was* scattered and which "naturally"—like all things—tends toward entropy. Furthermore—and this is the paradox to which Keller's text in particular alerts us—gathering is complicit in the very thing it seeks to remedy, because to gather together always also involves the re-

15. On the role of memory and the object (souvenir), see Stewart, *On Longing*, 132–151.

distribution of that which it means to keep in place, to contain, to hold on to. Gathering, after all, entails removing something from where it was found and situating it in a new space. Such transferral, then, although ostensibly in the service of granting an object place and thereby establishing order and meaning, in fact always leads to its displacement.

Saving or Sacrifice? Heinrich's Collections

These paradoxes—variations of which we have been exploring in the previous case studies—need to be kept in mind as we turn from the fate of Margret's things to the ways in which Heinrich too participates in different kinds of gathering and dispersal. The most important of these types relates directly to the junk queen's curiosities, their influence on the young Heinrich, and the question of their containment. Indeed, the degree to which Frau Margret's ultimately scattered collections play a decisive role in Heinrich's early development can be measured by his own capacity to contain her things, which not only "stuffed full" (39; 100) the open hall of her junk shop and the nooks and crannies of her home but in an importance sense also "fill" the container that is Heinrich's imagination. Keller signals Heinrich's status as such a repository at the beginning of the Margret chapter (I.6), where we learn that the spiritual crisis related in the previous chapter has left him in a state of emptiness: not only is his heart unable to be "filled" (*erfüllt*) with God's "tenderer feelings or intense spiritual joy" but his "imagination" also remains "barren" (38; *leer*, 99) as a result of his mother's "dutifully pious" Bible readings.

The cure for this spiritual and imaginative vacuum comes in the form of Heinrich's friendship with Margret, whom Keller introduces by immediately emphasizing her capacity to "fill up" a space characterized by being "dark" and "open":

> Meanwhile I had formed a friendship which came to the assistance of my questing fancy and delivered me from these barren torments, for my

mother being so simple and sober, it became to me what in other cases grandmothers and nurses with their store of legend are to the children who need such material for thought. In the house opposite was a spacious dark hall entirely stuffed full with old and new odds and ends. (39)

Indessen hatte ich eine Freundschaft geschlossen, welche meiner suchenden Phantasie zu Hülfe kam und mich von diesen unfruchtbaren Quälereien erlöste, indem sie, bei der Einfachheit und Nüchternheit meiner Mutter, für mich das wurde, was sonst sagenreiche Großmütter und Ammen für die stoffbedürftigen Kinder sind. In dem Hause gegenüber befand sich eine offene dunkle Halle, welche ganz mit altem und neuem Trödelkram angefüllt war. (100)

It is Heinrich's inner life, then, left un(ful)filled by his mother and her puritanical austerity, that becomes an ideal empty vessel to be loaded up with Margret's curiosities. Here as elsewhere in the chapter, however, the line between the intangible "material" (*Stoff*) of these tales and the tangible trifles and trinkets (*Trödelkram*) of Margret's trade becomes blurred.[16] The novel flags this confusion as a symptom of Heinrich's inability to separate fantasy from reality, a shortcoming for which Margret shares responsibility, and which he will spend a good portion of the novel trying to overcome. We thus see, for instance, how Heinrich treats Margret's actual things as both props and material evidence for the stories and esoteric beliefs the junk queen and her husband propagate:

Thus he [that is, Margret's husband] was the perfect complement of his wife in her imaginative capacity, and in this manner I had the opportunity of scooping [*schöpfen*] straight from the source what otherwise is served out to the children of educated classes in their books of fairy lore. Even if the material [*Stoff*] had not the pure and graceful naiveté of these books and was not calculated to teach such an innocent and childlike moral, nevertheless it always contained some human truth, and, especially as in Frau Margret's diverse collection of merchandise there was a rich mine that satisfied one's physical sense of perception, it certainly made my imagination somewhat precocious and susceptible to strong impressions, something after the fashion in which the children of the

16. In this passage, the key word is *stoffbedürftig* ("children who *need* such *material*"); see also the next two quoted passages, 50; 114 and 57; 122. In the latter, *Stoff* doubles for "fabric." (Holt's translation elides the word *Stoff*, though I add it to my modified version.)

people become early accustomed to the strong beverages of adults without being spoiled. (50–51)

Auf diese Weise ergänzte er trefflich das phantastische Wesen seiner Frau, und ich hatte so die Gelegenheit, unmittelbar aus der Quelle zu schöpfen, was man sonst den Kindern der Gebildeten in eigenen Märchenbüchern zurechtmacht. Wenn der Stoff auch nicht so rein und zierlich unbefangen war, wie in diesen, und nicht für eine so unschuldige kindliche Moral berechnet, so enthielt er nichtsdestoweniger immer eine menschliche Wahrheit und machte, besonders da in dem vielfältigen Sammelkrame der Frau Margret eine reiche Fundgrube die sinnliche Anschauung vervollständigte, meine Einbildungskraft freilich etwas frühreif und für starke Eindrücke empfänglich, etwa wie die Kinder des Volkes früh an die kräftigen Getränke der Erwachsenen gewöhnt werden, ohne zu verderben. (114–115)

The concrete things in Margret's "collection of merchandise" combine here with the insubstantial "material" (*Stoff*) recounted by her and her husband to form one fantastical reality that the young Heinrich takes in as if it were a fluid—that substance whose "collection" depends on a vessel to keep it in one place, to prevent its seeping away; in other words, to contain it. Heinrich first compares his absorption of Margret's tales and superstitions to "scooping" (*schöpfen*) some liquid from its source or stream (*Quelle*) before shifting to another variant of the metaphor in which taking in Margret's fantastical "material" amounts to an imbibing of intoxicating drink. In each case, Heinrich figures the stories and fables he gathers from the junk queen's realm as unstable, fluctuating "material," which complements the picture of her world as one of exchange and mutability. Margret emerges here as the medium of transmission, gathering together both narrative and concrete material not to preserve it but to pass it on, to send it down the stream so that it might serve as a productive source (*Quelle*) for the young Heinrich.

But what Heinrich at first produces with this fluid matter is equally as insubstantial. The things he has "scooped" (*schöpfen*) from Margret may be the raw material from which he "creates" (*schöpfen*) something new, but that something lacks concrete contours and thingly tactility, being merely the ephemeral fabrications of the imagination. The emphasis Heinrich continues to place on the substantiality and tangibility of the things he takes

from Margret seems ultimately to be undermined by this final, fantastical product:

> I used to go now and again [to Margret's house], eat or drink what I liked, sit down in a corner, or, when anything was happening, stand in the midst of the bargaining and commotion. I fetched books out, and demanded whatever I wanted among the objects of interest, or played with Frau Margret's jewels. The different persons who came to the house all knew me, and everyone was friendly to me, since this was pleasing to my patroness. I never did much talking, however, but I took care that none of the things that happened should escape my eyes and ears. Then laden with all these impressions I would cross the road and go back home where, in the quiet stillness of our sitting-room, I spun the material into a vast dream-fabric, my excited imagination setting the pattern. (57)

> Ich ging ab und zu, aß und trank, was mir wohlgefiel, setzte mich in eine Ecke oder stand mitten unter den Handelnden und Lärmenden, wenn etwas vorfiel. Ich holte die Bücher hervor und verlangte, wessen ich von den Sehenswürdigkeiten bedurfte, oder spielte mit den Schmucksachen der Frau Margret. Alle die mannigfaltigen Personen, welche in das Haus kamen, kannten mich, und jeder war freundlich gegen mich, weil dieses meiner Beschützerin so behagte. Ich aber machte nicht viele Worte, sondern gab acht, daß nichts von den geschehenden Dingen meinen Augen und Ohren entging. Mit all diesen Eindrücken beladen, zog ich dann über die Gasse wieder nach Hause und spann in der Stille unserer Stube den Stoff zu großen träumerischen Geweben aus, wozu die erregte Phantasie den Einschlag gab. (122)

For Heinrich, the actual things Margret has taken up into her private collection (books and jewels) mix together with those other "things" that—like so much of the material stuff in her realm of rummage—pass through her home, which in this case also consist of the events that unfold there, along with the people who visit and the stories they tell. Heinrich treats this array of input indiscriminately as sensory "things" that require "eyes and ears" to perceive and that might slip away from him if he is not vigilant. The diction of this passage figures the boy's activity of gathering and storing these various "things" as if they were objects: "laden" (*beladen*) with them, he takes them home, where he treats them as tangible and malleable "fabric" (*Stoff*—the same word as "material" in the previously discussed passage) to be worked with. The end result of

this labor, however, seems to be a refinement of materiality to its least substantial form: the fabric is "spun" out to diaphanous gossamer, the stuff of dreams. In his role as vessel, Heinrich may be "stuffed full" with Margret's things, but he does not quite know what to do with what he has stored. To simply hold on to this stuff as he receives it—without being compelled to transform or transfigure it—is not yet a viable option for him. On the one hand, this limitation is necessary to the trajectory of Heinrich's *Bildung* in the novel: his proclivity for the fantastical needs to be cured as he grows up, the trappings of Romanticism traded in for the sober eye of the Realist.[17] On the other hand, this inability to "hold on" to what he gleans from the world around him will, as we will see, continue to characterize his subsequent efforts at managing actual objects, despite his concerted efforts to safeguard them.

It appears, then, that the boy is not ready for Margret's curios—as the metaphor of drinking alcohol at a young age suggests—because he is unable to maintain the difference between this concrete world of things and the imaginary qualities ascribed to them. He treats objects and things as instruments whose only significance lies in allowing him access to an insubstantial world of fantasy in which they have no place. And yet at the same time it is clear that Heinrich longs for contact with mere matter in all its tangibility, messiness, and dirtiness. As he puts it, "I had need of something material" (67; *Ich bedurfte eines sinnlichen Stoffes*, 135), some actual objects to initiate him into a tactile engagement with the immediate world around him. This desire is what led him to Margret in the first place, where Heinrich sought refuge from his mother's oppressive puritanism and unwavering emphasis on the world of the spirit. Indeed, it is

17. This describes a common reading of Heinrich's development. See, for example, Gail K. Hart, *Readers and Their Fictions in the Novels and Novellas of Gottfried Keller* (Chapel Hill: University of North Carolina Press, 1989), 22–23. Hart, however, argues for a more nuanced picture of what elements of the imaginative life still need to be held on to. For a reading that rejects this model, see Eric Downing, *The Chain of Things: Divinatory Magic and the Practice of Reading in German Literature and Thought, 1850–1940* (Ithaca: Cornell University Press, 2018), 36–120. Downing argues that the "enchanted world"—locatable in the "attunements" between subjects and objects and between people and things—is essential to Keller's realism.

again his mother's insistence on only telling him stories and not pro-
viding him with any actual toys to play with that precipitates Hein-
rich's attempts first to build and then to gather his own objects so as
to satisfy this other desire. If earlier his mother's Bible readings had
left him intellectually and imaginatively "barren" or "empty," Hein-
rich is now left empty-handed. Margret may help stimulate and thus
(ful)fill his empty inner life, but it is only in partial imitation of her
accumulations of actual things that Heinrich can remedy his own
lack of sensory engagement with the world of objects and things.

Heinrich initially attributes this lack to the absence of a father
or other specifically male role model who could "teach me manual
dexterity and the arts" (67; 135). And although the lack of a male
figure seems to force Heinrich into forging a developmental path
alone, his subsequent experiments in constructing and then collect-
ing objects clearly emerge from his acculturation in the world of
Margret's rummage shop.[18] The junk queen thus assumes the po-
sition of heterodox maternal mentor, whose displays of storage and
safekeeping radically undermine the normative role of the mother
as figure of security, protection, and indeed enclosure. In fact, Hein-
rich's collections ultimately fail because he is unable to apply to
his own efforts the logic that governs Margret's idiosyncratic mode
of gathering. Thus, even though Heinrich's experiments with col-
lecting serve as homages to Margret's clutter of curiosities and junk
assemblages, they also differ starkly from these accumulations,
which are uncontained and allow for exchange and mutability.
Heinrich's experiments come closer to resembling the classical col-
lection. He sets out to fix and enclose the items he gathers, even
though this ends up leading to equally problematic consequences.
If Frau Margret's anti-collections demonstrate the inextricability of
dispersal and gathering, Heinrich's amateur collections push this
conclusion to one extreme, dramatizing the consequences of resis-
tance to dispersal, of insisting on holding on to the things one has
gathered, of storing them in ways that do not allow for the kind of
movement and circulation that characterized Margret's world of
things.

18. On the missing male role model, see Grätz, *Musealer Historismus*, 251.

Heinrich first tries collecting stones, which he gathers from the deposits left behind by streams and rivers. But it is not only "shining and multi-colored minerals, mica, quartz, and colorful pebbles" (67; 136) that he collects. Like Frau Margret, he also indiscriminately gleans anything whose "outer appearance" (68; *der äußere Schein*, 136) appeals to him, including worthless debris: "Glittering bits of slag, thrown out from the smelting works into the water, I thought were valuable fragments, glass beads I took for precious stones and Frau Margret's second-hand goods yielded me some junk [*einigen Abfall*] in the form of polished bits of marble and semitransparent alabaster scrolls, which besides were shot through with the glory of antiques" (67; 136). It should thus come as no surprise that Margret's "junk" too finds a place in this new collection, where Heinrich elevates it from its status as "fallen" and "worthless" (*Abfall*). It is as if her fluid storehouse provided an alternate source of flotsam and jetsam in a kind of terrestrial stream. All these hard objects the boy washes and dries in the sun before sorting and ordering them in preparation for finally storing them on beds of cotton inside "cases" that he has constructed just for this purpose (68; 136). To these "shelves and containers" he then attaches "labels bearing wonderful descriptions" (67; 136) in the manner of a curiosity cabinet or natural science display.

The various boxes that Heinrich constructs and uses belong to the larger motif of containment, adumbrated earlier, that plays a key role in the novel. Here they signal a distinct pretension to scientific inquiry that ends up being, in Heinrich's eyes, the root cause of the collection's failure. For he soon realizes that his pebbles and rocks have no actual value as scientific specimens, let alone as precious stones. They are utterly trivial and in some cases not even proper stones, but just hard inanimate matter such as glass. It is, peculiarly enough, their mere appearance that fascinates Heinrich and drives his collecting:

But it was only the outer appearance of it that pleased me, and when I saw how those other boys had a special name for each stone, and also possessed many remarkable ones inaccessible to me, such as crystal and ore, and grew to understand them too in a way that was beyond me altogether,

then the enjoyment died off for me, and saddened me. At that time I could not endure to see anything dead and discarded lying around; what I could not make use of, I hastily burnt or removed to a distance, so one day I laboriously carried the whole load of my stones down to the river, sank them in the waves, and went home quite mournful and dispirited. (68)

Allein es war nur der äußere Schein, der mich erbaute, und als ich sah, daß jene Knaben für jeden Stein einen bestimmten Namen besaßen und zugleich viel Merkwürdiges, was mir unzugänglich war, wie Kristalle und Erze, auch ein Verständnis dafür gewannen, welches mir durchaus fremd war, so starb mir das ganze Spiel ab und betrübte mich. Dazumal konnte ich nichts Totes und Weggeworfenes um mich liegen sehen, was ich nicht brauchen konnte, verbrannte ich hastig oder entfernte es weit von mir; so trug ich eines Tages die sämtliche Last meiner Steine mit vieler Mühe an den Strom hinaus, versenkte sie in die Wellen und ging ganz traurig und niedergeschlagen nach Hause. (136)

This passage suggests that what Heinrich values about these stones is precisely their lack of conventional value. He admires the stones in their mere appearance—their triviality. He becomes frustrated only when he sees others bestowing knowledge on their collections; in other words, importance. In part he recognizes that his collection is utterly dilettantish, unsystematic, and without purpose.[19] These stones are an attempt to hold on to what never lasts in Margret's junk shop, that site of exchange. Heinrich's endeavor to gather and preserve is an effort to overcome this circulation of objects while also indulging in the pleasure he takes in their mere appearance.[20] This is an unusual pleasure, however, because it is directed at what he insists on describing as "dead and discarded." Like Frau Margret, Heinrich gathers the shards and worn pieces that have no value. And he enjoys them as such, at least until he discovers that—from the perspective of the other children (who represent normative behavior)—he should be gathering what is valuable in order to acquire knowledge. He has been gleaning what pleases him, with no care for value but only for surface appearance. Like Margret's books, their value has little to do with what knowledge they might

19. Grätz, *Musealer Historismus*, 250.
20. Katharina Grätz writes that Heinrich displays a way of dealing with things that is "pre-rational." Grätz, *Musealer Historismus*, 250.

contain or inspire. Heinrich is engaged in salvaging what the waters have scattered and what would otherwise be overlooked and forgotten—even by his fellow stone collectors. His eventual rejection of this activity in turn leads to his refusal to hold on to anything, not just stones: he either burns, disposes of, or repurposes the things around him in an apparently complete rejection of the aesthetics of salvage. Heinrich fails in this first attempt to establish a collection, because he let himself be pressured by his peers to reject his method of collecting as inadequate, when in fact it is a variation on the activity he learned from Frau Margret.

Where with his stones it is Heinrich's own enjoyment that in the end "dies off" (68; 136), in his next two attempts at collecting it is the death of the items collected that precipitates the end of his hobby. First, he tries establishing a collection of butterflies and beetles. This process, however, requires exerting violence, which ultimately leads not just to the demise but also the destruction of his specimens. Heinrich begins by gathering caterpillars, which he places, as he says, "in captivity." Because he does not feed them properly and they consequently fail to transform into butterflies, he then tries to capture live butterflies. That naturalia such as insects need to be killed to be preserved in a collection leads in Heinrich's hands to something far more violent. These animals, he explains,

> gave me a lot of trouble in their killing and unscathed preservation; for these delicate creatures manifested a tenacious hold on life in my murderous hands, and by the time they were finally lifeless, their fragrance and color were destroyed and lost, and on my needles were ranged a mangled company of pitiable martyrs. (68)

> machten mir saure Mühe mit dem Töten und dem unversehrten Erhalten; denn die zarten Tiere behaupteten eine zähe Lebenskraft in meinen mörderischen Händen, und bis sie endlich leblos waren, fand sich Duft und Farbe zerstört und verloren, und es ragte auf meinen Nadeln eine zerfetzte Gesellschaft erbarmungswürdiger Märtyrer. (137)

That it might be possible to combine "killing" with "unscathed preservation," as if these acts somehow complemented each other, expresses the fundamental paradox of collecting that we explored in more detail in chapter 2. Keller here dramatizes the loss of the object

necessary for its entry into the collection with a vivid, though familiar, example that literalizes the logic of sacrifice at the activity's core.[21] In this case, however, the living thing is not just killed in order to be collected but is also dismembered. Unlike Margret, then, who merely collects what is "dead and discarded," Heinrich here *creates* it in and through the act of collecting. If in its classical conception, the collection is intended to restore what is dispersed to a state of unity, Keller offers us a modern paradigm of the undertaking, suggesting that the collected things ultimately coincide more with dispersal than with any such wholeness, that the achievement of this putatively restorative activity finally generates more scattered remains.

And as the logic of sacrifice dictates, these remains are also sacralized. Heinrich, as he had done with Margret's "looted" plunder, ascribes religious significance to the immobilized insects, whose killing resembles a crucifixion—skewered as they are on needles—and whose fate is to be "martyrs." Befitting this martyrdom, the insects' remnants—their "miserable remains" (*unseligen Reste*)—become relics, serving an important memorializing function within the economy of the collection. But when Heinrich then notes that they have become "the memorial of some day's adventure in the open air" (*das Denkmal eines im Freien zugebrachten Tages und eines Abenteuers*), it is unclear whether this remembered free movement belonged to the butterflies or to himself, out on the hunt for them. And when he writes that they continue to "reproach" (68; 137) him for his murderous actions, one wonders whether they are not just *unselig* because of their "miserable" state but that they are also, in fact, unholy (*un-selig*) or even cursed relics.[22] In any event, Heinrich wishes to forget, not to remember. His experiment with these

21. On the logic of sacrifice and the collection, see Susan M. Pearce, *On Collecting: An Investigation into Collecting in the European Tradition* (London: Routledge, 1995), 24–25.

22. Of this rebuke—they "spoke to me in a language of reproach"—Kerstin Roose notes that despite being described as "mute remnants" (*die stummen Überbleibsel*), they are nonetheless capable of speech. Roose, "Zwischen 'unseligen Resten' und literaturfähigen 'Abfällseln': Spuren einer Poetologie des Plunders im Werk Gottfried Kellers," in *Entsorgungsprobleme: Müll in der Literatur*, ed. David-Christopher Assmann, Norbert Otto Eke, and Eva Geulen, special issue, *Zeitschrift für deutsche Philologie* 133 (2014): 190–191.

insects, however, demonstrates that the collection cannot erase origins any more than it can preserve an object "unscathed."[23] One might even say that this particular collection in fact succeeds precisely *because* it fixes and safeguards material objects in the very state of destruction required for this immobilization and preservation in the first place and that as such "unholy relics" they also preserve a memory of the free movement necessarily lost in the process—whether that be the freedom of the insects or of the collector in search of his collectable things.

Heinrich nonetheless calls the whole undertaking a "failure," primarily because he discovers the possibility of collecting living things that does not require destruction: "This enterprise too ran aground [*scheiterte*] at last, when I saw a big menagerie for the first time" (69; 137). The ostensible failure in gathering and preserving butterflies thus leads to a final attempt to establish a collection with live animals. Here too the attention is initially given to the devices needed to contain the creatures:

> At once I made a resolution to found a menagerie myself, and I constructed a number of cages and cells. To do this, I very industriously adapted small boxes, manufactured some out of pasteboard and wood, and stretched in front of each a fencing of wire or string according to the strength of the creature destined for it. The first inhabitant was a mouse, which was conducted from the mousetrap to its cage with all the ceremony which would attend the installation of a bear. Then followed a young rabbit, a few sparrows, a blindworm, a larger snake, several lizards of varying color and size; soon a great stag-beetle together with many other beetles were languishing in the receptacles which were piled neatly one upon another. (69)

> Sogleich faßte ich den Entschluß, eine solche [Menagerie] anzulegen, und baute eine Menge Käfige und Zellen. Mit vielem Fleiße wandelte ich dazu kleine Kästchen um, verfertigte deren aus Pappe und Holz und spannte Gitter von Draht oder Faden davor, je nach der Stärke des Tieres, welches dafür bestimmt war. Der erste Insasse war eine Maus, welche mit eben der Umständlichkeit, mit welcher ein Bär installiert wird, aus der Mausefalle in ihren Kerker hinübergeleitet wurde. Dann folgte ein junges Kaninchen; einige Sperlinge, eine Blindschleiche, eine größere Schlange,

23. Recall that for Stewart the collection succeeds only by eliminating "labor and history." Stewart, *On Longing*, 160.

mehrere Eidechsen verschiedener Farbe und Größe, ein mächtiger Hirsch-
käfer mit vielen andern Käfern schmachteten bald in den Behältern,
welche ordentlich aufeinander getürmt waren. (137–138)

Containment now becomes a necessary element of the collection,
because without these different cages and cells, the animals would
escape from their captivity and be dispersed. Technologies of con-
tainment thus become essential to maintaining not just (as with the
stones) the order but also the integrity of the collection as such. They
establish the spaces in which objects can assume their new status
as things, fixed in place and removed from the world from which
they were taken.[24] The containers Heinrich builds here therefore
offer an alternative to complete immobilization, which would other-
wise have to be accomplished, as with the butterflies, by killing the
animals. When one spider manages to escape and crawl over his
hand and clothes, Heinrich's interest is only heightened (69; 138),
because this experience makes palpable the very challenge of his col-
lection that it in part accomplishes, however imperfectly: to keep
in a state of relative fixity things otherwise animate and inclined not
just to move about but also to scatter.

Yet Heinrich soon learns that this alternative to complete immo-
bilization is unsustainable and leads to the same unacceptable re-
sult that had marred his insect collection, namely death and dis-
memberment:

The mouse had gnawed its way out long ago and vanished, the slow-
worm had been broken long since, as also had the tails of my collection
of crocodiles [as Heinrich imagines the lizards], the little rabbit was skin
and bone, like a skeleton, and yet there was no longer room enough in
his cage for him, all the rest of the creatures were dying off and made
me so melancholy that I determined to kill them and bury them. I took
a long, thin piece of iron, heated it red-hot, and with a trembling hand I
thrust it through the grating and began to perpetrate a dreadful massa-
cre. But I had grown fond of all of them, and also I was so horrified at
the convulsive movements of the organism that I was destroying, that I
had to stop. I hurried down into the courtyard and dug a grave at the
foot of the little mountain-ash trees, cast the whole collection headlong

24. On containment and the collection, see Stewart, *On Longing*, 159.

into it, in their boxes, dead, half-dead and living, and hastily interred them. My mother said, when she saw what I had done, that I ought simply to have carried the creatures back to the open fields where I had caught them, and perhaps they might have recovered there. I saw the reasonableness of this and repented of my action; but the yard had long become a gruesome site for me, and I never dared obey the childish curiosity which always urges one to dig up and inspect anything that has been buried. (69–70)

Die Maus hatte sich längst durchgebissen und war verschwunden, die Blindschleiche war längst zerbrochen, sowie die Schwänze sämtlicher Krokodile, das Kaninchen war mager wie ein Gerippe und hatte doch keinen Platz mehr in seinem Käfig, alle übrigen Tiere starben ab und machten mich melancholisch, so daß ich beschloß, sie sämtlich zu töten und zu begraben. Ich nahm ein dünnes langes Eisen, machte es glühend und drang mit zitternder Hand damit durch die Gitter und begann ein greuliches Blutbad anzurichten. Aber die Geschöpfe waren mir alle lieb geworden, auch erschreckte mich das Zucken des zerstörten Organismus und ich mußte innehalten. Ich eilte in den Hof hinunter, machte eine Grube unter den Vogelbeerbäumchen, worin ich die ganze Sammlung, tote, halbtote und lebende, in ihren Kasten kopfüber warf und eilig verscharrte. Meine Mutter sagte, als sie es sah, ich hätte die Tiere nur wieder ins Freie tragen sollen, wo ich sie geholt hätte, vielleicht wären sie dort wieder gesund geworden. Ich sah dies ein und bereute meine Tat; der Rasenplatz war aber lange eine schauerliche Stätte für mich, und ich wagte nie jener kindlichen Neugierde zu gehorchen, welche es immer antreibt, etwas Vergrabenes wieder auszugraben und anzusehen. (138–139)

We see here how keenly aware Keller is of the paradoxes set in motion by the activity of collecting. The very means used to maintain the menagerie have led to its disintegration. Life cannot persist in captivity and thus either breaks free or succumbs. Heinrich's response to the collapse of his collection is not to attempt to save it (by constructing better cages and keeping the animals better fed) but to participate in the destruction by slaying as many of the animals as he can and then burying them (dead or alive) in the ground. In an ironic twist, the cages and boxes meant to maintain the collection become coffins in which each animal is interred—another perverse (and, it seems, inevitable) manifestation of the imperative to preserve by means of containment.

Heinrich appears unable to imagine the alternative of saving the animals by freeing them from their cages, cells, and boxes, as his

mother later suggests. It is such an apparent *inverse* of collecting that would in fact preserve the things collected: to relinquish the objects of his collection to where they belong, uncaptured in the wild.[25] With this recommendation, Heinrich's mother becomes aligned with Margret as a principle of (ex)change and movement, leaving behind a salient sense that maternal protection necessitates abjuring containment. In following their advice, Heinrich would, of course, have to remove himself from any active role in the process of collecting, which explains why he ignores them. Instead, he can only decide between maintaining the menagerie, which, even were he to succeed in keeping the animals captive, appears to have dire consequences for these creatures (and thus for the success of the collection), or destroying the menagerie entirely, which is to establish another kind of collection in the grave of dead creatures. He chooses the latter, and the place where he finally buries his collected animals is made memorial, becoming an almost haunted space, a "gruesome site" that keeps Heinrich from digging it up again, demonstrating finally that the ostensible destruction of the menagerie did not secure its disappearance but only transformed it into another physical marker of loss.

Salvaging the Worthless

The redemption of these failed experiments comes in a surprising form, one that reveals the movement of gathering, dispersal, and recollection to be one of the driving forces of the novel's narrative. One of the key containers in the story is Heinrich's travel chest or

25. Compare a late, nearly undecipherable poem by Keller titled "Friede der Kreatur" (Peace of the creature), which begins with an image of spiders crawling over the speaker, reminiscent of this episode in *Green Henry*, and ends with the speaker's avowal that if he had a child, "I would bravely teach it / To capture spiders with its little hand / And kindly to release them" (Würd ich's mutig lehren, / Spinnen mit dem Händchen fassen / Und sie freundlich zu entlassen). Quoted in Gerhard Kaiser, "Ein Blick in Kellers Bestarium," in *Dichtung als Sozialisationsspiel: Studien zu Goethe und Keller*, ed. Gerhard Kaiser and Friedrich Kittler (Göttingen: Vandenhoeck & Ruprecht, 1978), 125.

trunk (*Koffer*), which he takes with him everywhere and to which Keller frequently draws our attention, at times in great detail (such as when it is being packed for his initial journey to Germany, 18–21). This trunk, which importantly holds both those things that have meaning for him and "all kinds of worthless nothings" (395; *Wertlosigkeiten*), is itself the space of additional technologies of containment, including little boxes for smaller items (e.g., a "needle case" and a "dainty little box" [20]) and, most significantly, the portfolio (*Mappe*) containing his drawings and etchings, what he calls his "itinerant museum" (*wanderndes Museum*, 21).[26] In what I read as a proleptic allusion to Heinrich's failed animal collections, the trunk is also referred to as a "Noah's ark," once explicitly in the first version of the novel, on Heinrich's arrival in Germany (*Arche Noä*, 56) and twice without reference to Noah in the second version of the novel, before Heinrich departs from home ("little ark," 379, 395; *kleine Arche*, 467, 486).[27] Noah's gathering and safekeeping of animals represent the classical redemptive model of collecting naturalia, contrasting sharply with Heinrich's horrific slaughter. Moreover, Noah does not only collect and preserve but he also does what the young Heinrich would not, which is to let the animals loose. The biblical patriarch thus collects in order to save, though this salvaging can only be carried out by returning the collected creatures to the spaces where they belong—effectively letting them re-scatter.

The narrative that picks up after Heinrich's "Story of My Youth" (*Jugendgeschichte*) ends follows this pattern with profound

26. *Wertlosigkeiten* appears only in Gottfried Keller, *Der grüne Heinrich: Zweite Fassung*, ed. Peter Villwock; *Sämtliche Werke in fünf Bänden* (Frankfurt am Main: Deutscher Klassiker Verlag, 1996), 3:486. The other quotations here (and later) that are missing corresponding citations to the English translation are from the very early parts of the book that do not appear in the novel's second version (they are thus entirely missing from Holt's translation).

27. In the first version of the novel's frame narrative structure, the allusion is proleptic only when considering the discourse of the narrative. It is analeptic when considering the events of Heinrich's life as a chronological sequence. These temporalities are more straightforward in the novel's second version, in which the packing and unpacking of the trunk come after the events of Heinrich's youth have been recounted. There the Noah allusion is thus only analeptic.

consequences for his *Bildung* and for the actual objects he amasses.[28] We get a hint of what will come in the description of his trunk that we read on his arrival in Munich; that is, before the story of his youth begins:

> His enormous old-fashioned wooden trunk stood in the middle of the floor and appeared to be inexhaustible; for aside from the abundant multiplicity of things that his mother had provided for his basic needs, he carried along a considerable supply of other things from which he could not separate himself, even though a good portion had no other value other than that up to then Heinrich had them daily before his eyes and in his hands. He did not yet know the condition in which one jettisons every dispensable book, every little case or box of old ... and unyielding and scared, seeking the future, one keeps on living for years with the crammed luggage of a courier, in rooms that are equally scantily furnished, a bed, a table, a sofa, four chairs, and everything in the miserable elegance similar to what a junk dealer or furniture renter offers, and arranged for the taste of a starving widow.

> Sein gewaltiger altväterlicher Holzkoffer stand mitten auf dem Boden und schien sich nicht erschöpfen zu wollen; denn außer dem reichlichen Vielerlei, womit ihn die Mutter für des Leibes Bedürfnis versorgt hatte, führte er auch einen ziemlichen Vorrat an sonstigen Dingen mit, von denen er sich nicht hatte trennen können, obschon ein guter Teil keinen andern Wert hatte, als daß Heinrich bisher die Sachen täglich vor Augen und in Händen sah. Er kannte den Zustand noch nicht, wo man jedes entbehrliche Buch, jedes Kästchen oder Schächtelchen aus alter Zeit ... über Bord wirft und starr und ängstlich seine Zukunft suchend ... mit dem zusammengepreßten Gepäcke eines Kuriers jahrelang dahinlebt, in Wohnungen, die ebenso knapp eingerichtet sind, ein Bett, ein Tisch, ein Sofa, vier Stühle, und das alles in der jämmerlichen Eleganz, wie sie der Laden eines Trödlers oder Möbelverleihers darbietet und der Geschmack einer hungrigen Witwe zusammenstellt. (55)

Heinrich has gathered his things together, including not only the narrative of his youth but also the events that constitute that narrative (for his telling is a mode of re-collection), and he now unpacks them in anticipation of a new life. And yet, as the narrator suggests, the

28. The inset story of Heinrich's youth provides further evidence of the boy's "desire for collecting" (*Sammlungslust*, 322) beyond the early experiments discussed already.

new narrative trajectory that begins here will involve the gradual loss of the very things that he has just taken out of their "ark," which he will need to "jettison", piece by piece so that he will end up in a place populated only meagerly by the throwaway things of a junk dealer. The several hundred pages of the novel that pick up from this point in the story, in fact, culminate in an episode involving just such a junk dealer, the male counterpart to Margret.[29] By the beginning of the novel's fourth volume Heinrich has already shuffled off a good amount of his belongings and is living in an apartment utterly lacking "a museum-like abundance" (*einer museumartigen Fülle*) and "a tranquility of blissful clutter" (*einer beschaulichen Kramseligkeit*), being instead characterized by "emptiness and absence of decoration" (*Leere und Schmucklosigkeit*, 655). These bare surroundings may at first aid in his painterly productivity, but the art he creates here, too, must eventually be relinquished—and it is the junk dealer who makes this possible. Keller, however, suggests that Heinrich's gradual loss of his possessions—especially his paintings and drawings—is imperative to his development, the proper continuation of that "emptying of his Noah's ark" that began at the start of his mature years.

In ultimately selling his works to the local rummage dealer (*Trödelmännchen*), Heinrich thus participates in a (necessary) dispersal of his collected things.[30] At the beginning, this dispersal happens piece by piece, but by the end Heinrich treats his remaining artworks as scraps and pieces that need to be carefully gathered so that they may be delivered to the junk dealer for re-dispersal: Heinrich had "carefully gathered together [*zusammengesucht*] the last scraps and fragments [*die letzten Fetzen und Fragmente*]" (737). Keller suggests that this act of gathering to disperse constitutes a more authentic and thus, despite appearances, a more successful mode of collecting. Its authenticity stems from Heinrich's willingness to relinquish his

29. In the novel's first version this opening narrative is suspended while we are presented with the "Story of My Youth."

30. I count his created paintings among those collected things. The most noble way to add an item to your collection is to create it yourself, as Benjamin writes of the book collector, with a nod to Jean Paul's Maria Wutz. Walter Benjamin, "Unpacking My Library: A Talk about Collecting," in *Selected Writings*, 2:488; *Gesammelte Schriften*, 4:390.

things, which aligns him with Margret and thereby marks his own artworks as belonging to a similar category of "triviality" that she peddled. This association—which is strengthened by the fact that it is another junk dealer through whom the dispersal of his art takes place—also introduces a critical turn in Heinrich's development. For in letting go of his paintings and sketches he takes the first step toward arriving at the important knowledge that they are not important as works of art. Herein also lies the success of Heinrich's paradoxical collecting-through-dispersal. For in losing his artworks (by selling them to the junk dealer) and thereby recognizing their relative worthlessness, he is able to gain them back, which happens literally in that he finds many of them at the Graf's home near the novel's end and collects the rest from the junk dealer after his death. Heinrich thus relinquishes these works and in this relinquishing is able to re-find them. This "restoration" of the lost paintings and drawings, however, also happens in another sense: in being able to accept their "triviality," their failure to be great works of art, Heinrich reestablishes a meaningful relation to his past strivings by moving beyond them.

This recognition of his art's triviality is perhaps the only actual development in Heinrich's otherwise wayward and unsuccessful *Bildung*. For this reason, once his works are "returned" to him, Heinrich paints some more without any pressure to make great art, and thereafter promptly lets all his paintings and drawings go again, allowing the Graf to keep the old ones and selling the new ones. However, although the latter are indeed all sold, they are not dispersed among multiple buyers but rather collected together again by the Graf, who secretly purchases them to keep for himself (875). Keller thereby slyly sets back in motion the continued dialectic of gathering and dispersal that moves the book toward its close. Ultimately Heinrich's paintings (old and new) are collected together in the end, but only because—unlike with his menagerie—he is able to let them go completely.

This dynamic appears in other parts of the novel too, such as when Heinrich's long love letters to Anna are first burned, then saved, then composed "on an open sheet of paper" that is "laid" in a stream that Heinrich hopes will carry it to the Rhine River and

then out to the ocean. Despite this elaborate scattering via water, the letter finds its way back to the other object of his love, Judith, who saves it among her things (206; 317). Similarly, his later declaration of love to Anna (which contains the best of what Heinrich says "I had gathered [*angesammelt*] in my casual and haphazard [*zerstreuten*] education"—note the conjunction of "collecting" and "dispersal"), a confessional letter that the wind blows into an apiary where it gets stuck and is effectively lost (220–221; 339), also reappears in the hands of Margot, who recites it in front of Anna (237; 360). Much later the letter reappears in Heinrich's dream, where it is preserved in the apiary and returned to him just before Judith swiftly plucks it from his hands (576–577; 763). What is lost is regained but usually in order to be relinquished again.[31] This dialectic, as seen at play in the loss, restoration, re-dispersal, and re-collecting of his art, also describes the unusual path of Heinrich's *Bildung*, which succeeds only by virtue of its failure. The wisdom he has gained in the end is, at best, that he has gained little wisdom—at least in the novel's first version.[32] And yet this lack is redeemed

31. Compare Vedder, "'einige sonderbare Abfällsel,'" 146–147 on "scattered inheritance" (*verwehtes Erbe*) in the novel. Gail Hart identifies an act of dispersal that leads to a return of what was dispersed in the second version of the novel, where Dortchen's poem, written on a strip of paper and scattered to the winds, "returns to him in a potentially seductive form" in the verses found in the stained-glass window of the inn where he and Judith dine. Hart, *Readers and Their Fictions*, 31. For another, though different, reading of dispersal in the novel, see Eric Downing's interpretation of Anna's death, which he sees as precipitating a dispersal of her spirituality and life "into the visible and material things in the natural world," resulting ultimately in "a sense of all-embracing relation and unity." Downing, *Chain of Things*, 110.

32. A less strong version of this claim would be that Heinrich fails as an artist so that he may learn how to be a successful member of bourgeois society. But this integration back into society (in accordance with the classical structure of the *Bildungsroman*) does not come to pass in the novel's first version, which is my main focus in this chapter. In any event, in the second version of the novel, Heinrich also has to recognize the failure of his art in order to arrive at this putative *telos* of his *Bildung*. Ursula Amrein writes that Heinrich's failed life is not fully suspended in the second version but is further illuminated and commented on. Amrein, "Atheismus—Anthopologie—Ästhetik: Der 'Tod Gottes' und Transformationen des Religiösen im Prozess der Säkularisierung," in Der grüne Heinrich: *Gottfried Kellers Lebensbuch—neu gelesen*, ed. Wolfram Groddeck (Zurich: Chronos, 2009), 111. Keller himself wrote that Heinrich's artistic pursuits were "an error [*Irrtum*]." Letter to Hermann

by being worked out in and as his life's story. What is gained, ultimately (both for us and, to a degree, for him), is the narrative— another type of re-*collection*—that preserves even what has been deemed trivial as indispensable elements in the realist reconstruction of a life.

The primary manifestation of that narrative is an object doubly contained: once on the level of the story in Heinrich's travel chest and again on the level of the discourse within the larger telling of Heinrich's life. This is the manuscript of his "Story of My Youth," that final possession of Heinrich's that remains at his lowest point the only thing kept safe in his otherwise empty travel chest ("with his empty trunk, in which alone lay the 'Story of My Youth'" [750]). We are thus led to presume that it is also ultimately the only thing left in there on his return home at the novel's very end. But these story-objects (as manuscript and as embedded story) are only the most consequential narrative stand-ins for the various other "trivialities" that—following Barthes and Moretti—"fill up" the book and that Keller treats as pieces within an even larger container, which is the book itself. The heterodiegetic narrator of the book's first version tellingly begins the novel by describing Zurich and its inhabitants as pieces on display "as if in an open curiosity cabinet [*Raritätenschrein*]" (14). *Green Henry* ends up being Keller's own cabinet of curiosities, displaying with complex sophistication the ways in which maintaining such a container of things significant requires the simultaneous accumulation and exhibition of things trivial and ostensibly worthless. Indeed, the line between this curiosity cabinet and Fontane's junk room disappears the closer we look at Keller's novel and its impulse for containment and dispersal.

A similar claim could be made for much of Keller's other work, especially the novellas collected in *The People of Seldwyla* (*Die Leute von Seldwyla*, 1873–1874), which showcase the social and economic margins of a (fictional) town in a way that asks us to ques-

Hettner from January 5, 1854. Quoted in Grätz, *Musealer Historismus*, 251. On the failure of Heinrich's artistic development and the novel's ultimate disillusionment with respect to its protagonist's development, see also Gerhard Kaiser, *Gottfried Keller: Das gedichtete Leben* (Frankfurt am Main: Insel Verlag, 1981), 135–138.

tion the value of what is ostensibly without value. Kerstin Roose writes that "what society has deemed worthless" turns out to be constitutive of this book's narrative program.[33] We even see this mobilization of "worthlessness" on the level of things, particularly in the novella "The Three Righteous Comb-Makers" (Die drei gerechten Kammmacher), in which we learn about one character's collection of keepsakes as a series of containers emerging within containers. This dizzying proliferation of the various chests, boxes, cases, lockets, and more suggests that in the end what is being held in them is actually really nothing—or indeed nothing but the potential to contain itself. For if it is the collection whose contents have been scattered that represents the most authentic collection, then this ideal would find its consummate expression in the empty containers themselves, the spaces in which things might be gathered but which—by virtue of their emptiness—acknowledge that such collecting is only possible by letting them enter back into the world.

Keller's Junk-Room Realism

Keller is not the only realist in the German tradition who confronts the problem of a world newly inundated with trivial things, as is evident from the conspicuous presence of collectors, scavengers, antiquarians, and junk dealers in texts from the period.[34] These and related figures struggle with the proliferation and fragility of things in diverse ways, serving variously as the sites of exchange and preservation that draw attention to the precarious place and feeble function of marginal material objects. Many of the works themselves are littered with trivial things not only generally but also specifically, with transitory junk, valueless antiques, discarded keepsakes, and

33. Roose, "Zwischen 'unseligen Resten' und literaturfähigen 'Abfällseln,'" 195.
34. See Grätz's discussion of the nineteenth-century figure of the junk man or *Trödelmann*. Grätz, *Musealer Historismus*, 272–273. See also Sabine Schneider, "Vergessene Dinge: Plunder und Trödel in der Erzählliteratur des Realismus," in *Die Dinge und die Zeichen: Dimensionen des Realistischen in der Erzählliteratur des 19. Jahrhunderts*, ed. Sabine Schneider and Barbara Hunfeld (Würzburg: Königshausen & Neumann, 2008), 157–174.

out-of-commission appliances and furniture.[35] These motifs index realism's concern with selection, categorization, and storage; in other words, its obsession with managing the "multifariousness" of the world, which includes the incidental not just in the form of actual objects and things (obsolete and otherwise) but also as scenes, settings, and situations that are subordinate or even superfluous to the main action.[36]

These "fillers" (Moretti), palpable and legible in the nineteenth century more than ever before, emerge as the fabric of ordinary existence. And because such objects, details, and trivialities fill up the world, they ought also to appear—in some way or another—in representations of that world, at least if these are to be commensurate with the everyday reality they purport to portray. Among the realist's arsenal of means for "coming to terms with contingency," as one scholar puts it, is the transformation of the banal and irrelevant into something significant, ordered around an idea, made relevant and aesthetic.[37] At the start of the chapter we saw how such transfiguration of the trivial was indeed a programmatic operation of realism, one that also happens to conform to a classical model of collecting. For Walter Benjamin, too, the transformation of objects-in-the-world into collected things constitutes "transfiguration," the way in which a new context bestows relevance and importance on what is otherwise unassuming. The resulting transformation, however, often obscures the banal origin of things. Once transfigured, after all, fillers cease to function only—if at all—as fillers, such that they disappear into the ordered construct of the work.

35. See Schneider, "Vergessene Dinge," and Kerstin Roose, "'Herzensmuseen' und 'Kammern der Merkwürdigkeiten: Konnotationen des Plunders bei Wilhelm Raabe, Friedrich Gerstäcker und Gottfried Keller," in *Die Grenzen der Dinge: Ästhetische Entwürfe und theoretische Reflexionen materieller Randständigkeit*, ed. Lis Hansen, Kerstin Roose, and Dennis Senzel (Wiesbaden: Springer VS, 2018), 59–85. See also Orlando, *Obsolete Objects in the Literary Imagination*.

36. Ludwig, "Der poetische Realismus," 149.

37. Michael Andermatt, "Kontingenz als Problem des bürgerlichen Realismus: Raumgestaltung bei Fontane und Keller," in *Gottfried Keller und Theodor Fontane: Vom Realismus zur Moderne*, ed. Ursula Amrein and Regina Dieterle (Berlin: De Gruyter, 2008), 43.

Gottfried Keller handles this dilemma by mobilizing an alternative model of collecting that showcases fillers as an index of the everyday in all its contingency and multifariousness while nonetheless keeping them from cluttering the text. Instead of appropriating the marginal and insignificant as necessary features of a mimetic system that ultimately has no room for such trivialities, subsuming them into the tidy collection of the text, Keller carves out spaces for them within this system in which they can pile up and even proliferate. In *Green Henry* these spaces serve as loci for collecting that are marked by both disorder and dispersal. As we have seen, however, the novel warns against keeping these containers sealed tight—against too cleanly dividing order from clutter. Only by allowing for the free movement of objects in and out can the collection proper be achieved; only by constructing the parameters within which dispersal becomes productive can collecting be truly realized. To collect, we learn from Keller, is not so much to overcome the scattered state of things as to convey—and even to participate in—this state. As we saw throughout *Green Henry*, collecting is complicit in dispersal: either the things gathered must be removed from where they belong (and in the process be dismembered), or else the collection must serve primarily—in a Noachian fashion—to aid in re-dispersal, to redistribute things back into the world.

This model of collecting, wherein gathering and preservation are dialectically informed by dispersal, characterizes the key collections in Keller's novel—from Margret's shop to Heinrich's travel trunk (*Koffer*) and art portfolio (*Mappe*)—which become the sites of trivialization and transferal as well as the spaces that both "contain" junk (allowing it to be visible) but do not "contain" it (by fixing it in place). This coincidence of the trivial and the transient (encapsulated in the concept of junk as the *discarded*) is structurally and thematically critical to the novel, instantiated in Heinrich's act of relinquishing his artworks, an act of dispersal that ends in collection and re-collection. In this way the dialectic of dispersal and collecting is inscribed into the narrative logic of the novel as *Bildungsroman*: the ability to recognize triviality becomes *the* epistemic achievement of Heinrich's development. For only by realizing that

his work is trivial and letting it go can he redeem it: his works become important for having led him to the necessary recognition that they are of no real importance. In this way, while working firmly within the realist tradition and engaging with the programmatic concerns of realist aesthetics, Keller locates the solution to the problem of things in a radical form of scattering and in a recognition of the value of what is without value: both bring him in closer alignment with the modernists discussed in this book than with his slightly older contemporaries Stifter and Gotthelf.

Ultimately, the text functions for Keller as a medium of collecting (it is, after all, his "curiosity cabinet"), in which we find various zones between order and dispersion: spaces of dispersion *within* order that allow for disorder to exist while still being kept in check. In this way Keller demonstrates that, despite Fontane's objections, the junk room may in fact be the apposite metaphor to describe one critical operation of realism—at least as he mobilizes it. As the place where things are stored that are not needed but that one does not wish to throw out, the junk room uniquely expresses realism's demand simultaneously to incorporate and exclude the trivial. The junk room represents that dialectical space of removal and preservation where contingency and triviality—without which the everyday cannot be properly conveyed—are stored up and negated but not eliminated. In the junk room things are both held on to and thrown out. Or rather, they are *held on to by being thrown out*—a perfect figure for the paradoxical way in which things are also preserved in Keller's novel as a whole.

Moreover, as in Margret's world of trinkets and trivialities, although the things set aside in the junk room appear to be the casualties of collecting—those leftovers and remnants that decisively do *not* belong to the ordered whole—they also make up their own kind of anti-collection. The junk queen's shop, Heinrich's travel trunk, his portfolio of drawings, the little old junk man's rummage collection—these are the spaces of containment in the novel where the trivial is at once sequestered and preserved, neutralized, and—in the process—reactivated. Like the junk room, these are not static spaces, but those through which things move and to which objects and curiosities can be added as well as excised. These are the spaces

that allow for things to be transferred in and out of the ordered whole from which they are ostensibly separated, ultimately revealing the line dividing the neatly maintained world of functionality and meaning from that of the throwaway pile to be permeable.

In the end, contrary to what Fontane's metaphor might suggest, there is no actual "outside" to realism's handling of rummage, certainly not in Keller's case. Although the trivial may constitute everyday reality, the author does not take it from the world and place it in the work, as would the collector. Rather, the author him- or herself *generates* the trivial as a constitutive element in and of the reproduction of the everyday. The process of containment is thus not a precondition of the text but part of its self-constitution. Writers do not approach the world as already divided into spaces that, on the one hand, hold what is relevant and consequential and, on the other, what is obsolete and incidental. Instead, in their efforts to construct a world that is not just plausible but also necessary, they generate this division themselves. More precisely, the realist puts forth a delimited (because finite and constructed) version of everyday reality in which things are (in one way or another) ordered and meaningful; in doing so, this reproduction of reality allows for that which does not fit into its purposeful pattern to become knowable. In this way, the incidental becomes a necessary byproduct of realism's undertaking, a byproduct that cannot be disposed of lest the distinction to which it owes its existence no longer be operative. Both part of the realm of necessity and meaningfulness and excluded from it at the same time, the incidental and trivial assume a liminal status by virtue of which they can move across these zones.[38]

The result in Keller's work is not "ordering without producing waste," as Kerstin Roose puts it, but the other way around: the process of ordering *involves* the creation of waste. Realism necessarily generates triviality—in other words, junk.[39] It both needs it and

38. On the liminal status of junk and its relation to the process of division, see Roose, "Zwischen 'unseligen Resten' und literaturfähigen 'Abfällseln,'" 177.

39. Roose, "Zwischen 'unseligen Resten' und literaturfähigen 'Abfällseln,'" 196. A similar claim might be made of collecting in relation to the notion of the trivial, which as a concept becomes more prominent with the advent of preservationist collecting.

needs to distinguish itself from it. Without the trivial there would be no justification for realism's main impulse to find a law and ideal in what seems to lack them. Realism thus needs there to be such triviality to overcome, and it needs to overcome this triviality because it cannot allow it to threaten the integrity and truthfulness of the ideal reality it aims to represent. It is in this way that, as Roose rightly says, the literary text can "clean up without throwing out" (*entsorgen, ohne zu entsorgen*), which is to say that it does not just throw unwanted matter away but rather contains and preserves it—*in the junk room*. The realism practiced by Keller, however, also needs the trivial because in *having been* overcome it still remains contained in the work and as such serves as an index of that which (putatively) constitutes reality. The redemption of the trivial thus involves making it visible while keeping it contained—in the collection that is the text.

Dust (*GLAUSER*)

In this final chapter we turn our attention to dust, that most "trivial, meager, petty, scanty, puny, and picayune" of substances, as Joseph Amato writes in his cultural history of the particulate matter, and a substance that is also quintessentially dispersed.[1] Dust is not only the material trace of all things' transience, comprising the withered, pulverized remains of both the animate and inanimate; it is also itself highly elusive, existing at the limits of tangibility. The fleeting remnant of things, dust evades not only our grasp but often also our sight. These qualities are sedimented into the etymologies of the word. The English "dust," for instance, is related to the German *Dunst*, meaning vapor or mist, which explains why we rarely

1. Joseph A. Amato, *Dust: A History of the Small and the Invisible* (Berkeley: University of California Press, 2000), 4. On dust's dispersal, see Michael Marder, *Dust* (New York: Bloomsbury, 2016), 33–34. Marder also notes that "dust is pre-dispersed in its very gathering" (55).

speak of individual particles of dust but only of the collective noun.[2] As singular matter—the mote of dust—it is effectively imperceptible; only in vast quantities, either cloud-like in the air or accumulated on things, can we claim it has any substantiality. These concrete appearances, however, signal the border between what can be grasped and what is too small or diffuse to be considered solid matter. The German word for dust, *Staub*, is related to the verb *stieben*, presumably because, similar to what our vaporous *dust* suggests, anything "swiftly running away" (to paraphrase *Duden*'s definition) would leave behind a cloud of it (we say "to leave someone in the dust"). This meaning of *stieben* as a quick movement (typically away or apart) is directly related to its primary denotation "to whirl apart in little pieces"; in other words, "to scatter," a definition that brings us back to dust and also emphasizes the key characteristic that distinguishes it from its relative, dirt. The latter is solid and permanent and is thus associated with the land and "the essence of place." Dust, in contrast, being light and nearly insubstantial, is "susceptible to winds and breezes," which disperse it willy-nilly.[3]

The capacities, let alone simply the desire, to collect dust remain, therefore, very limited.[4] Indeed, it was not until the late nineteenth century that anyone considered gathering dust for any purpose other than disposing of it (already a difficult undertaking).[5] The paradigm shift emerged in the field of criminology, where dust soon be-

2. Marder links this usage back to the proto-Indo European root *dheu*. Marder, *Dust*, 4.

3. J. Gordon Ogden, *The Kingdom of Dust* (Chicago: Popular Mechanics, 1912), 23.

4. The stuff around us, we say, "gathers dust," both literally and figuratively. In the first sense, the surfaces of most inanimate objects serve as media for the actual accretion of dust; these are the places where what seems to be without substance becomes both visible and tangible. Once dust has accumulated in layers upon objects and things, we are able to encounter what was previously vaporous, indistinct, and seemingly immaterial as actual matter. When we say something is "collecting dust," however, we usually mean it metaphorically: the object in question is untouched, neglected, without purpose or use. That which has collected dust is the definition of the object turned thing.

5. Marder describes how trying to eliminate dust only leads to its re-dispersal. Marder, *Dust*, 3.

came the center of attention, playing a key role in the development of new methods for gathering microscopic "trace" evidence. The Austrian criminal jurist Hans Gross was one of the first to insist that investigators collect and examine dust found anywhere in connection with a crime. In his *Criminal Investigations: A Practical Handbook* (*Handbuch für Untersuchungsrichter als System der Kriminalistik*)—first published in 1893, translated into English soon thereafter, and reprinted numerous times up to the 1970s—Gross dedicates a whole section to gathering evidence in the form of dust.[6] He defines dust as "our surroundings in miniature," explaining, "Every dusty object is covered with a collection of tiny particles from those bodies that are found in lesser or greater proximity to them."[7] In elaborating how important it is not to overlook this nearly invisible matter, Gross finds himself describing both dust and the investigator as engaged in the activity of collecting. Only because dust has already "collected" somewhere can it be collected. Every object is covered "with a collection" of its tiny specks; dust "collects itself" in the pockets of jackets and behind minute pieces of jewelry.[8] This dust needs to be "carefully collected" and put under the microscope, so that it can "tell its story": "Such dust [that is, that collected on clothing] tells us in its composition that story of the person in question while he had worn that piece of clothing."[9]

Gross's book inspired other criminological studies on the value of trace evidence. In 1918 the chemist Georg Popp published the article "Microscopy in the Service of the Criminal Investigation," in which he details how the origin of dust can be determined by magnification. In 1923 in the same journal as Popp's article, *Archiv für Kriminologie*, Karl Giesecke published "On Dust in Clothing Pieces and Its Meaning for Criminal Investigation," in which he catalogs the most common kinds of dust that can be found in the

6. Hans Gross, *Handbuch für Untersuchungsrichter als System der Kriminalistik*, 5th rev. ed. (Munich: J. Schweizer Verlag, 1908), 1:246–248. Gross's attention to this particulate matter is by no means limited to this one part of the book.
7. Gross, *Handbuch für Untersuchungsrichter*, 246.
8. Gross, *Handbuch für Untersuchungsrichter*, 247, 248.
9. Gross, *Handbuch für Untersuchungsrichter*, 247.

clothing of various professionals, from bakers to factory work-
ers.[10] By far the most influential criminologist to write about dust
was Edmond Locard, whose seven-volume *Traité de Criminalis-
tique* (1931–1940) is considered a milestone of forensic science.
Locard's "The Analysis of Dust Traces," originally published in his
own *Revue International de Criminalistique* in 1929, provides a
highly detailed taxonomy of types of dust and how to recognize
their origins under the microscope. Locard says he was inspired to
undertake his detailed study both by Gross's work and Doyle's
Sherlock Holmes stories. Having, as he writes, "absorbed the ideas
of Gross and Conan Doyle," Locard details the nature and compo-
sition of dust, where to locate it and how to collect it, and how to
analyze it first by means of sorting and then by microscopic and
microchemical examination. Locard's actions are driven by the be-
lief that "the microscopic debris that cover our clothes and bodies
are the mute witnesses, sure and faithful, of all our movements and
of all our encounters."[11]

Suddenly the scene of a crime, especially the relatively sealed-off
space of the interior, becomes the site where dust takes on immense
importance. Writing in the wake of these criminological advance-
ments, Walter Benjamin saw this connection between the interior,
the detective, and dust quite clearly. According to him, the bourgeois
interior is both the site of collecting and the birthplace of detective
fiction. Both are born of a living space that functions as an enclo-
sure in which the inhabitants seek to leave their mark on things:
"The traces of the inhabitant are imprinted in the interior. Enter the

10. Georg Popp, "Die Mikroskopie im Dienste der Kriminaluntersuchung,"
Archiv für Kriminologie 70, no. 149 (1918): 149–156. Karl Giesecke, "Über den
Staub in den Kleidungsstücken und seine Bedeutung für die Kriminaluntersuch-
ung," *Archiv für Kriminologie* 75, no. 14 (1923): 14–40.
11. Edmond Locard, "The Analysis of Dust Traces: Part I," *American Journal
of Police Science* 1, no. 3 (May–June 1930): 276. For a discussion of the relation
between forensic science and detective fiction, with, however, little attention to
these particular figures and innovations, see Ronald Thomas, *Detective Fiction
and the Rise of Forensic Science* (New York: Cambridge University Press, 1999).
See Lawrence Frank, *Victorian Detective Fiction and the Nature of Evidence: The
Scientific Investigations of Poe, Dickens, and Doyle* (New York: Palgrave, 2004),
for how detective fiction engaged with new discourses of scientific investigation.

detective story, which pursues these traces."[12] Benjamin singles out Edgar Allen Poe, who scanned the surface of domestic things with acuity, as "the first physiognomist of the domestic interior." Tracking down the trace of things (*den Dingen auf der Spur*), always "on the hunt," Poe's detective mobilizes a canny ability to read the interior "as a picture puzzle" (*als Vexierbild*). He deciphers the traces left behind on the various coverings and containers that the bourgeois uses, reading "the contours of the banal" for clues hidden in the everyday.[13]

It is here that dust accumulates—on the surfaces of coverings and containers devised by the bourgeois both as protection and as means to maintain the traces of their use: "The étuis, dust covers [*Überzüge*], sheaths with which the bourgeois household of the preceding century encased its utensils were so many measures taken to capture and preserve traces [*Spuren aufzufangen und zu verwahren*]."[14] As Benjamin notes, it is the fabric plush, commonly found in this bourgeois space, that becomes ideal for capturing that most ubiquitous material of the interior, dust: "Plush as dust collector [*Staubfänger*]. Mystery of dustmotes playing in the sunlight. Dust and the 'best room' [*gute Stube*]."[15] If the collector presumably "catches" dust to remove it from this space—in other words, to make it invisible—the detective seeks to make it visible, to capture it as evidence. Neither task is so straightforward, given the nature of dust. Indeed, dust is not only the near-invisible residue of domestic life but also, as the particles "playing" in the sunlight, that which makes visibility possible. For it is the presence of dust in the atmosphere, where it refracts the sun's light, that allows us to perceive light in the first place. Without it, interior spaces in particular would

12. Benjamin, *Arcades Project*, 9; *Gesammelte Schriften*, 5:53.

13. Benjamin, *Arcades Project*, 212 (translation modified); *Gesammelte Schriften*, 5:281. On the role of objects in detective fiction, see Joanna Sońko, "Objects Don't Lie: The Truth and Things in Detective Stories," in *Materiality and Popular Culture: The Popular Life of Things*, ed. Anna Malinowska and Karolina Lebek (New York: Routledge, 2017), 157–166.

14. Benjamin, *Arcades Project*, 226; *Gesammelte Schriften*, 5:298.

15. Benjamin, *Arcades Project*, 103; *Gesammelte Schriften*, 5:158.

appear hopelessly dark.[16] Thus, like the light it refracts, dust must remain invisible to be effective. To focus on dust is to see what—although itself necessarily unseen—makes seeing possible. As the object of forensic attention, dust therefore ultimately reveals as much about the epistemological complications involved in gathering evidence—to what degree the truth sought can be located in the visible—as it does any scientific imperative to master the empirical data.

In this chapter I look to the ways dust and its larger cousin, sand, figure in the work of Friedrich Glauser, where they occupy a problematic role at the border between what is visible and invisible, present and absent, pointing to the elusiveness of evidence and the problems inherent in any attempt to reconstruct the past out of its material remains in the present. Although the Swiss author's work is well known among aficionados of detective fiction (the annual, prestigious German crime fiction award is named after him), it has also suffered from this association, rarely being treated from a literary critical perspective that is not focused solely on questions of genre. Sharing the conviction expressed by Peter von Matt that Glauser's debut "belongs to one of the benchmarks against which the literary landscape of Switzerland is to be measured," I insist that Glauser be read as a consummate literary author with strong modernist proclivities.[17] My readings thus zero in on the minute level of language (for example, the single word and its resonances) and the ways Glauser mobilizes networks of images and associations to problematize the narrative material (the crime story) that is his books' ostensible focus. In this way I approach Glauser's texts as his detective approaches the environment around him: on the microscopic scale. In doing so, I demonstrate how Glauser's prose, though on the surface realist in orientation, incorporates modernist techniques: the text functions as an intricate space where multiple semantic and thematic strands in-

16. Amato, *Dust*, 5. See also Alfred Russel Wallace, "The Importance of Dust: A Source of Beauty and Essential to Life," in *The Wonderful Century: Its Successes and Its Failures* (London: Swan Sonenschein: 1898), 70–72.

17. Peter von Matt, "Die Fäulnis hinter den Fassaden: Über Friedrich Glauser," in *Die tintenblauen Eidgenossen: Über die literarische und politische Schweiz* (Munich: Hanser, 2001), 220.

tersect, without fully resolving, against the backdrop of epistemological doubt. Attention to the interplay of these strands reveals a body of literature finely attuned to larger questions of matter and materiality, their value as evidence, and the limits involved in their attempted gathering and preservation.

The image of collecting that emerges will be a familiar one—though with a twist. As in previous chapters, we find here a procedure of gathering and preservation that fails to restore any lost state. However, no such restoration is ever really possible in the realm of detective fiction. The crime committed can rarely be reversed—certainly not in cases of murder. The detective's task is only to gather evidence in the hope of piecing together a picture of what happened, to be able to offer insight into how it is that we only have these pieces and not a whole. From this perspective, evidence always points to what is missing—even when that evidence adds up to an epistemologically sound reconstruction of the crime. For what such a "whole picture" of things reveals is that a whole is in fact no longer available. The fragmentary pieces gathered together by the detective, pieced into a patchwork, may provide access to their origins, but that picture of origins is only a reminder of its distance from us, its inaccessibility. The collection of evidence, itself only constituted of fragments, cannot restore the state of things prior to their dispersal. A "complete collection" is still incomplete, or rather, the complete collection of criminological evidence is the closest we get to seeing things in their scattered state. We collect precisely in order to see the world of dispersed things better.

Glauser's work offers an intricate picture of this paradoxical undertaking of the detective as collector, made more complex and compelling in the first two Sergeant Studer novels, where the main evidentiary object is dust.[18] Like its related particulate matter, ash and sand, dust is naturally scattered material that exists on the limits of visibility and tangibility. In what ways might it be collected, sorted, stored, or restored? The minute remnant of things, dust is

18. My analysis focuses on the first two Studer novels that Glauser published. Although he wrote *Fever (Die Fieberkurve)* before *In Matto's Realm (Matto regiert)*, it was published after it.

nearly impossible to gather, let alone reconstitute in its original object form. On the one hand, then, dust embodies the purest form of dispersal, that which is most resistant to the restorative promises of collecting. But on the other hand, precisely as such scattered stuff, dust takes its place among the paradigmatic items of the modern, nonrestorative (*antapocatastatic*) collection, where, like the piece of evidence, it points to a state of things lost. In what follows I illustrate how in Glauser's detective fiction this particulate matter assumes the position of collected evidence, and how making it properly visible as the residue of violence requires a different mode of gathering and preservation, one in which failing to reconstruct the crime (and dust failing its evidentiary function) precipitates a different kind of justice. Here, ultimately, collecting comes closest to merely letting things scatter. We pick things up *in order to see* them slip away. Collecting thus makes possible a distinct mode of seeing, one that, as the analysis of Glauser's Sergeant Studer novels will show, also has important ethical consequences.

Plumes of Ash and Scattered Dust in *Thumbprint*

Minute, particulate matter can be found all over Glauser's work. Dust, above all, appears most frequently as the defining smell of spaces, both interior and exterior.[19] It also recurs as a visible residue on the surface of things that, in its dispersed form, gets in the way both of seeing properly and of being able to breathe.[20] Yet dust

19. For the dusty smell of the interior, see Friedrich Glauser, *Fever*, trans. Mike Mitchell (London: Bitter Lemon Press, 2006), 33, 35, 127 (the metro), 137, 161; Friedrich Glauser, *Die Fieberkurve*, ed. Julian Schütt (Zurich: Unionsverlag, 2013), 38, 39, 126, 135, 156. The smell of dust outside is mentioned in Glauser, *Fever*, 84 (*Die Fieberkurve*, 86) and Friedrich Glauser, *The Chinaman*, trans. Mike Mitchell (London: Bitter Lemon Press, 2007), 8, 11; Friedrich Glauser, *Der Chinese*, ed. Rudolf Bussmann (Zurich: Unionsverlag, 1998), 11, 14.
20. Examples of accumulated dust can be found in Glauser, *Fever*, 95 (*Die Fieberkurve*, 97); Glauser, *Chinaman*, 6, 34, 67–69, 86, 108 (accumulated on clothing), 110 (sawdust), 123, 160 (*Der Chinese*, 10, 34, 64–66, 83, 103, 105, 118, 132 [elided in the translation], 152); and Friedrich Glauser, *Spoke*, trans. Mike Mitchell (London: Bitter Lemon Press, 2008), 8, 136, 152 (*Die Speiche [Krock & Co.]*, ed.

also, as we will see, comprises key evidence. When at the beginning of *Fever* we learn that the forensic analyst Godofrey spends his days analyzing dust, we are reminded of Gross's and Locard's methods.[21] Sure enough, it is not much later that we find out that Sergeant Studer himself, Glauser's principal investigating protagonist, has had professional experience with both men: "He'd worked with Gross in Graz and Locard in Lyon."[22] Particulate powder also appears in the Studer novels as an essential element for properly done fingerprint analysis, which requires "graphite powder," a dust-like substance that, as we learn in *Fever*, only reveals the hidden fingerprint because some of it can be dispersed ("blown away") while the rest remains stuck to the oils left behind by human skin.[23] In Glauser's work in general, dust also emerges from the desert, where the second half of *Fever* and the entirety of *Gourrama* are set. Here we encounter legionnaires whose faces are "covered in dust" or "powdered with dust" and whose fate seems to be caught up with the endless sand of the desert.[24] This barren sabulous landscape Glauser himself had been exposed to as a legionnaire and, in *Gourrama* especially, the desert sand becomes synonymous with these soldiers' desertion, such that, as Peter Utz writes, it "reflects back their inner

Bernhard Echte [Zurich: Unionsverlag, 1999], 6, 100, 112. Numerous examples of dust that can be smelled and seen in *Thumbprint* and *In Matto's Realm* are provided in the later analyses.

For dust in the eyes, see Friedrich Glauser, *Der Tee der drei alten Damen*, ed. Mario Haldemann (Zurich: Unionsverlag, 2005), 215 and Glauser, *Spoke*, 97–98 (*Die Speiche*, 72). For dust in the lungs, see Glauser, *Chinaman*, 123 (*Der Chinese*, 118; here it is clearly ash) and the later discussion of *Thumbprint*. Dust gets into Studer's sinuses too, making him sneeze, in Glauser, *Chinaman*, 8; *Der Chinese*, 11.

21. Glauser, *Fever*, 3; Glauser, *Die Fieberkurve*, 8.

22. Glauser, *Fever*, 38; Glauser, *Die Fieberkurve*, 42. Locard and Gross are mentioned throughout the Studer novels. Gross's *Handbuch für Untersuchungsrichter* and Locard's works appear in Glauser, *Chinaman*, 52, 147; Glauser, *Der Chinese*, 51, 140. See Martin Stingelin, "Das 'Unvermessbare': Berechenbarkeit versus Unwägbarkeit. Alphonse Bertillon, Hans Gross, Edmond Locard und Rudolf Archibald Reiss in den Kriminalromanen Friedrich Glausers," in *Anthropometrie: Zur Vorgeschichte des Menschen nach Maß*, ed. Gert Theile (Munich: Wilhelm Fink, 2005), 125–138.

23. Glauser, *Fever*, 62; Glauser, *Die Fieberkurve*, 65.

24. Glauser, *Fever*, 192; Glauser, *Die Fieberkurve*, 186. Friedrich Glauser, *Gourrama*, ed. Bernhard Echte (Zurich: Unionsverlag, 2013), 97.

emptiness."[25] Thus when dust or sand appears in Glauser's novels and stories, either as a descriptive word or as a naturalistic detail, it recalls the dusty winds of the barren Moroccan desert, as well as the stuffy interiors of the mental institutes Burghölzi and Münsingen where Glauser confronted another kind of solitude. Finally, powdery particulate recalls the morphine, opium, and cocaine whose grasp Glauser was for so long unable to escape.[26]

Dust plays a particularly prominent role in the first Sergeant Studer novel *Thumbprint* (*Schlumpf Erwin Mord*), published serially in the *Zürcher Illustrierten* in 1936 and then in book form later that same year.[27] The book is littered with references to particulate in various forms, from the dust on Sonja Witschi's beret (38; 40) and the layers of dust in the interior of the Witschis' home (68, 77; 67, 76) to the ash and plumes of smoke generated by its characters' predilection for cigarettes and cigars (e.g., 89–90; 87) and the gunpowder and ashen particulate left behind by the suspected murder weapons (e.g., 111; 106–107). These last traces end up being decisive for Studer's resolution of the crime, as we find out in the penultimate chapter, when Studer confronts the murderer Aeschbacher with the hitherto elusive material evidence:

> "Did you find what you were looking for in my garage yesterday evening?"
> Studer took a puff at his cigar (it suddenly tasted much better) and answered calmly, "Yes."

25. Peter Utz, "Robert Walser's *Jakob von Gunten*: A 'Zero' Point of German Literature," in *Robert Walser: A Companion*, ed. Samuel Frederick and Valerie Heffernan (Evanston, IL: Northwestern University Press, 2018), 164.

26. Hashish is described as being pulverized into "dust" in the story "Kif." Friedrich Glauser, *Gesprungenes Glas: Das erzählerische Werk; 1937–1938*, ed. Bernhard Echte, (Zurich: Unionsverlag, 2001), 4:90.

27. This debut appeared under the title *Wachtmeister Studer* (Sergeant Studer) and was partly altered and abridged. I use the restored version with Glauser's intended original title: Friedrich Glauser, *Schlumpf Erwin Mord*, ed. Walter Obschlager (Zurich: Unionsverlag, 1998), 174. For the English, I use the following: Glauser, *Thumbprint*, trans. Mike Mitchell (London: Bitter Lemon Press, 2004). These editions (first English, then German) are henceforth cited parenthetically, even where the German is not provided.

"What did you find there?"

"Dust."

"That all?"

"It was enough."

A pause. Aeschbacher seemed to be thinking. Then he said, "Dust? In the map pocket?"

"Yes." (181)

"Habt Ihr gestern abend in meiner Garage gefunden, was Ihr gesucht habt?"

Studer nahm einen Zug aus seinem Stumpen (er schmeckte plötzlich viel besser) und antwortete ruhig:

"Ja."

"Was habt Ihr denn gefunden?"

"Staub."

"Sonst nichts?"

"Das hat genügt."

Pause. Aeschbacher schien nachzudenken. Dann sagte er:

"Staub? In der Landkartentasche?"

"Ja." (174)

A number of motifs revolving around the protean substance of dust come together in this critical climactic scene. First, there is the substance itself, here referred to merely as "dust," which we found out in the previous chapter consists primarily of gunpowder and ash. Studer removed this evidence from the side pocket of Aeschbacher's car where the road map is typically stored. With this specific site of discovery, Glauser not so subtly indicates that this particulate matter serves as the metaphorical atlas that allows Studer to locate the murderer. Studer has read the dust as one would a road map, leading him to this spot. In a moment the detective will imagine himself with a magnifying glass, creeping along the floor in search of more dust: "Dust in the map pocket of a car! So what? Next thing he'd be crawling round the floor with a magnifying glass in his hand scouring the carpet for clues!" This image, far from merely evoking "the sharp-witted English detective with deductions . . . Sherlock Holmes" (183–184; 176), as Studer himself thinks, in fact aligns him with dust in a more debased context. For it evokes the serpent in the garden of Eden, who is cursed to spend the rest of its days slithering on the ground and

eating dust (Genesis 3:14: "Upon thy belly shalt thou go, and dust shalt thou eat all the days of thy life"). Although Studer, who in the next novel describes himself as "condemned [*verdammt*] to solve crimes," does not imagine himself *eating* dust, he does constantly take dust into his body in the form of cigar smoke.[28] As we will see, this habit of the sergeant's is hardly as incidental as it might at first appear, and it is therefore not without significance that the key exchange just quoted begins with him taking a puff of his beloved Brissago cigarillo.

The ashen particulate that guides Studer to the murderer thus also comes in close contact with the ash and plumes of the sergeant's preferred smoke. Those plumes, in particular, appear frequently in the book, reminding us of the similarity between dust and clouds (*Dunst*) of smoke both visually and etymologically. To smoke is of course to send billions of ashen particles of dust into the air.[29] Glauser is keenly aware of this affinity and exploits it to make another connection between the ashen particulate produced by the murderer and that produced by Studer's incessant smoking. That connection comes via the word *Aeschbacher*. Although it is clear from "-bacher" (*of the stream*) that the first part of the mayor's name refers not to ash (*Asche*) but rather to the grayling (*Äsche*), a fish that would be found in a stream, the etymology of the name for the animal in German—related, of course, to the descriptive used in English—derives from the grayish color of ash. Were this allusion itself not clear enough, in the chapter "The Thumb Print," during the scene when Studer observes Aeschbacher at the tavern, Glauser emphasizes the connection between ash and the mayor by means of wordplay:

> The yellow gleam of the two ceiling lamps, swathed in clouds of blue smoke, was reflected in the carafes. Distinctly Studer heard the sound of

28. Friedrich Glauser, *In Matto's Realm*, trans. Mike Mitchell (London: Bitter Lemon Press, 2005), 78. Friedrich Glauser, *Matto regiert*, ed. Bernhard Echte (Zurich: Unionsverlag, 1998), 79. These editions hereafter are cited parenthetically, German following English.

29. Amato, *Dust*, 3: "An average puff of a cigarette has been estimated to contain 4 billion particles of dust." See also Ogden, *Kingdom of Dust*, 12.

a match being struck on the ribbed strip of the pottery ash-tray [*Aschen-becher*]. Aeschbacher relit his cigar. (89–90)

Auf den Literkaraffen spiegelte sich der gelbe Schein der zwei Decken-lampen, die in einem bläulichen Rauch*dunst* schwammen. Deutlich hörte Studer das Anstreichen eines Zündholzes an der gerillten Fläche des porzellanenen *Aschenbechers*. Gemeindepräsident *Aeschbacher* zün-dete seinen erloschenen Stumpen an. (87; my emphasis)

Here clouds of smoke, described using that same German word (*Dunst*) from which our "dust" comes, mingle with the sounds and smells of Aeschbacher smoking a cigar. Glauser emphasizes that these plumes are ashen particles by drawing attention to the ashtray on the table and then links the ash that is accumulated there to the mayor by bringing his name into close graphical con-tact with the word for that receptacle. The result is a mismatched echo effect in which we hear the ashtray imperfectly repeated in the name of the mayor. Technically, Glauser uses a form of pho-netic chiasmus, juxtaposing two words that are nearly identical save for the inversion of the /a/ and /ε/ phonemes: *Aschen*-becher (ash-tray) / Aesch-*bacher*. This play of vowels brings the word *Asche* into prominence as an aural repetition, a kind of mirroring that also corresponds to the mirroring carried out with real ash in the form of the *Rauchdunst* (smoke) that Studer sees "reflected" in the carafe.

In that reflection, the omnipresent plumes of smoke generated by cigars appear as clouds of ashen particulate, and both are linked—via Aeschbacher's name and ultimate identity as the murderer—to the particles of dust that are the final piece of the puzzle in Studer's investigation. And yet, as already suggested, Studer collects this dust in two ways. He not only scrapes dust—in the form of ash and gunpowder—from Aeschbacher's car into a protective envelope for analysis, collecting it as forensic evidence, but he also collects dust—in the form of ashen particulate—into himself by smoking. Studer's love of cigarillos would be completely insignificant, a mere detail from life that gives him character, were it not for the fact that his smoking contributes to a lung infection that nearly kills

him.[30] Glauser first hints at Studer's dangerous intake of smoke directly after he ponders the meaning of the "black spots" (140; *die schwarzen Punkte*, 134) in the photograph of the crime scene: "Studer coughed. He couldn't hold it back any longer, otherwise the smoke would have settled on his lungs" (142; Studer hustete. Es ging einfach nicht mehr, der Rauch setzte sich sonst in seiner Lunge fest, 136).[31] Glauser here links this sedimentation of ashen particulate infesting Studer's lungs with the ashen particulate, "black spots," he seeks for evidence. These "spots" are soon located directly in Studer's lungs. In the antepenultimate chapter "The Use of a Microscope," Dr. Neuenschwander refuses to continue the discussion of Studer's evidentiary dust, which the detective had just inspected under the microscope, before carrying out an inspection of the sergeant himself:

> "But you must tell me"—his index finger pointed at the envelope—
> "where you got that dust. Stop. Not now. First of all take off your jacket
> and shirt, then lie down on that couch so I can have a listen and see
> what's going on inside your chest." . . .
> Dr Neuenschwander listened through his stethoscope and tapped
> Studer's chest, tapped and listened. He seemed particularly interested
> in the area where Studer could feel the piercing spot [*den stechenden
> Punkt*]. (172)

> "Aber Ihr müßt noch sagen, wo Ihr den Staub da," er deutete mit dem
> Zeigefinger auf das Kuvert, "gefunden habt. Halt, nicht reden jetzt. Zu-
> erst Kittel auszuziehen, Hemd, dann legt Ihr Euch dort auf das Ruhebett,
> damit ich ein wenig hören kann, was in Eurer Brust los ist." . . .
> Dr. Neuenschwander horchte, klopfte, klopfte, horchte. Besonders
> schien ihn die Stelle zu interessieren, an der Studer den stechenden Punkt
> spürte. (165)

The answer to the question of the origins of the dust seems to come in the form of an examination of Studer's lungs. The doctor's

30. In *Fever* we get an idea of how many Brissagos Studer smokes in a day when he lights up his fourteenth on returning home in the evening. Glauser, *Fever*, 112; Glauser, *Die Fieberkurve*, 111.

31. Translation of *schwarze Punkte* (black spots) modified here and throughout to illustrate the consistency of Glauser's use of the morpheme *Punkte*.

listening and tapping—which Glauser narrates doubly and chiasti-cally (*horchte, klopfte, klopfte, horchte*)—are related to Studer's fevered state and the pain in his chest, which he refers to here, as earlier in the novel, as a "stabbing pain" or, more literally, a "pierc-ing spot": "On the right side of his chest, fairly low down, he could feel a piercing spot [*ein stechender Punkt*]" (162; 155). The inflam-mation of the lungs is exacerbated by the detective's cigarillo habit, which the doctor makes clear when, after this examination, he ex-claims, "Of course, Brissagos" (172; 165), and declares the sergeant "ripe for a hospital bed" (173; 165). These tiny black spots—the dust inside and outside Studer—converge here while also recalling other such "spots" earlier in the book. The investigating judge, for instance, declares to Studer at the start of the novel that this is a case with "some obscure factors," literally "some dark spots" (21; *einige dunkle Punkte*, 23). What Studer seeks, of course, is a "clue" in the form of material evidence: "einen Anhalts*punkt*" (114; my emphasis).[32] And indeed, key evidence appears in the form of "black spots" that look like—and turn out to be—ash, visible only with magnification in the photograph of the crime scene, but because of the ephemerality of such particulate, no longer traceable as forensic evidence: "Those black spots [*Die schwarzen Punkte*] on the pine needles next to the head. . . . What might those black spots [*die schwarzen Punkte*] mean? They looked as if they could be tiny scraps of burnt cigarette paper" (140; 134). The closer Studer gets to the particles of ashen dust that will solve the case, clearing up its "dark spots," the more he takes in, quite literally, this same ashen dust from his cigarillos, weakening him physically and mentally, intensi-fying the pain of the "piercing spots" inside him that returns again at the precise moment that he reveals the dust to Aeschbacher (183; 176)—and bringing him closer to his grave. Dr. Neuenschwander's request that Studer lie on the "couch" (172) for examination takes on another register of meaning in this context, *Ruhebett* (165) being a euphemism for the final resting place.

32. Unfortunately, Mitchell's translation—"something to work on" (119)—fails to capture this meaning.

Yet it seems as though Studer needs to proceed in this manner: collecting evidence in the form of ashen dust also requires collecting similar ashen particulate by inhaling it, taking it into himself. Approaching the solution to the question of who brought death to the village of Gerzenstein thus also requires approaching his own death. In Witschi's shed, another dusty interior where Studer finds concrete evidence in the form of ashen particulate, Glauser describes how the abundant "tiny, glittering dust motes [*winzige, glänzende Staubteilchen*; translation modified]" are visible in the streams of light and enter the detective's body: "He coughed. The dust was getting into his lungs" (110; 106). This same dust-saturated air is akin to what Studer, on arriving in Gerzenstein, describes metaphorically when asking about the history of this small town:

> Just tell me the story from the very beginning. It's not so much facts I need as the air these people breathe, so to speak. You know what I mean? The tiny little things [*kleine Sächeli*] no one pays any attention to, but which can illuminate the whole case ... Illuminate! ... As far as that's possible, of course. (75; translation modified)

> Erzähl einmal die Geschichte von Anfang an. Ich brauch weniger die Tatsachen als die Luft, in der die Leute gelebt haben ... Verstehst? So die kleinen Sächeli, auf die niemand achtgibt und die dann eigentlich den ganzen Fall erhellen ... Hell! ... Soweit das möglich ist, natürlich. (74)

Studer claims here that he does not want "facts" but rather a sense of the atmosphere.[33] This atmosphere, however, comprises not so much the air as the miniscule stuff the air contains. Using an adjective for "small," together with a diminutive (the Swiss vowel shift plus -*li* suffix), Studer describes this stuff as doubly minute: *kleine Sächeli*, "tiny little things." Such overlooked matter, that which no one regards but that is nonetheless everywhere, floating impalpably about in the air, can provide clarity that concrete facts cannot. The sergeant's metaphor expresses not just that he wants to breathe the air that the people in Gerzenstein breathe, to understand the world that sur-

33. On the role of atmosphere (and its sidelining of plot) in Glauser's work, see Martin Rosenstock, "An Atmosphere of Malaise: Failures of Detection in Friedrich Glauser's *Matto regiert* (1936)," *German Quarterly* 94, no. 1 (2021): 99–115.

rounds and shapes them but also that this air is full of tiny, usually invisible things that he wants to "take in." Furthermore, similar to how the dust in the atmosphere or in an enclosed space does not impede but rather promotes light and visibility, this miniscule matter serves for Studer as a means of "illumination" (75; *erhellen ... Hell,* 74).[34] In this way, the "tiny little things" in the atmosphere are not unlike the particulate Studer himself contributes to the omnipresent dust in the air by his smoking, which at a later point the detective counterintuitively claims will "clear the air" (138; *reinigt die Atmosphäre,* 133).

The tiny particles that Studer locates, collects, inspects under the microscope, and ultimately presents to Aeschbacher similarly serve to illuminate things, though in a different manner. Let us return to these "black spots." Initially it is the *absence* of particulate traces that characterizes the crime. The coroner's assistant insists that Witschi's death could not have been the result of suicide because of the lack of "traces of powder on the skin" (35; *Pulverspuren auf der Haut,* 36). Witschi might have been able to shoot himself behind the right ear (he had long, flexible arms), but had he done so, the revolver shot at such close range would have left a visible residue of gunpowder, referred to elsewhere in the novel as *Pulverstaub* (167; "gunpowder"; literally, "[gun]powder dust," 174) or simply *Staub* ("dust," as at 175; 167 or in the key confrontation with Aeschbacher with which we began this section, 181; 174).[35] Evidence that Witschi was nonetheless able to shoot himself without leaving traces on his skin—which would correspond to one highly plausible narrative of events and exculpate Schlumpf—emerges in the dusty shed that Studer and local ex-convict and musician Schreier examine together. Here they find an unhinged door that had apparently been used for shooting practice. The fifteen bullet holes in the door, however, reveal a strange pattern of traces, which Studer identifies as "powder marks" (111; *Pulverspuren,* 107)

34. Amato, *Dust,* 5. See also Wallace, "Importance of Dust," 70–72.

35. That shooting a gun should result in the creation of "dust," in one form or another (gunpowder traces and a corpse—the residues of killing) becomes chillingly real as Studer discusses with the coroner's assistant the absence of the former such "dust," gunpowder, in the presence of the latter such "dust," the dead body of Witschi (33–36; 36–38).

and "deflagration marks" (*Deflagrationsspuren*), and the narrator as "scorch marks" (*Verbrennungsspuren*) or just "marks" (*Spuren*): "Five of the holes had these marks [*Spuren*]. Round the sixth they were less distinct, and they grew fainter the farther down the bullet holes were. The last three had clean edges, the wood around them was white" (111; 106–107). The detective's attention is here directed at the progressive disappearance of "marks" or, more precisely, "traces" (*Spuren*). Again, key evidence comes not in the form of the presence but in the absence (or *absenting*) of particulate gunpowder. Yet that absenting itself leaves marks behind, as Schreier's explanation for the pattern makes clear: Witschi was testing how to shoot his revolver without leaving traces by putting crumpled cigarette paper in the barrel, which would then absorb the "little particles of powder" (*Pulverteilchen*), thus leaving behind clean points of entry (translation modified). As Studer contemplates this technique he lights a piece of the cigarette paper Schreier had found in the shed:

> There was a brief, bright spurt of flame. Studer shone the torch on the ash. All that was left was a tiny black residue. Still, assuming Witschi had used several papers, not all the ash would have disappeared. Traces of it had to be found in the wound.[36] (112)

> Es gab eine kurze, sehr helle Flamme. Auf die Asche ließ Studer den Lichtkegel der Lampe fallen. Ein winziger schwarzer Rest . . . Und doch: angenommen, Witschi hatte ein paar Blättli gebraucht, so war die Asche sicher nicht ganz verschwunden. Spuren davon mußten in der Wunde zu finden sein. (108)

In these circumstances, when the revolver was fired the ashen particulate of gunpowder would combine in the barrel with the cigarette paper, which would then go up in smoke, leaving ashen remains in the form of a "tiny black residue." Yet, all this dust would not just disappear, even if Witschi was trying to make the remnants of powdery particles invisible. Like the clouds of particulate created by Studer's Brissago, of which Glauser reminds us here by way of the cigarette paper, this black residue is apparently ungraspable in

36. Translation modified. Mitchell also curiously omits the final sentence here.

its near insubstantiality. And yet also like Studer's cigarillo plumes, it might not only have dissipated in the air but may have also lodged inside the body itself.

The coroner's assistant, however, finds no such evidence, suggesting that the traces of the attempt to make the evidence of shooting invisible must be more minute than even microscopic dust. Studer's first instinct is to find something more tangible and visible that he can hold on to as indisputable material evidence. Yet although he at first considers the door with the bullet holes as such a potentially reliable piece of concrete proof, he has to concede that it, too, could end up being turned to ashes: "As long as they don't burn it. . . . That would be our evidence gone. Evidence? A nice solid piece of evidence!" (113; 109). It is as though the reminder that even the solid door can be reduced to ashes makes Studer realize what flimsy proof the ashen particles themselves are as forensic evidence. At the crime scene, they would no doubt already have been scattered to the winds, becoming part of the atmosphere. The only way to determine that such particles of ash might have been present at the scene is to examine one of the photographs of the victim, which Studer later does, first through a magnifying glass but with the intention of enlarging it even more to better identify the "black spots" just barely visible next to Witschi's head: "They looked as if they could be tiny scraps of burnt cigarette paper" (140; 134). That this photograph is Studer's only evidence of the existence of these ashen particles plays into the nexus of motifs involving the difficulty of gathering and holding on to particulate matter as material proof, because, of course the photographic medium itself is constituted by microscopically tiny particles. Are these minuscule silver halide crystals the only way Studer can properly collect the "tiny little pieces" of ash?

This ashen dust ends up being the wrong evidence, however, at least for identifying Witchi's killer: it turns out there was a second gun, which was used to murder Witschi after his failed suicide attempt with the first weapon (the one that left the particulate residue captured in the photograph). The traces left by the second Browning pistol—they are the same model; hence, the importance of distinguishing them on the fine-grained level of gunpowder and

ash—are what Studer gathers together from the map pocket inside Aeschbacher's car, inspects under the microscope, and presents to Aeschbacher in the penultimate chapter (the exchange quoted at the start of this section). Given that matching particles of gun dust were not found at the scene of the crime, however, it is unclear how this dust would serve as incriminating evidence. Studer's thoughts betray this doubt: "And what evidence did Studer have? . . . His examination of the dust under the microscope? It was enough for him. But for a jury, a jury that would be made up of farmers? They'd laugh him out of court. Even the examining magistrate would" (182–183; 175). This imagined humiliation in the face of a disbelieving justice system echoes Aeschbacher's actions in Studer's dream earlier in the book, in which the mayor laughs at Studer's inability to solve the crime (93; 91), seeming to call into question the detective's entire methodology. What good is the ashen particulate as proof in this case? How did gathering it as evidence help unravel the mystery? Indeed, after presenting the evidence to Aeschbacher, Studer realizes he cannot make everything fit together: "Many things went through his mind. But he couldn't get all the pieces to fall into place [*sie wollten sich nicht ordnen*]" (182; 175). Isn't that precisely the task of collecting: to bring together and establish order to scattered things?

The answers to these questions get at the central paradox of collecting as it figures in this novel. Studer *has* to collect this dust—indeed, he is "condemned" to collect it—but doing so does not bring justice. It neither restores the dead nor does it deliver the murderer to jail—if anything, it only brings more death. The dust Studer finally locates—and which he calls "the last link" (175; *das letzte Glied*, 166) in the case—thus seems to be utterly worthless. And indeed, that is what it is, in the end. It comes to nothing. The final words of the book, "Nüt Apartigs" (189; "nothing special," 197)—which are Studer's response to the investigating magistrate's questions about what he had uncovered—become a trivializing punctuation mark for the whole investigation. The novel thus raises this question: What does it mean to gather and (at least try to) preserve what is ultimately only trivial? What does it mean to heed such trivial matter in its apparent worthlessness—its being "nothing special"—

in a context in which justice is at stake? In this context, Studer's efforts correspond to the paradoxes of collecting as I have explored them throughout this book: to collect in essence involves *making trivial*. To remove the object from its environment and install it in a collection is to transform it into a thing, to reduce its object-value. But this process also affords a new relationship with that object-become-thing, allowing us to see it in its mere thingliness or materiality. In this case, the near-insubstantial object collected does not just uncover its own insignificance but also apparently points to the insignificance of evidence *as such*—to the fact that no matter how many pieces the detective gathers up and tries to preserve, he will be unable to restore them. He cannot ever fully render justice. His collecting of trace elements has only helped him to see this futility—but at a cost. For Studer's gathering of ashen particulate ultimately has deleterious consequences: it brings him close to death. In a variation on the trope of the detective coming too close to the truth, which wears away at him or makes him insane, Studer's collecting of evidence in the form of ashen dust parallels his own harmful intake of ashen particulate into his lungs.[37] Condemned to "crawling round the floor" (184; 176) breathing in dust, Studer gathers this evidence using his own body—and at his own peril. What is trivial, "nothing special," a mere particulate residue of matter bordering on nothingness, itself a consequence of things disappearing or being made to disappear, infects Studer and seems intent on reducing him too to dust.

Studer, however, escapes this fate. As Aeschbacher drives the two of them to the main police station in Thun (Studer lets him drive, thinking he has given up), where the mayor is to be handed over, he swerves off the road and into the lake—a brazen attempt to kill both himself and the detective. Aeschbacher dies by drowning, an ironic end given his name: as ash (the dead body), he returns not to the earth but is scattered in and dispersed by the stream (*Bach*). Studer

37. Doyle's Sherlock Holmes is the paradigm for the motif of the detective who loses touch with reality the closer he gets to the truth. Von Matt discusses Studer's fundamental "weakness," linking it to Chandler's Philip Marlowe and to the illness and fever that set in the closer he gets to the truth. Von Matt, "Die Fäulnis hinter den Fassaden," 221–222.

survives, having ejected himself from the car before it went into the water—but the ash he had collected to "prove" Aeschbacher's guilt is scattered too. Glauser's ending suggests that Studer's survival is in some way connected to this re-dispersal of the gathered dust. The particulate matter is only hinted at in the final chapter, and in the end Studer decides not to reveal the truth about Aeschbacher. This decision obviates the need for evidentiary dust. The "evidence" (in the form of dust) is lost, the murderer (slowly becoming dust) is dead, and Studer is freed from his illness. The painful spots inside him are gone (194; 187), but so are the black spots that had brought the case to a climax. What Studer collected cannot be preserved without it reducing him to the same state as the collected thing itself: to dust. The redemption of the thing, in this novel at least, becomes a redemption of himself from being reduced to a thing.

Medical Objects and Dust: *In Matto's Realm*

In his next novel *In Matto's Realm* (*Matto regiert*), published the same year as *Thumbprint* both serially and in book form in 1936, Glauser pursues similar motifs of particulate matter as evidence and its significance (or lack thereof) for resolving a crime. *In Matto's Realm* reintroduces us to Sergeant Studer, who attempts to solve a double disappearance in a mental institute in the canton of Bern. One of those disappearances soon becomes what looks to be a murder, when Studer discovers the body of the director of the institute at the bottom of a ladder leading to the furnace. Glauser may have chosen this place as the central crime scene in memory of his own stay at the Münsingen clinic in 1919, where he not only wrote a dramatic sketch called "Mattos Puppentheater" (Matto's puppet theater), an Expressionistic exploration of the later novel's themes, but also worked as a stoker. Bernhard Echte describes Glauser's activity in this capacity as consisting primarily of "sweeping together ash" (*Asche zusammenkehren*).[38] Glauser's own de-

38. Bernhard Echte, "Nachwort," in Glauser, *Matto regiert*, 251–263 (here, 252).

scription in a letter to Robert Binswanger from January 1919 places
the emphasis instead on dust:

> Have to sweep and brush and become sooty and run about and sweat
> and ruin my hands. I'm as black as a moor and have a mustache. . . .
> That I cough till I'm as red as a crab and spit up coal dust is uninterest-
> ing and negligible.

> Muß kehren und fegen und rußen und laufen und schwitzen und mir die
> Hände ruinieren. Bin schwarz wie ein Mohr und trage einen Schnurr-
> bart. . . . Daß ich huste, bis ich krebsrot bin und schwarzen Kohlen-
> staub spuke, ist uninteressant und nebensächlich.[39]

Glauser's dismissal of being saturated both internally and externally
by coal dust is meant ironically, of course. And yet, with the words
"uninteresting and negligible" he evokes the key problem of par-
ticulate matter both as minute but omnipresent stuff and as what
in the later detective fiction concerns the question of the significance
of triviality. For, of course, dust is itself "uninteresting and negligi-
ble," except when it is generated in vast amounts in an enclosed
space, like in a furnace. Glauser here resembles his own Studer in
Thumbprint, condemned to eat dust, taking black cigarillo smoke
(ashen particulate) into his lungs just as he had taken coal dust (an-
other kind of ashen particulate) into himself as a stoker and later
as a coalminer.[40]

Dust permeates *In Matto's Realm* even more than it does the first
Studer novel, although this is in part because it takes place within
a sanitarium, an enclosed space in which dust constantly accumu-
lates. Indeed, the smell of dust is a persistent motif in the book,

39. Friedrich Glauser, *Briefe*, 2 vols., ed. Bernhard Echte and Manfred Papst
(Zurich: Unionsverlag, 2013), 1:43.

40. In 1924 Glauser also spent some time working in a coal mine in Charleroi,
Belgium, where, as he later wrote in a journalistic report called "Zwischen den
Klassen" (Between the classes), "coal dust . . . accumulates in the lungs." Friedrich
Glauser, *Der alte Zauberer: Das erzählerische Werk; 1930–1933*, ed. Bernhard
Echte and Manfred Papst (Zurich: Unionsverlag, 2000), 2:113. See Gerhard Saner,
Friedrich Glauser: Eine Biographie (Zurich: Suhrkamp, 1981), 170–174. Glauser
also incorporated this experience in the mines into the story "Im Dunkelen" (In the
dark) and the novel fragment *Charleroi*.

always accompanied by the smell of floor polish and usually also by the smell of medicine: "There was a medicinal smell combined with dust and floor polish, a strange smell that was to haunt Studer for days" (13; 17).[41] The combination of scents seems to allude to the Sisyphean attempt to keep the surface of things clear of dust. No matter how often the dust is vacuumed (the German for which is significant here: *staubsaugen*, mentioned on 150, 156; 145, 150) or the surfaces dusted and polished (see 242; 231), the gray particulate builds up again. That a pharmacological smell can also be found in the mix is not only, given the clinical setting, a naturalistic detail but also inflects this motif of the removal of dust with curative connotations. The staff at this institute take pains to clear away the dark residue of their patients' traumas and psychoses, "the darkness inside" (*das dunkle Innere*) that haunts them much like the allegorical Matto, who is "lurking in the darkness" (206; 197) and yet rules over the whole clinic, his "dark realm [*Reich*]" (11; 16). It should be no surprise, then, that the closer Studer gets to where Matto supposedly lives, in the space above Dr. Laduner's residence, the more the smell of dust dominates and that of floor polish and medicine disappears: "The corridor above Dr. Laduner's apartment smelt of dust and nothing else; the smell of medicaments and floor polish was completely absent" (219; 208).

We do not just smell dust everywhere; we see it too—but usually in connection with Dr. Borstli, the former director of the institute, found dead in the basement furnace room. Here, "in the grey dust" (71; 73), Studer discovers his body stretched out "on the dusty stone floor" (72; 74), his face "covered with a dusting of yellow ash" (71; 73). It is here, too, that Studer collects what he thinks are key pieces of evidence in the form of a gray linen sack that is filled with "fine sand" (69; 71; translation modified) along with some dust, which Studer combs out of the hair of the dead director and which he intends to put under the microscope. The fine particulate of dust becomes, as in the previous novel, indistinguishable from that of ash, although potentially it may contain slightly larger and more coarse particles of sand: "Perhaps a microscopic examination would reveal

41. This distinct odor is mentioned again on 26, 33, 49; 30, 37, 53.

some tiny, glittering grains of sand among all the ash that would doubtless be there" (70; 71). Like dust, sand is the result of processes of abrasion and disintegration, which reduce larger matter to the minute particle or kernel that is without distinction and of little value. In Glauser, sand and dust frequently comingle, as mentioned earlier. Both recall the desert, that expanse of empty space where one feels most alone, abandoned to the elements. Borstli's apartment is such a space. Its surfaces "covered in dust" (82; 82), its air permeated by the smell of ash and smoke (82; 83), this room exudes loneliness: "Now he could see what it was that filled the whole apartment. Loneliness" (83; 83). And while Studer later uses *verwüstet* (122 and 123; "devastation," 126) to describe Borstli's ransacked office, this play on *wüst* ("desolate") and *Wüste* ("desert") suggests that this space too is marked by loneliness, emptiness, and barrenness.

Sand and dust are further linked to mental illness, not only via dust's exclusive olfactory presence near Matto's "dark" realm but also by way of the "darkness" of the unconscious, the seat of "disorder" (110; 108) and of "dark impulses" (205; 196; translation modified in both cases). (In a telling moment, Dr. Laduner corrects Studer's use of "dark" to describe his suspicion about a patient by interjecting the word "subconscious" [141; 136].) And in a later passage that was originally censored, Glauser provides a snippet of Hitler's speech being broadcast over the radio, in which the German dictator aligns illness with devastation—"desolate, . . . sick" (206; *verwüstet, krank*, 196)—by way of that same polysemous word that Studer had used to describe Borstli's office (*das verwüstete Bureau*, 122), a word whose allusion to the sabulous landscape of the desert, although unintended in the original context, Glauser activates by placing it soon after Studer's interior monologue about loneliness ("What was it that was at the bottom of every human being? Loneliness" [205; 196]) and right before Dr. Laduner proposes using reason to "light up the darkness inside [*das dunkle Innere*]" (206; 197) of his patients. In this way, sand, solitude, darkness, and sickness are brought together in a cluster of motifs that also link up to the frequent appearances of dust and soot. Glauser mobilizes these motifs to mark the figures in the novel

who are wasting away in loneliness or are cursed by the chaotic darkness within them. They are beset by the fine particles of sand and dust that accumulate within the walls of the institute like the layers of ash in the furnace room, the actual site of the murder—that attempt to hasten someone's return to dust.

The novel stages two attempts to collect various forms of this scattered particulate matter, attempts to shine a light or bestow order on it, to weigh its value and significance, to ponder its meaning, to make it matter. The first effort is made by Dr. Laduner, who refers to the ungraspable elements of life as "imponderables" (e.g., 12; *Imponderabilien*, 17). These are things insubstantial, intangible, unable to be actually weighed—and thus they escape our attempts to hold on to them or to make sense of them. When he says of his patients' psyches that they are "difficult to grasp" (142; 136), he means it literally, which is why he tries to reach them concretely and tangibly "by way of a detour through the body."[42] In this way his patients become mere objects to be experimented on. Dr. Laduner's mode of gathering and grasping "imponderables" thus translates into an actual collecting of bodies in the institute. Indeed, Ward K is described as a "museum of Gothic statues" (79; 80). The inventory of this museum's collection, however, soon becomes a list of its dead (197; 188), those who succumb to the doctor's experimental treatment. Like the paradigmatic collector, Laduner cannot seem to hold on fully to his collected things without at the same time inflicting harm on them, despite his intention of thereby saving them. "Minds are fragile things" (232; Seelen sind zerbrechlich, 222), he explains. Ultimately, he ends up doing more than "break" them. "So this is where I murder my patients" (169; 162), Dr. Laduner jokes, though it turns out that he is, to a degree, telling the truth, because his experiments have led to a sharp increase in deaths. The victims of his experimental therapy are then collected again in the "mortuary" (*Totenkammer*), what Dr. Laduner calls "the last stage" (75; *die letzte Station*, 76)—a grim image of the inevitable consequences of collecting the living.

42. My translation of "auf dem Umweg über den Körper" (137). Compare Mitchell's translation at 142.

The most prominent of Dr. Laduner's collected objects is Peter Pieterlen, the model for the success of his new therapy who is repeatedly referred to as "the object for demonstration" (*das Demonstrationsobjekt*).[43] Pieterlen, however, escapes not only the deadly fate of some of Laduner's test subjects but also the doctor's secure grasp altogether, going missing at the start of the book and in the end succeeding in fleeing to France. But he is the exception. Most remain trapped in the institute's spiderweb, which is how Studer describes the entire place: both architecturally and clinically it is designed for gathering and ultimately devouring its prey (140–141; 135). "The object for demonstration Pieterlen" is not just the prime example of Laduner's transformation of person into thing; Pieterlen also belongs to the same network of granular and particulate motifs that connect the central players in the plot. For Peter (or Pierre, as he is also called) Pieterlen's name identifies him as a "stone" (Greek, *petrús*).[44] When Laduner responds to Pieterlen's proclivities for shattering windows with the comment, "How can you go about rebuilding, Studer, if you don't destroy things first?" (112; 109), it becomes clear that the doctor's therapeutic method involves precisely such "smashing" (111; *Zertrümmern*, 109) of his patients. Recall that he sees their minds as "fragile" or "breakable" (*zerbrechlich*)—Pieterlen's first and foremost—such that the "stone" Peter is reduced not only to rubble but even more to sand, leading to a patient who is "sick," "destroyed," and "desolate" (*krank, verwüstet*). Pieterlen is importantly also the one who made the sand sack that Studer collects at the scene of Börstli's apparent murder.

Furthermore, Pieterlen's family name, which refers to a municipality near Biel (where we are told he was born [19; 23]), is etymologically related to "pearl" (the French name for the region is *Perles*), connecting him to another hard, shiny object. Just as Laduner's

43. My translation. Mitchell renders it "classic case," which is certainly more idiomatic. The German, however, suggests not only that Pieterlen is an "object" but also that his value is purely functional as an aid in demonstrating the validity of Dr. Laduner's methods.

44. Careful readers will note how Glauser at times plays with this character's name, in particular near the end of the chapter "Matto's Puppet Theatre," in which a short paragraph starts with "Pierre Pieterlen" and ends with "stone" (226; 215).

therapy introduces a pathogen into his patients in the hope of producing a cure, so too (at least in popular belief) when the irritant sand (*Peter*) gets inside a shelled mollusk it produces a pearl (*Pieterlen*). As proof of the success of his methods—sand transformed into a pearl—"the object for demonstration Pieterlen" is no mere thing in a collection. He remains within the doctor's grasp as a tool to be put in service to a specific end. Laduner's collection of patients, then, which is meant to bring order to their psychological "dis-order," is a perversion of the classical model of collecting, one in which the attempted redemption of the thing leads only to its utter destruction.[45]

Studer's approach serves as the countermodel to this purely destructive collecting. If Laduner is shown "grasping" his collected objects—namely, his patients' fragile psyches—and thereby destroying them so that they crumble into sand and dust, Studer is shown carefully gathering up these particulate pieces, yet without actually fully "grasping" them. "Unfortunately, you haven't grasped anything, Studer" (259; Sie haben leider nichts begriffen, Studer, 247), Laduner says at the very end of the novel, meaning of course that the sergeant has not only "understood" nothing about the case but also, by way of a play on *greifen*, implying that the physical evidence he has gathered has slipped away from him.[46] Studer has failed to hold on to anything. This "not-grasping" characterizes the sergeant's mode of collecting evidence, as we already saw in *Thumbprint*, where in the end, he loses the forensically significant dust. There he had to relinquish the evidence, lest it infiltrate him fully and bring about his own demise. Here, too, the evidence is relinquished, but in a way that reveals a different dynamic, one that is nonetheless still determined by the paradoxical process of collecting, as becomes clear near the start of the chapter "A Chinese Proverb," which inaugurates the novel's denouement:

45. "There was no order there [*Unordnung*], it was illness [*Krankheit*]" (110; 107).

46. Translation modified. Connecting these motifs, Studer had described the loneliness that saturated Borstli's apartment as "graspable" (*zum Greifen*) (103). Mitchell translates this as "almost palpable" (105).

Studer opened his suitcase and placed various objects on the round table, which once, on an evening that seemed long ago, had had a lamp on it with a glowing floral shade. Beside the lamp had been the files on Pieterlen, the object for demonstration.

Dr Laduner took his hand away from his eyes and looked at the table. Nice and neatly laid out on it were the following objects: an old wallet, a sandbag that looked like a huge gray salami, a piece of coarse gray cloth, two envelopes, a piece of paper with writing on it and a wad of hundred-franc notes.

"Very nice," said Laduner. "Are you going to donate these objects to a police museum, Studer?" (228; translation modified)

Studer öffnete die Handtasche und legte nacheinander verschiedene Gegenstände auf den runden Tisch, der einmal, an einem Abend, der fern schien, eine Lampe mit leuchtendem Blumenschirm getragen hatte, und neben der Lampe hatten die Akten gelegen des Demonstrationsobjektes Pieterlen.

Dr. Laduner nahm die Hand von den Augen und blickte auf die Tischplatte. Auf ihr lagen, fein säuberlich, folgende Gegenstände:

Eine alte Brieftasche, ein Sandsack, der aussah wie ein riesiger grauer Schübling, ein Stück groben grauen Stoffes, zwei Enveloppen, ein beschriebenes Blatt und ein Bündel Hunterternoten.

"Nett," sagte Dr. Laduner. "Wollen Sie die Gegenstände einem Polizeimuseum schenken, Studer?" (218)

This passage brings Studer's collected evidence into virtual contact with Laduner's collected objects, which had been spectrally present in the files that had lain on the same table on which Studer now lays out his things. These files refer generally to Laduner's larger collection of patients. The file is a medium of collecting after all, and it functions here as a reminder of how Laduner has reduced all his patients to a collection of experiments and observations—to data. They, like the patient to whom these particular files belong, Pieterlen, are merely "objects." That much is clear to Studer, who just a few pages earlier made explicit this connection between patient and thing, specifically the file: "What had Pieterlen been? A bundle of files" (225; 215). In the precise place where this objectified version of Laduner's prize object was laid out for him earlier in the novel, Studer now lays out for the doctor his own collection of objects, which importantly includes four media of containment: a wallet, a small sack, and two envelopes. Three of these four containers hold

particulate matter in the form of either dust or sand. (The fourth, the wallet, holds an additional medium of collecting, the inventory of the dead—a list that Laduner had earlier tried to reduce to yet another particulate matter, namely ash, by burning it.) The battle of the wits of these two men—one of whom represents the intuitive genius of the detective, the other the calculating genius of the scientist—thus begins with a presentation of the objects of their respective collections.

Laduner's response to Studer's exhibition of his evidence inaugurates this final conflict and frames it explicitly in terms of collecting: "Are you going to donate these objects to a police museum, Studer?" This sarcastic question brings to a head a number of the concerns of the book as a whole and is critical for understanding how Glauser's work negotiates the paradoxes of collecting in the context of the detective novel. The question only has rhetorical force because forensically significant objects belong not in a museum but in an evidence room. Objects are, of course, collected in both places. In the evidence room, however, they are not entirely removed from their spheres of use but are refunctionalized for the purpose of solving a crime. In the museum, contrarily, the object is fully removed from the world of practical undertakings, relinquishes its functionality entirely, and is valuable only as an index of how distant it in fact is from present, practical concerns.[47] Such is the importance of Studer's evidence in Laduner's eyes. The sergeant's collected objects are purely trivial, without any bearing on the present circumstances. They therefore belong in a museum of forensic artifacts, withdrawn from the realm of practical application and only meant to be viewed as quaint examples of outdated methods.

This conception of the museum manifests a variation of one of the paradoxes of collecting. It implies that only things of no importance are gathered and preserved. Nontrivial objects, in contrast,

47. This view discounts the value of historical objects that might be "functionalized" as part of archaeological research to reconstruct a past. As such the museum object and forensic evidence are much closer than Laduner's quip would presume. As we will see, the line between untouched collected object and refunctionalized collected object becomes dangerously blurry in Laduner's own practice.

must remain part of our available supply of accessible, tangible, and useful phenomena. The collected thing, from this perspective, is trivia par excellence. It must not only remain untouched and un-used (if not unusable) but is furthermore only important by virtue of no longer being important; it is in other words only worthy to be in the collection because it can now be set aside to collect dust. This logic informs Laduner's conception of his own collecting in a perverse and ultimately lethal way. The doctor treats his patients as similar to such collectable things, useless to society and thus in need of being taken up into his institute, that "museum of Gothic stat-ues" (79; 80) where they will be kept safe. Laduner's stated intent to find a cure and restore these people to society is belied by his actions, however, and it soon becomes clear that his collected things are being horrifically refunctionalized in experiments that have had a high casualty rate. Glauser suggests this is the inevitable conse-quence of the activity of collecting, whether the object is turned thing and thereby damaged or whether that thing is redeployed in efforts that undermine the very impulse to collect in the first place.

Laduner's question—"Are you going to donate these objects to a police museum, Studer?"—collapses the difference between Stu-der's collected things, which he lays out "nice and neatly" (*fein säu-berlich*), and the doctor's objects, which are sequestered in the dusty, dirty interiors of the institute. For this reason it should come as no surprise that, having pronounced the collection trivial, Laduner seizes Studer's evidence (with the telling exception of the bundle of money, the one thing undeniably *not* trivial) and locks it away in a cupboard, pocketing the key. His judgment meets with little resis-tance, because it turns out that none of Studer's evidence carries any weight in this case (even Caplaun's confession letter gets the story wrong). This inconsequentiality applies in particular to the granu-lar and particulate matter collected in the two envelopes: "He lifted up one of the envelopes. 'Sand!' he said. Then the other. 'Dust'" (229; 219). This otherwise scattered, minute matter, which Studer has col-lected in paper enclosures and carried around with him throughout the novel, is supposed to be key to the investigation. But instead of providing the necessary pieces to reconstruct the crime, these fine

particles end up being marginal to the case and—as in *Thumbprint*—ultimately merely trivial. The narrator is at first unusually circumspect about the fact that the ostensibly immaterial particulate that Studer deems worthy of collecting and preserving does not in fact constitute forensically significant evidence. When, midway through the novel, Studer inspects the dust collected at the crime scene under the microscope we are told, "The sergeant seemed pleased with the result" (152; 147), but nothing more. Only near the end of the book do we find out that this microscopic analysis of the dust served as a "proof" that the sand sack was not used as the murder weapon: "The slides he had prepared . . . confirmed that [*bewiesen diese Auffassung*]" (217; 207). The evidentiary function of the collected dust is to reveal that it is *not* evidence, that it is of no importance to the crime. Like the thing taken into the collection, it is only important by virtue of not being important in the outside world.

Studer's method of gathering up and preserving the pieces, then, turns out to fall far short of the goal of many a collector. The sergeant's hodge-podge collection of dust and sand does not help reconstruct the crime and thus fails to reestablish order. That Studer not only failed to "grasp" but also (literally) failed to hold on to his evidence would seem to condemn his investigative abilities—again. He was unable to bestow on them any significance for the case at hand; he failed to place them in a context in which they might make sense of what happened, to provide a clear picture of the transgression in whose wake they were found.[48] These failures call into question the foundation on which the entire genre of detective fiction rests. Has the novel failed us as readers, too?[49] The figure who is

48. In the literature, this failure is typically figured in terms of the lack of any final, unambiguous truth (in modernity), which means that any "solution" provided by the detective is necessarily constructed and subjective. See, for example, Christa Baumberger, *Resonanzraum Literatur: Polyphonie bei Friedrich Glauser* (Munich: Wilhelm Fink, 2006), 139–141.

49. Thomas Kniesche suggests that the genre of the detective novel, with its "plot-centered structure and claims to edification," belongs among those institutions that are "radically challenged" by Glauser in the book. Kniesche, *Einführung in den Kriminalroman* (Darmstadt: Wissenschaftliche Buchgesellschaft, 2015), 117.

supposed to guide us through the murky regions of madness and murder cannot himself get a grasp on things.[50] Even the actual murderer, Dreyer, escapes from the police (though he is run over and killed in the process). The person responsible for the most deaths at the clinic, Laduner, remains in power, unaccounted for. He is the least graspable of them all: "He was like an eel, was this Dr Laduner, always slipping out of your grasp" (248; Wie ein Aal war dieser Dr. Laduner, nie konnte man ihn fassen, 237).

And yet, the dynamic of collecting in fact shifts in the sergeant's favor at precisely the point when Laduner confiscates Studer's evidence, locking it away as if in a museum, condemning it to being a "mere triviality." Having aligned Studer's dust and sand with Laduner's patients, Glauser suggests that the sergeant's relinquishing of the dust and sand is actually a trade-off: Laduner gets the sand/dust, but Studer gets Pieterlen (stone/pearl). Recall that Pieterlen's disappearance was one of the first mysteries of the novel: reduced from stone to sand through Laduner's treatment, he slipped through the cracks of the institute and got away. It is Studer who locates him, in the action prior to this standoff with Laduner. The sergeant, however, does not apprehend him and bring him back to the institute. Studer instead lets him go. This refusal to capture, this *not-grasping*, turns out to be the most productive act of rendering justice in the novel.

Making the Invisible Visible

Like the scattering of dust at the end of *Thumbprint* and Studer's inability to fully grasp the collected dust and sand in their triviality in *In Matto's Realm*, this letting go of Pieterlen expresses Glauser's poetics of collecting as inextricable from dispersal in ways that have

50. Rosenstock illustrates how Studer does not correspond to the classic detective of the genre's Golden Age, who "articulates a deep faith in the knowability of the world" and "in the human being's capacity to acquire this knowledge and then leverage it for the improvement of society." Rosenstock, "An Atmosphere of Malaise," 111.

both epistemological and ethical consequences. Epistemologically, Studer's methods suggest that whatever knowledge we gain from things can only be a negative knowledge. The truth is not something that can be pieced together from singular pieces of evidence. Rather, it emerges from the minute pieces that refuse to fit into that whole. Consequently, the thing collected for forensic evidence may refer back to its origin—an act of violence—but only because that origin precipitated its transformation from object into thing. The evidentiary thing helps provide insight into the crime because it has relinquished its claim to being restored to objecthood.[51] Studer's abandonment and scattering of evidence acknowledge this paradox: the thing grants epistemic access to its origins only *because* it has been dispersed, only *in* its state of dispersal, which is the result—the residue—of a crime that can never be fully or directly known (lying as it does in an irretrievable past).

Curiously, our knowledge of dust is similarly indirect. In fact, we rarely see it in its particularity. What we see by virtue of dust's presence are the spaces in which it occurs. However, as mentioned earlier, it is only because of dust's dispersal—and its resulting invisibility—that it is able thus to make the environment visible. "Scattered throughout the atmosphere and the universe," Joseph Amato explains, "its refracting power helps account for why and how humans see light itself."[52] What we see when we "see" dust is the space illuminated by it, but in which it necessarily disappears. To be able to recognize dust at all *requires* that it remain scattered. To see this near-invisible matter in its dispersal is to see that it cannot be seen—or that it cannot be properly seen without its dispersal. The best knowledge of this particulate we can gain is to recognize that its elusively scattered and intangible existence—its refusal to be directly apprehended or grasped, its invisibility—makes our knowledge of the visible world possible in the first place.

51. Even if the crime is supposedly solved (the wrongdoer identified and apprehended), in most cases the violence cannot be undone. This is especially true of the crimes depicted in Glauser's books, where it is sometimes questionable whether they have even been properly solved.

52. Amato, *Dust*, 5.

The ethical implications of dust's dispersal emerge from an allegorical reading of the particulate matter in the Studer novels that is related to this paradoxical visible invisibility. For what Glauser exposes, ultimately, is the way in which the "trivial" people in society are made invisible by the institutions that want to assure order and prosperity.[53] Dust, sand, and ash stand in for the forsaken, the dispossessed, and the downtrodden, those elements of society that are swept under the rug and out of sight. These include the crumbled fragments of Laduner's therapy, not just Pieterlen and Caplaun but also all the other victims who end up on the list of the dead. And they include the poverty-stricken Witschis, as well as the other washed-up denizens of ailing Gerzenstein, who fall victim to financial, domestic, and sexual abuse. Dr. Laduner wants to lock these elements up, trapping them in his web. His mode of collecting, however, leads to more dead. Studer tries to bring them out into the open, into the light. But this requires a different mode of collecting, one that acknowledges the need for dispersal, for letting the gathered pieces go. Where Laduner tries to grasp them, thereby inflicting violence, turning people into things for experimental purposes, Studer gathers up the pieces, but only to free them from their material circumstances, their conditions of oppression. The result is resolutely *not* to reintegrate them into society, but instead to show them as individuals struggling to survive in a society that has rejected them, one in which they have no place. In this way, Studer's dispersal of evidence appears as a tacit acknowledgment not so much that the conditions prior to the crime cannot be restored, but that restoring those conditions is not even desirable. For these conditions are the *real* crime. As Peter von Matt puts it, Glauser downplays the importance of the single wrongdoer in the first Studer novel because he wants to disabuse us of the notion that "his elimination would also restore the whole." According to von Matt, Glauser is more interested in exposing the larger problems of Swiss society, including the economic misery and consolidation of power in the elites that have deeper consequences for injustice in the

53. See Kniesche's reading of *In Matto's Realm* as an institutional critique. Kniesche, *Einführung in den Kriminalroman*, 116.

country.[54] These conditions can only be fully seen by recognizing how they render the individuals pulverized in it invisible. To make them visible *in their invisibility* means treating them like the particles of dust to which they have been reduced and then letting them be—scattered. Glauser's text becomes the new space in which these dispersed victims can be properly seen, even if only negatively against the societal backdrop that renders them marginal, meager, or simply mad.

54. Von Matt, "Die Fäulnis hinter den Fassaden," 223. Julia Karolle similarly shows that guilt itself is dispersed among many in the village in *Thumbprint* and is not localizable in any one person. She reads this fact as part of Glauser's critique of *Heimatliteratur*. K. Julia Karolle, "The Role of Language in the Construction of Identity and the Swiss Crime in Friedrich Glauser's *Gourrama, Der Tee der Drei alten Damen,* and *Schlumpf Erwin Mord* (PhD diss., University of Wisconsin, Madison, 2001), 197–198.

CONCLUSION

The case studies gathered in *The Redemption of Things* have taken our exploration of collecting as it informs literature and cinema in varying, at times not fully reconcilable, directions. For this reason, it behooves us to return to the book's theoretical framework as elaborated in chapter 1 and to consider how the paradigms of materiality, preservation, and representation detailed there start to assume different contours when examined through the lenses provided by our idiosyncratic examples. Indeed, the close readings carried out in the three main parts of the book complicate the models with which we began, ultimately providing a more nuanced picture of the semiotics of materiality.

We see these complexities above all in the concepts of the object and the thing gleaned from Heidegger. Although the distinction between these categories of materiality initially helped identify the different ways we encounter and deal with the stuff of the world— either unreflectively, as integrated into a meaningful context, or by

"noticing" it in its sheer materiality—the individual case studies revealed that this differentiation is not so stable or clear-cut. In being worn down, used up, and discarded, objects do tend toward thingliness, but things can just as well be treated as objects. Neither category, furthermore, can be easily aligned with a normative schema: although the object might correspond to the reliable and secure mastery of materiality, that mastery can also appear as manipulation or subjugation (think of Dr. Laduner's patients in chapter 7). The thing meanwhile might exemplify the forsaken and broken down, but it too can become productive and ultimately meaningful.

In large part the uncertainty in this distinction results from the apparent lack of objects—or the lack of apparent objects—in our examples. From the start we have been dealing with the *mere thing*, that which has ostensibly already lost or relinquished its objecthood. And yet in most of our cases that former object status cannot be adequately—if at all—identified. If the object transformed into a thing is supposed to allow us to see, spectrally, the thing's former objecthood, what would this properly functioning or unquestionably relevant material object have been in, for instance, the case of Glauser's dust and sand? This particulate matter does not really belong to anything concrete or identifiable in these novels. Instead, it points to the crime itself as the site where the distinction between objects and things begins to break down. Yet, when forensic evidence is collected to reconstruct a crime, Glauser shows us that this reconstruction is only ever partial and that it cannot restore what was lost. The other case studies raise similar questions about the stability of these categories of materiality, the relative ease with which we divide up the stuff in the world into what is useful and what is useless, alive and dead, fleeting and permanent. Heinrich's art is only useful in being recognized as trivial. Geiser's cut-up books are meant to be mnemonics but end up replicating the old man's scattershot mind. Sludge and debris, "dirt and stones," become the productive ingredients of a new kind of writing for Gotthelf. Fischinger can only make the fleeting moment permanent by letting it flit by. And the preservation of Walchon's mosses, like the House of Sentze's continued flourishing, is made possible only by their desiccation and dormancy.

In none of these cases is the object or former object-status of things clearly defined or circumscribed, remaining at best incidental to the thingliness of the collected items. In most of the cases, in fact, we encounter these things first and foremost as mere things—marginal, precarious, abandoned—not as objects. They are already displaced, broken, or without a fixed place. Their origins hardly matter; perhaps they were once intact or in place, but these lost states have little bearing on the present concern with their dispersal. This picture of thinghood in relation to the object thus looks markedly different from the everyday examples provided in chapter 1: the door latch and the typewriter. For in these cases, the former objecthood of each emerges clearly in the encounter with the respective thing. We find nothing fully resembling this kind of epistemic recovery of an object's meaningfulness, usefulness, or situatedness in our case studies. In its place we encounter things whose objecthood either does not really matter or only matters insofar as its loss characterizes our experience of materiality as such.

Yet although loss is critical to this experience, the case studies in this book demonstrate that this loss should not be equated with nostalgia for the object. In place of any longing for or fetishizing of the object, the works analyzed in the preceding chapters encourage different modes of dealing with, understanding, and potentially rescuing the world of variously and complexly scattered things. Indeed, the logic of collecting, as it is mobilized in the aesthetic sphere, makes possible a renewed encounter with things that at the same time helps wean us from the desire for objects, from our tendency to fix, hold, contain, explain, and master the material world. From the perspectives provided by these cases, the object of nostalgia is little more than a wish-image lying in an irretrievable past (or a hoped-for future). The redemption of things involves recognizing and accepting the forsaken, broken, and discarded not as deficient objects that are in need of repair or restoration but as valuable signs of the precariousness of our material world in the here and now. It involves seeing the distinction between objects and things as emerging ultimately from our different interactions with (or comportments to) that world. If objecthood is another way of describing a relation to materiality that ignores, disavows, or tries to forget the

"fragmentary, disordered, and cluttered" (*Bruchstückhafte, Unge-
ordnete und Überhäufte*), as Benjamin describes it, that accumu-
lates around us, then thinghood—made especially palpable in the
collection—describes an openness or receptivity to this condition
(with Flusser, our "Be-*ding*-ung"), with all its attendant difficulties
and uncertainties.[1]

Collecting as Practical Activity, Collecting as Poetic Activity

Although this book's three parts present new ways of conceptualizing
literary and cinematic work in terms of the logic of collecting, the
insights gleaned from these studies also help us better understand the
conflicted nature of collecting as a practical undertaking. In particu-
lar, they reveal the ways in which the musealization of material speci-
mens necessarily hides the destruction and displacement inherent to
it and how even amateur collectors are engaged in an "anarchic
activity"—their desire for order, preservation, and permanence inevi-
tably coming up against the reality that their assemblages will only
ever be a patchwork comprising the disfigured and dislocated.[2] To be
sure, exhibition artists and museums in the late twentieth and early
twenty-first centuries have attempted to confront these conflicts and
contradictions, as is evident above all in the debates around repatria-
tion, the return of looted art currently in (predominantly Western)
museums to their (predominantly non-Western) countries of origin.
Contemporary artists moreover have been most effective in combat-
ing the forces of musealization by making works of art that cannot
be held in an exhibition space, either because they are fundamentally
ephemeral or because they only exist as part of an environment in
flux. In the German-language tradition we might look to Dieter
Roth's art-objects made from decaying and rotting food or more re-
cently to Urs Fischer's *Faules Fundament* (Rotten Foundation, 1998),

1. Benjamin, *Origin of the German Trauerspiel*, 201; *Der Ursprung des
deutschen Trauerspiels*, in *Gesammelte Schriften*, 1:363.
2. Benjamin, *Gesammelte Schriften*, 3:216.

a brick-and-mortar wall built on fruits and vegetables that end up decomposing, threatening the whole structure's stability and leading to piles of crumbled and fetid trash. Thomas Hirschhorn constructs multimedia exhibition and performance spaces out of cheap, everyday material that has no surplus value and that is later broken down, discarded, or reused in other contexts. In resisting the impulses of musealization, these and similar ephemeral works of contemporary art also raise questions about the imperative to collect what fundamentally eludes conventional means of preservation.[3]

These difficulties are just as salient in museum spaces that display not works of art but instead the artifacts of history, themselves scattered both in time and space, no longer belonging to the era to which they now testify nor to the area in which they were situated. Some such museums have nonetheless attempted to make these paradoxes of collecting apparent and productive. Among these is Porto M, a museum on the Italian island of Lampudesa.[4] Here locals have gathered the debris and detritus left behind by boats of migrants that continue to arrive on the island, which is one of the primary ports of entry to Europe. The artists and activists who established this museum undertake a peculiar kind of salvage at the two boat junkyards on the island where hundreds of impounded migrant ships have piled up. The people these boats carried have long since gone, but their traces remain in the form of lost and abandoned things: blankets, life vests, stuffed animals, shoes, and other clothing; photographs, letters, and books; and also bottles of medicine, cans and bags of food; along with other ephemera. In Porto M these things are put on display, though not in a way one would expect in the institution of the museum. Instead of labeling, categorizing, or even protecting these lost items, they are exhibited in mostly random accumulations, free of attempts to provide a story

3. See Katrina Windon, "The Right to Decay with Dignity: Documentation and the Negotiation between an Artist's Sanction and the Cultural Interest," *Art Documentation: Journal of the Art Libraries Society of North America* 31, no. 2 (September 2012): 142–157.

4. The museum is documented in the Austrian director Jakob Brossmann's 2015 film *Lampudesa im Winter* and in the 2016 short *eMMMMe—Porto M. Lampudesa* by Lorenzo Sibiriu.

or history, free of the imperative to link them to a specific time or place, and without any attempt to repair or restore them. The impression created by this space is that one has entered "a lost and found office, where the objects seem to wait for their owners to bring them back home."[5]

These owners, however, will not come to rescue their things, for they too have been displaced. And that, ultimately, is what this collection of scattered things conveys. As Federica Mazzara writes, in its "refusal to archive, name or restore," Porto M "participates in and shares the marginality and displacement experienced by the migrants and refugees."[6] Such a refusal to restore expresses an acceptance of the state of things: there is no identifiable space to which these items might be returned because this "origin" is itself not fixed or determinable. These scattered things belong to a people who have scattered, a people who have no "proper place" or home, whose lives are marked by placelessness. (Lampedusa itself is not the destination for these migrants, but merely a first stop on their journeys.) In most cases, their actual origins are countries to which they cannot return or to which they do not want to return—they are regions of instability and uncertainty. To be brought back there would result in their certain death. To be "scattered" from these origins therefore represents a condition of desperation—but also of hope, however precarious. The collection at Porto M thus does not evoke any nostalgia for objects or origins but instead makes palpable the dispersal of people and things that marks this historical moment. It also cultivates a profound ambivalence toward this state of dispersal, which is at once experienced as loss and as an overcoming of catastrophe. The refugees and migrants may be "saved" in their dispersal (in escaping from the violence and chaos that reign in their regions), but like the lost and abandoned things collected at Porto M, these people remain uprooted and vulnerable. Many of them do not survive at all. We see here—as we did in a completely different

5. Federica Mazzara, "Objects, Debris and Memory of the Mediterranean Passage: *Porto M* in Lampedusa," in *Border Lampedusa: Subjectivity, Visibility and Memory in Stories of Sea and Land*, ed. Gabriele Proglio and Laura Odasso (Cham, Switzerland: Palgrave Macmillan, 2018), 164.

6. Mazzara, "Objects, Debris and Memory," 167, 161.

context in Glauser's novels—how the paradoxes of collecting contribute to making visible and, in doing so, redeeming what is considered to be waste, not just things discarded but also lives rejected or refused by the dominant forces of political and economic control.[7]

These few examples from institutional spheres suffice to illustrate how, in view of the inextricability of collecting and dispersal, the practical concerns with preserving materiality become especially urgent, demanding singular and at times surprising interventions. They also provide a useful contrast to our case studies, the sites not of practical but of poetic collecting. Unlike in the museum, in our literary and cinematic examples we do not encounter inanimate things or ordered assemblages of material stuff, but instead discover collecting at work as a dynamic process. In place of depicting the material world as if it were an immobile collection, the static object of museal observation, these works set in motion and make constitutive of their aesthetic production the paradoxical procedures of gathering and preservation. It is therefore not so much the stable presence of objects as it is their mercurial movements that characterize these works; movements that foreground the precarious status of objects, their tendency to fade, flitter, fall apart, to become mere things; movements that reveal how any apparent closeness to the material world also involves a certain distance, how things' propinquity also points to privation.

Because the things disclosed in these works point not only to the world in its materiality but also back to the artwork, they take on poetological significance, serving as the material not just *for* but also *of* poetic activity. The artwork, then, becomes not only the space where the problem of things plays itself out but also the site where that problem is taken up and worked through in and as a feature of the thingly work itself. Furthermore, by staging different transferrals and transformations of objects and things in and out of meaningful contexts, in and out of secure spaces, the works central to my investigation demonstrate how difficult it is to fully grasp the mute stuff of the world—in part because any such grasping performs, precipitates, or participates in the loss of its integrity as object, as stable,

7. Mazzara, "Objects, Debris and Memory," 160.

knowable, useful matter. These works are thus constantly pointing back to their own representational undertakings, their own endeavors to provide a new context (in the form of the poetic work) in which mere things might become meaningful. But as with the items installed in the presumably secure space of the collection, this new context can only make things meaningful as ciphers of their own precarious significance. In the end, the inadequacy to preserve things fully becomes the very means by which their thingliness becomes palpable—in the collection that is the artwork.

By virtue of these peculiar and at times conflicted qualities, our case studies are ultimately able to teach us valuable lessons for coming to terms with the deterioration of objects and the dispersal of things characteristic of our world. In effect, they cultivate a certain thingly sensitivity, a heightened awareness of the material world around us and of the different ways we interact with it. Key among these are the attempts to, with Vilém Flusser, "orient ourselves" in this world by intervening in it, devising means for reversing the scattering of things by holding and thus having what—like us—is fundamentally impermanent.[8] Yet the contradictory impulses of gathering and preservation acted on in and by our literary and cinematic examples lead to peculiar outcomes. We find here highly idiosyncratic instantiations of salvage, in which things forsaken are often only rescued by awakening and sharpening our recognition that they need rescue in the first place. The transformation of objects into things consequently emerges as a perceptual shift—and thus not any essential distinction—that allows for an epistemic and even ethical "grasp" of thingliness. The operations of collecting—like the works in which these operations variously unfold—are revealed to be self-reflexive undertakings that lay bare the scattered state of things in and through the processes meant to impede it.

We might take these conclusions one step further, to the point, in fact, where the dispersal that I have argued is integral to collecting ends up not just challenging but also effectively nullifying the efforts to gather and preserve. We saw versions of this picture emerge in Glauser, Frisch, and even Keller, where the principles of gather-

8. Flusser, *Dinge und Undinge*, 9.

ing and preservation ultimately lead to a return of things to the scattered states from which they were taken. These case studies showed how, because the means by which we appropriate things too often end in their damage or destruction, to preserve them properly we have no choice but to let them go. Such rescattering relinquishes any claim on things and on their restoration, thereby acknowledging that the unrestored state in which they "naturally are" is closer to an authentic condition of things—in their proliferation and fragility—than the wish image of our collections.

Seen in this way, the imperative to "save" things by means of gathering and preservation has to be reconsidered. Instead, should our proper relation to the things around us be *not* to grasp them, *not* to appropriate them, *not* to install them into a new context, *not* to try to preserve them—but just to let them be? If that is the case, then why even collect in the first place? Indeed, some of the works I analyzed in this book suggest that we gather *in order* to let things go and that this process is a necessary means of bringing things close, of seeing what we otherwise overlook—which triggers the recognition that they can only really be preserved by being returned to the entropic states from which they were taken. If the collection discloses the loss of objects that it itself instantiates, then from one perspective that loss must be met by a commensurate abandonment of what was collected. We collect therefore not so much to counteract dispersal as to participate in it.

Letting Things Scatter (*Rilke*)

I would like to return to the poetry of Rainer Maria Rilke, with whom we began this book, to tease out the implications of this conclusion that in the final analysis collecting does not remedy dispersal but instantiates it. Consider the image of collecting and dispersal as it appears in this early poem of Rilke's, first published in 1899 in the collection *Mir zur Feier* (To celebrate myself):

Du mußt das Leben nicht verstehen,
dann wird es werden wie ein Fest.

Und laß dir jeden Tag geschehen
so wie ein Kind im Weitergehen
von jedem Wehen
sich viele Blüten schenken läßt.

Sie aufzusammeln und zu sparen,
das kommt dem Kind nicht in den Sinn.
Es löst sie leise aus den Haaren,
drin sie so gern gefangen waren,
und hält den lieben jungen Jahren
nach neuen seine Hände hin.[9]

You don't need to understand life,
then it will become like a celebration.
And let every day happen to you
like a child who in passing by
lets every breeze
bestow on it numerous blossoms.

To gather these up and save them,
does not occur to the child.
It loosens them gently from its hair,
where they were so gladly trapped,
and to the lovely years of youth
holds out its hands for more.[10]

This poem urges the reader to live life without trying to understand it, offering as an extended metaphor for such not-grasping the figure of the child who refuses to hold on to the blossoms that have been blown into its hair, which it loosens and lets rescatter to the

9. Rilke, *Werke*, 1:71. I am especially grateful to Erik Born who—in a rather remarkable recitation from memory—alerted me to this poem.

10. My translation of the opening couplet renders Rilke's German straightforwardly. It should be noted, however, that the mere granting of permission to forgo "understanding," as expressed in the first line, takes on a more imperative quality after the second line's "dann." It would thus not be inaccurate to gloss the opening line more forcefully as "be sure not to understand life" or even "you must fail to understand life." Such a reading, however grammatically tenuous, would make the first line's "nicht" negate "verstehen" instead of the modal verb. Charlie Louth, for instance, reads the line in this manner. Compare his translation of this couplet: "Only by not being understood can life become a celebration." Louth, *Rilke*, 41.

winds.[11] The movement of the poem is thus from dispersal to gathering to redispersal. The gathering that is the static midpoint of this movement, however, is not undertaken by the child itself, who "does not think" to pick up and save (*aufzusammeln und zu sparen*) the blossoms. The child's nonconceptual interaction with things precludes any such appropriation. Instead, it is the forces of dispersal themselves—the wafting of the winds (*Wehen*)—that leads to their collection. The scattering of things that characterizes our entropic world thus itself becomes imbued with the tendency to gather: blossoms do not just fly away randomly but can also—equally randomly—find the space to be arrested in their flight. Gathering therefore occurs here, but only as an unwilled consequence of the movement of things that human gathering typically intends to halt.

The child becomes the passive site of this "collection" of blossoms, which it receives as if they were a gift (*schenken*). Yet this gift is importantly only accepted in an act of refusal. The blossoms that have gathered in its hair the child frees back into the winds that had brought them there. In a further twist, this willful act of rescattering coincides with a gesture of receptivity, as we read in the poem's final couplet: "und hält den lieben jungen Jahren / nach neuen seine Hände hin." After loosening the gathered blossoms to the dispersing breezes, the child "holds out its hands for more" in a gesture suggesting both abandonment and acceptance: its open hands release the things gathered and welcome new ones at the same time. Dispersal and the desire for gathering coincide here, but in a way that transforms the idea of collecting they inform into a passive activity.

This description of the intertwined forces of gathering and dispersal comprises Rilke's main metaphor for how one ought to comport oneself in and toward the world. The imperative here is to *let go* of grasping the meaning of things. In the words of "Scent" (Der Duft), the Rilke poem with which we started this book, we should let them be *unbegreiflich* (ungraspable). Only as that which cannot be fully "grasped" can life become joyful and celebratory: "wie ein

11. On the "you" in poetry as an appeal to the reader, with emphasis on the work of Rilke, see William Waters, *Poetry's Touch: On Lyric Address* (Ithaca: Cornell University Press, 2003).

Fest." Rilke's wordplay emphasizes the tactility of this process: instead of holding on to something tightly (*fest*), we need to let it slip away. For life to become like a celebration (*Fest*) we have to avoid fixing things in place, making them *fest*, permanent, constant. Any such arresting of things—pinning them down—has to be renounced in favor of abandoning them to the forces of dispersal, an abandonment that Rilke aligns with the renunciation of understanding: we let go of grasping the thing both tactilely and conceptually. Thus, the gathering in this poem happens, as it were, unknowingly and without active effort on the part of the human. Rilke encourages us to let collecting *happen to us*.

In renouncing the active appropriation of things, we should, the poem proposes, let them come to us—by means of the natural forces of dispersal. We should in essence let dispersal do the collecting, which in this poem is transformed into an activity always already at work in things. In its most authentic form, then, collecting becomes celebratory of the way things are—of the scattered nature of the world. Rilke suggests we ought not lament this state but rather turn toward it in joy and playfulness. Loss—instantiated by the natural forces of dispersal—here becomes constitutive of a life lived in relation to things without any need to instrumentalize them, let alone to have and to hold them.

The poem thus offers a radical vision of collecting as an aleatory occurrence that we cannot control—nor should we try to. To grasp and appropriate objects inevitably does them violence. The best we can do is let them gather themselves—and then help them to redisperse. Such is the redemption of things: not a grasping but a relinquishing. The classical collection, which forces things into categories, takes place under the imperative to fully understand, to impose on them an inflexible identity, fixing things both practically and conceptually. Modern collecting tries to "preserve" things *as* the nonidentical, that which eludes our understanding and our abilities to fix meaning without a remainder. Such preservation demands a gesture similar to Rilke's child's: an openness and receptivity to things and a willingness to let them go at the same time.

To be sure, Rilke's poem puts us far from the idea of collecting in any practical sense. It pushes the logic of modern collecting as I

have been developing it in this book to an extreme, where it seems to disappear entirely as recognizable social practice. But it reemerges, I want to insist in closing, as a utopian idea that expresses an authentic relationship to the world in which objects necessarily elude our grasp. At times this study has picked up the ethical, especially ecological, implications of this stance. The stakes, in the third decade of the twenty-first century, could not be more urgent. As our notion of collecting to preserve becomes decreasingly viable, the next phase in the history of human collecting may involve a monstrous manifestation of gathering and dispersal in which trash and waste pile up and spread out, leaving little room for us, let alone the other life on this planet. Perhaps we should heed Rilke's advice: be like children and try to reestablish a relationship with our environment and its things that allows them simply to be—without any need for us to grasp them. Only in this way might we avoid doing both ourselves and the world of things further harm.

WORKS CITED

Adorno, Theodor W. *Negative Dialectics*. Translated by E. B. Ashton. London: Routledge, 1973.

Ajouri, Philip. "Zu einigen Sammlungs- und Ausschlussprinzipien beim Publikationstyp der 'Gesammelten Werke': Gottfried Kellers *Gesammelte Werke* (1889) und Goethes Ausgabe letzter Hand (1827–30)." In *Sprachen des Sammelns: Literatur als Medium und Reflexionsform des Sammelns*, edited by Sarah Schmidt, 513–527. Paderborn: Wilhelm Fink, 2016.

Amato, Joseph A. *Dust: A History of the Small and the Invisible*. Berkeley: University of California Press, 2000.

Amrein, Ursula. "Atheismus—Anthopologie—Ästhetik: Der 'Tod Gottes' und Transformationen des Religiösen im Prozess der Säkularisierung." In *Der grüne Heinrich: Gottfried Kellers Lebensbuch—neu gelesen*, edited by Wolfram Groddeck, 111–140. Zurich: Chronos, 2009.

Andermatt, Michael. "Kontingenz als Problem des bürgerlichen Realismus: Raumgestaltung bei Fontane und Keller." In *Gottfried Keller und Theodor Fontane: Vom Realismus zur Moderne*, edited by Ursula Amrein and Regina Dieterle, 41–61. Berlin: De Gruyter, 2008.

Arendt, Hannah. *The Human Condition*, 1958. 2nd ed. Chicago: University of Chicago Press, 1998.

Arnold, Sonja. *Erzählte Erinnerung: Das autobiographische Gedächtnis im Prosawerk Max Frischs*. Freiburg im Breisgau: Rombach Verlag, 2012.

Asendorf, Christoph. *Batteries of Life: On the History of Things and Their Perception in Modernity*. Berkeley: University of California Press, 1993.

Assmann, Aleida. "Die Sprache der Dinge: Der lange Blick und die wilde Semiose." In *Materialität der Kommunikation*, edited by Hans Ulrich Gumbrecht and K. Ludwig Pfeiffer, 237–251. Frankfurt am Main: Suhrkamp, 1988.

Assmann, David-Christopher, Norbert Otto Eke, and Eva Geulen, eds. *Entsorgungsprobleme: Müll in der Literatur*. Special issue, *Zeitschrift für deutsche Philologie* 133 (2014).

Auerswald, Bernhard. *Anleitung zum rationellen Botanisiren*. Leipzig: Verlag von Veir & Comp., 1860.

Aumont, Jacques. *L'œil interminable: Cinéma et peinture*. Paris: Librairie Seguier, 1989.

Aust, Hugo. "Apekte des Beschreibens und Verstehens von Handlungen: Zu Jeremias Gotthelfs *Die Wassernot im Emmental*." In *Formen realistischer Erzählkunst: Festschrift for Charlotte Jolles*, edited by Jörg Thunecke and Eda Sagarra, 93–98. Nottingham: Sherwood Press, 1979.

———. *Realismus*. Stuttgart: Metzler, 2006.

Barthes, Roland. *Camera Lucida: Reflections on Photography*. New York: Hill and Wang, 2010.

———. *Image. Music. Text*. Translated by Stephen Heath. New York: Hill and Wang, 1977.

Baudrillard, Jean. *The System of Objects*. London: Verso, 2005.

Baudry, Jean-Louis. "The Ideological Effects of the Basic Cinematographic Apparatus." *Film Quarterly* 28, no. 2 (1974–1975): 39–47.

Baumberger, Christa. *Resonanzraum Literatur: Polyphonie bei Friedrich Glauser*. Munich: Wilhelm Fink, 2006.

Belknap, Robert E. *The List: The Uses and Pleasures of Cataloguing*. New Haven, CT: Yale University Press, 2004.

Bellour, Raymond. "Concerning 'The Photographic.'" In *Still Moving: Between Cinema and Photography*, edited by Karen Beckman and Jean Ma, 253–276. Durham, NC: Duke University Press, 2008.

———. "The Film Stilled." *Camera Obscura* 24 (1990): 99–124.

Bembibre, Cecilia and Matija Strlič. "Smell of Heritage: A Framework for the Identification, Analysis and Archival of Historic Odours." *Heritage Science* 5, article no. 2 (2017): 1–11. https://doi.org/10.1186/s40494-016-0114-1.

Benjamin, Walter. *The Arcades Project*. Translated by Howard Eiland and Kevin McLaughlin. Cambridge, MA: Harvard University Press, 1999.

———. *Gesammelte Schriften*. Edited by Rolf Tiedemann and Hermann Schweppenhäuser. 7 vols. Frankfurt am Main: Suhrkamp, 1991.

———. *Origin of the German Trauerspiel*. Translated by Howard Eiland. Cambridge, MA: Harvard University Press, 2019.

------. *Selected Writings.* Volume 2, *1927–1934.* Edited by Michael W. Jennings, Howard Eiland, and Gary Smith. Cambridge, MA: Harvard University Press, 1999.

------. *Selected Writings.* Volume 3, *1935–1938.* Edited by Howard Eiland and Michael W. Jennings. Cambridge, MA: Harvard University Press, 2002.

Bennett, Jane. *Vibrant Matter: A Political Ecology of Things.* Durham, NC: Duke University Press, 2010.

Bergson, Henri. *Creative Evolution.* Translated by Arthur Mitchell. New York: Henry Holt, 1926.

BIBLIA, Das ist: Die gantze Heilige Schrifft, Alten und Neuen Testaments. Translated by Johannes Piscator. Bern: Bondeli, 1755.

Bies, Michael, Sean Franzel, and Dirk Oschmann, eds. *Flüchtigkeit der Moderne: Eigenzeiten des Ephemeren im langen 19. Jahrhundert.* Hannover: Wehrhahn Verlag, 2017.

Blaser, Klauspeter. "Totesfluten—Glaubensbrücken—Lebensströme: Theologische Anmerkungen zu Gotthelfs 'Die Wassernot im Emmental.'" In *Erzählkunst und Volkserziehung: Das literarische Werk des Jeremias Gotthelf,* edited by Walter Pape, Hellmut Thomke, and Silvia Serena Tschopp, 185–198. Tübingen: De Gruyter, 1999.

Blümlinger, Christa. "The Figure of Visual Standstill in R.W. Fassbinder's Films." In *Between Stillness and Motion: Film, Photography, Algorithm,* edited by Eivind Røssaak, 75–84. Amsterdam: University of Amsterdam Press, 2011.

Böhme, Hartmut. *Fetischismus und Kultur: Eine andere Theorie der Moderne.* Reinbek bei Hamburg: Rowohlt, 2012.

------. *Fetishism and Culture: A Different Theory of Modernity.* Translated by Anna Galt. Berlin: De Gruyter, 2014.

Braddock, Jeremy. *Collecting as Modernist Practice.* Baltimore: Johns Hopkins University Press, 2012.

Braungart, Georg. "'Katastrophen kennt allein der Mensch, sofern er sie überlebt': Max Frisch, Peter Handke und die Geologie." In *Figurationen der literarischen Moderne,* edited by Carsten Dutt and Roman Luckscheiter, 23–41. Heidelberg: Winter Verlag, 2007.

Broch, Hermann. *Die Schlafwandler,* 1931–1932, in *Kommentierte Werkausgabe,* vol. 1, edited by Paul Michael Lützeler. Frankfurt am Main: Suhrkamp, 1979.

------. *The Sleepwalkers.* Translated by Willa and Dewin Muir. New York: Vintage, 1996.

Brod, Max. "Der Dichter Franz Kafka." In *Juden in der deutschen Literatur,* edited by Gustav Krojanker, 55–62. Berlin: Welt-Verlag, 1922.

Brown, Bill. "Thing Theory." In *Things,* edited by Bill Brown, 1–22. Chicago: University of Chicago Press, 2004.

Buchan, Suzanne. *The Quay Brothers: Into a Metaphysical Playroom.* Minneapolis: University of Minnesota Press: 2011.

Buchberger, Reinhard, Gerhard Renner, and Isabella Wasner-Peter, eds. *Portheim: sammeln & verzetteln; Die Bibliothek und der Zettelkatalog des Sammlers*

Max von Portheim in der Wienbibliothek. Vienna: Wienbibliothek im Rathaus / Sonderzahl Verlagsgesellschaft, 2007.

Butler, Michael. "Max Frisch's *Man in the Holocene*: An Interpretation." *World Literature Today* 60, no. 4 (1986): 574–580.

Clifford, James. "On Collecting Art and Culture." In *The Predicament of Culture: Twentieth Century Ethnography, Literature, and Art*, 215–252. Cambridge, MA: Harvard University Press, 1988.

Cohen, Robert. "Zumutungen der Spätmoderne: Max Frischs 'Der Mensch erscheint im Holozän.'" *Weimarer Beiträge* 54, no. 4 (2008): 541–556.

Columella. *On Agriculture*, vol. 2. Cambridge, MA: Harvard University Press, 1954.

Cox, Christopher. *Sonic Flux: Sound, Art, and Metaphysics.* Chicago: University of Chicago Press, 2018.

Crane, Susan. *Collecting and Historical Consciousness in Early Nineteenth-Century Germany.* Ithaca: Cornell University Press, 2000.

Crauwels, Geert. "Über die sprachlose Sprache: Modi memoranda und Collage als Kompositionstechnik in *Der Mensch erscheint im Holozän.*" In *Max Frisch: Citoyen und Poet*, edited by Daniel de Vin, 106–199. Göttingen: Wallstein Verlag, 2011.

Crum, Howard. *Structural Diversity of Bryophytes.* Ann Arbor: University of Michigan Herbarium, 2001.

Curtis, Robin. *Conscientious Viscerality: The Autobiographical Stance in German Film and Video.* Berlin: Edition Imorde, 2006.

Darwin, Charles. *Origin of the Species*, 1859. Cambridge: Cambridge University Press, 2009.

Daston, Lorraine, ed. *Things that Talk: Object Lessons from Art and Science.* Cambridge, MA: MIT Press, 2004.

de Duve, Thierry. "Exposure and Snapshot: The Photograph as Paradox." *October* 5 (1978): 113–125.

Deleuze, Gilles. *Cinema 1: The Movement-Image.* Minneapolis: University of Minnesota Press, 2001.

Doane, Mary Ann. *The Emergence of Cinematic Time: Modernity, Contingency, the Archive.* Cambridge, MA: Harvard University Press, 2002.

Douglas, Mary. *Purity and Danger: An Analysis of Concepts of Pollution and Taboo*, 1966. 2nd ed. London: Routledge, 2002.

Downing, Eric. "Caves, Collections, Classics: Displacement in Wilhelm Raabe's *Das Odfeld.*" *Germanic Review* 94, no. 1 (2019): 1–15.

———. *The Chain of Things: Divinatory Magic and the Practice of Reading in German Literature and Thought, 1850–1940.* Ithaca: Cornell University Press, 2018.

———. *Double Exposures: Repetition and Realism in Nineteenth-Century German Fiction.* Stanford: Stanford University Press, 2000.

Dunwiddie, Peter. "The Study of Useless Things." *Sanctuary* 29, no. 4 (1990): 24.

Echte, Bernhard. "Nachwort." In Friedrich Glauser, *Matto regiert*, edited by Bernhard Echte, 251–263. Zurich: Unionsverlag, 1998

Eckel, Winfried. "Einzelgedichte 1902–1910." In *Rilke-Handbuch: Leben–Werk–Wirkung*, edited by Manfred Engel, 336–354. Stuttgart: Metzler, 2013.

Eggers, Michael. "Cryptogamic Kissing: Adalbert Stifter's Novella *Der Kuss von Sentze* (1866) and the Reproduction of Mosses." In *Biological Discourses: The Language of Science and Literature around 1900*, edited by Robert Craig and Ina Linge, 169–187. Oxford: Peter Lang, 2017.

Ehlbeck, Birgit. *Denken wie der Wald: Zur poetologischen Funktionalisierung des Empirismus in den Romanen und Erzählungen Adalbert Stifters und Wilhelm Raabes*. Bodenheim: Philo, 1998.

Elsner, John, and Roger Cardinal. Introduction to *The Cultures of Collecting*, edited by John Elsner and Roger Cardinal, 1–6. London: Reaktion, 1994.

Finkelde, Dominik. "Der nicht aufgehende Rest—zum Widerstreit zwischen Objekt und Ding in der Moderne." In *Sprachen des Sammelns: Literatur als Medium und Reflexionsform des Sammelns*, edited by Sarah Schmidt, 97–123. Paderborn: Wilhelm Fink, 2016.

———. "Tautologien der Ordnung: Zu einer Poetologie des Sammelns bei Adalbert Stifter." *German Quarterly* 80, no. 1 (2007), 1–19.

———. "Vergebliches Sammeln: Walter Benjamins Analyse eines Unbehagens im fin de siècle und der europäischen Moderne." *Arcadia: Internationale Zeitschrift für Literaturwissenschaft* 41, no. 1 (2006): 187–204.

———. "Wunderkammer und Apokalypse: Zu W. G. Sebalds Poetik des Sammelns zwischen Barock und Moderne." *German Life and Letters* 60, no. 4 (2007): 554–568.

Fischinger, Oskar. *München-Berlin Wanderung*. 35mm film print.

———. *Ten Films*. Center for Visual Music. DVD.

Fleming, Paul. *Exemplarity and Mediocrity: The Art of the Average from Bourgeois Tragedy to Realism*. Stanford: Stanford University Press, 2009.

Flusser, Vilém. *Dinge und Undinge: Phänomenologische Skizzen*. Munich: Hanser, 1993.

Foucault, Michel. *The Order of Things: An Archaeology of the Human Sciences*. New York: Pantheon, 1970.

Frahm, Jan-Peter, and Jens Eggers. *Lexikon deutschsprachiger Bryologen*. Norderstedt: Books on Demand, 2001.

Frank, Lawrence. *Victorian Detective Fiction and the Nature of Evidence: The Scientific Investigations of Poe, Dickens, and Doyle*. New York: Palgrave, 2004.

Frederick, Samuel. *Narratives Unsettled: Digression in Robert Walser, Thomas Bernhard, and Adalbert Stifter*. Evanston, IL: Northwestern University Press, 2012.

Frisch, Max. *Man in the Holocene*. Translated by Geoffrey Skelton. Champaign, IL: Dalkey Archive Press, 2007.

———. *Der Mensch erscheint im Holozän*. Frankfurt am Main: Suhrkamp, 1979.

Grätz, Katharina. *Musealer Historismus: Die Gegenwart des Vergangenen bei Stifter, Keller und Raabe*. Heidelberg: Universitätsverlag Winter, 2006.

Giesecke, Karl. "Über den Staub in den Kleidungsstücken und seine Bedeutung für die Kriminaluntersuchung." *Archiv für Kriminologie 75*, no. 14 (1923): 14–40.

Glauser, Friedrich. *Der alte Zauberer: Das erzählerische Werk; 1930–1933.* Edited by Bernhard Echte and Manfred Papst, vol. 2. Zurich: Unionsverlag, 2000.

———. *Briefe.* 2 vols. Edited by Bernhard Echte and Manfred Papst. Zurich: Unionsverlag, 2013.

———. *The Chinaman.* Translated by Mike Mitchell. London: Bitter Lemon Press, 2007.

———. *Der Chinese.* Edited by Rudolf Bussmann. Zurich: Unionsverlag, 1998.

———. *Fever.* Translated by Mike Mitchell. London: Bitter Lemon Press, 2006.

———. *Die Fieberkurve.* Edited by Julian Schütt. Zurich: Unionsverlag, 2013.

———. *Gesprungenes Glas: Das erzählerische Werk; 1937–1938.* Edited by Bernhard Echte, vol. 4. Zurich: Unionsverlag, 2001.

———. *Gourrama.* Edited by Bernhard Echte. Zurich: Unionsverlag, 2013.

———. *In Matto's Realm.* Translated by Mike Mitchell. London: Bitter Lemon Press, 2005.

———. *Matto regiert.* Edited by Bernhard Echte. Zurich: Unionsverlag, 1998.

———. *Schlumpf Erwin Mord.* Edited by Walter Obschlager. Zurich: Unionsverlag, 1998.

———. *Die Speiche (Krock & Co.).* Edited by Bernhard Echte. Zurich: Unionsverlag, 1999.

———. *The Spoke.* Translated by Mike Mitchell. London: Bitter Lemon Press, 2008.

———. *Der Tee der drei alten Damen.* Edited by Mario Haldemann. Zurich: Unionsverlag, 2005.

———. *Thumbprint.* Translated by Mike Mitchell. London: Bitter Lemon Press, 2004.

Goergen, Jeanpaul. "Oskar Fischinger in Germany: 1900 to 1936." In *Oskar Fischinger 1900–1967: Experiments in Cinematic Abstraction*, edited by Cindy Keefer and Jaap Guldemond, 42–49. Amsterdam: EYE Filmmuseum and Center for Visual Music, 2013.

Gotthelf, Jeremias. *The Black Spider.* Translated by Susan Bernofsky. New York: New York Review Books, 2013.

———. *Sämtliche Werke in 24 Bänden [und 18 Ergänzungsbänden].* Edited by Rudolf Hunziker and Hans Bloesch. Erlenbach-Zurich: Eugen Rentz Verlag, 1921–1977.

Gross, Hans. *Handbuch für Untersuchungsrichter als System der Kriminalistik*, vol. 1, 5th rev. ed. Munich: J. Schweizer Verlag, 1908.

Grote, Andreas, ed. *Macrocosmos in Microcosmo: Die Welt in der Stube; Zur Geschichte des Sammelns 1450–1800.* Wiesbaden: Springer Fachmedien, 1994.

———"Vorrede—Das Objekt als Symbol." In *Macrocosmos in Microcosmo: Die Welt in der Stube; Zur Geschichte des Sammelns 1450–1800*, edited by Andreas Grote, 11–17. Wiesbaden: Springer Fachmedien, 1994.

Groys, Boris. *Logik der Sammlung am Ende des musealen Zeitalters*. Munich: Hanser, 1997.

Gunning, Tom. "An Aesthetic of Astonishment: Early Film and the (In)credulous Spectator." In *Film Theory and Criticism: Introductory Readings*, edited by Leo Braudy and Marshall Cohen, 818–832. Oxford: Oxford University Press, 1999.

———. "Before Documentary: Early Nonfiction Films and the 'View' Aesthetic." In *Uncharted Territory: Essays on Early Nonfiction Film*, edited by Daan Hertogs and Nico de Klerk, 9–24. Amsterdam: Stichting Nederlands Filmmuseum, 1997.

———. "What's the Point of an Index? Or, Faking Photographs." In *Still Moving: Between Cinema and Photography*, edited by Karen Beckman and Jean Ma, 23–40. Durham, NC: Duke University Press, 2008.

Häntzschel, Günter. *Sammel(l)ei(denschaft): Literarisches Sammeln im 19. Jahrhundert*. Würzburg: Königshausen & Neumann, 2014.

Hart, Gail K. *Readers and Their Fictions in the Novels and Novellas of Gottfried Keller*. Chapel Hill: University of North Carolina Press, 1989.

Heidegger, Martin. *Being and Time*. Translated by John Macquarrie and Edward Robinson. New York: Harper and Row, 1962.

———. "Das Ding (1950)." In *Vorträge und Aufsätze*, edited by Friedrich-Wilhelm von Hermann. Vol. 7, *Gesamtausgabe*, 165–188. Frankfurt am Main: Klostermann, 2000.

———. *Feldweg-Gespräche*. Edited by Ingrid Schüßler. Vol. 77, *Gesamtausgabe*. Frankfurt am Main: V. Klostermann, 1995.

———. *Poetry, Language, Thought*. Translated by Albert Hofstadter. New York: Harper & Row, 1971.

———. *Sein und Zeit*. 17th ed. Tübingen: Max Niemeyer, 1993.

———. "Der Ursprung des Kunstwerkes." In *Holzwege*, 1–74. Frankfurt am Main: V. Klostermann, 1994.

Hofmeister, Wilhelm. *Vergleichende Untersuchung der Keimung, Entwickelung und Fruchtbildung höherer Kryptogamen (Moose, Farrn, Equisetaceen, Rhizocarpeen und Lycopodiaceen) und der Samenbildung der Coniferen*. Leipzig: Verlag von Friedrich Hofmeister, 1851.

Holl, Hanns Peter. "Über Gotthelfs *Die Wassernot im Emmental am 13. August 1837*." In *Katastrophen und ihre Bewältigung: Perspektiven und Positionen*, edited by Christian Pfister and Stephanie Summermatter, 43–51. Bern: Haupt Verlag, 2004.

Impey, Oliver, and Arthur MacGregor, eds. *The Origins of Museums: The Cabinet of Curiosities in Sixteenth- and Seventeenth-Century Europe*. Oxford: Oxford University Press, 1986.

Kaiser, Gerhard. "Ein Blick in Kellers Bestarium." In *Dichtung als Sozialisationsspiel: Studien zu Goethe und Keller*, edited by Gerhard Kaiser and Friedrich Kittler, 125–134. Göttingen: Vandenhoeck & Ruprecht, 1978.

———. *Gottfried Keller: Das gedichtete Leben*. Frankfurt am Main: Insel Verlag, 1981.

Kaiser, Michael. *Adalbert Stifter: Eine literaturpsychologische Untersuchung seiner Erzählungen.* Bonn: Bouvier, 1971.

Karolle, K. Julia. "The Role of Language in the Construction of Identity and the Swiss Crime in Friedrich Glauser's *Gourrama, Der Tee der Drei alten Damen,* and *Schlumpf Erwin Mord.*" PhD diss., University of Wisconsin, Madison, 2001.

Kaulen, Heinrich. "Rettung." In *Benjamins Begriffe,* edited by Michael Opitz and Erdmit Wizisla, 619–664. Frankfurt am Main: Suhrkamp: 2000.

Keller, Gottfried. *Green Henry.* Translated by A. M. Holt. London: John Calder, 1985.

———. *Der grüne Heinrich: Erste Fassung.* Edited by Thomas Böning and Gerhard Kaiser. Vol. 2, *Sämtliche Werke in fünf Bänden.* Frankfurt am Main: Deutscher Klassiker Verlag, 1985.

———. *Der grüne Heinrich: Zweite Fassung.* Edited by Peter Villwock. Vol. 3, *Sämtliche Werke in fünf Bänden.* Frankfurt am Main: Deutscher Klassiker Verlag, 1996.

Kimmerer, Robin Wall. *Gathering Moss: A Natural and Cultural History of Mosses.* Corvallis: Oregon State University Press, 2003.

Kirby, Lynne. *Parallel Tracks: The Railroad and Silent Cinema.* Durham, NC: Duke University Press, 1997.

Kniesche, Thomas. *Einführung in den Kriminalroman.* Darmstadt: Wissenschaftliche Buchgesellschaft, 2015.

Köhn, Eckhardt. "Sammler." In *Benjamins Begriffe,* edited by Michael Opitz and Erdmut Wizisla, 695–724. Frankfurt am Main: Suhrkamp, 2000.

Koselleck, Reinhart. "'Neuzeit': Remarks on the Semantics of Modern Concepts of Movement." In *Futures Past: On the Semantics of Historical Time,* translated by Keith Tribe, 222–254. New York: Columbia University Press, 2004.

Krajewski, Markus. *Paper Machines: About Cards and Catalogs, 1548–1929.* Cambridge, MA: MIT Press, 2011.

Kreienbrock, Jörg. *Malicious Objects, Anger Management, and the Question of Modern Literature.* New York: Fordham University Press, 2012.

Kubelka, Peter. "The Theory of Metrical Film." In *The Avant-Garde Film: A Reader of Theory and Criticism,* edited by P. Adams Sitney, 139–159. New York: New York University Press, 1978.

Leslie, Esther. *Hollywood Flatlands: Animation, Critical Theory and the Avant-Garde.* London: Verso, 2002.

Linnaeus, Carolus. *Systema naturae, 1735.* Facsimile of the first edition. Nieuwkoop: B. de Graaf, 1964.

Liston, Andrew. *The Ecological Voice in Recent German-Swiss Prose.* Oxford: Peter Lang, 2011.

Locard, Edmond. "The Analysis of Dust Traces, Part I." *American Journal of Police Science* 1, no. 3 (May–June 1930): 276–298.

Louth, Charlie. *Rilke: The Life of the Work.* Oxford: Oxford University Press, 2020.

MacLeod, Catriona. *Fugitive Objects. Sculpture and Literature in the German Nineteenth Century.* Evanston, IL: Northwestern University Press, 2014.

Mainberger, Sabine. *Die Kunst des Aufzählens: Elemente zu einer Poetik des Enumerativen.* Berlin: De Gruyter, 2003.

Maleuvre, Didier. *Museum Memories: History, Technology, Art.* Stanford: Stanford University Press, 1999.

Malkmus, Bernhard. "'Man in the Anthropocene': Max Frisch's Environmental History." *PMLA* 132, no. 1 (2017): 71–85.

Marclay, Christian. *Record without a Cover.* Recycled Records, 1985. Phonograph Record.

Marder, Michael. *Dust.* New York: Bloomsbury, 2016.

Marquard, Odo. "Wegwerfgesellschaft und Bewahrungskultur." In *Macrocosmos in Microcosmo: Die Welt in der Stube; Zur Geschichte des Sammelns 1450–1800,* edited by Andreas Grote, 909–918. Wiesbaden: Springer Fachmedien, 1994.

Marx, Karl. *Capital: A Critique of Political Economy,* vol. 1. Translated by Ben Fowkes. London: Penguin, 1990.

Mazzara, Federica. "Objects, Debris and Memory of the Mediterranean Passage: *Porto M* in Lampedusa." In *Border Lampedusa: Subjectivity, Visibility and Memory in Stories of Sea and Land,* edited by Gabriele Proglio and Laura Odasso, 153–173. Cham, Switzerland: Palgrave Macmillan, 2018.

McHale, Brian. *Postmodernist Fiction.* London: Routledge, 1987.

McIsaac, Peter M. *Museums of the Mind: German Modernity and the Dynamics of Collecting.* University Park: Pennsylvania State University Press, 2007.

Mendelson, Lois. *Robert Breer: A Study of his Work in the Context of the Modernist Tradition.* Ann Arbor, MI: UMI Research Press, 1981.

Moretti, Franco. "Serious Century." In *The Novel.* Volume 1, *History, Geography, and Culture,* edited by Franco Moretti, 364–400. Princeton: Princeton University Press, 2006.

Moritz, William. *Optical Poetry: The Life and Work of Oskar Fischinger.* Bloomington: University of Indiana Press, 2002.

Müller, Claudia. *"Ich habe viele Namen": Polyphonie und Dialogizität im autobiographischen Spätwerk Max Frischs und Friedrich Dürrenmatts.* Munich: Wilhelm Fink, 2009.

Müller, Karl. *Deutschlands Moose oder Anleitung zur Kenntniss der Laubmoose Deutschlands, der Schweiz, der Niederlande und Dänemarks.* Halle: G. Schwetschke'scher Verlag, 1853.

Muschg, Walter. "Einleitung des Herausgebers." In *Werke in zwanzig Bänden,* by Jeremias Gotthelf, edited by Walter Muschg, 15:vii–xxiii. Basel: Verlag Birkhäuser, 1951.

——. "Jeremias Gotthelf. Sein Leben und seine Dichtung." In *Werke in zwanzig Bänden,* by Jeremias Gotthelf, edited by Walter Muschg, 1:5–60. Basel: Verlag Birkhäuser, 1951.

O'Brien, Martin. *A Crisis of Waste? Understanding the Rubbish Society.* London: Routledge, 2007.

Obschlager, Walter. "Man, Culture, and Nature in Max Frisch's *Der Mensch erscheint im Holozän.*" In *A Companion to the Works of Max Frisch*, edited by Olaf Berwald, 197–210. Rochester: Camden House, 2013.

——. "Risse: Kleiner Versuch, einer Spur im Werk Max Frischs nachzugehen." In *Leben gefällt mir: Begegnungen mit Max Frisch*, edited by Daniel de Vin, 51–57. Brussels: Literarischer Treffpunkt, 1992.

Ogden, J. Gordon. *The Kingdom of Dust*. Chicago: Popular Mechanics, 1912.

Orlando, Francesco. *Obsolete Objects in the Literary Imagination: Ruins, Relics, Rarities, Rubbish, Uninhabited Places, and Hidden Treasures*. New Haven, CT: Yale University Press, 2006.

Pangritz, Andreas. "Theologie." In *Benjamins Begriffe*, edited by Michael Opitz and Erdmut Wizisla, 774–825. Frankfurt am Main: Suhrkamp, 2000.

Pazzini, Karl-Josef. "'Das kleine Stück des Realen': Das Museum als 'Schema' (Kant) und als Medium." In *Open Box: Künstlerische und wissenschaftliche Reflexionen des Museumsbegriffs*, edited by Michael Fehr, 312–322. Cologne: Wienand, 1998.

Pearce, Susan M. *On Collecting: An Investigation into Collecting in the European Tradition*. London: Routledge, 1995.

Peterson, Jennifer Lynn. *Education in the School of Dreams: Travelogues and Early Nonfiction Film*. Durham: Duke University Press, 2013.

——. "Travelogues and Early Nonfiction Film: Education in the School of Dreams." In *American Cinema's Transitional Era: Audiences, Institutions, Practices*, edited by Charlie Keil and Shelley Stamp, 191–213. Berkeley: University of California Press, 2004.

Pfeifer, Annie. "A Collector in a Collectivist State: Walter Benjamin's Russian Toy Collection." *New German Critique* 45, no. 1 (2018): 49–78.

Pickar, Gertrud Bauer. "'Es wird nie eine Pagode': Max Frisch's *Der Mensch erscheint im Holozän.*" *Seminar* 19, no. 1 (1983), 33–56.

Plumpe, Gerhard, ed. *Theorie des bürgerlichen Realismus*. Stuttgart: Reclam, 1985.

Pomian, Krzysztof. *Collectors and Curiosities: Paris and Venice, 1500–1800*. Cambridge: Polity Press, 1990.

Popp, Georg. "Die Mikroskopie im Dienste der Kriminaluntersuchung." *Archiv für Kriminologie* 70, no. 149 (1918): 149–156.

Preisendanz, Wolfgang. *Wege des Realismus: Zur Poetik und Erzählkunst im 19. Jahrhundert*. Munich: Wilhelm Fink, 1977.

Preuss, Matthias. "How to Disappear Completely: Poetics of Extinction in Max Frisch's *Man in the Holocene.*" In *Texts, Animals, and Environments: Zoopoetics and Ecopoetics*, edited by Frederike Middlehoff, 253–265. Freiburg im Breisgau: Rombach, 2019.

Ragg-Kirkby, Helena. *Adalbert Stifter's Late Prose: The Mania for Moderation*. Rochester, NY: Camden House, 2000.

Richter, Gerhard. "Critique and the Thing: Benjamin and Heidegger." In *Sparks Will Fly: Benjamin and Heidegger*, edited by Andrew Benjamin and Dimitris Vardoulakis, 27–63. Albany: SUNY Press, 2015.

Rilke, Rainer Maria. *Duino Elegies.* Translated by Edward Snow. New York: North Point Press, 2000.

———. *Werke: Kommentierte Ausgabe in vier Bänden.* Edited by Manfred Engel, Ulrich Fülleborn, Horst Nalewski, and August Stahl. Frankfurt am Main: Wissenschaftliche Buchgesellschaft, 1996.

Roads, Esme, Royce E. Longton, and Peter Convey. "Millennial Timescale Regeneration in a Moss from Antarctica." *Current Biology* 24, no. 6 (2014): R222–R223. https://doi.org/10.1016/j.cub.2014.01.053.

Roose, Kerstin. "'Herzensmuseen' und 'Kammern der Merkwürdigkeiten': Konnotationen des Plunders bei Wilhelm Raabe, Friedrich Gerstäcker und Gottfried Keller." In *Die Grenzen der Dinge: Ästhetische Entwürfe und theoretische Reflexionen materieller Randständigkeit,* edited by Lis Hansen, Kerstin Roose, and Dennis Senzel, 59–85. Wiesbaden: Springer VS, 2018.

———. "Zwischen 'unseligen Resten' und literaturfähigen 'Abfällseln': Spuren einer Poetologie des Plunders im Werk Gottfried Kellers." In *Entsorgungsprobleme: Müll in der Literatur,* edited by David-Christopher Assmann, Norbert Otto Eke, and Eva Geulen, 175–196. Special issue, *Zeitschrift für deutsche Philologie* 133 (2014).

Rosenstock, Martin. "An Atmosphere of Malaise: Failures of Detection in Friedrich Glauser's *Matto regiert* (1936)." *German Quarterly* 94, no. 1 (2021): 99–115.

Saner, Gerhard. *Friedrich Glauser: Eine Biographie.* Zurich: Suhrkamp, 1981.

Schmidt, Sarah. "Fremdeigene Wortreste—Spache als Sammlung in Herta Müllers Collagen." In *Sprachen des Sammelns: Literatur als Medium und Reflexionsform des Sammelns,* edited by Sarah Schmidt, 593–620. Paderborn: Wilhelm Fink, 2016.

———, ed. *Sprachen des Sammelns: Literatur als Medium und Reflexionsform des Sammelns.* Paderborn: Wilhelm Fink, 2016.

Schneider, Sabine. "Vergessene Dinge: Plunder und Trödel in der Erzählliteratur des Realismus." In *Die Dinge und die Zeichen: Dimensionen des Realistischen in der Erzählliteratur des 19. Jahrhunderts,* edited by Sabine Schneider and Barbara Hunfeld, 157–174. Würzburg: Königshausen & Neumann, 2008.

Scholem, Gershom. *Die jüdische Mystik in seinen Hauptströmungen.* Frankfurt am Main: Alfred Metzner, 1957.

———. *Major Trends in Jewish Mysticism.* New York: Schocken Books, 1941.

Selge, Martin. *Adalbert Stifter: Poesie aus dem Geist der Naturwissenschaft.* Stuttgart: W. Kohlhammer, 1976.

Senzel, Dennis. "Makulatur." In *Handbuch Literatur & Materielle Kultur,* edited by Susanne Scholz and Ulrike Vedder, 422–424. Berlin: De Gruyter, 2018.

Serres, Michel. *Malfeasance: Appropriation through Pollution?* Translated by Anne-Marie Feenberg-Dibon. Stanford: Stanford University Press, 2011.

Shklovsky, Viktor. *Theory of Prose.* Normal, IL: Dalkey Archive Press, 1990.

Sitney, P. Adams. *Visionary Film: The American Avant-Garde 1943–2000.* 3rd ed. Oxford: Oxford University Press: 2002.

Soćko, Joanna. "Objects Don't Lie: The Truth and Things in Detective Stories." In *Materiality and Popular Culture: The Popular Life of Things*, edited by Anna Malinowska and Karolina Lebek, 157–166. New York: Routledge, 2017.

Sommer, Manfred. *Sammeln: Ein philosophischer Versuch.* Frankfurt am Main: Suhrkamp, 1999.

Sontag, Susan. *On Photography*, 1977. Reprint, New York: Picador, 2001.

Steemans, Philippe, Alain Le Hérissé, John Melvin, Merrell A. Miller, Florentin Paris, Jacques Vernier, and Charles H. Wellman. "Origin and Radiation of the Earliest Vascular Land Plants." *Science* 324, no. 5925 (2009): 353.

Sternberg, Michael P. "The Collector as Allegorist: Goods, Gods, and the Objects of History." In *Walter Benjamin and the Demands of History*, edited by Michael P. Sternberg, 88–118. Ithaca: Cornell University Press, 1996.

Stewart, Susan. *On Longing: Narratives of the Miniature, the Gigantic, the Souvenir, the Collection*, 1984. Reprint, Durham, NC: Duke University Press, 1993.

Stifter, Adalbert. "Preface to *Many-Colored Stones.*" In *German Novellas of Realism*, edited by Jeffrey L. Sammons, 1–6. New York: Continuum, 1989.

———. *Sämtliche Erzählungen nach den Erstdrucken.* Edited by Wolfgang Metz. Munich: Deutscher Taschenbuch Verlag, 2005.

———. *Werke und Briefe: Historisch-Kritische Gesamtausgabe.* Edited by Alfred Doppler and Wolfgang Frühwald. Stuttgart: W. Kohlhammer, 1978–.

Stingelin, Martin. "Das 'Unvermessbare': Berechenbarkeit versus Unwägbarkeit; Alphonse Bertillon, Hans Gross, Edmond Locard und Rudolf Archibald Reiss in den Kriminalromanen Friedrich Glausers." In *Anthropometrie: Zur Vorgeschichte des Menschen nach Maß*, edited by Gert Theile, 125–138. Munich: Wilhelm Fink, 2005.

Stobbe, Urte. "Evolution und Resignation: Zur Verbindung von Klima-, Erd- und Menschheitsgeschichte in Max Frischs *Der Mensch erscheint im Holozän.*" *Zeitschrift für Germanistik* 24, no. 2 (2014): 357–370.

Stocking, George W., Jr. *Objects and Others: Essays on Museums and Material Culture.* Madison: University of Wisconsin Press, 1988.

Thomas, Ronald. *Detective Fiction and the Rise of Forensic Science.* New York: Cambridge University Press, 1999.

Trentmann, Frank. *Empire of Things: How We Became a World of Consumers, from the Fifteenth Century to the Twenty-first.* New York: Harper Collins, 2016.

Twellmann, Marcus. "Literarische Osculologie nach Adalbert Stifter: 'Der Kuß von Sentze.'" *Zeitschrift für deutsche Philologie* 128, no. 4 (2009): 531–544.

Utz, Peter. *Kultivierung der Katastrophe: Literarische Untergangsszenarien aus der Schweiz.* Munich: Wilhelm Fink, 2013.

———. "Redeströme, Bilderbrücken, Schriftschwellen: Gotthelfs 'Wassernot im Emmental' in literarischer Sicht." In *Erzählkunst und Volkserziehung: Das literarische Werk des Jeremias Gotthelf*, edited by Walter Pape, Hellmut Thomke, and Silvia Serena Tschopp, 171–183. Tübingen: Niemeyer, 1999.

——. "Robert Walser's *Jakob von Gunten*: A 'Zero' Point of German Literature." In *Robert Walser: A Companion*, edited by Samuel Frederick and Valerie Heffernan, 143–169. Evanston, IL: Northwestern University Press, 2018.

Vedder, Ulrike. "Alexander Kluges Museumspoetik." *Alexander Kluge-Jahrbuch* 6 (2019): 81–95.

——. "'einige sonderbare Abfällsel': Gottfried Kellers verlustreiches Schreiben." In *Ökonomien der Armut: Soziale Verhältnisse in der Literatur*, edited by Elke Brüns, 143–156. Munich: Wilhelm Fink, 2008.

——. "Poetik des Sammelns." *Museumskunde* 78 (2013): 8–15.

——. "Zwischen Depot und Display: Museumstechniken in der Literatur des 19. Jahrhunderts." In *Archiv/Fiktionen: Verfahren des Archivierens in Literatur und Kultur des langen 19. Jahrhunderts*, edited by Daniela Gretz and Nicolas Pethes, 35–49. Freiburg im Breisgau: Rombach, 2016.

Vedder, Ulrike, Gisela Ecker, and Martina Stange, eds. *Sammeln—Ausstellen—Wegwerfen*. Königstein/Ts.: Helmer, 2001.

Vico, Giambattista. *The New Science of Giambattista Vico: Unabridged Translation of the Third Edition (1744)*. Translated by Thomas Goddard Bergin and Max Harold Fisch. Ithaca: Cornell University Press, 1988.

von Matt, Peter. "Die Fäulnis hinter den Fassaden: Über Friedrich Glauser." In *Die tintenblauen Eidgenossen: Über die literarische und politische Schweiz*, 220–224. Munich: Hanser, 2001.

Wallace, Alfred Russel. "The Importance of Dust: A Source of Beauty and Essential to Life." In *The Wonderful Century: Its Successes and Its Failures*, 69–85. London: Swan Sonenschein, 1898.

Waters, William. "The *New Poems*." In *The Cambridge Companion to Rilke*, edited by Karen Leeder and Robert Vilain, 59–73. Cambridge: Cambridge University Press, 2010.

——. *Poetry's Touch: On Lyric Address*. Ithaca: Cornell University Press, 2003.

Weber, Christoph. "Gottes lebendige Predigt: Katastrophendarstellung und -deutung in Jeremias Gotthelfs *Die Wassernot im Emmental*." *Euphorion: Zeitschrift für Literaturgeschichte* 106, no. 4 (2012): 415–437.

Weidmann, Heiner. *Flanerie, Sammlung, Spiel: Die Erinnerung des 19. Jahrhunderts bei Walter Benjamin*. Munich: Wilhelm Fink, 1992.

Weingartner, Rolf, and Thomas Reist. "Gotthelfs 'Wassernot im Emmental'—Hydrologische Simulation des Extremwassers vom 13. August 1837." In *Katastrophen und ihre Bewältigung: Perspektiven und Positionen*, edited by Christian Pfister and Stephanie Summermatter, 21–41. Bern: Haupt Verlag, 2004.

Westerwinter, Margret. *Museen erzählen: Sammeln, Ordnen und Repräsentieren in literarischen Texten des 20. Jahrhunderts*. Bielefeld: Transcript, 2008.

Windon, Katrina. "The Right to Decay with Dignity: Documentation and the Negotiation between an Artist's Sanction and the Cultural Interest." *Art Documentation: Journal of the Art Libraries Society of North America* 31, no. 2 (September 2012): 142–157.

Wolfendale, Peter. *Object-Oriented Philosophy: The Noumenon's New Clothes.* Falmouth: Urbanomic, 2014.

Yacavone, Kathrin. *Benjamin, Barthes and the Singularity of Photography.* New York: Continuum, 2012.

Yates, Frances. *The Art of Memory*, 1966. Reprint, Chicago: University of Chicago Press, 2001.

Young, Rob. "Don't Sleeve Me This Way." *The Guardian*, February 14, 2005. http://www.theguardian.com/music/2005/feb/14/popandrock.

Zeller, Christoph. "Magisches Museum: Aspekte des Sammelns in der Literatur des 19. Jahrhunderts." *Jahrbuch der Raabe-Gesellschaft* (2005): 74–103.

INDEX

CPSIA information can be obtained
at www.ICGtesting.com
Printed in the USA
LVHW031151211221
706818LV00003B/382